# RODIN

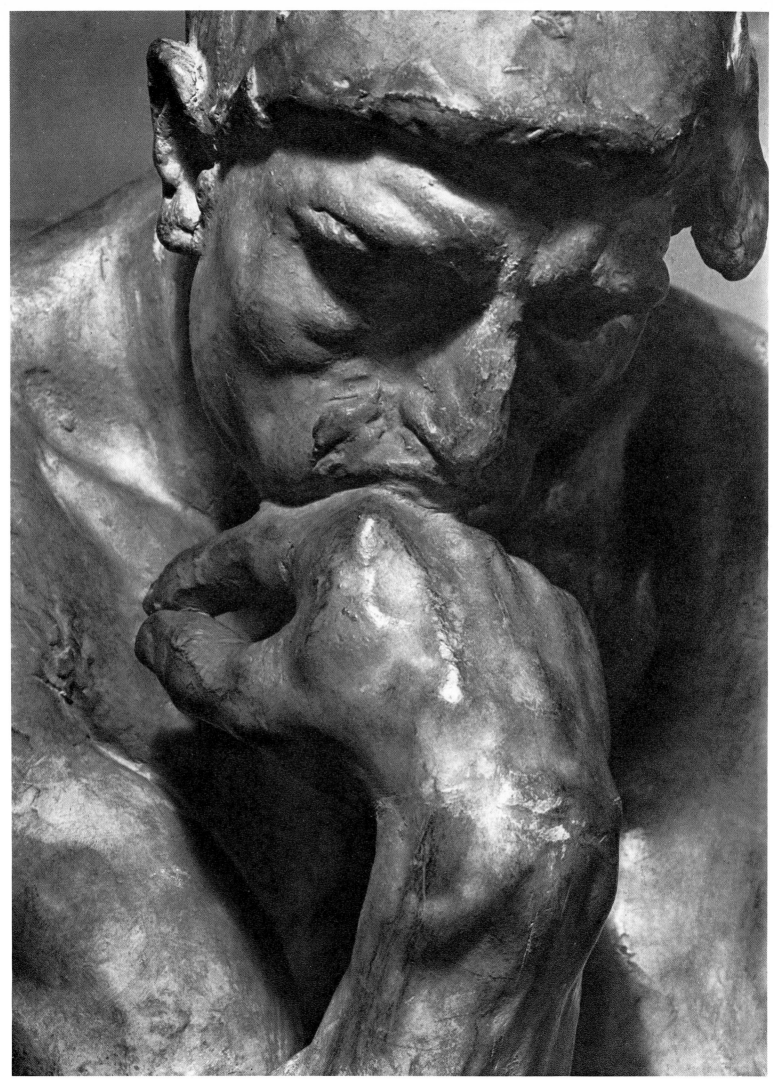

THE THINKER. DETAIL OF PLATE 16.

# Rodin

## SCULPTURES

Selected by Ludwig Goldscheider

Photographed by Ilse Schneider-Lengyel

Introduced by Sommerville Story

# PHAIDON

Phaidon Press Limited, Littlegate House, St. Ebbe's Street, Oxford, OX1 1SQ

First published 1939
Ninth edition 1979
Second impression 1985

ISBN 0 7148 1946 8 hardback
ISBN 0 7148 2024 5 paperback

Printed in Spain by Heraclio Fournier, S.A. Vitoria

# Auguste Rodin and his Work

EVERY GREAT THINKER is a mystery and a puzzle to his contemporaries. Auguste Rodin was not only the greatest sculptor since Michelangelo, but he was the greatest thinker in stone of modern times, perhaps ever since the prehistoric age when men first began to think it possible to shape in stone the presentments of living things. Who will venture to contemplate his wonderful collection of groups, figures and busts, and not require some guidance in the master's meaning? There is the great art and the technique, than which none are more remarkable, and behind these there is the soul in his work. How are we to read that soul?

The Burghers of Calais, for instance (Pl. 41). This is not merely a group of six men marching off to execution, but every man in the group is alive with character and with a meaning which those who will may read. The St. John has a significance different from the mystical figures of the Prophet with which centuries of religious art have familiarized us. So with his Venuses, his allegorical figures, his Naiads, his studies of men (and one is struck with how much more frequently, in comparison with some other sculptors, he depicts the force of man rather than the grace of woman). And his Balzac (Pls. 63-7)—was it without deep thought that such a man represented the author of the 'Comédie Humaine' as he did, in a way that set all the critics and dilettantes agog? Rodin himself realized that his meaning was sometimes hard to fathom. "I am," he said once, "like the Roman singer who replied to the yells of the populace, 'Equitibus cano'—I only sing for the knights" (that is, for the select few). All great thinkers and artists have felt this at times. Yet Rodin contradicted this, as he was right to do, when he left all his work to the nation with a view to helping others to attain education in art. He knew that nothing great and durable can really be for the few, either in art or in any other manifestation of human activity, and Rodin is for the world, as he wished to be.

## RODIN'S LIFE

AUGUSTE RODIN was a Parisian, born in a working-class quarter, close to the Latin Quarter—No. 3, rue de l'Arbalète—on November 12, 1840. His father, Jean-Baptiste Rodin, a native of Normandy, born at Yvetot, a modest office employee at the time his son was born, later became an inspector at the Prefecture of Police. His mother, Marie Cheffer, was from Lorraine. The family seems to have been very united and highly religious. Rodin was the younger of two children. His sister, who was two years older than he, became a nun, but died in 1862 after a short illness. He had been

greatly attached to her, and her death caused him much grief and suffering. In spite of the modesty of the family's position, the two children were brought up and educated with great care, the girl Marie at a convent and Auguste first at the friars' school in the Val-de-Grâce quarter and afterwards at Beauvais, at a school founded by his uncle, a man of considerable culture who had taken up teaching as a profession and succeeded in making an interesting position for himself. Auguste remained with his uncle until his fourteenth year.

The child's taste for drawing was already so pronounced that his father placed him then at the school of drawing and mathematics in the Rue de l'École de Médecine. This institution was known as the 'little school', to distinguish it from the official Fine Arts School; it was especially intended for the education of young artisans going in for artistic industries. No higher future was thought of for the boy at that time. The director of this school was a man named Belloc, but there was also a professor, Lecocq de Boisbaudran, who has left behind him a great name not as artist but as teacher, for he created a remarkable system of teaching drawing by the training of the memory, and thus helped to form a number of famous artists. Among his pupils were Fantin-Latour, Cazin, Legros, Lhermitte, the sculptor Dalou and the medallist Chaplain. There was another professor, a sculptor named Fort, who also had great influence over young Rodin, who in fact in later years declared that he owed his vocation to him. The youth also studied at the Gobelins school, where there was a professor named Lucas, for whom he expressed almost equal gratitude. These men all doubtless discovered in the studious and earnest young fellow the qualities that form an artist. As his bent became evident, it was decided to consult a sculptor named Maindron, who then enjoyed a considerable reputation. His verdict being favourable, young Rodin gave in his name at the École des Beaux-Arts. He was rejected three times.

Then for some years he earned money by exercising various crafts more or less allied to the sculptor's profession—moulder, ornamenter, goldsmith, and so on, all the time gathering valuable experience for his career of an artist. At the age of twenty-three Rodin, impelled by grief at the death of his beloved sister, took religious vows and entered the monastery of the Eudistes, in the Faubourg St. Jacques. This devotional impulse, however, did not last long, and five or six months afterwards he returned home. A little later he united his life to Rose Beuret, the faithful companion who was by his side for fifty years and only predeceased him by a few months.

In 1864 Rodin started to follow the lessons of Barye, the animal sculptor (1795–1875), who was an admirable and powerful artist, but as a teacher is said to have lacked enthusiasm. Then he entered the studio of Carrier-Belleuse (1824–87), another sculptor of great talent, a pupil of David d'Angers, and remained as assistant to him more or less for six years. But although Rodin called himself the pupil of both these artists, in order to conform to the rules of the Salon, he only followed the public

lectures of the one and was the employee of the other. Up to that time, the known works by Rodin are very few, except several commercial orders, which were commissioned, such as the Caryatids of the Gobelins theatre, the chimney piece of the Gaîté Theatre, decorative reliefs in the Long Gallery of the Louvre Museum (Salle de Rubens), etc. There is a bust of his father (Pl. 1), which according to a legend in the family was made when he was seventeen, but which Rodin himself said dated from a year or two before his next work—the bust of Father Eymard (Pl. 2), the superior of the Societas Sanctissimi Sacramenti, to whom the young man became greatly attached during his short stay at the monastery. The date of this work was 1863. It is not surprising that this excellent priest, for whose memory Rodin always felt a great veneration, soon felt that the young man's true vocation was not the cloister. He arranged a studio for him, and after a while gently urged him to change his views and go home. This bust shows great powers of observation, fidelity to and comprehension of nature. The third work known is the famous 'Man with the broken nose' (Pl. 3), which he sent to the Salon and which was refused.

During the siege of Paris Rodin remained in the city and shouldered a gun as a National Guard. But in February 1871, having been judged unfit for military service, he went with Carrier-Belleuse to Belgium, with the idea of continuing to work beside him. But a dispute or misunderstanding arose, and Rodin left him and joined the Belgian sculptor Van Rasbourg, who continued the decoration of the Stock Exchange at Brussels begun by the French artist, and also worked on the Palais des Académies. He did work also on his own account, and in 1875 (a year in which he made a first timid appearance at the Salon with two busts), having put by a little money, he carried out a long nurtured ambition to go to Italy and study the works of Donatello and of Michelangelo. But his resources, naturally, were modest and he did not stay long. Most of his time was spent at Florence and Rome, but he also visited Venice and Naples. He came back enthusiastic and filled with the influence of the two great masters.

His next work shows the influence of Donatello, although it was sufficiently original to make the young sculptor immediately famous and to arouse a remarkable controversy. This was the statue first called 'Man awakening to Nature', now known as the 'Age of Brass'. Some of his confrères and critics professed to see in this work an imposture, and accused him of taking a mould from Nature. It led to the first scandal of Rodin's career (it was followed by numerous others), and the young sculptor was defended in a collective protest signed by a number of sculptors and painters. The State soon afterwards repaired the offence by acquiring the bronze of the incriminated statue, and a third-class medal was awarded to the sculptor. A little later, too, the State acquired his St. John the Baptist (Pl. 6), which was placed in the Luxembourg. The appearance of these two works brought him a great many new friends in the artistic and intellectual worlds. About this time Rodin was working at the decoration of the

## 'The Gate of Hell'

Trocadéro Palace, Paris (now demolished), with the sculptor Legrain, and he modelled a number of terracotta busts in the style and manner of the eighteenth century. Then the Under-Secretary for Fine Arts, as an *amende honorable* for the aspersions that had been cast on him, offered him the choice of a State command. Rodin, still burning with enthusiasm from his Italian studies, asked to be allowed to execute a door for the future Museum of Decorative Arts, and, inspired by Dante, chosè for his subject 'The Gate of Hell' (Pls. 8-16).

In 1877 Rodin returned to Paris, where he settled definitely after making a tour of France to visit the Cathedrals. It was the first of several such tours, for, like his great predecessor, Michelangelo, Rodin was intensely interested in cathedral and other architecture. He dreamed at one time indeed of being an architect, and during his various journeys was fond of studying architectural details, sketching and taking notes. (In the year 1910 his book 'Les Cathédrales de France' was published, illustrated with drawings by him.) Like some of his great predecessors, he touched various branches of art and shone in all—portraiture, landscape, etching, and even ceramics; for when he was employed for a time at the State Porcelain Manufactory at Sèvres (1879–82, with his old chief Carrier-Belleuse) he made several highly creditable vases. His journeys in France, therefore, like his trip to Italy, left a deep impression on him. On the occasion of a visit he made to Marseilles to work on the Fine Arts Palace, with an artist named Fourquet, he was greatly struck with the Greek type of beauty of the women in the Provençal towns.

The order for the 'Gate of Hell' was confirmed in 1880, and Rodin started work on it. This enormous task occupied and fascinated him for over twenty years, and on it he expended all the varied sides of his stupendous genius. As with all his other work, its chief characteristic is life in movement. It contains some 186 virile or graceful figures in all the phases of anguish, terror or voluptuousness. The famous statue of 'The Thinker' (which at first he called 'The Poet': Pls. 14-16) was to command and contemplate all these varied scenes. For a long time this was the work on which Rodin concentrated all his best energies; he made hundreds of drawings and models for it. Later on he seemed to tire of it or at any rate, he criticized his own conceptions; and for some years he used it as a sort of reservoir from which to evoke the varied forms of his work. It may be said indeed that nearly all his passionate figures came from the Gate. But in later years again he returned to this great work and set about the task of getting it definitely fixed in marble and bronze. It was never, however, completely finished.

About 1882 a studio was placed at Rodin's disposal free of charge by the Government in the State marble repository in the Rue de l'Université. During these years numbers of his works were shown at the Salon—for instance, St. John preaching (Pl. 6), the Creation of Man, Ugolino (Pl. 21), and the busts of J. P. Laurens (Pl. 18), Legros (Pl. 17), Dalou (Pl. 25), Victor Hugo and others. It was in these years that the

sculptor came to know some of the leading literary men of the age, such as Alphonse Daudet and the Goncourts. In 1880 he competed for the monument of the National Defence to be erected at Courbevoie, at the gates of Paris, where a great stand of the French had taken place in 1871, when they were defeated. The work he sent in, 'The Genius of War', was not selected, as it was judged to be 'too ferocious'. This monument was chosen in 1916 by a Dutch committee who wished to offer a monument to the city of Verdun to commemorate the heroic defence of that place, which had gone far towards crushing the attempt made against the liberties of humanity. Rodin presented the work to the committee, and they accepted it with enthusiasm. In 1883 he received an order for an equestrian statue of General Lynch for South America. In 1884 the town of Calais opened a competition for a monument in memory of Eustache de St. Pierre, the historic burgher who had delivered the keys of the town to the English King. Rodin competed, and instead of a single figure he showed the hero accompanied by five of his companions in misfortune (Pls. 36-45). He obtained the order for the work, though not without difficulty, and devoted ten years of study and labour to it. The monument was inaugurated in 1895, and again it aroused criticism and discussion.

All or nearly all Rodin's greater works led to intense and often bitter controversies. Such were the Claude Lorrain, executed for Nancy in 1889, and erected in 1892; the Victor Hugo, which was refused by the commission because the sculptor had made a seated figure instead of an erect one, as was required for the architectural ensemble (See Pl. 65 and note). The seated statue was, however, placed in the Luxembourg and the Minister of the day ordered a Victor Hugo erect for the Panthéon. It was the same with the monument he made of President Sarmiento, of the Argentine Republic, for Buenos Aires. But the most bitter controversy of all was over the famous Balzac monument, which was ordered by the Société des Gens de Lettres and was exhibited at the Salon of 1898 (Pls. 63-4, 66-7). The society refused the work. The president, the poet Jean Aicard, in disgust at this decision, resigned; the statue was returned to the artist's studio at Meudon, and the order was passed on to Falguière. In London again the committee who had ordered from Rodin a monument to Whistler did not accept it.

Nevertheless there were those who recognized and acclaimed the genius of the artist, and these, whether French or foreign, were enthusiastic. Among other valuable testimonies to his worth about this time, a group of admirers contributed in 1886 for the casting of 'The Kiss' (Pl. 49). Critics like Gustave Geffroy and Octave Mirbeau supported him with their pens during this most difficult period. His portraits, as the late Léonce Bénédite, curator of the Rodin museum in Paris, remarked, would alone have brought fame to any other artist—such works as the busts of Madame Rodin (Pls. 59, 62), Carrier-Belleuse, Dalou, Puvis de Chavannes, Henri Rochefort.

# Late Works · Rodin's Death

For England he did the busts of Henley, the poet, who was then editor of the 'Magazine of Art', George Wyndham, Bernard Shaw (Pls. 78-80), Lord Howard de Walden, Mrs. Hunter, Lady Sackville, Lady Warwick, and Miss Fairfax. For America his busts included those of Mr. Harriman, Mrs. Simpson, Mrs. Potter Palmer, Mr. Kay and Mr. Ryan. It was owing to the last-named gentleman's initiative and generosity that the Rodin collection at the Metropolitan Museum in New York was inaugurated.

The monument to Bastien Lepage was erected at Damvilliers (Meuse) in 1889. In this year during the Universal Exibition, a number of his works were shown at the Georges Petit gallery in Paris. These included the Perseus and Gorgon and the Danaïd (Pl. 34), among his most recently completed subjects (besides the Galatea, Walkyrie, the Fall of a Soul into Hades, Perseus, St. George, Bellona, St. John, the Burghers of Calais, the Thinker, Bastien Lepage, and others). The result was highly satisfactory for the sculptor. In the same year the foundation of the Société Nationale des Beaux-Arts, in which he occupied a prominent position, assured Rodin's status as the chief of a school. An exhibition held in a special pavilion in the Place de l'Alma in 1900 constituted a veritable triumph for him. Tardy fame had now begun to catch him up. His 'Thinker' was made the object of a subscription among his admirers, who offered it to the people of Paris, and it was placed, in 1906, in front of the Panthéon. Four reliefs made for the villa of Baron Vitta at Evian were shown at the Luxembourg museum in 1905. Altogether forty-two of his works were shown at the Luxembourg.

The one great passion which filled the career of this man of great genius was work, and his life was filled with it. It was indeed scarcely interrupted except for a few journeys to Belgium, England and Rome. In 1903 he went to Prague to attend an exhibition of his work. Temptations were held out to induce him to go to America, but he could never make up his mind. In later years he regretted that he had never been to Greece. Among his latest works were busts of the Duc de Rohan and Georges Clemenceau (Pl. 91), and of Pope Benedict XV, done at Rome in 1915. The last work of all was the bust of M. Etienne Clémentel, then Minister of Commerce (Pl. 90). In 1916 the sculptor was struck down by illness and had to take to his bed. He recovered slowly, but had to give up all work. He then began to set his artistic property in order and to occupy himself with the Rodin Museum. His beloved wife on February 13, 1917, died and, never recovering from this blow, Rodin himself succumbed on November 17, 1917. He was buried in the garden of his villa at Meudon, with a replica of the 'Thinker' watching over the grave.

All that last summer he scarcely left his villa at Meudon, where he lived surrounded by two lady cousins who looked after him, by M. Léonce Bénédite, and one or two other devoted friends. Occasionally, but with increasing rarity, he would go to the

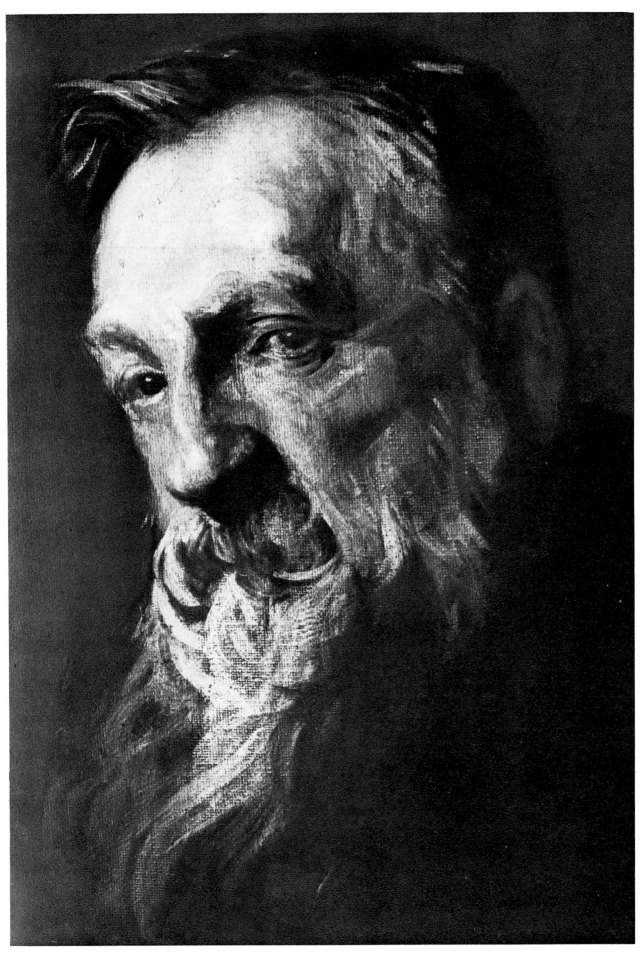

AUGUSTE RODIN

DETAIL FROM A PORTRAIT BY JACQUES-EMILE BLANCHE

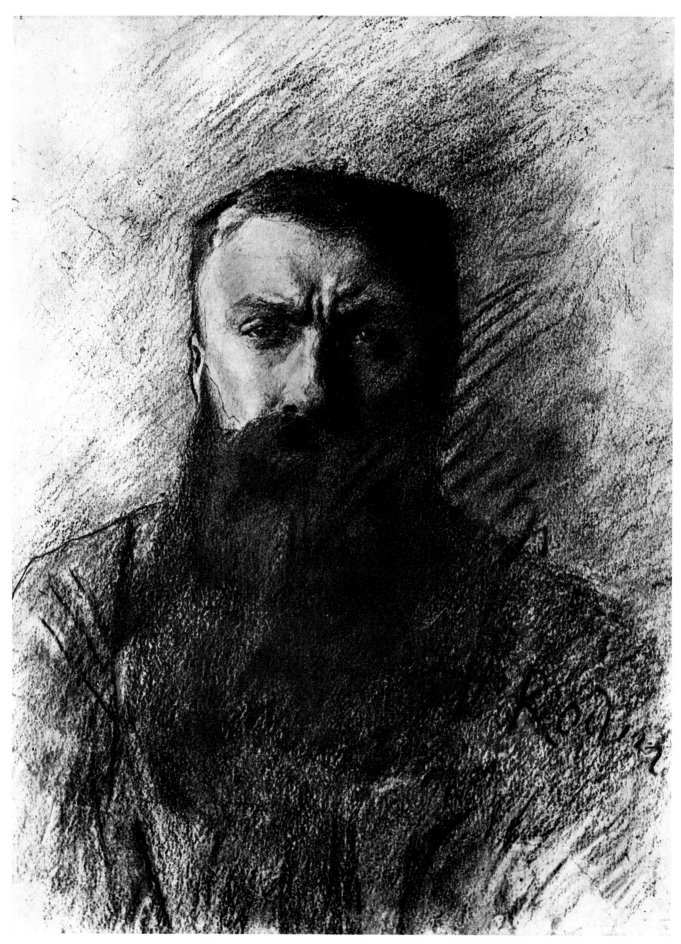

SELF-PORTRAIT OF RODIN. DRAWING

Hôtel Biron (the Rodin Museum) or make up a little party with one or two friends. He showed himself affectionate and gay, and grateful for all attentions, his old combative spirit seeming to have left him.

Rodin was singularly indifferent to worldly honours, the only distinction he desired being the recognition of his work. Academical honours he never sought, but he keenly appreciated the approval of his foreign admirers, and the distinctions conferred on him by foreign bodies, such as the doctorate *honoris causa* given him by Oxford.

Rodin, as his friend Camille Mauclair described him, was of medium stature, with an enormous head on a massive trunk; prominent nose, flowing grey beard, and small bright eyes, in which there was the appearance of shortsightedness with a gentle irony. The impression of power in the man was emphasized by the rolling gait from his haunches, the 'rocky' aspect of the troubled brow under rough bushy hair, the bony aquiline nose and ample beard. This impression, however, was partly contradicted by the reticent fold of the mouth, the quick regard, which was at once penetrating, malicious and naive ("one of the most complex I have ever seen", adds M. Mauclair), and above all by the husky voice, modulated with difficulty and mixed with grave inflexions. He appeared simple, precise, reserved, courteous and cordial without excess. By degrees his timidity would give place to a tranquil and simple authority. He showed neither over-emphasis nor awkwardness, and his general manner was rather sad than inspired. An immense energy seemed to issue from his sober and measured gestures. The slowness and apparent embarrassment of his speech and the pauses in his conversation gave it particular significance.

In the presence of one of his works Rodin had a way of explaining it which was elliptical but clear. He said what was essential, finishing his words with a gesture. He used to contemplate his creations lovingly, and sometimes even seemed to be astonished and contemplative at the idea of having created them, speaking as if they existed apart from himself. Gradually under Rodin's simplicity were discovered qualities that had at first been hidden; he was ironical, sensual, nervous and proud. In himself were found *in posse* all the passions he expressed with such troubled magnificence, and one began to understand the secret bonds between this calm man and the art he revealed. He was the companion of these white mute creatures of his, he loved them and entered into their abstract lives, and had moral obligations towards them. They were his sole preoccupation. He was restrained in the expression of his ideas and opinions and rather summary in his dealings with people. His cordiality gave the impression that he wished to have done quickly with social duties. Very capable of friendship, he limited it to a tacit understanding on the essential subjects of thought; he had less faith in individuals than in general ideas. Devoted to his work as he was, he only tolerated other things with polite boredom, and had a horror of discussions or of being disturbed.

As to bad artists, he took no notice of them—he did not criticize them. He endured all the violent discussions and all the unjust criticism heaped on his own works without saying anything, for he was too proud to discuss the matter. At the time of the Balzac quarrel, his friends advised him to fight, since the terms of his contract were entirely to his advantage. But he thanked them for the advice and withdrew his statue without saying a word.

This was not weakness, for Rodin's life had been a hard one. It arose from the dignity of his inner being and indifference to the passing phases of life. He cared for few things, but those few he was much attached to. Reading but little, he was intense in his admiration of certain authors. One of these was Baudelaire. He was passionately fond of music, especially Gluck, but rarely talked of it.

He simplified all things in his life and disliked all that was unessential. When one knew him well it was impossible to separate him from his work. His statues were the states of his soul. Just as Rodin seemed to break the fragments around the statue away from the block in which it had been concealed, so he himself seemed to be a sort of rock hiding various forms and crystallized growths. For him work lovingly accomplished was the secret of happiness, and to love life and natural forms, and do nothing to outrage Nature's laws, was all his morality. He seemed to be isolated in his time by his genius as well as by the character of his artistic conception, but in reality this isolation was only apparent. After his years of hard struggle and neglect or contumely he had become a master to whom young artists looked up. As the artist Pierre Roche expressed it, he had 'opened a vast window in the pale house of modern statuary, and had made of sculpture, which had been a timid, compromised art, one that was audacious and full of hope'.

# RODIN'S WORK

WORK WAS THE LAW of Rodin's life, and his career was one long-sustained effort. No man ever worked harder, and there are few who have any idea of his vast output over a long life. With the passion of genius, and an insatiable desire to create, he had the patience of a monk of the Middle Ages. Towards the end of his life he declared that he was only just beginning to understand the laws of sculpture. He was often criticized or ridiculed on account of the length of time he took over his work, but this arose from excessive conscientiousness. "A work even when finished is never perfect," he would say. He spent five years in modelling the two female statues that represent the Muses in his Victor Hugo statue. Over the 'Balzac' he spent seven years, and as it was leaving his studio he regretted that he could not keep it with him still a while so as to add touches which he thought would help to perfect it. He warned

youthful workers against believing in inspiration and told them they would achieve nothing except by hard work, In later years he was, in fact, apt to underrate the rôle of inspiration in artistic work, and would contemptuously call such talk 'a dream'. Work was to him the true religion. But inspiration represented something else to Rodin; and he liked to keep a work by him so that he could, as he contemplated it long after others might have considered it finished, make touches here and there suggested by sudden ideas of improvement. He has been compared to one of those nameless artificers of the Middle Ages who spent all their lives in chiselling the figures round a cathedral; but in the general breadth of his character and his sympathies he was a descendant of the Greeks, with the naturalism of the Greeks allied to deep religious sentiment.

No artist ever understood the conditions of matter or the laws of plastic like Rodin. For long he oscillated, as he himself said, between the influence of Michelangelo and that of Phidias, the Christian and the pagan—the expressive and the plastic. Finally his allegiance lay between the Greeks and the Gothic. Follow nature, was his watch-word all through his life. He was intensely imbued with the mystery of Nature and the freshness of the art of the ancients.

He would not admit the existence of ugliness in nature. "That which one commonly calls ugliness in nature may in art become great beauty," he would say. "As it is simply the power of character which makes beauty in art," he explained on one occasion, "it often happens that the more a creature is ugly in nature, the more it is beautiful in art. In art only those things that are characterless are ugly—such as have no beauty without or within. For the artist worthy of the name all is beautiful in nature, because his eyes boldly accepting all truth shown outwardly, read the inner truth as in an open book. That which is ugly in art is that which is false and artificial—that which aims at being pretty or even beautiful instead of being expressive"—in other words, that which is mannered, all parade, without soul and without truth. To disguise or attenuate the facts of Nature in order to please the undiscerning was for him the work of an inferior artist. One sees in works like the 'St. John' (a simple peasant, though an illuminated one, as it were, with his mouth open) and the 'Burghers of Calais' (simple rough men, nude under their 'sack' shirts, and with nothing heroic about them either in face or posture) how implacably he insists upon the absolute interpretation of nature, refusing to sacrifice anything to conventional ideas of beauty. No sculptor understood better than he all the possibilities of the nude. He used to draw comparisons between the modelling of a body and that of a landscape.

Up to his thirtieth year Rodin was almost exclusively engaged in helping to carry out the work of others. But he was all the time learning, and those long years of apprenticeship were invaluable in giving him varied experience in the study of effects in grouping and dexterity in the use of the sculptor's tools, while they afforded him

## Rodin's Use of Models

endless opportunities for the criticism of defects. In his Brussels experiences he had the advantage of doing work on a large scale out of doors, and of observing the effects of climate on sculpture, and how each figure appeared under the changing aspects of the day. He early realized that the spontaneous attitudes of the living model are the only ones that should be represented in statuary, and that any attempt to dictate gesture or pose must destroy the harmonious relation existing between the various parts of the body. In the observance of this law primarily resided the superiority of antique over modern sculpture. Another of his discoveries was that as, under the suggestion of successive impulses, the outlines of the body are continually changing—muscles swelling or relaxing in a sort of rhythmic flow or ripple—the sculptor has ample opportunity of choosing the reliefs and curves that most faithfully and most effectively interpret the pose they accompany.

Rodin's method of working, writes Paul Gsell, was singular. He had in his studio a number of nude models, men and women, in movement or reposing. Rodin paid them to supply him constantly with the picture of nudity in various attitudes and with all the liberty of ordinary life. He was constantly looking at them, and thus was always familiar with the spectacle of muscles in movement. Thus the nude, which to-day people rarely see, and which even sculptors only see during the short period of the pose, was for Rodin an ordinary spectacle. Thus he acquired that knowledge of the human body unclothed which was common to the Greeks through constant exercise in sports and games, and learned to read the expression of feeling in all parts of the body. The face is usually regarded as the only mirror of the soul, and mobility of features is supposed to be the only exteriorization of spiritual life. But in reality there is not a muscle of the body which does not reveal thoughts and feeling.

So when Rodin caught a pose that pleased him and that seemed expressive—the delicate grace of a woman raising her arms to arrange her hair or inclining the bust to lift something, or the nervous vigour of a man walking—he wanted the pose kept, then quickly he seized his implements and a model was made, and then just as swiftly he passed to another. Herein is shown the difference between Rodin's method in watching for the attitudes of nature and that of so many of his contemporaries, who pose their models on pedestals and arrange the positions they wish them to assume as if they were lay figures. It was never his habit, as we have seen, to undertake a work, complete it, and have done with it. He always had by him a number of ideas and thoughts on which he meditated patiently for years as they ripened in his mind.

It was after 1900, when his reputation was firmly established, that Rodin conceived the daring idea of exhibiting human figures (such as 'Meditation', 'The Walking Man', etc.) deprived of a head, legs or arms, which at first shock the beholder, but on examination are found to be so well balanced and so perfectly harmonized that one

can only find beauty in them. And his reason for this is artistically profound, though it might be thought that it was pushing the 'religion of art' to extremes. In the development of a leading idea—of thought, of meditation, of the action of walking, his desire was to eliminate all that might counteract or draw attention from this central thought. "As to polishing nails or ringlets of hair, that has no interest for me," he said; "it detracts attention from the leading lines and the soul which I wish to interpret." Nevertheless he did not by any means underestimate the technique of his art. Though he regarded it as only a means to an end, he said the artist who neglects it will never attain his object, which is the interpretation of feelings and ideas. "One must have a consummate sense of technique," he said, "to hide what one knows."

On one occasion he told Paul Gsell of a valuable lesson in the science of modelling which he had received from a certain Constant, who worked in the studio where he started as a sculptor. He was one day watching him modelling a capital with foliage in clay, and said, "Rodin, you are going about that badly. All your leaves look flat—that's why they don't seem real. Make them so that some of them will be shooting their points out at you. Then on seeing them one will have the sense of depth. Never look at forms in extent but in depth. Never consider a surface except as the end of a volume, and the more or less broad point which it directs towards you." He followed this valuable advice and discovered later that the ancients had practised exactly this method of modelling; hence the vigour and suppleness of their works.

The influence of Michelangelo on Rodin was great, as we have seen. He made copies at one time of some of Rubens' pictures from memory, so deeply had he studied them. He also declared that from Rembrandt he had learned much in the way of chiaroscuro in sculpture. Later he was interested in Japanese art, which the Goncourt brothers did so much to popularize in France; the attitudes of some of his models are said to have been suggested by Japanese paintings. But all forms of art interested him—Egyptian, Aztec, Far Eastern, or French eighteenth century, and he was always learning. He used to say that a visit to the Louvre affected him like beautiful music or a deep emotion and incited him to renewed efforts. Rodin was particularly interested in the depiction of elemental natures. His mind harked back to the origins of things, and over and over again he represented beings that were blossoming into humanity from primitive or elemental conditions, creatures that are not very distant from the nature in which they have grown—part animal, part human, or such as have sprung from trees, fountains and the material of elemental life. For him, as for the early Greeks, all Nature was teeming with semi-human form: he saw dryads in the woods and nereids in the streams and their physical natures and aspect differed but little from the elements that gave them birth. Numbers of his creatures are issuing from matter, others are assimilated with trees, with rocks or the earth itself. Nature being the source of all life, it seems as if he could hardly conceive of life removed from this source of energy.

# Plates

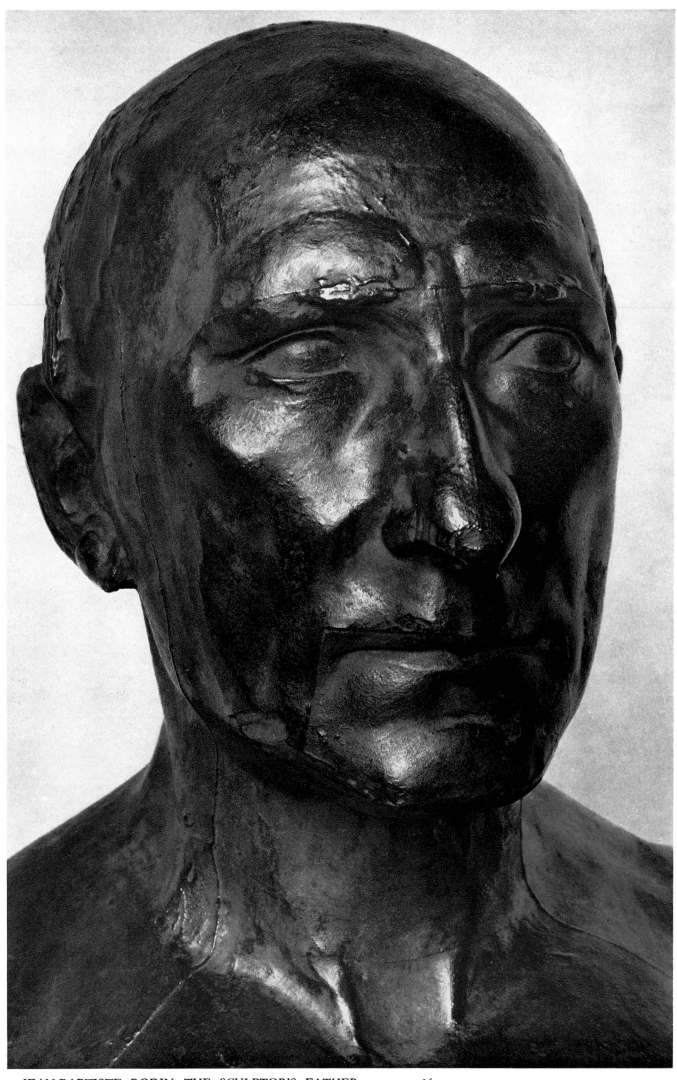

1. JEAN-BAPTISTE RODIN, THE SCULPTOR'S FATHER. BRONZE. 1860.

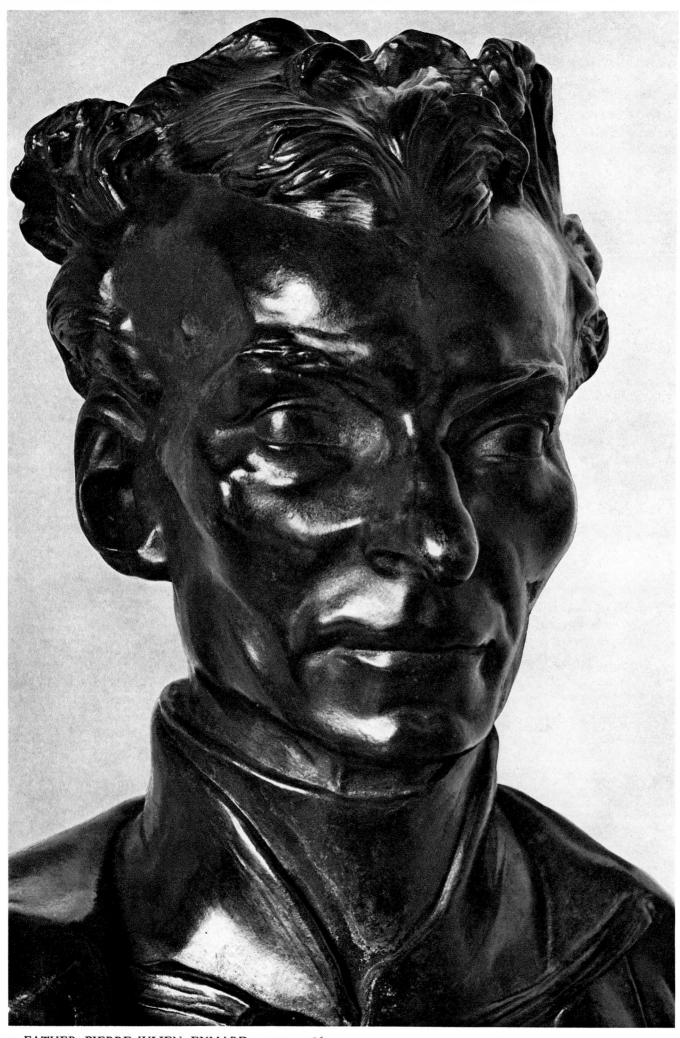

2. FATHER PIERRE-JULIEN EYMARD. BRONZE. 1863.

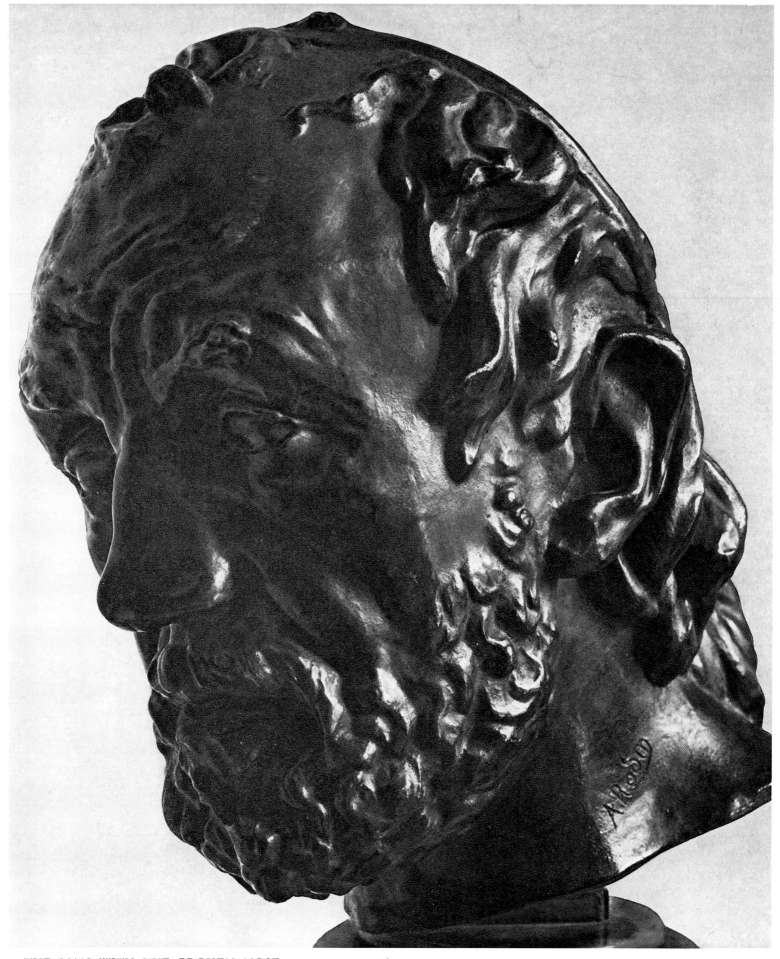

3. THE MAN WITH THE BROKEN NOSE. BRONZE MASK. 1864.

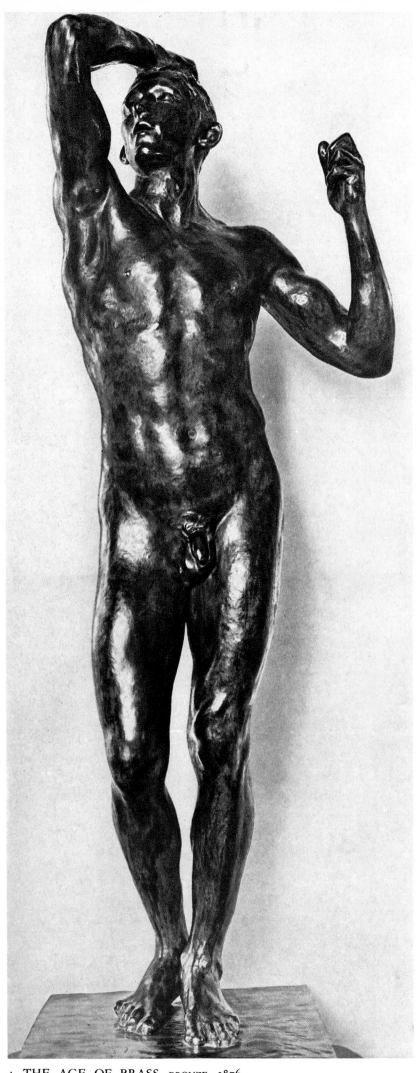

4. THE AGE OF BRASS. BRONZE. 1876.

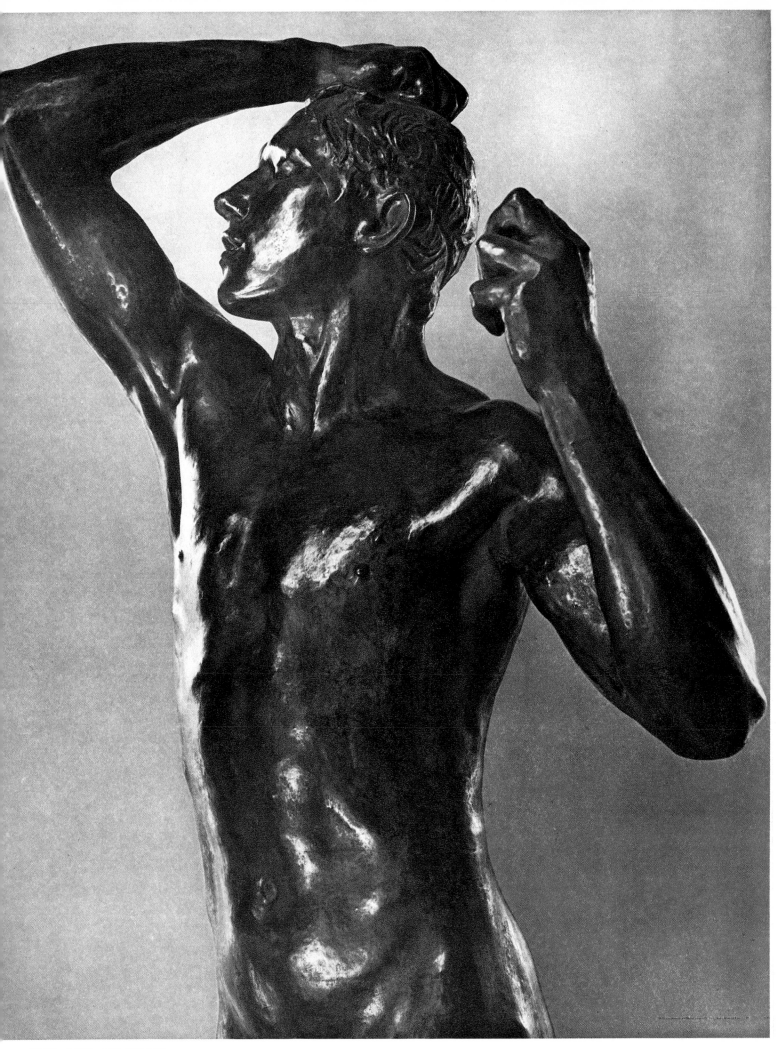

5. THE AGE OF BRASS. DETAIL.

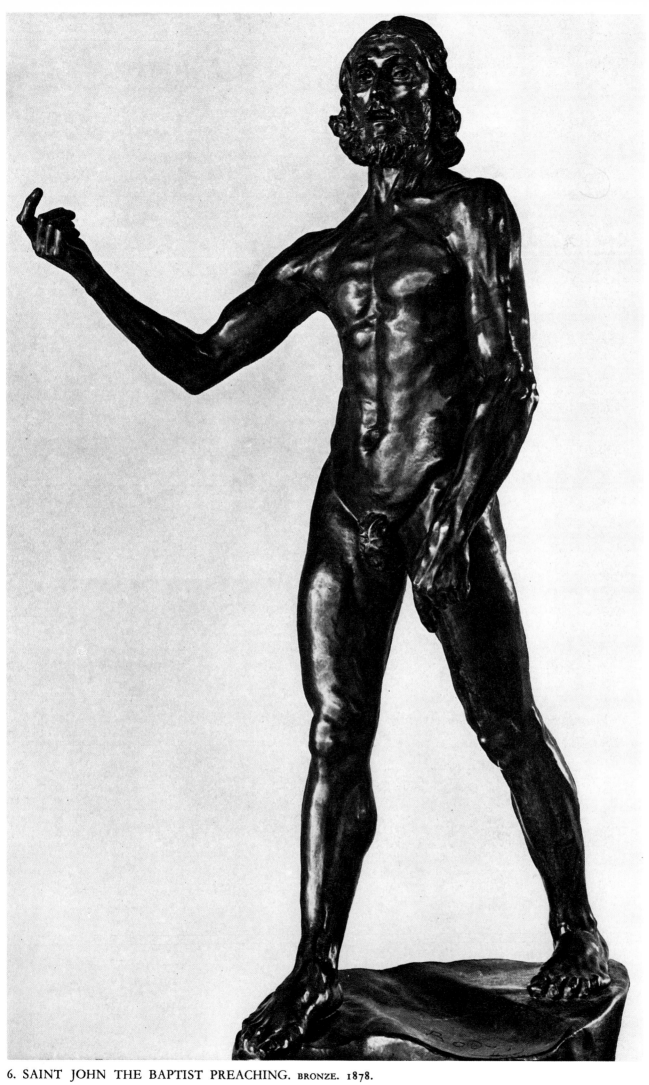

6. SAINT JOHN THE BAPTIST PREACHING. BRONZE. 1878.

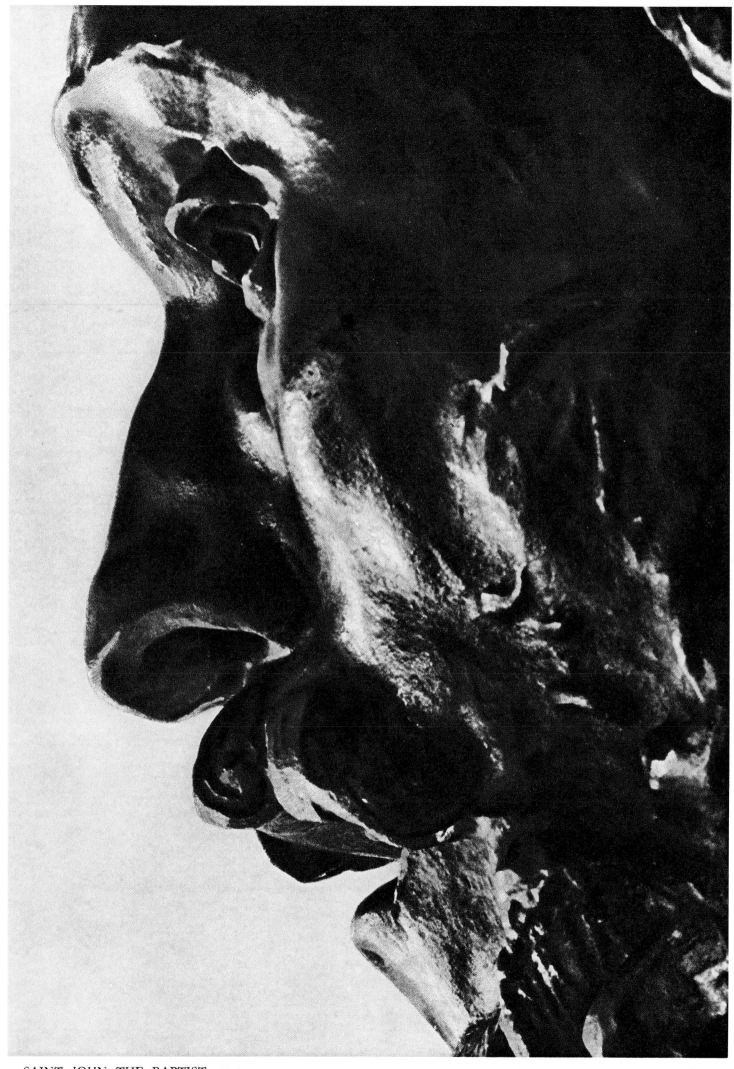

7. SAINT JOHN THE BAPTIST. DETAIL.

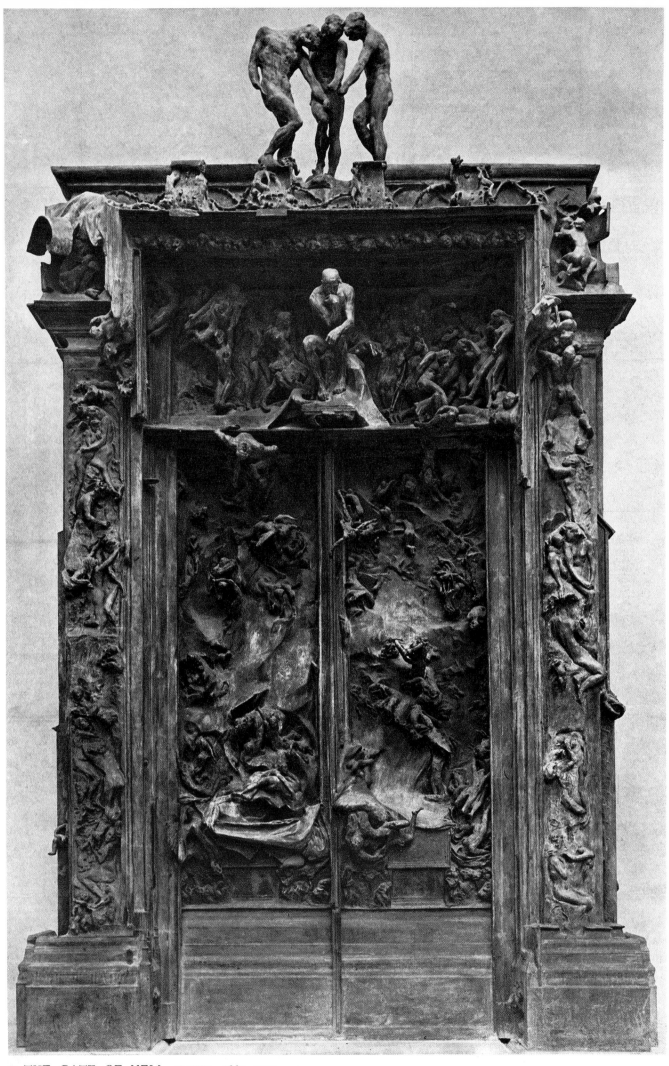

8. THE GATE OF HELL. BRONZE. 1880-1917.

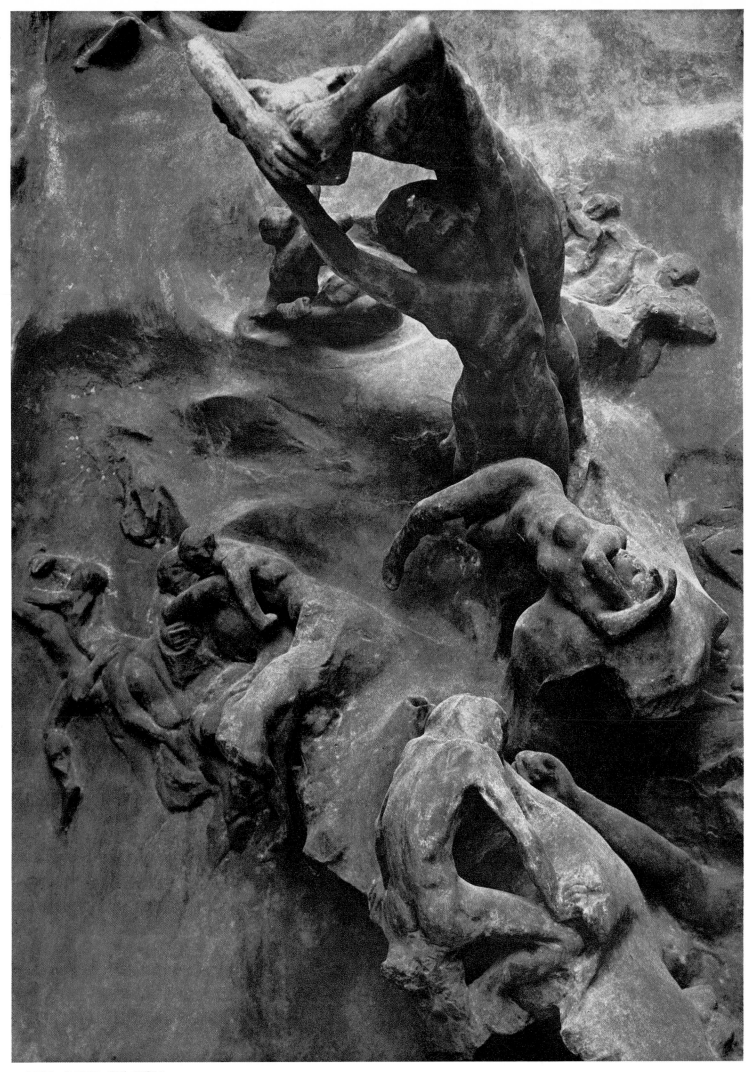

9. THE GATE OF HELL. DETAIL.

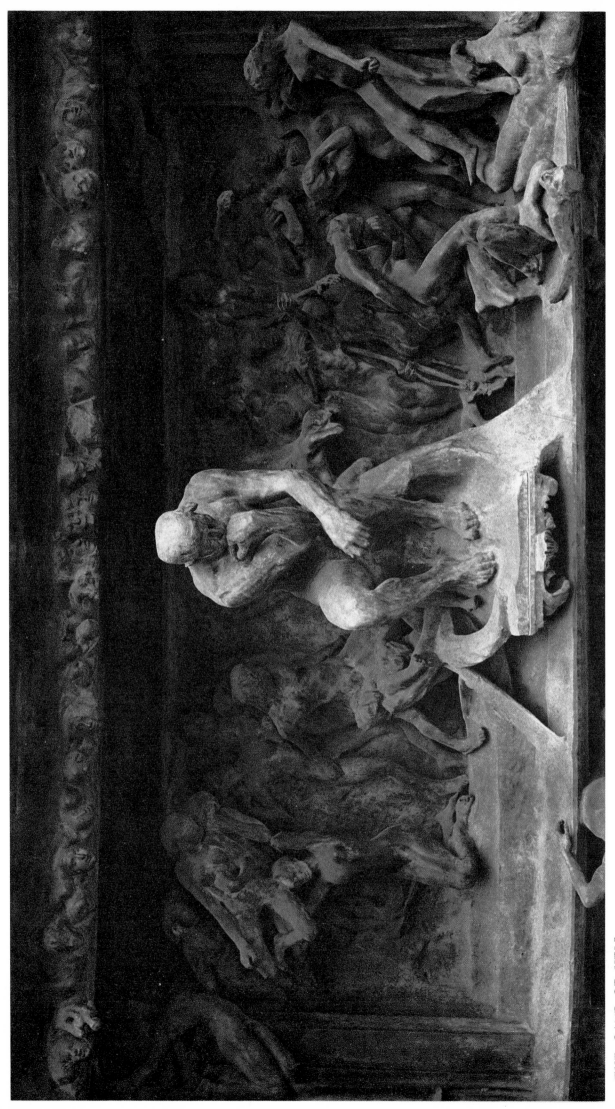

10. THE GATE OF HELL. DETAIL.

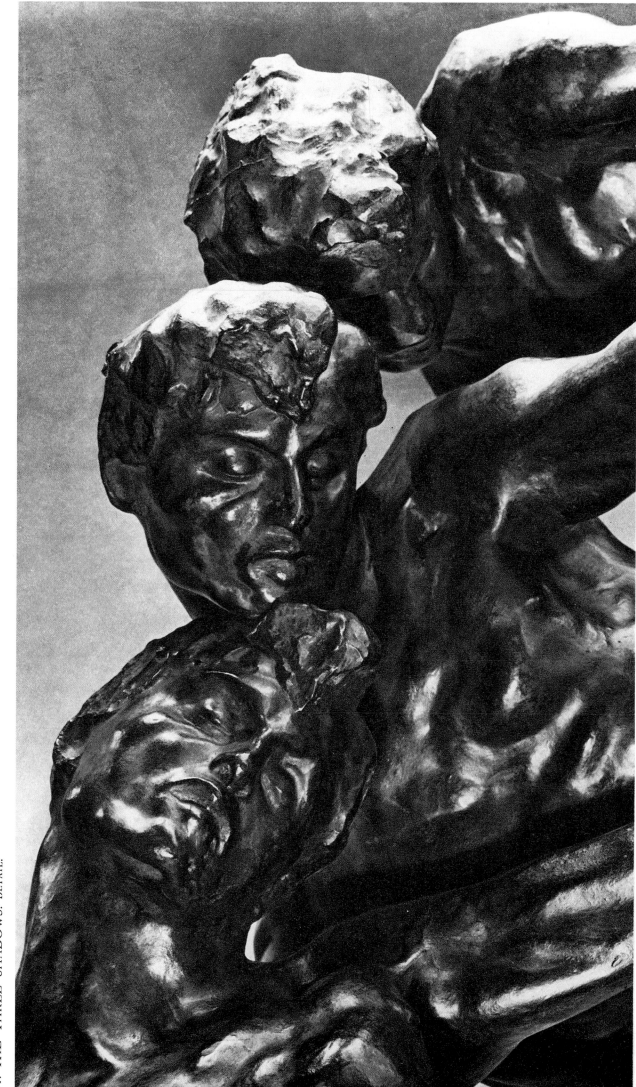

11. THE THREE SHADOWS. DETAIL.

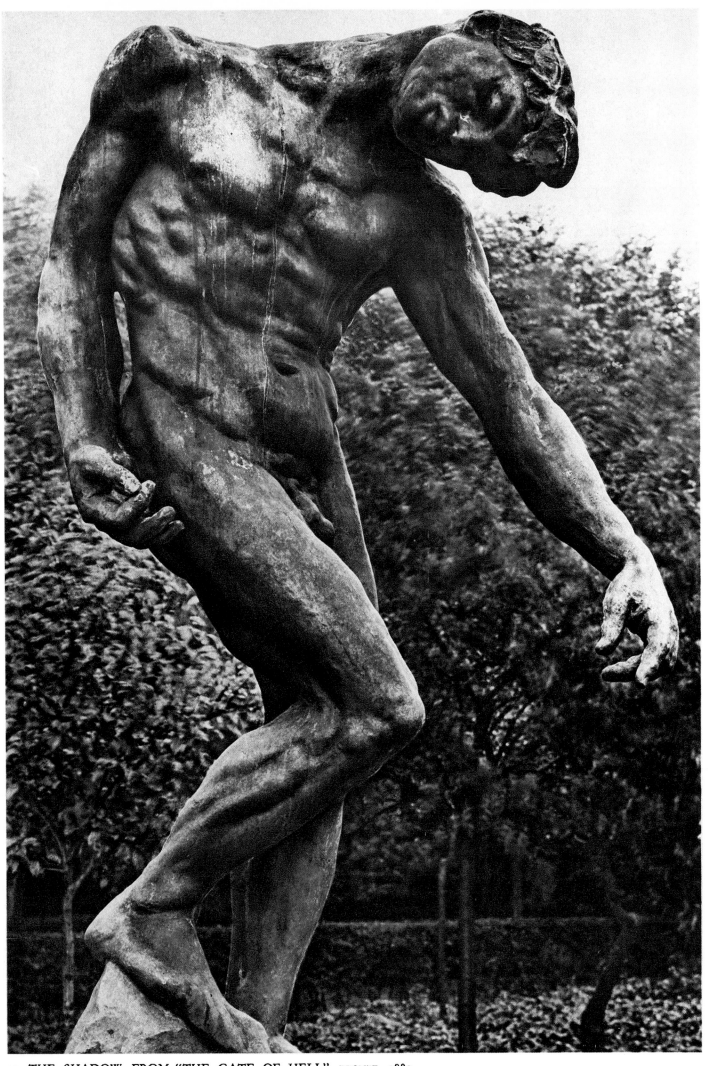

12. THE SHADOW. FROM "THE GATE OF HELL". BRONZE. 1880.

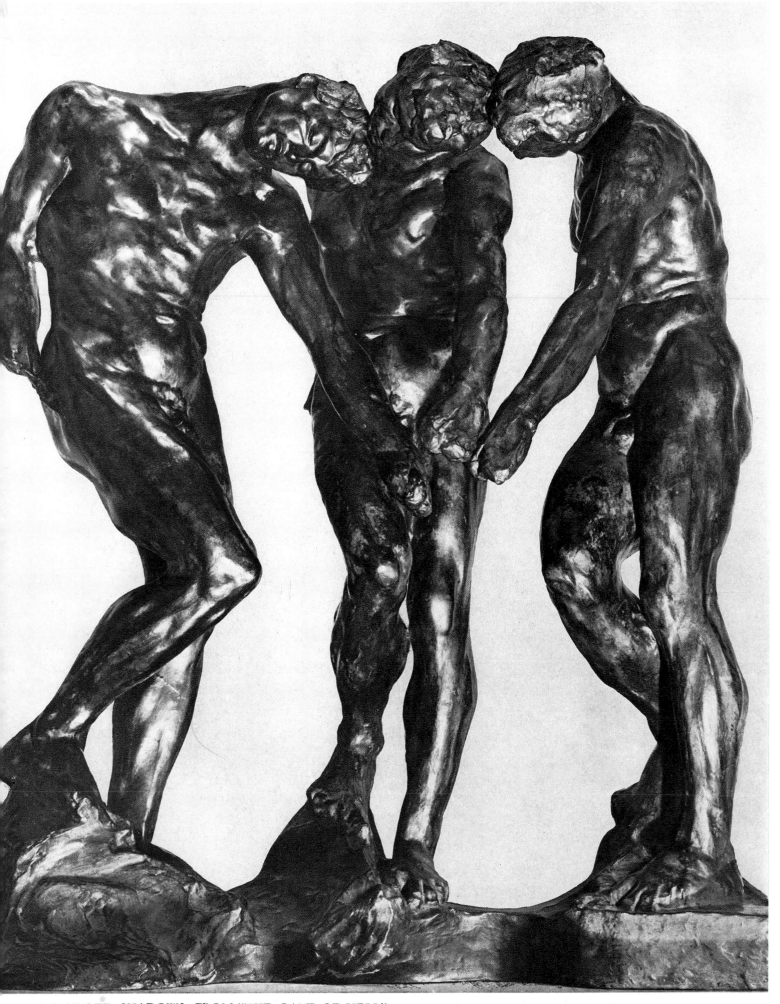

13. THE THREE SHADOWS. FROM "THE GATE OF HELL". BRONZE. 1880.

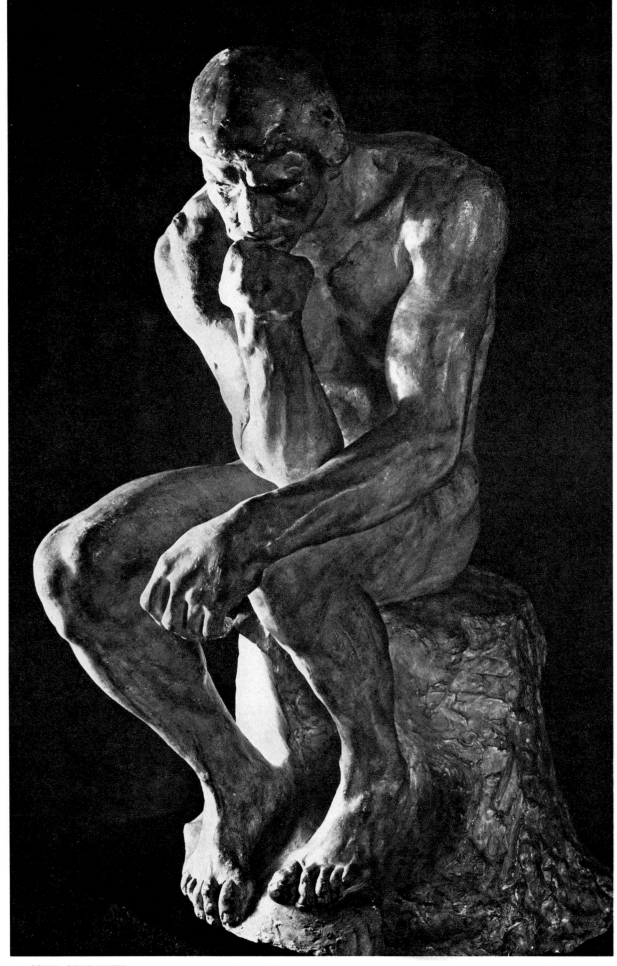

14. THE THINKER. PLASTER MODEL. 1879–1880.

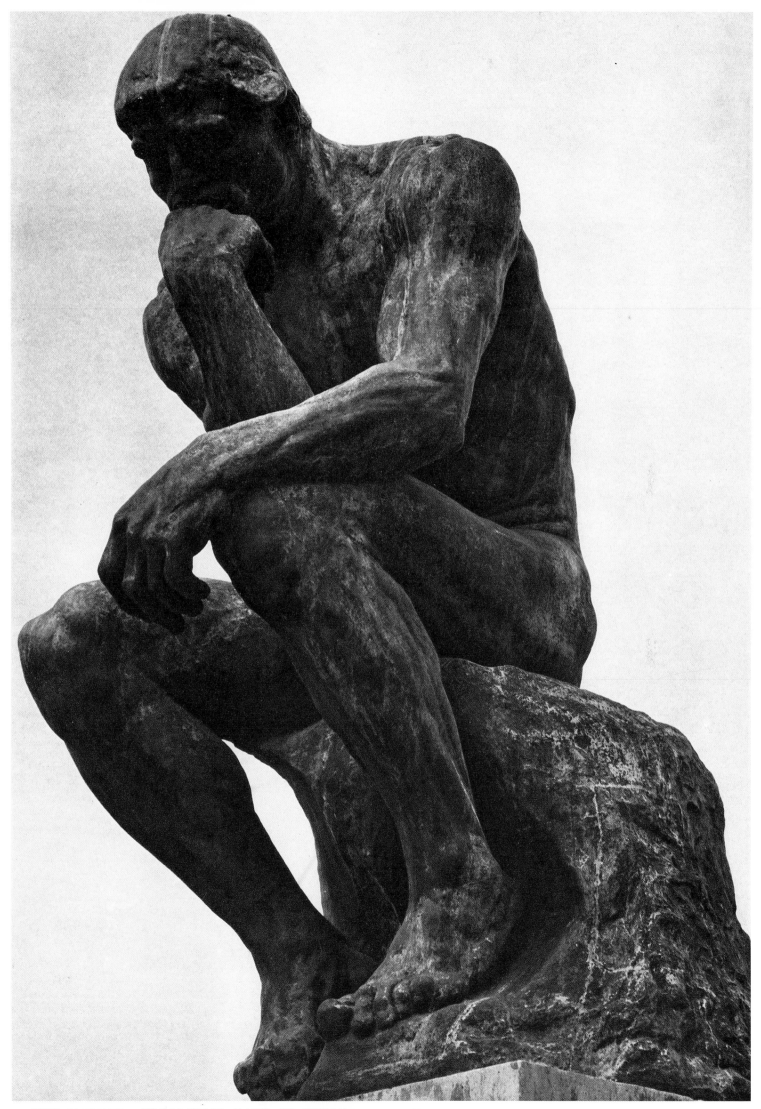

15. THE THINKER. FROM "THE GATE OF HELL". BRONZE. 1880–1900.

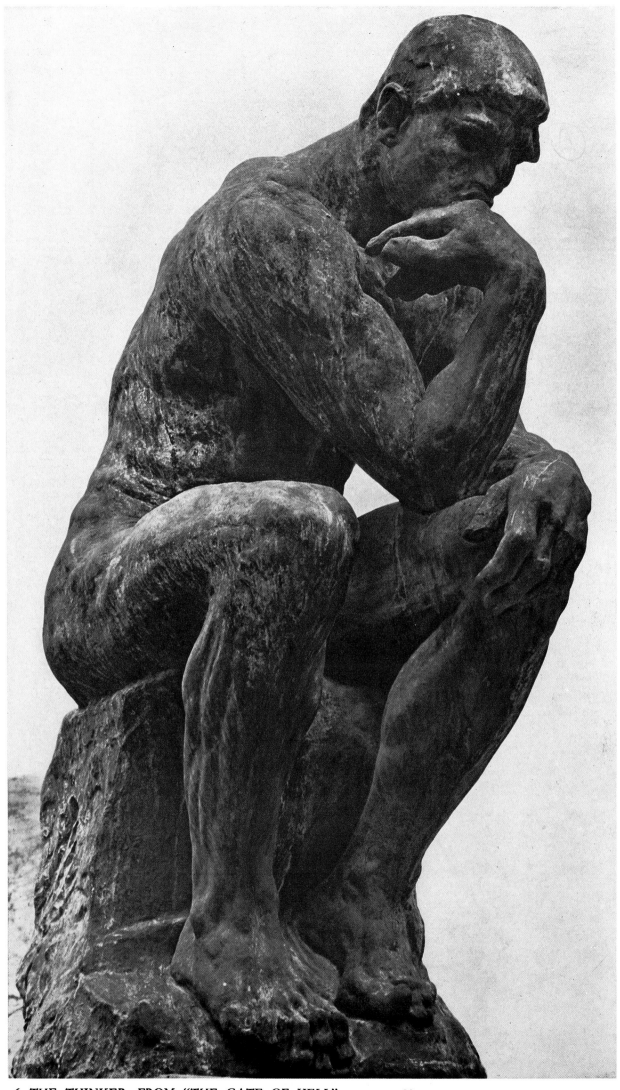

16. THE THINKER. FROM "THE GATE OF HELL". BRONZE. 1880–1900.

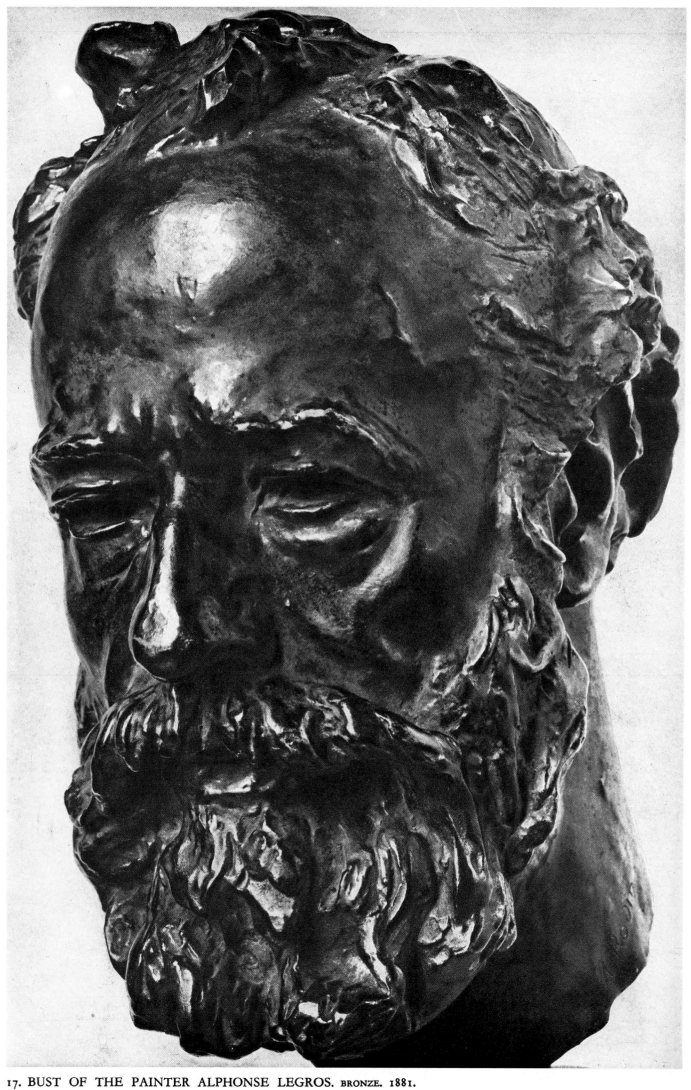

17. BUST OF THE PAINTER ALPHONSE LEGROS. BRONZE. 1881.

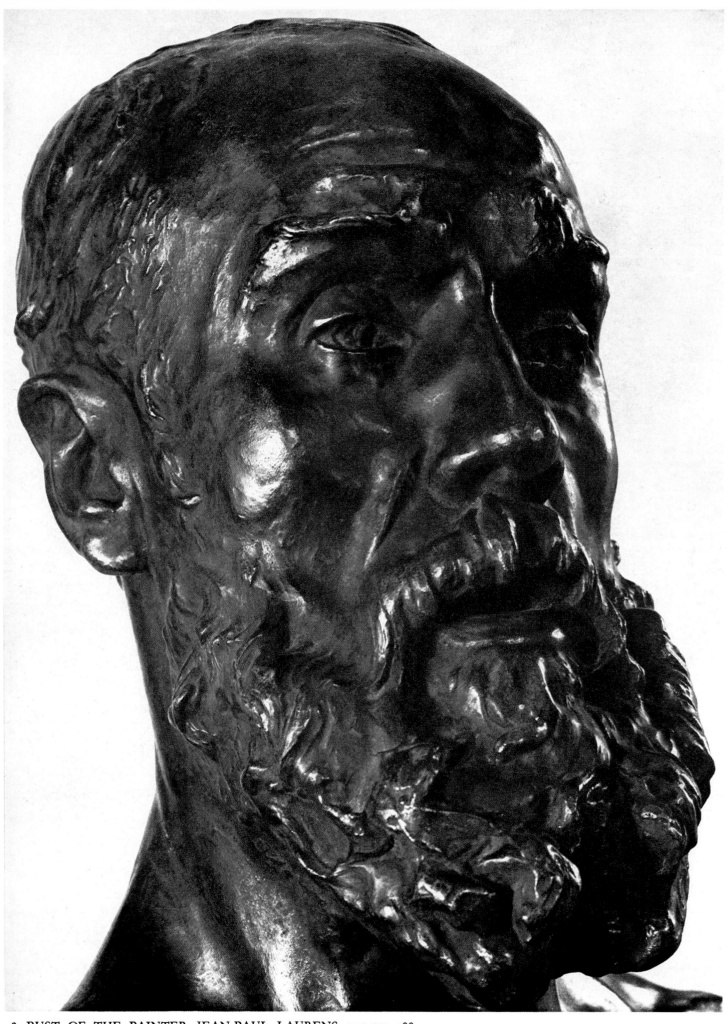

18. BUST OF THE PAINTER JEAN-PAUL LAURENS. BRONZE. 1881.

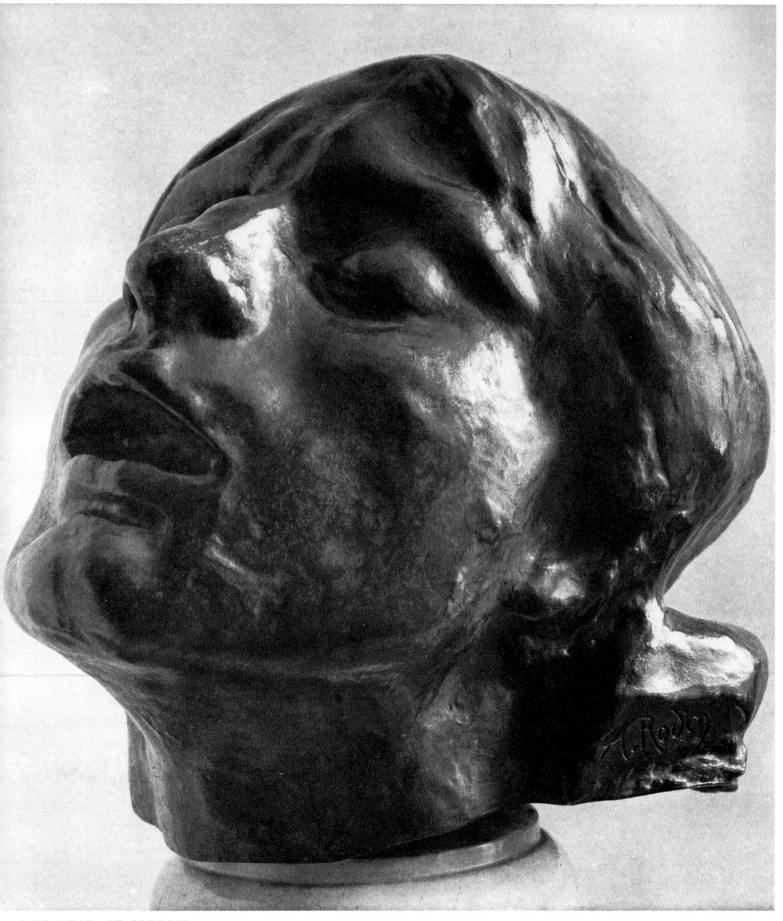

19. THE HEAD OF SORROW. BRONZE. 1882.

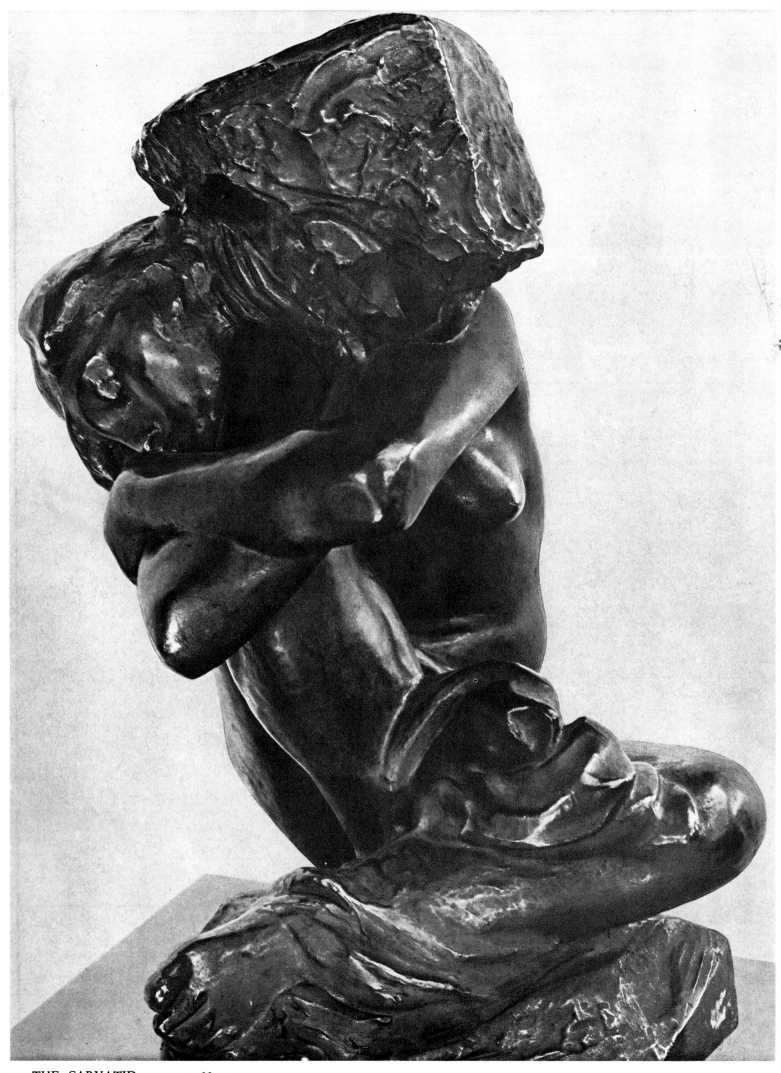

20. THE CARYATID. BRONZE. 1880–1.

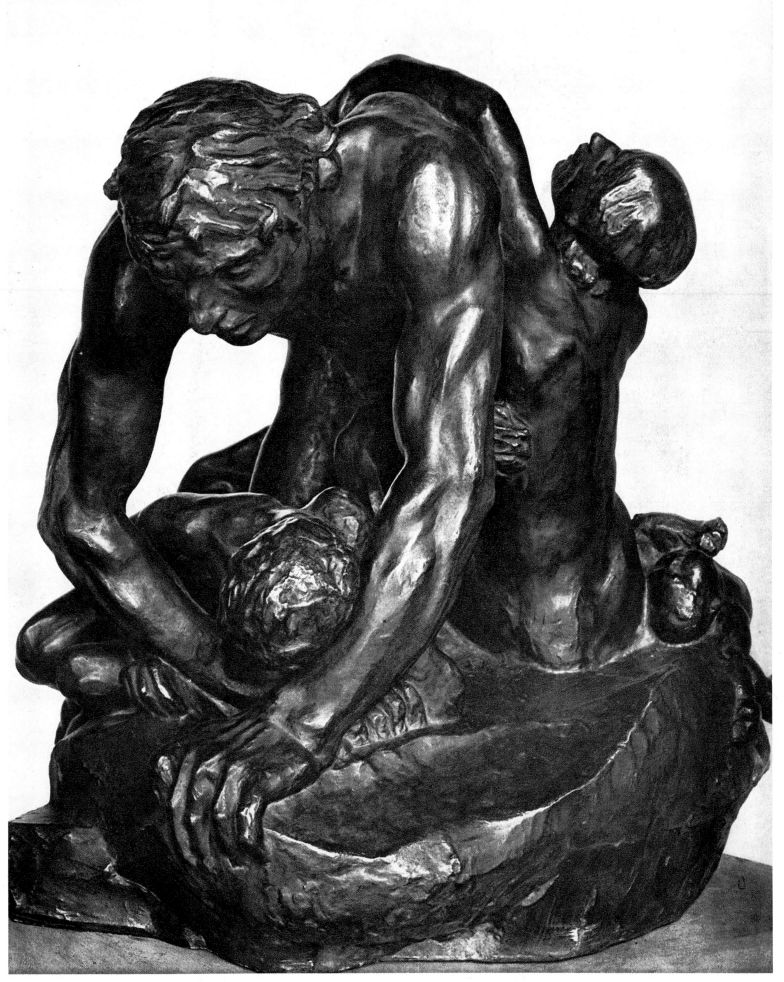

21. UGOLINO. BRONZE. 1882.

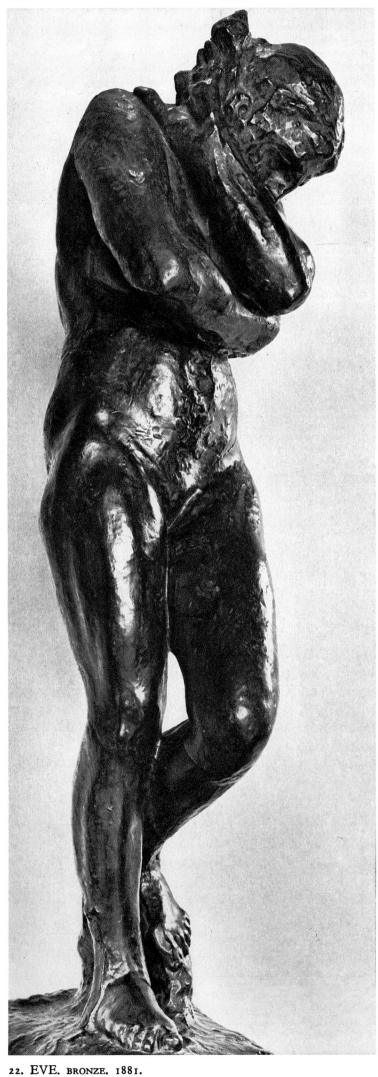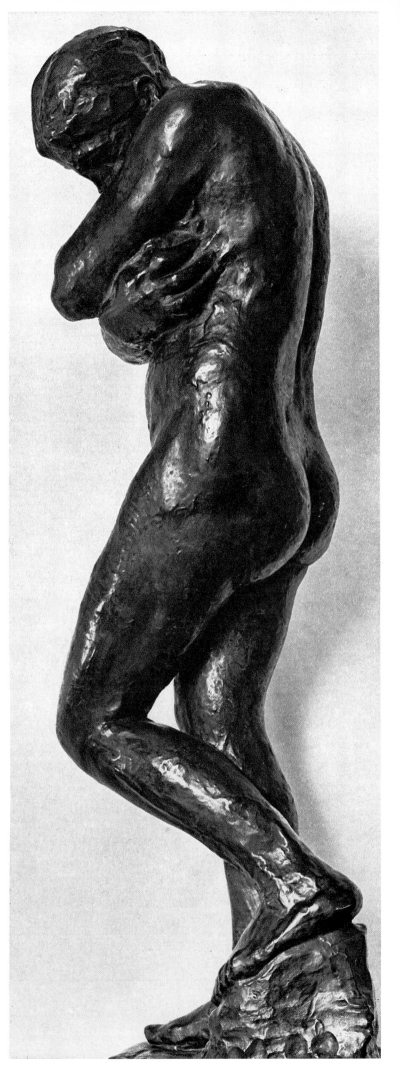

22. EVE. BRONZE. 1881.

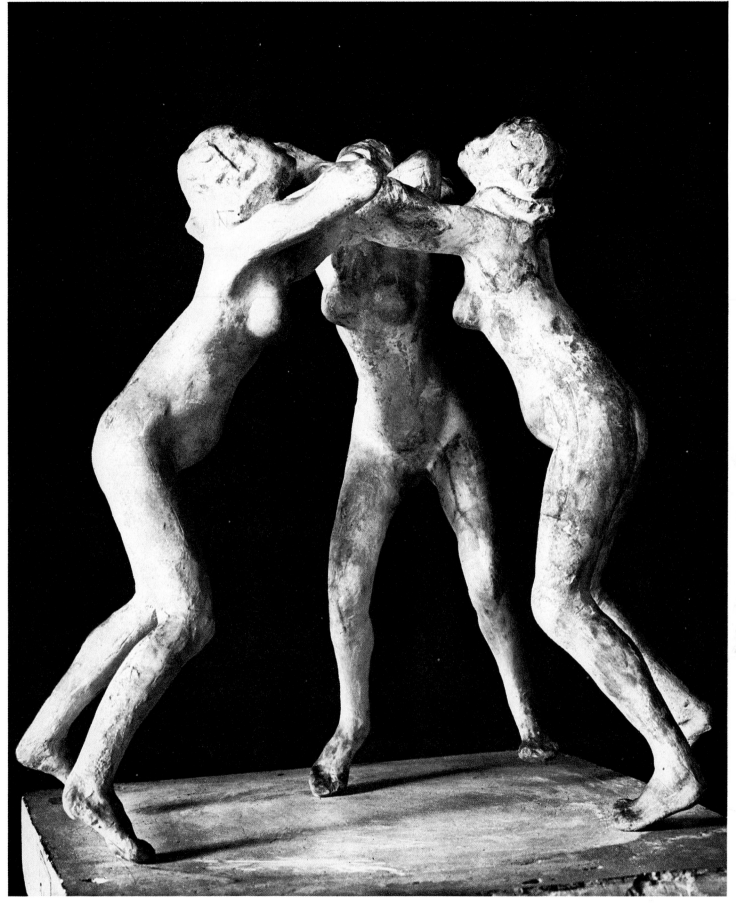

23. THE THREE FAUNS. PLASTER. 1882.

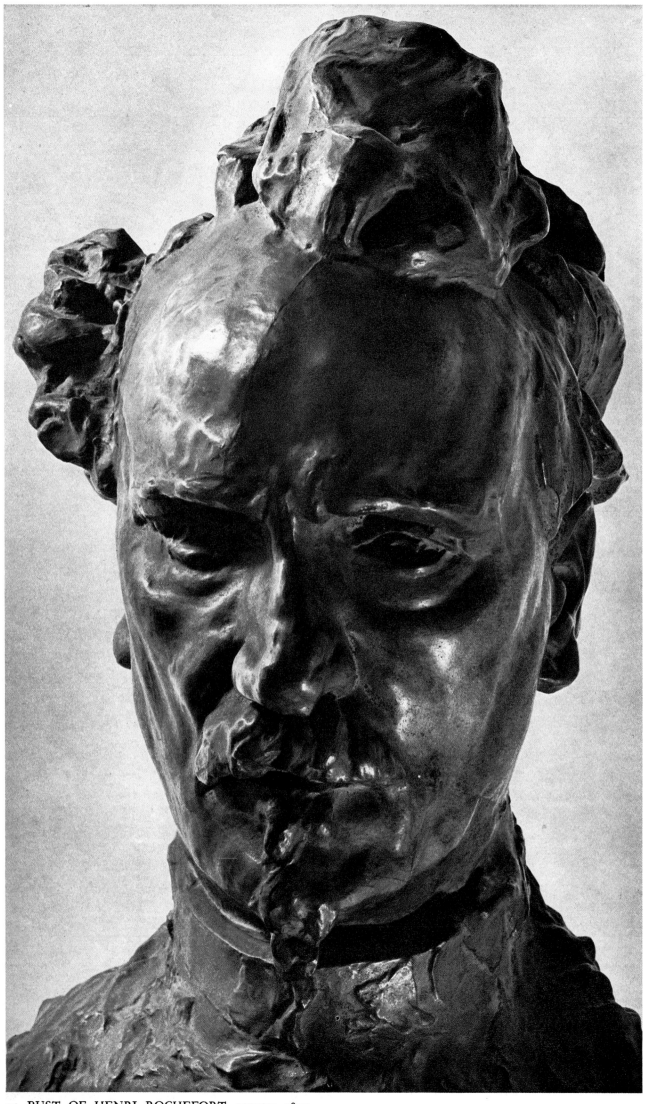

24. BUST OF HENRI ROCHEFORT. BRONZE. 1897.

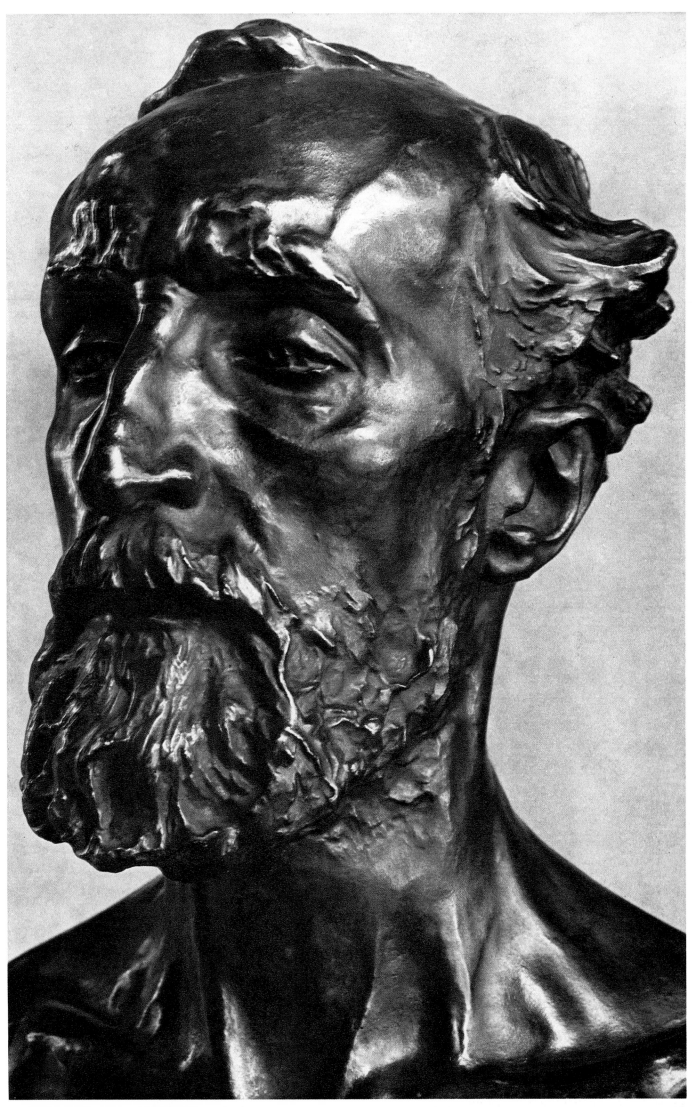

25. BUST OF THE SCULPTOR DALOU. BRONZE. 1883.

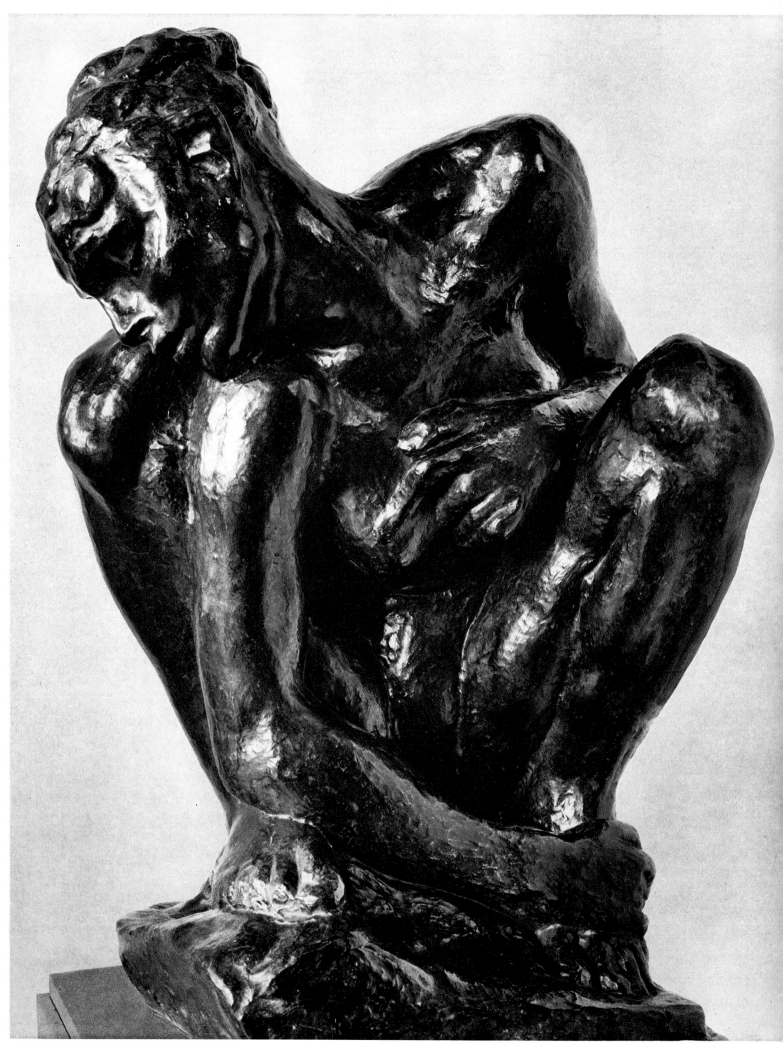

26. THE CROUCHING WOMAN. BRONZE. 1882.

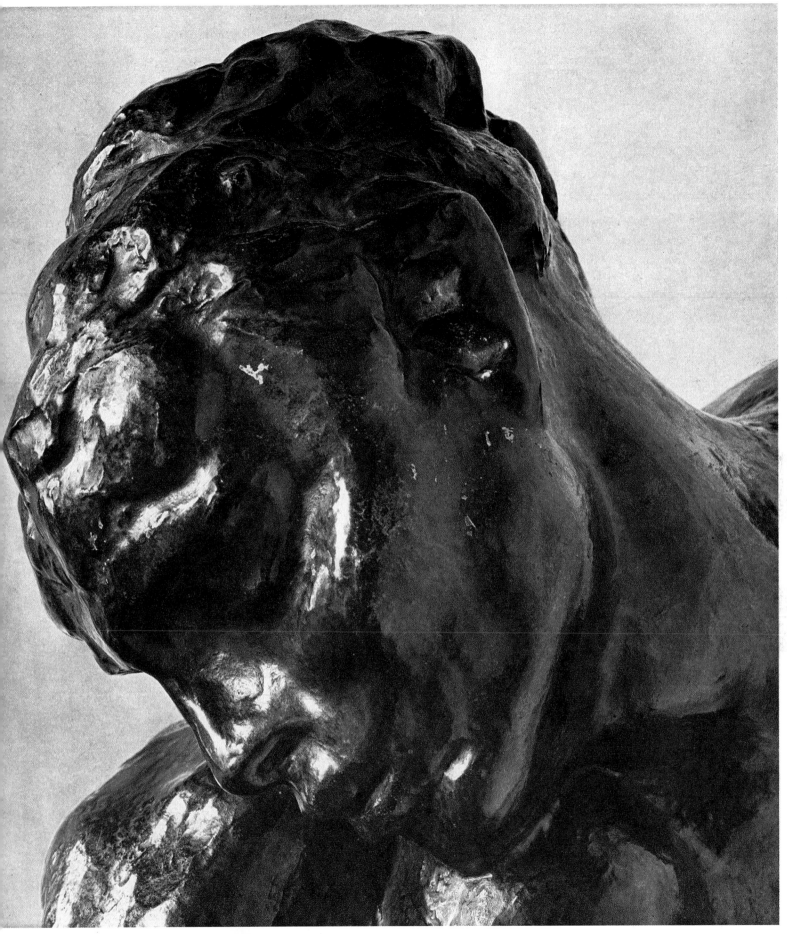

27. THE CROUCHING WOMAN. DETAIL.

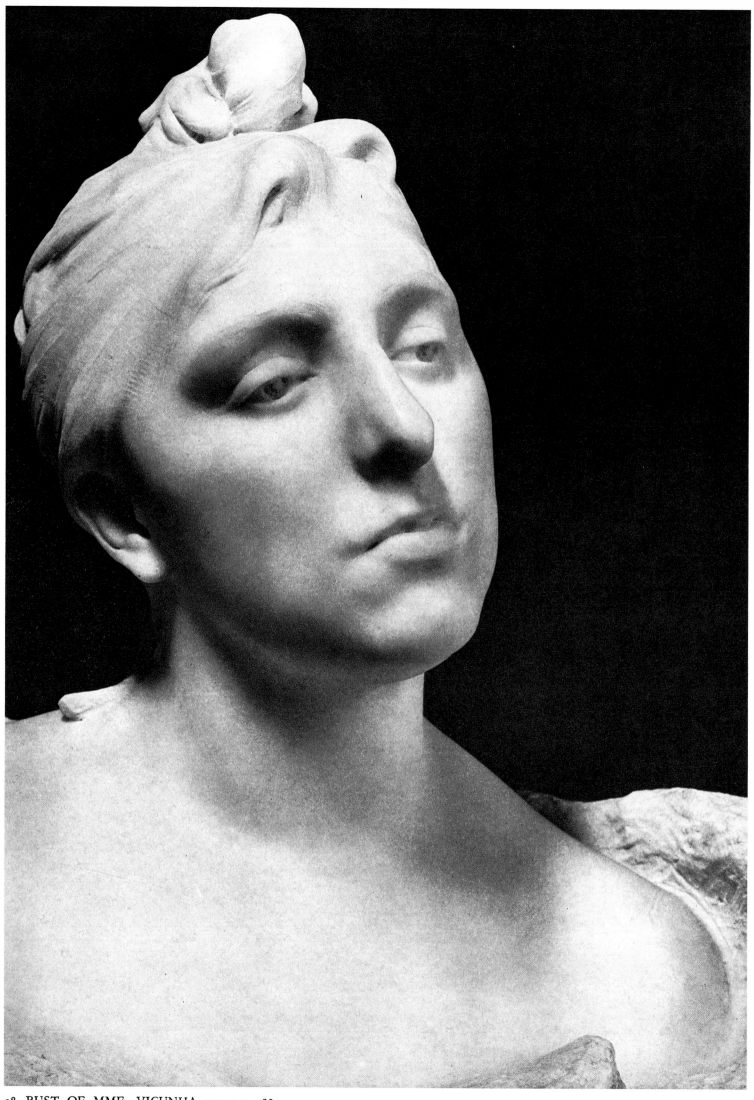

28. BUST OF MME. VICUNHA. MARBLE. 1884.

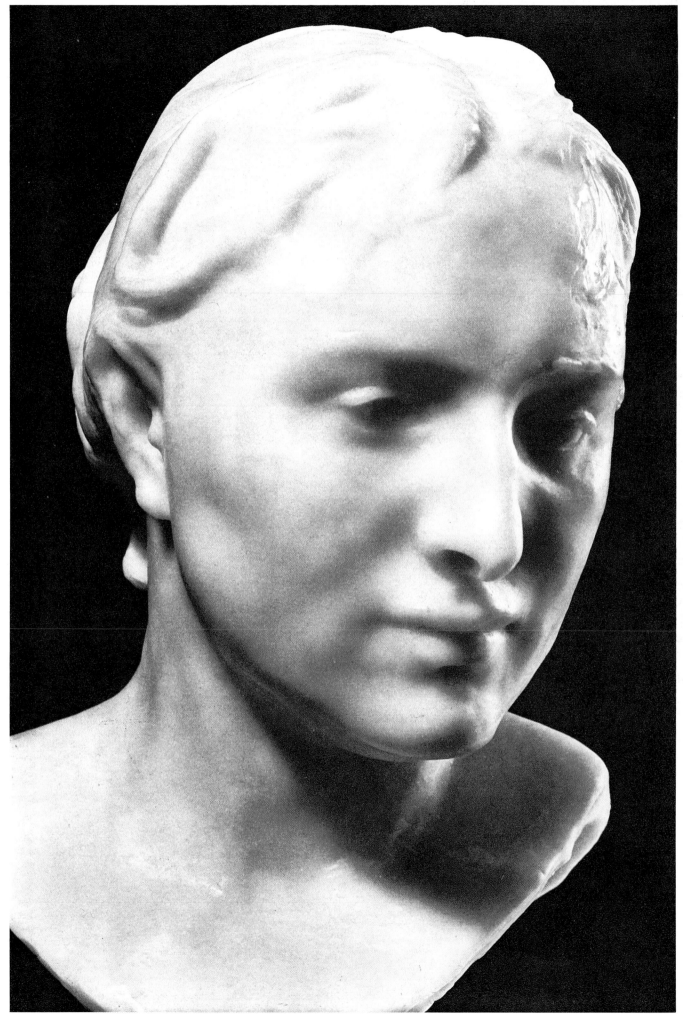

29. BUST OF MRS. RUSSELL. WAX. BEFORE 1888.

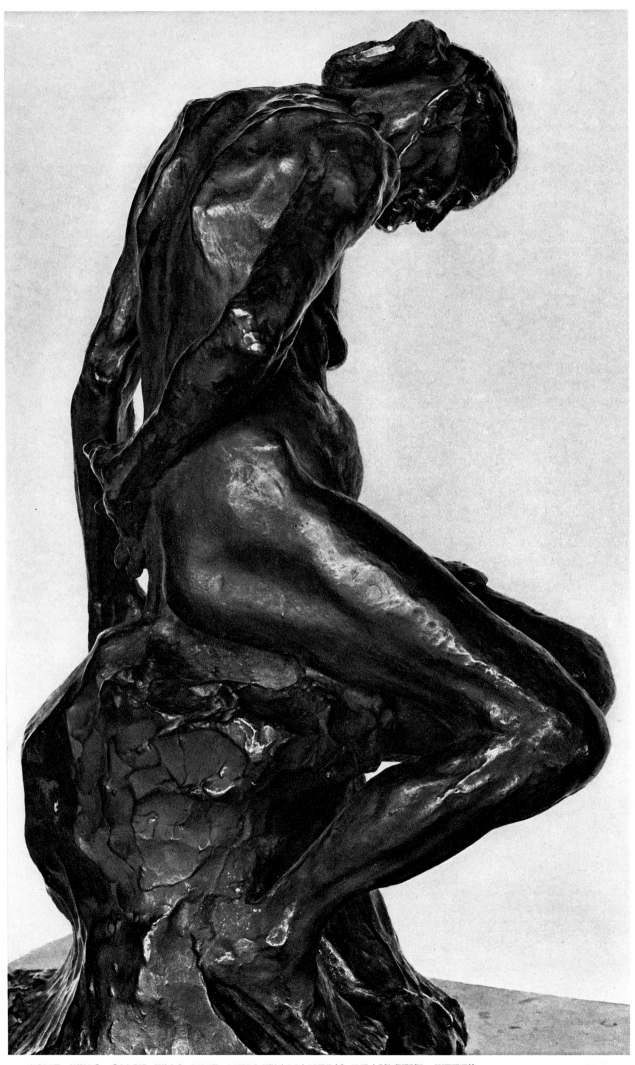

30. "SHE WHO ONCE WAS THE HELMET-MAKER'S BEAUTIFUL WIFE". BRONZE. BEFORE 1885.

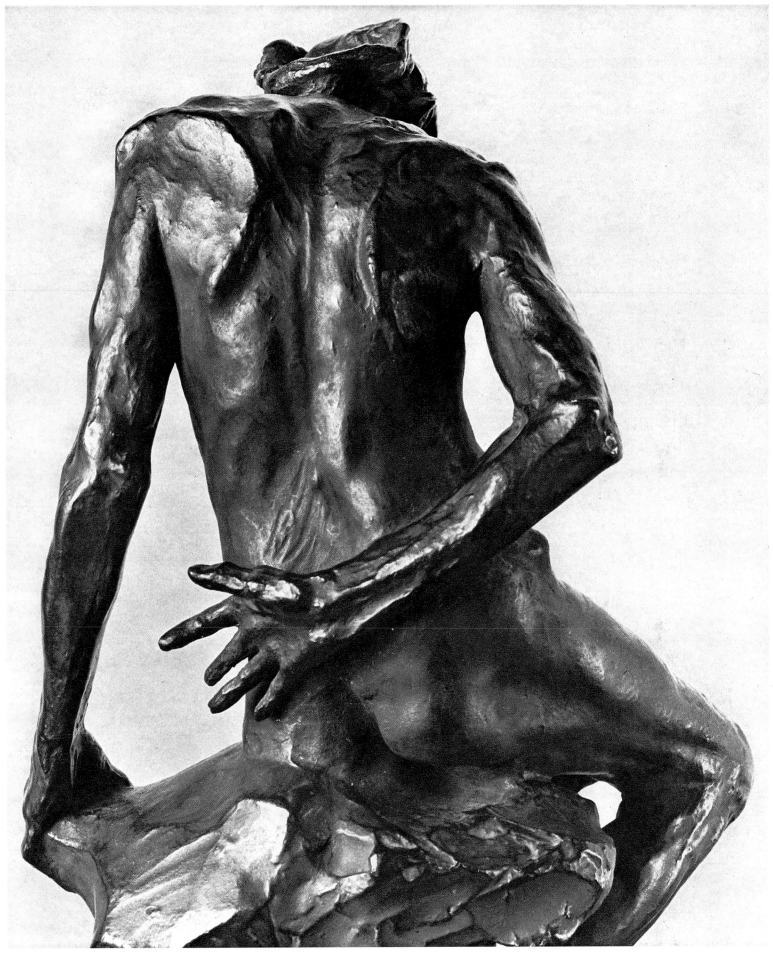

31. "THE HELMET-MAKER'S WIFE". BACK VIEW.

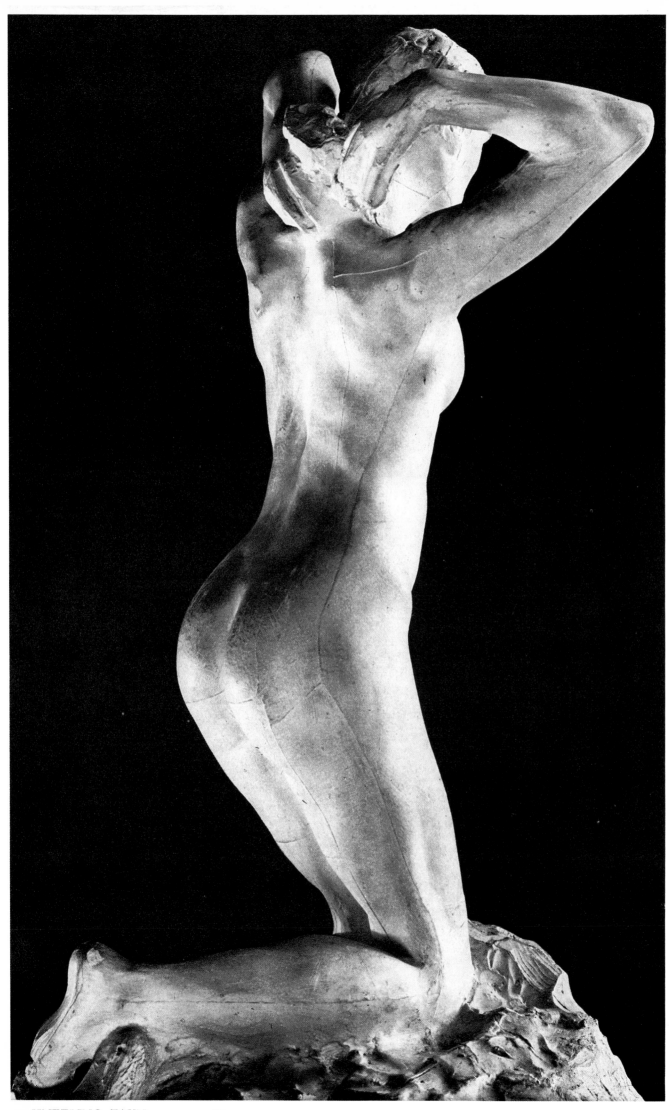

32. KNEELING FAUN. PLASTER. 1884.

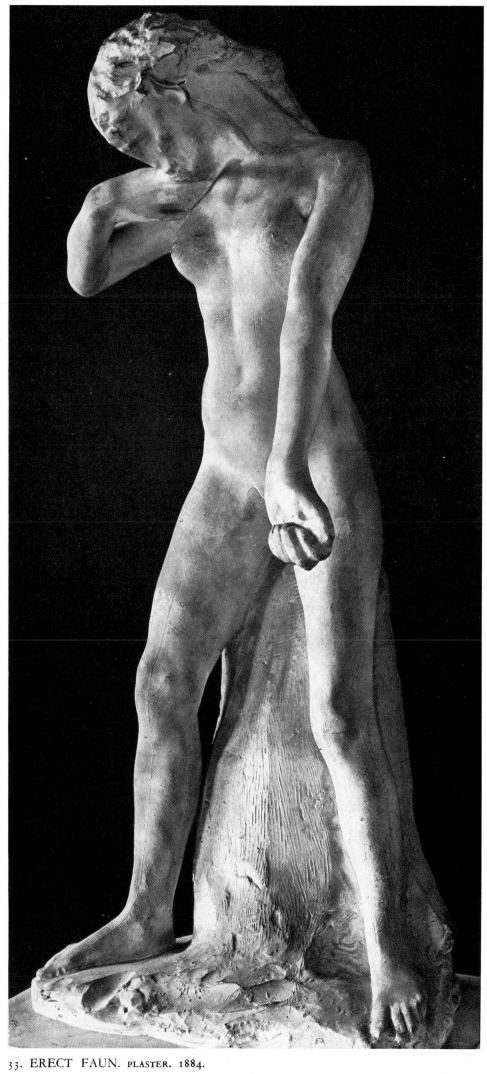

33. ERECT FAUN. PLASTER. 1884.

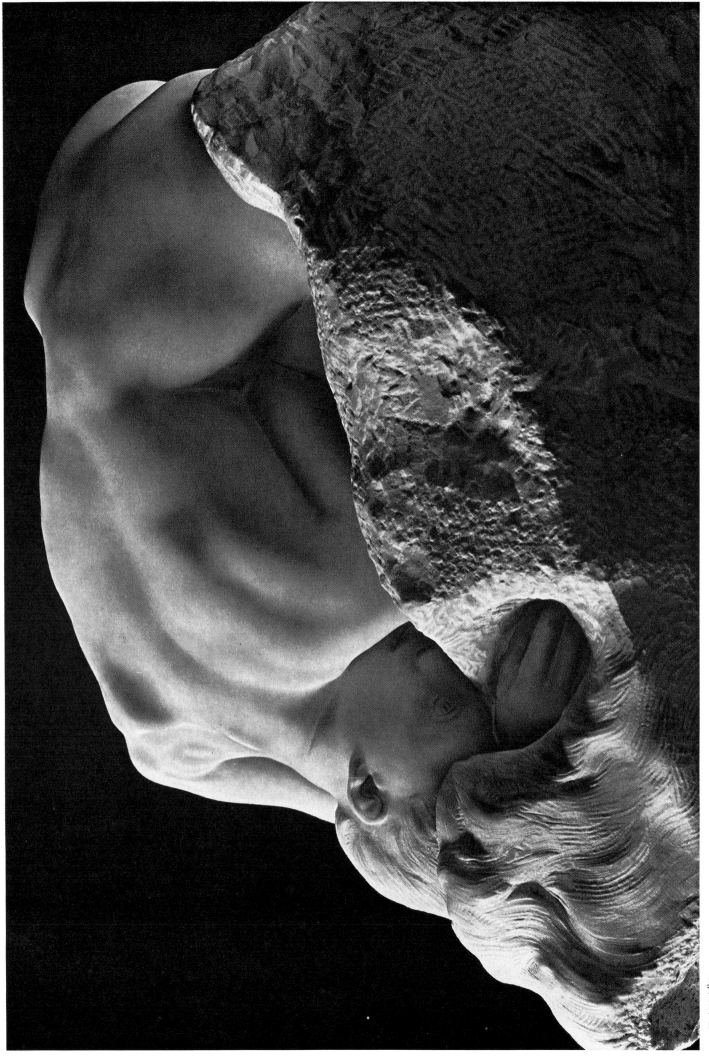

34. DANAÏD. MARBLE. 1885.

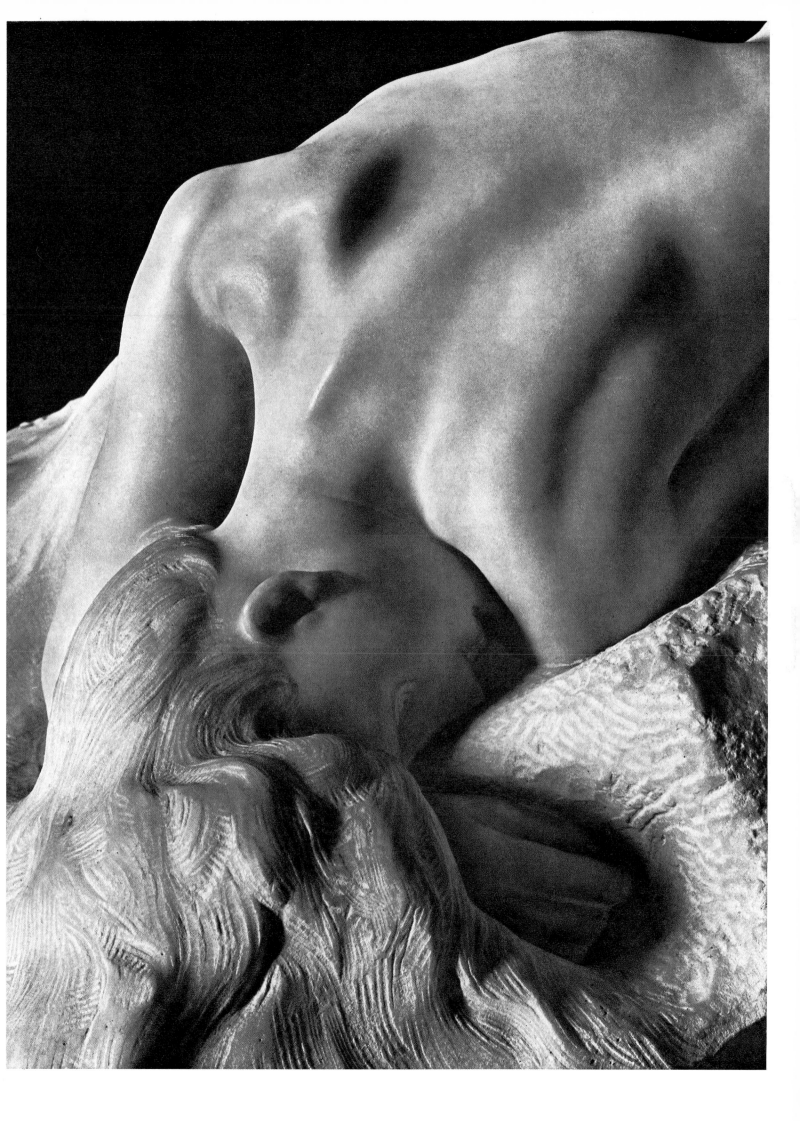

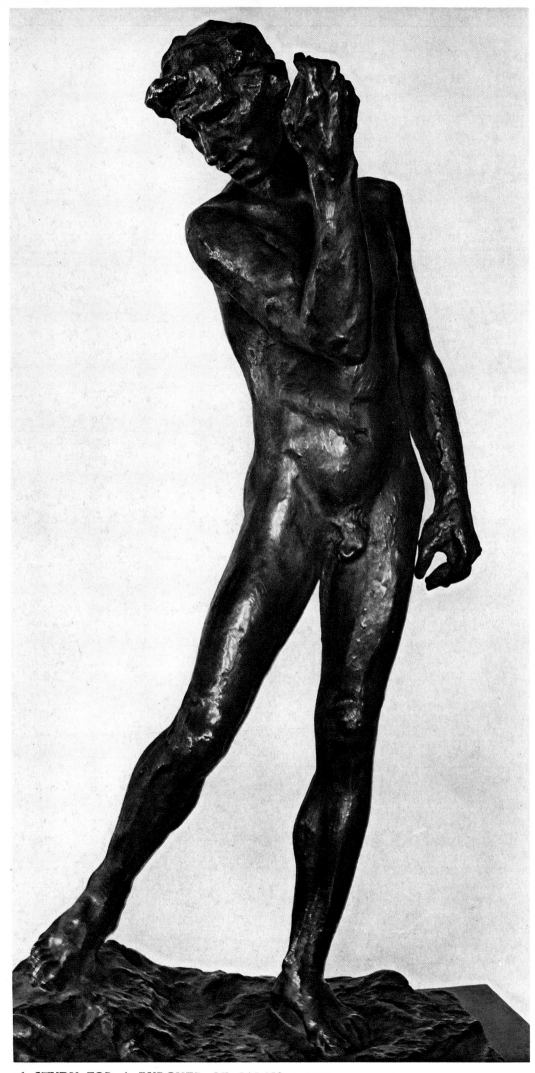

36. STUDY FOR A BURGHER OF CALAIS. BRONZE.

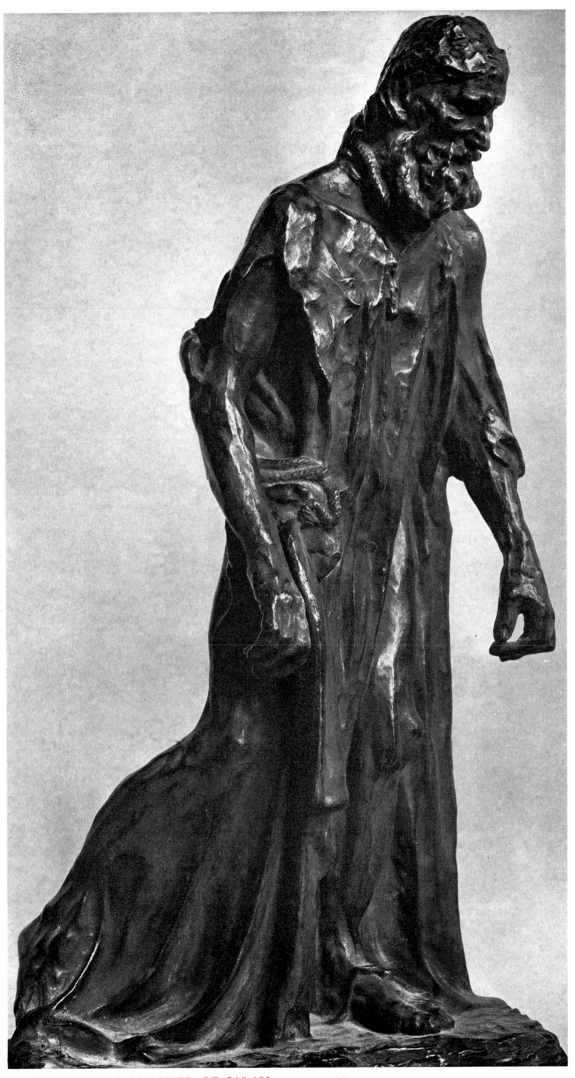

37. STUDY FOR A BURGHER OF CALAIS. BRONZE. 1884.

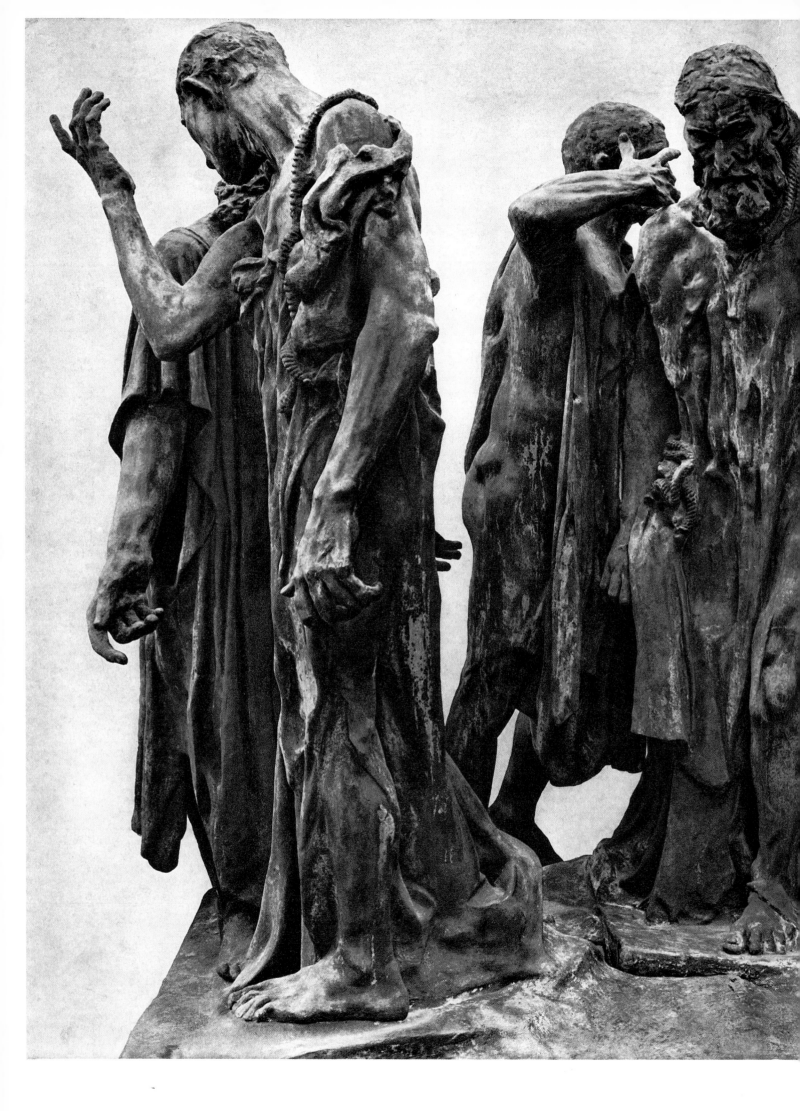

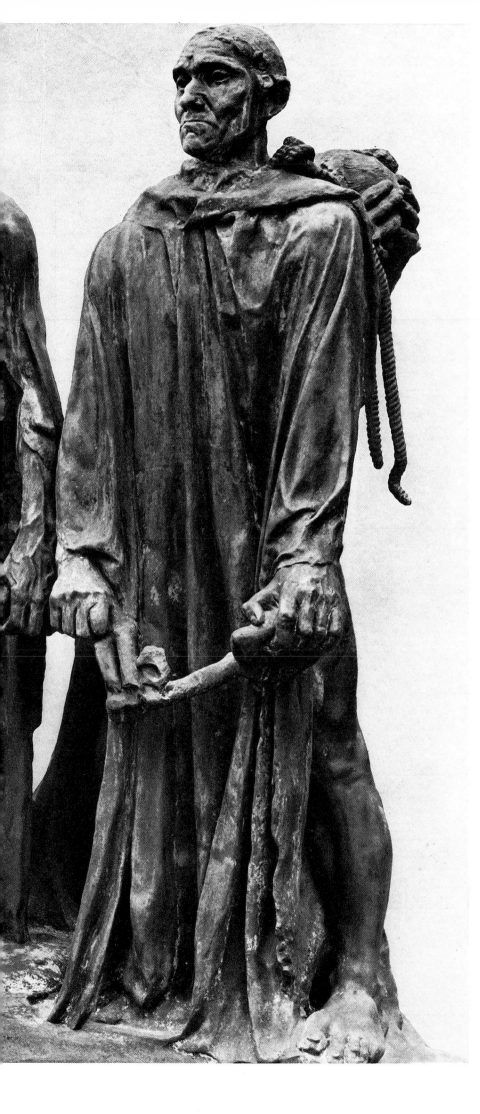

38. THE BURGHERS OF CALAIS
PLASTER. 1884–1886.

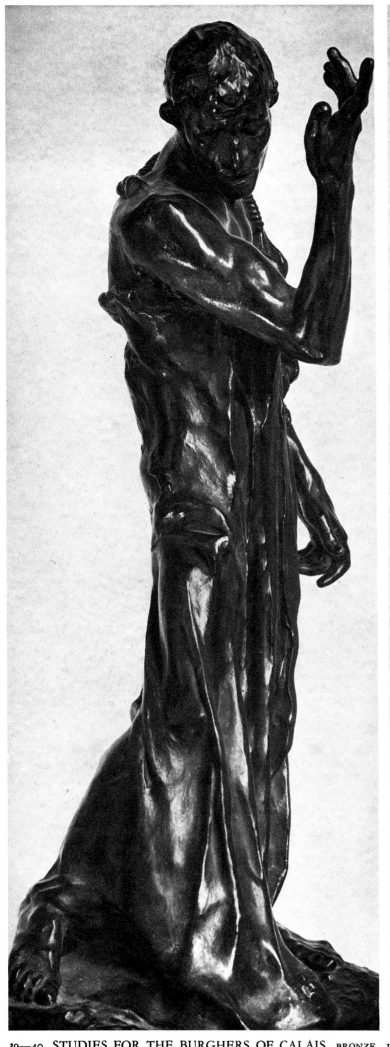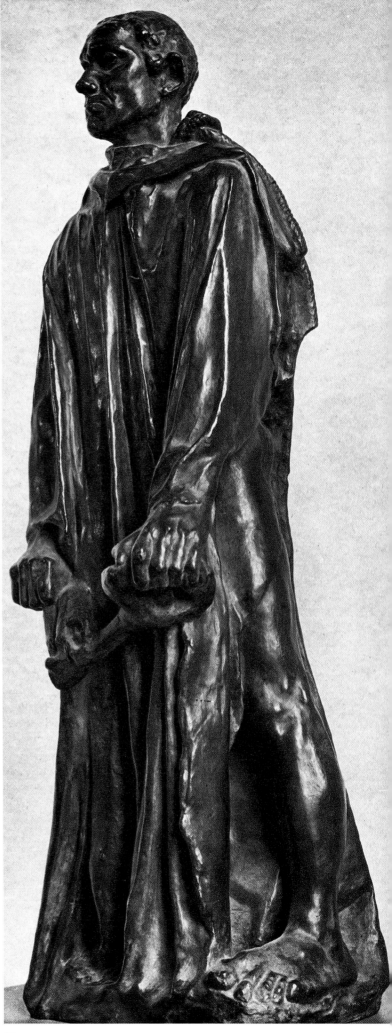

39—40. STUDIES FOR THE BURGHERS OF CALAIS. BRONZE. 1884.

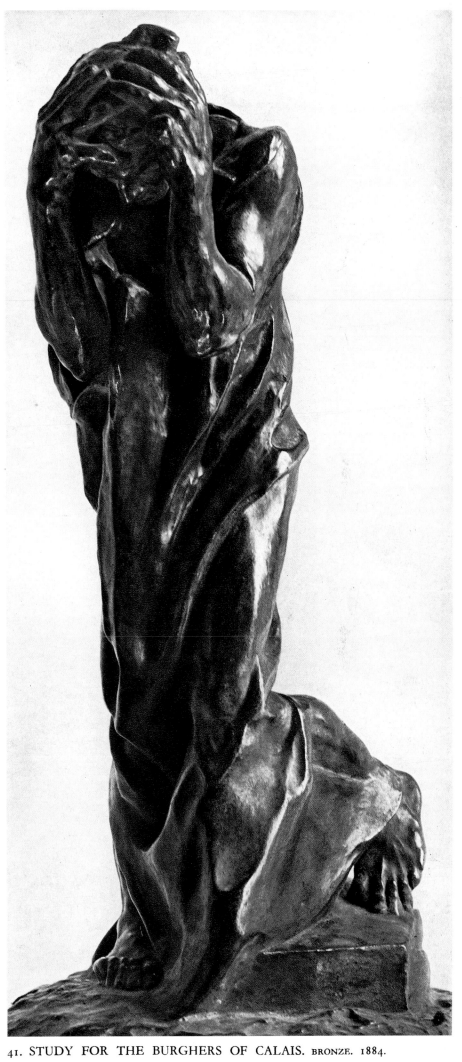

41. STUDY FOR THE BURGHERS OF CALAIS. BRONZE. 1884.

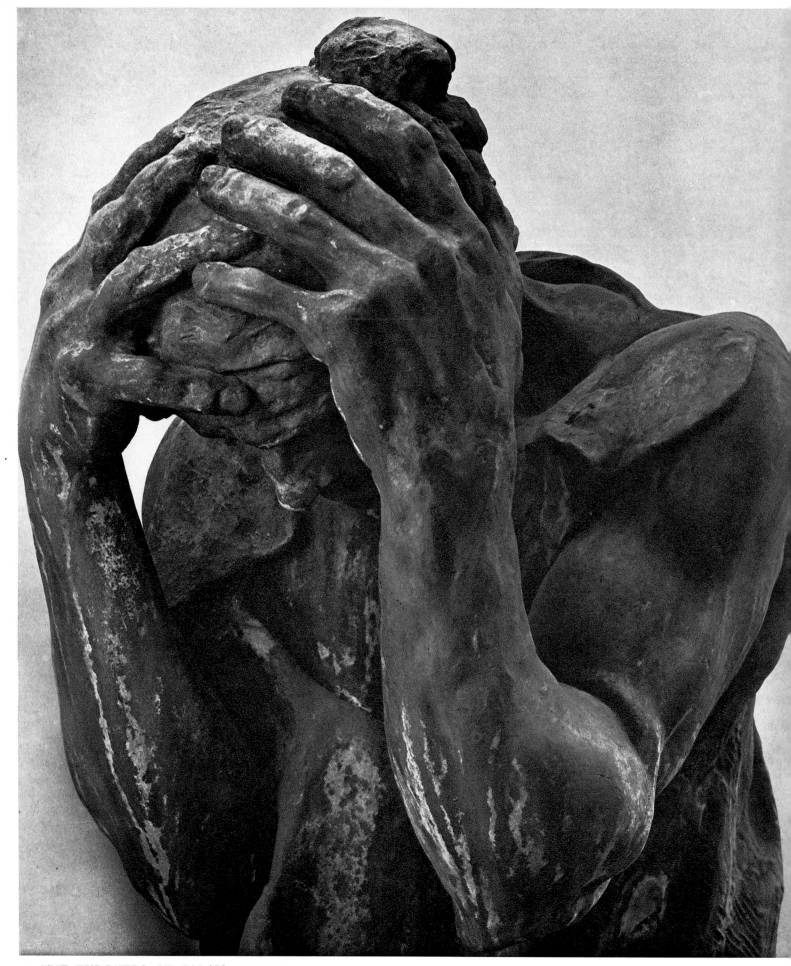

42. THE BURGHERS OF CALAIS. DETAIL.

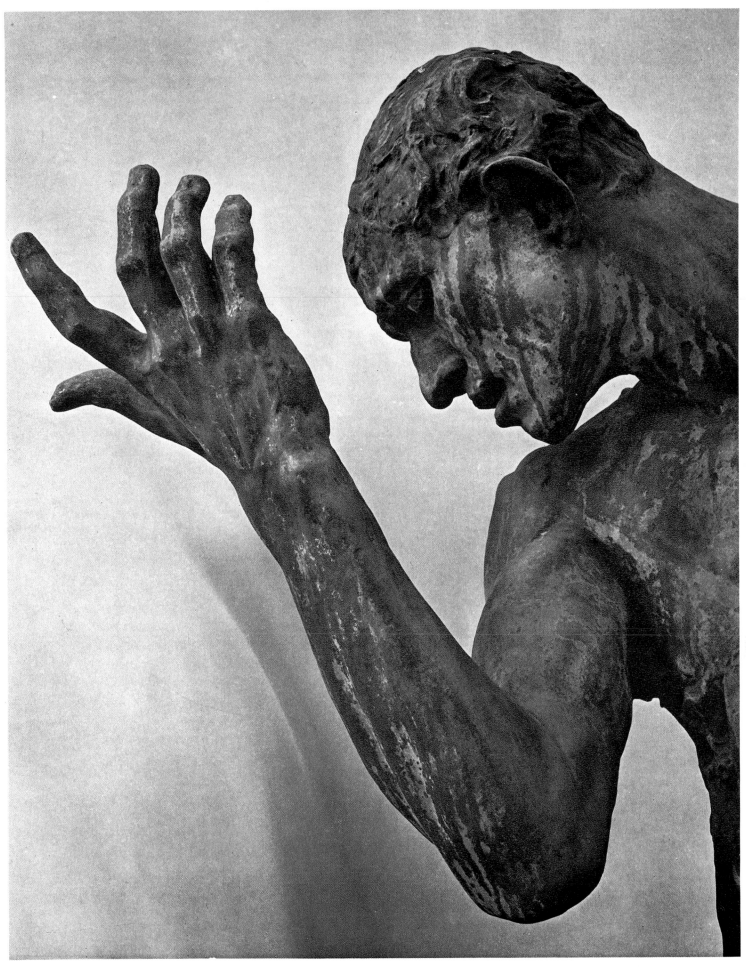

43. THE BURGHERS OF CALAIS. DETAIL.

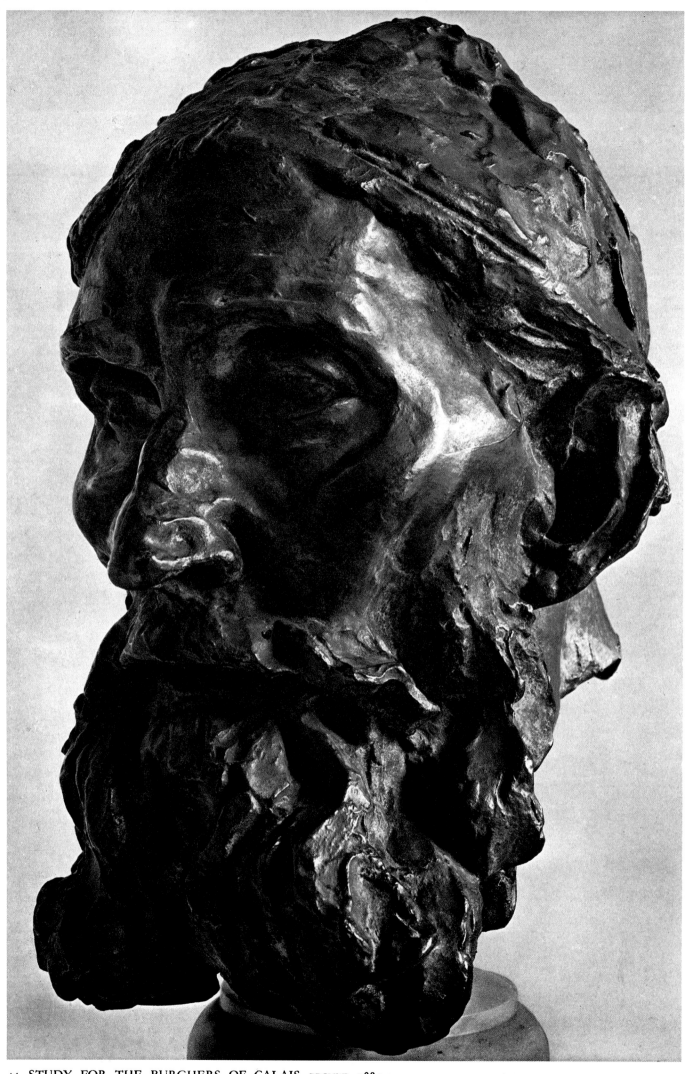

44. STUDY FOR THE BURGHERS OF CALAIS. BRONZE. 1884.

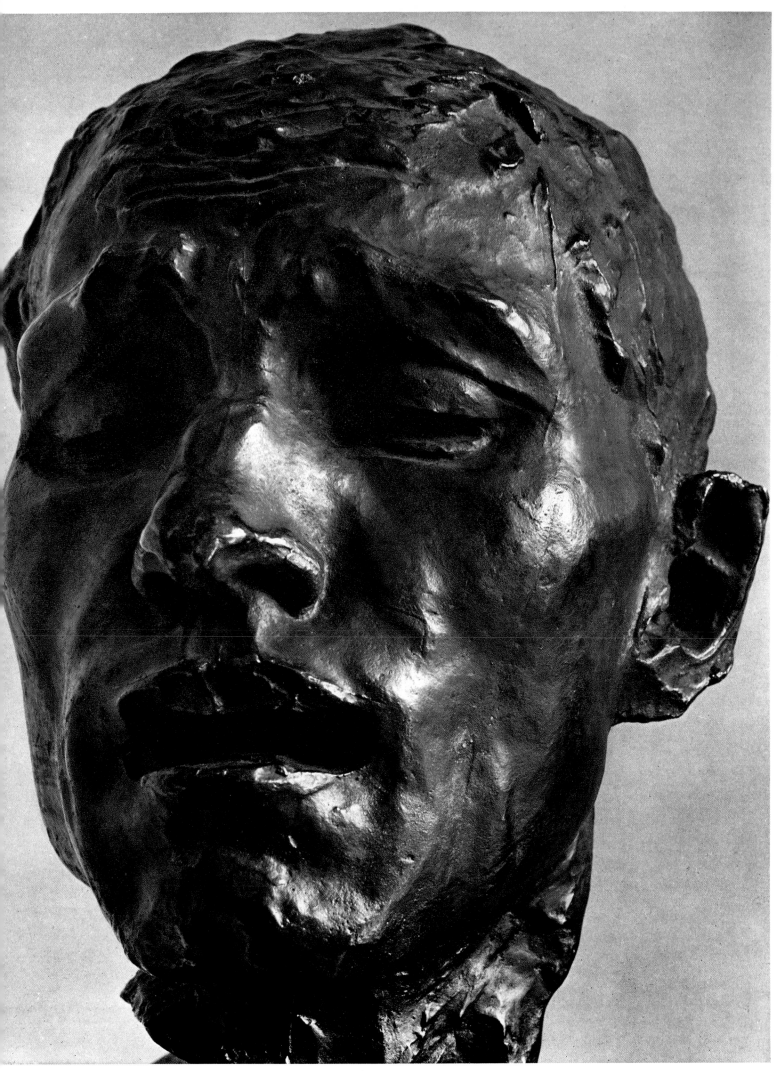

45. STUDY FOR THE BURGHERS OF CALAIS. BRONZE. 1884.

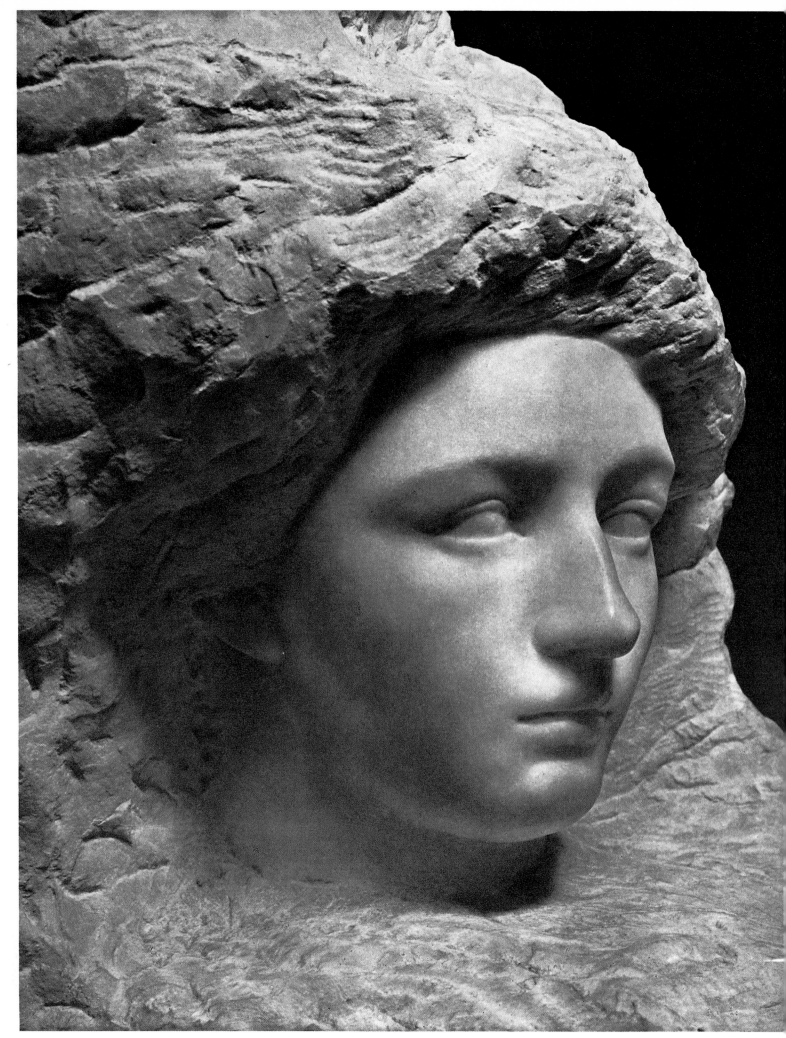

46. AURORA. MARBLE. 1885.

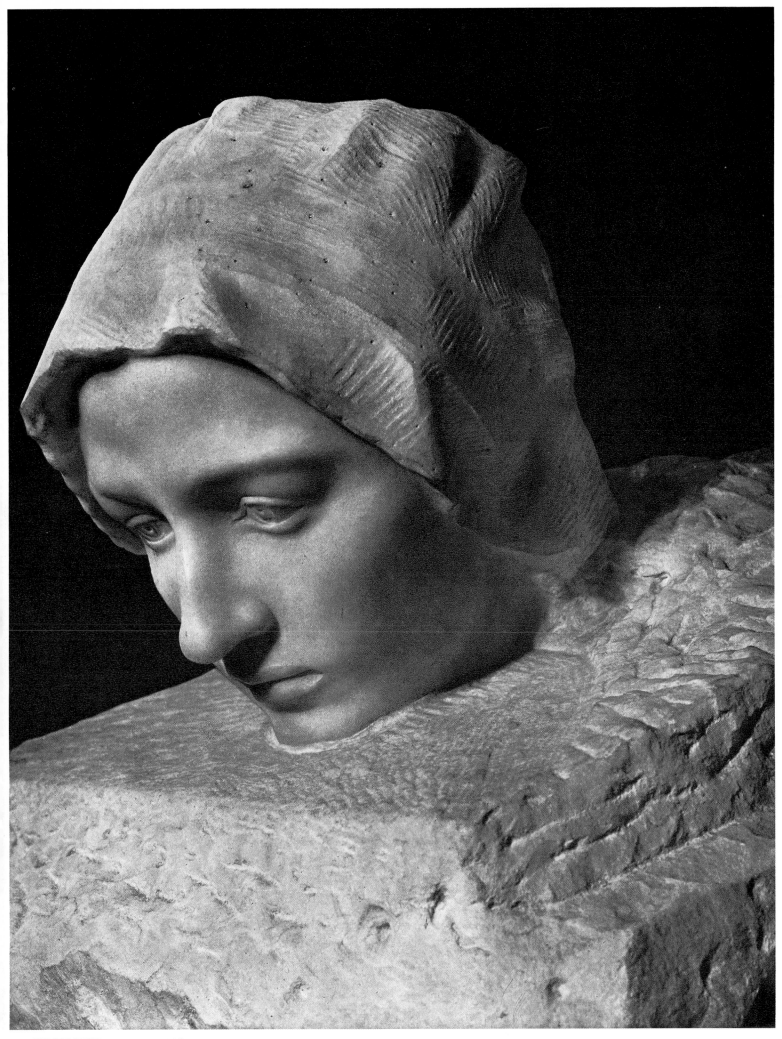

47. THOUGHT. MARBLE. 1886.

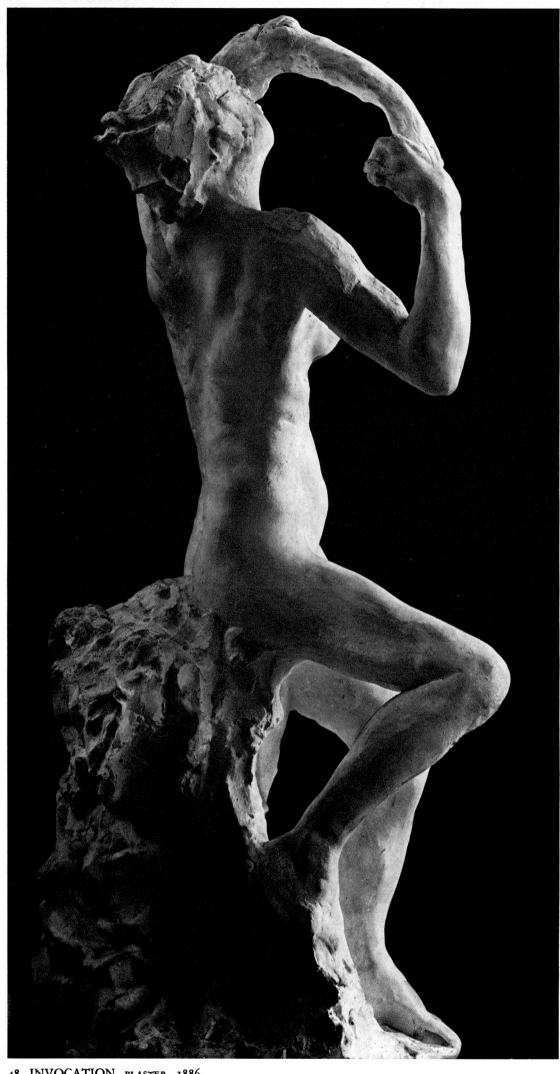

48. INVOCATION. PLASTER. 1886.

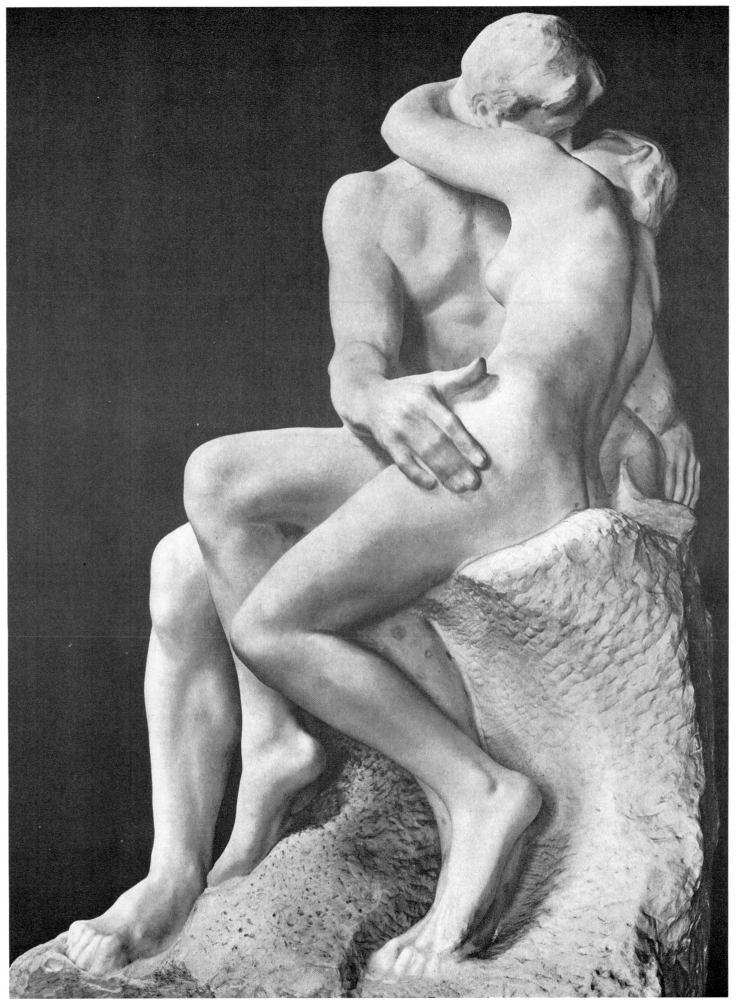

49. THE KISS. MARBLE. 1886.

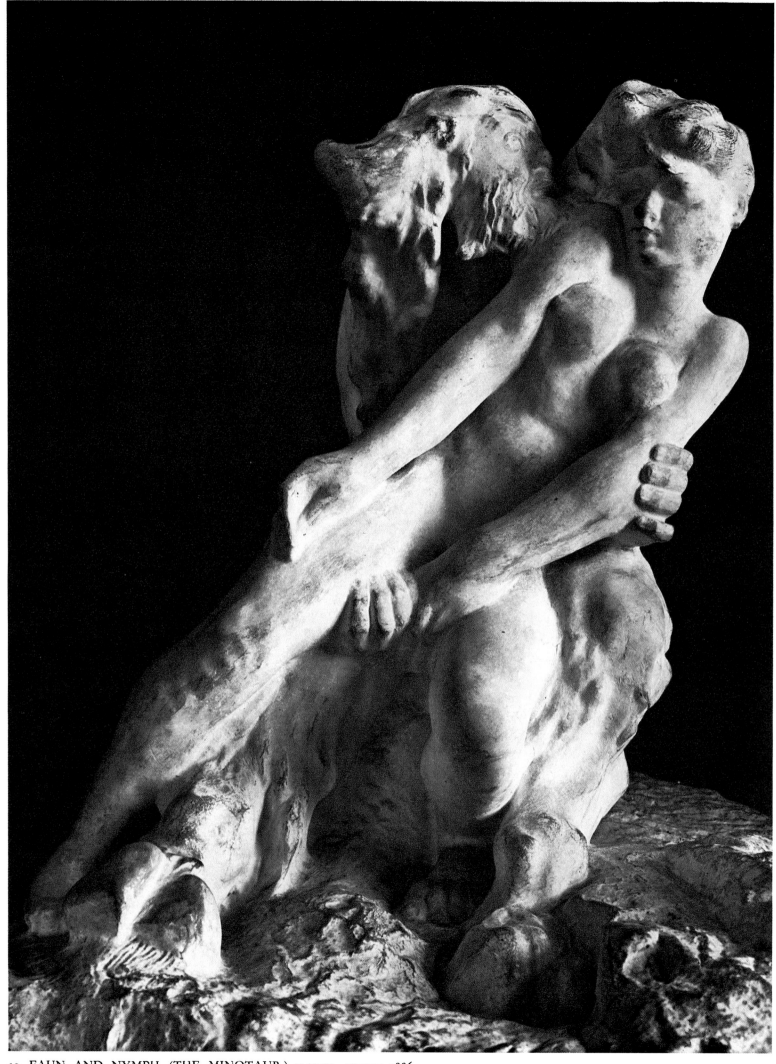

50. FAUN AND NYMPH. (THE MINOTAUR.) PLASTER. BEFORE 1886.

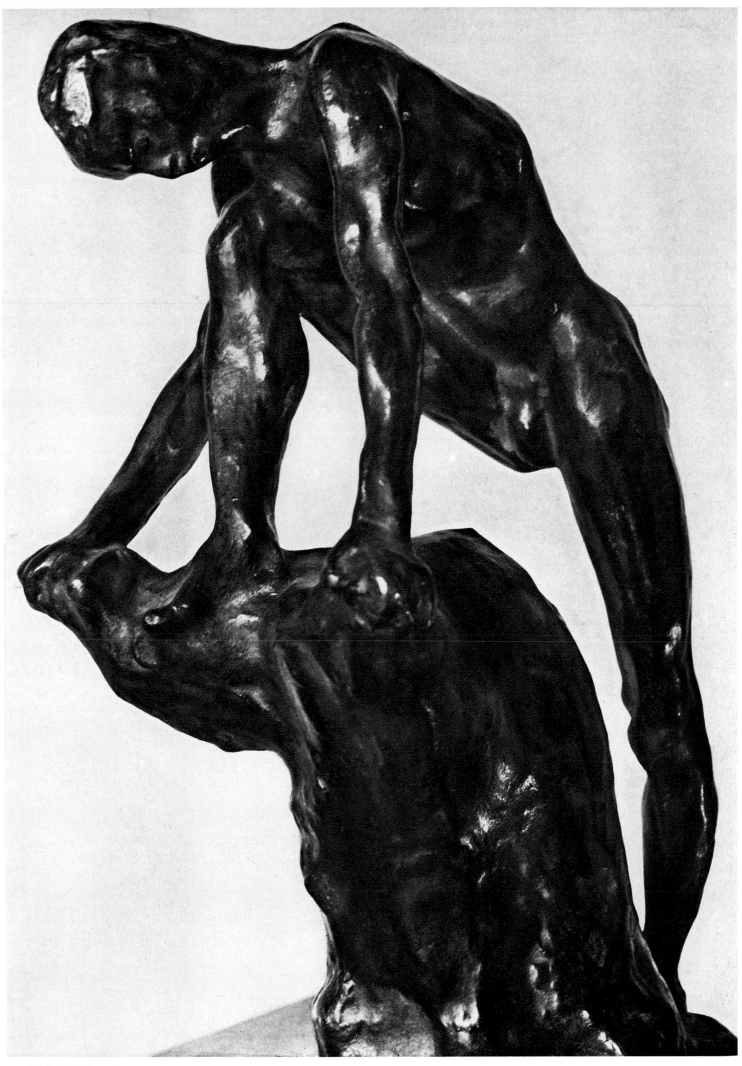

51. POLYPHEMUS. BRONZE. 1888.

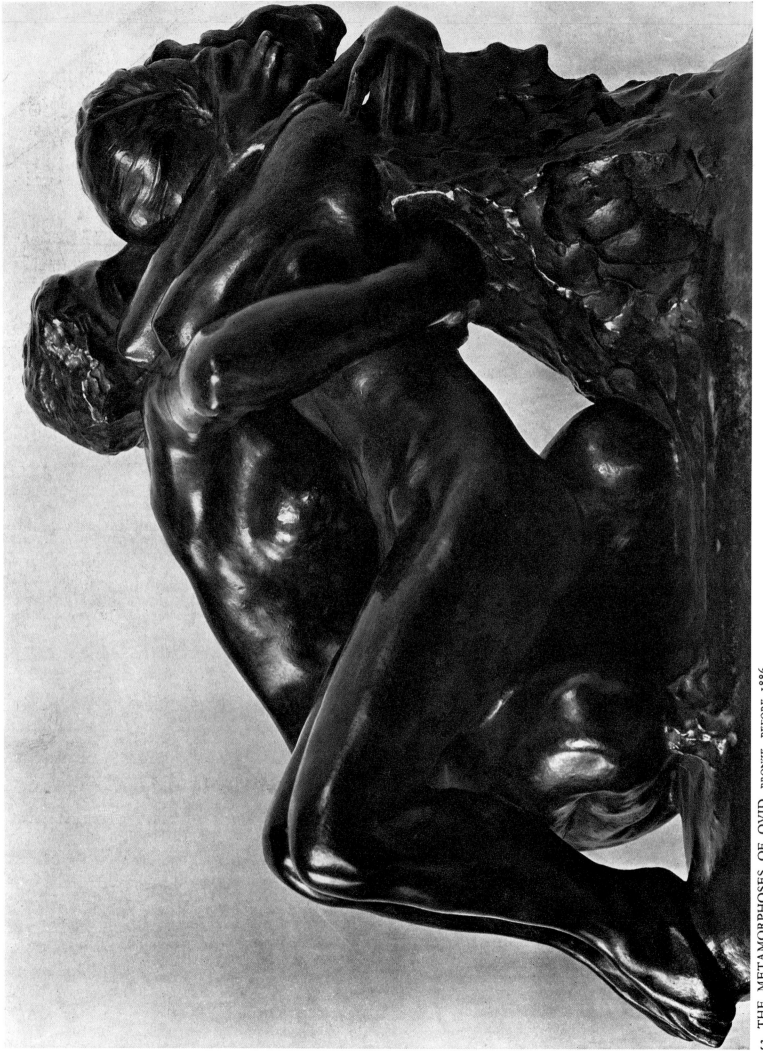

52. THE METAMORPHOSES OF OVID. BRONZE. BEFORE 1886.

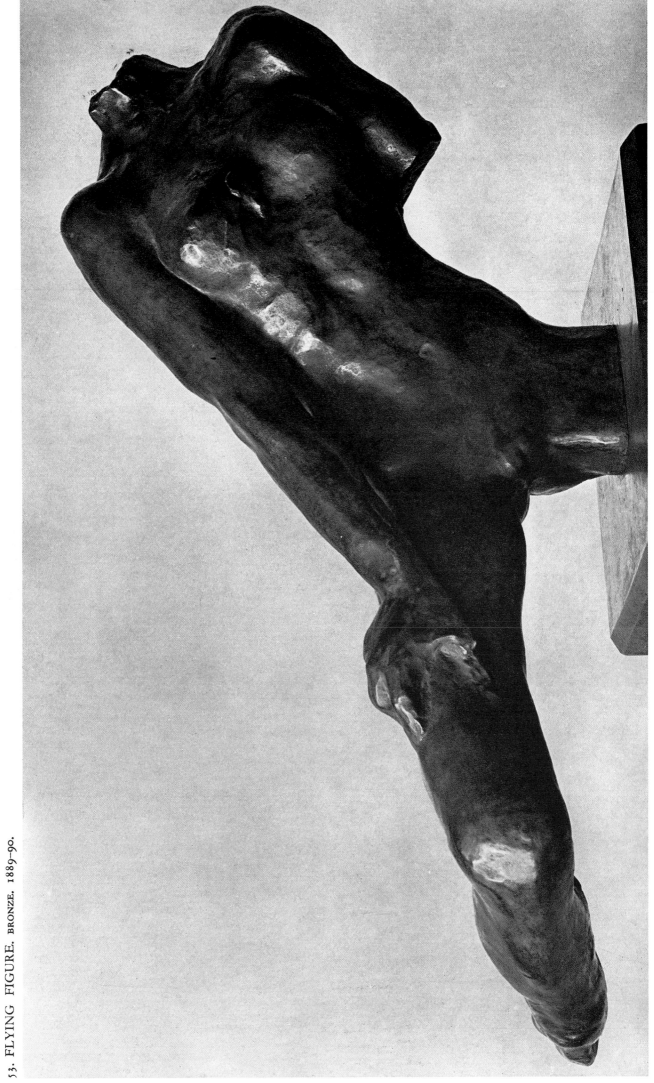

53. FLYING FIGURE. BRONZE. 1889–90.

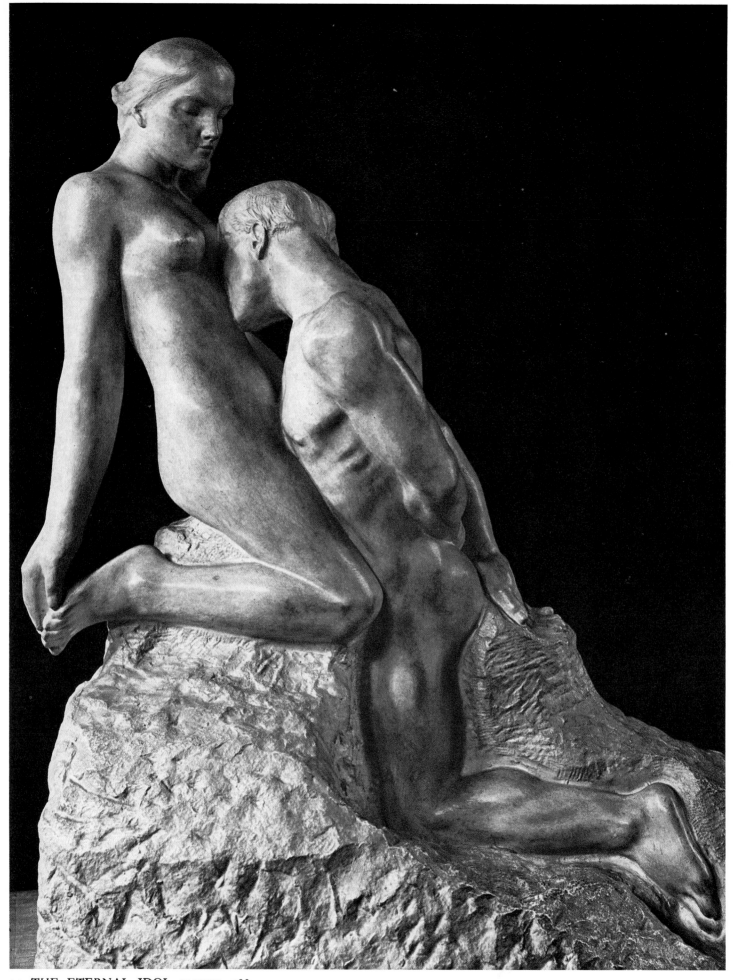

54. THE ETERNAL IDOL. PLASTER. 1889.

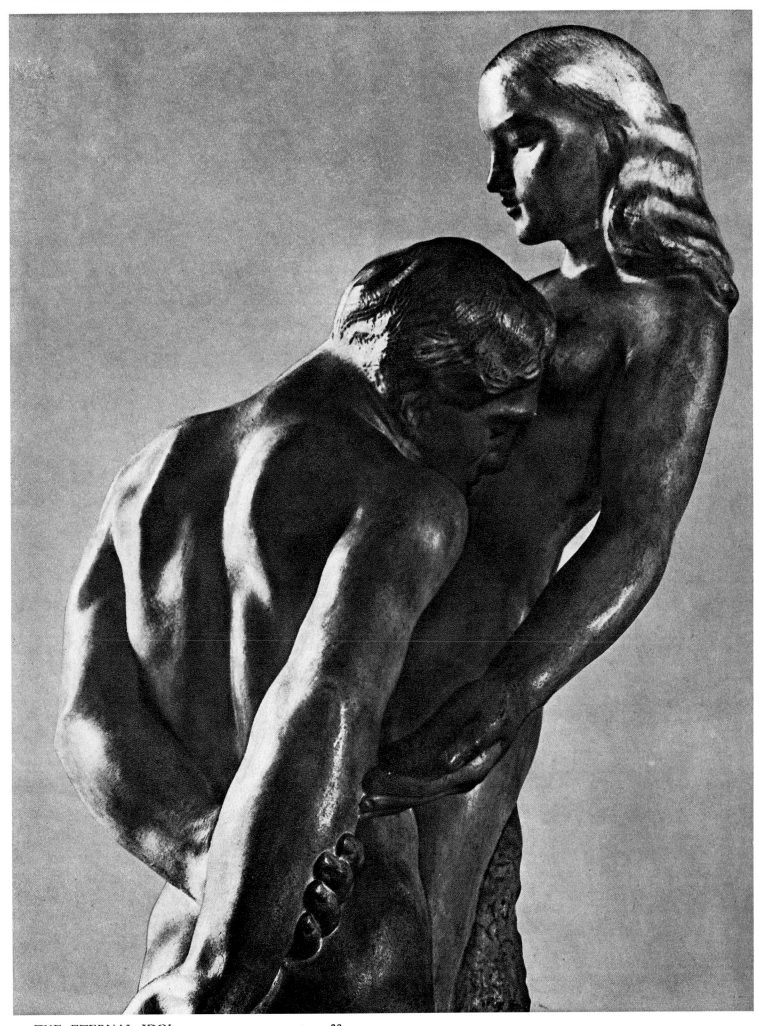

55. THE ETERNAL IDOL. DETAIL OF THE BRONZE. 1889.

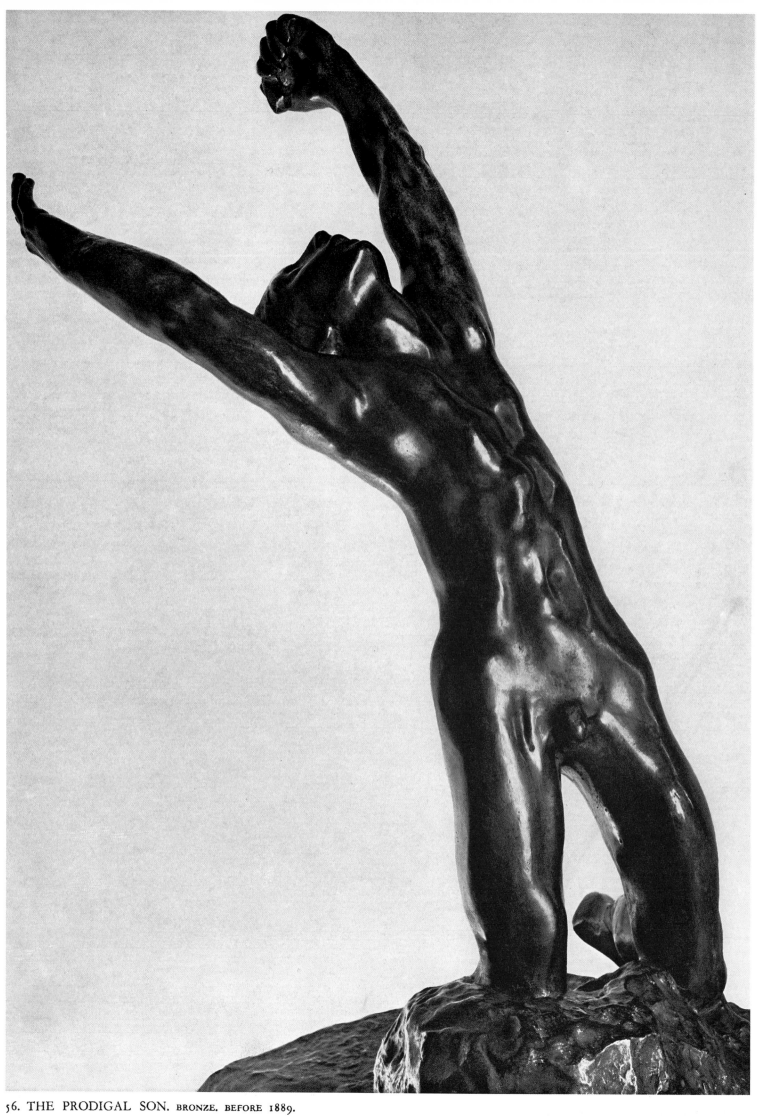

56. THE PRODIGAL SON. BRONZE. BEFORE 1889.

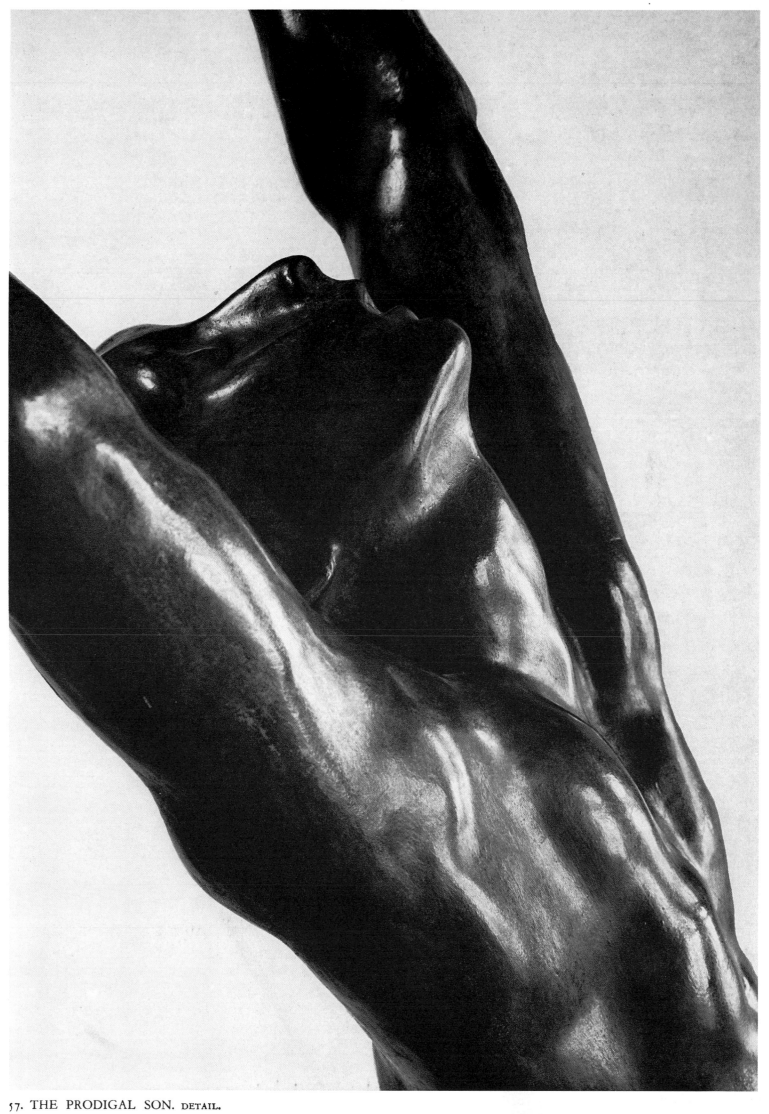

57. THE PRODIGAL SON. DETAIL.

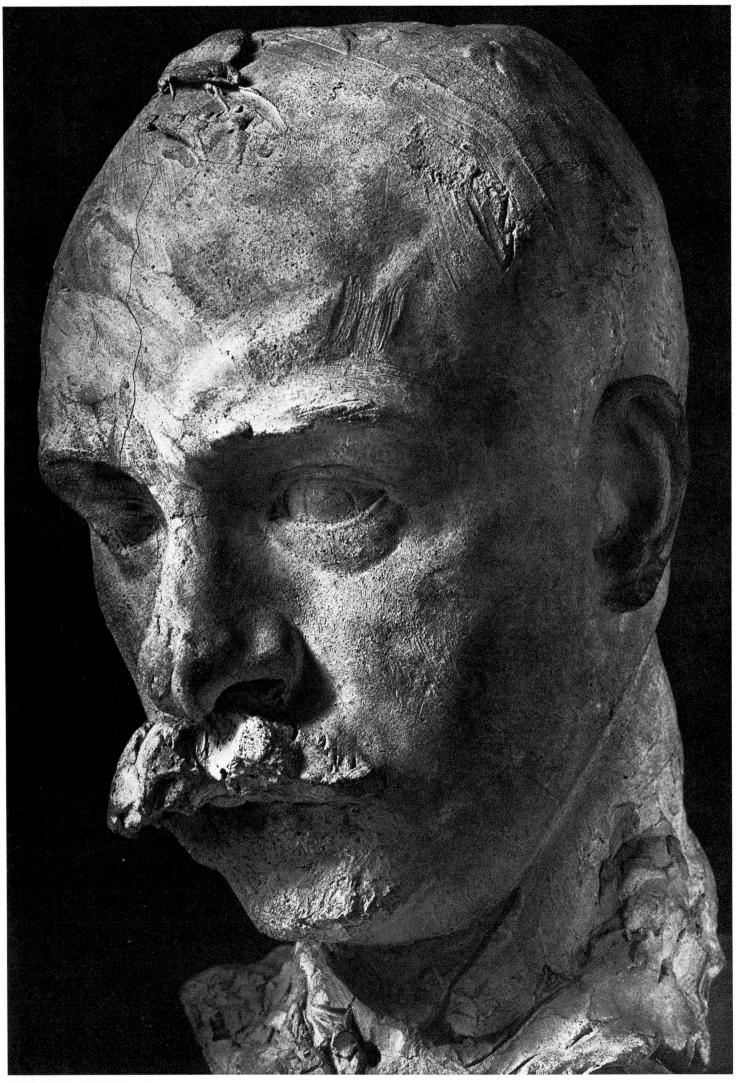

58. OCTAVE MIRBEAU. TERRACOTTA. 1889.

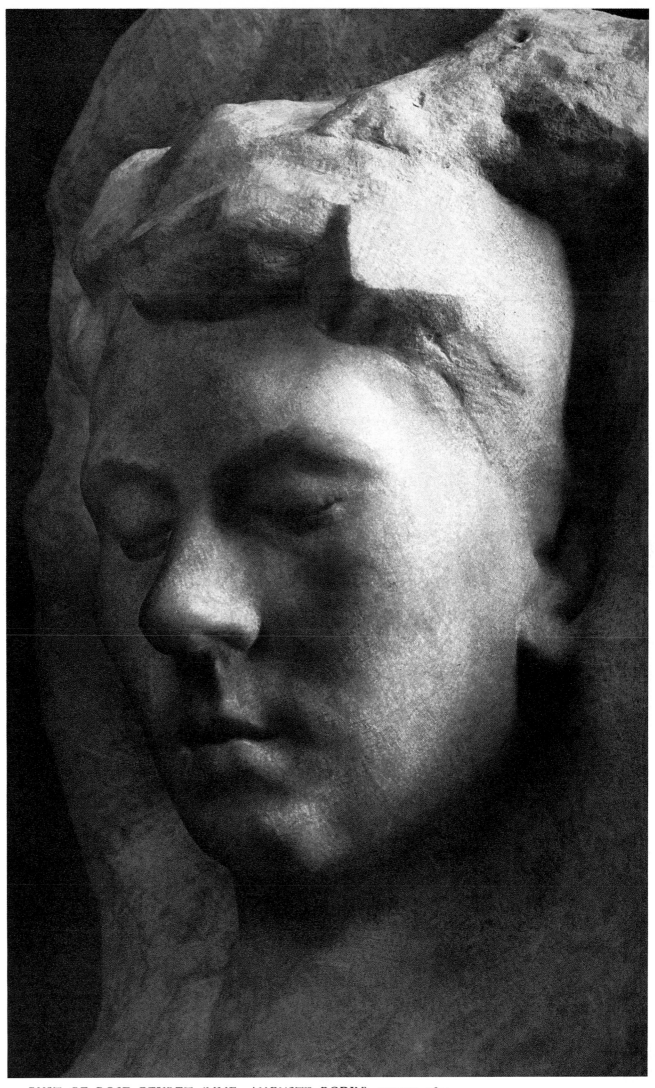

59. BUST OF ROSE BEURET (MME. AUGUSTE RODIN). MARBLE. 1890.

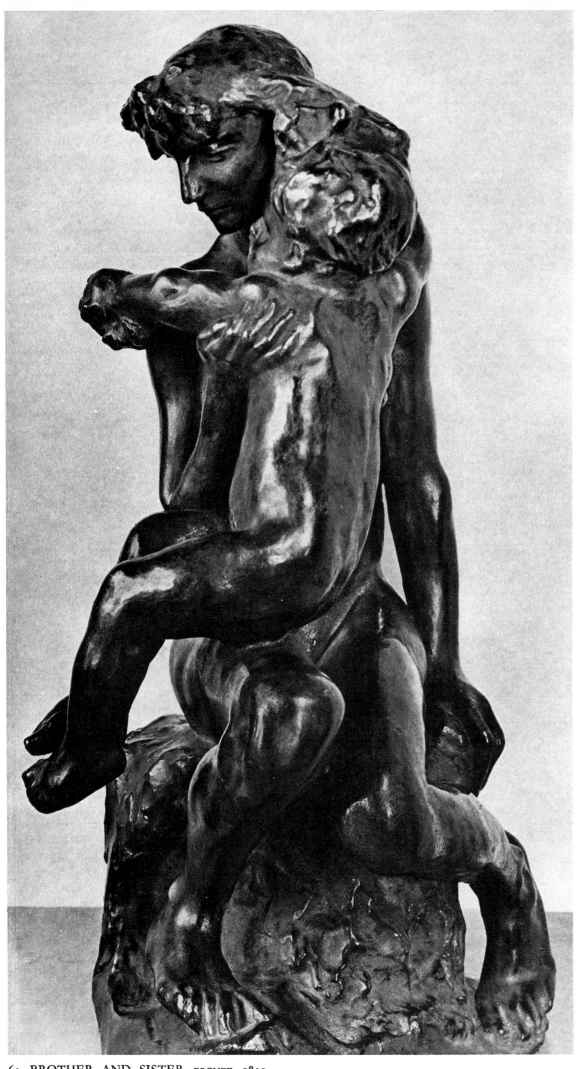

60. BROTHER AND SISTER. BRONZE. 1890.

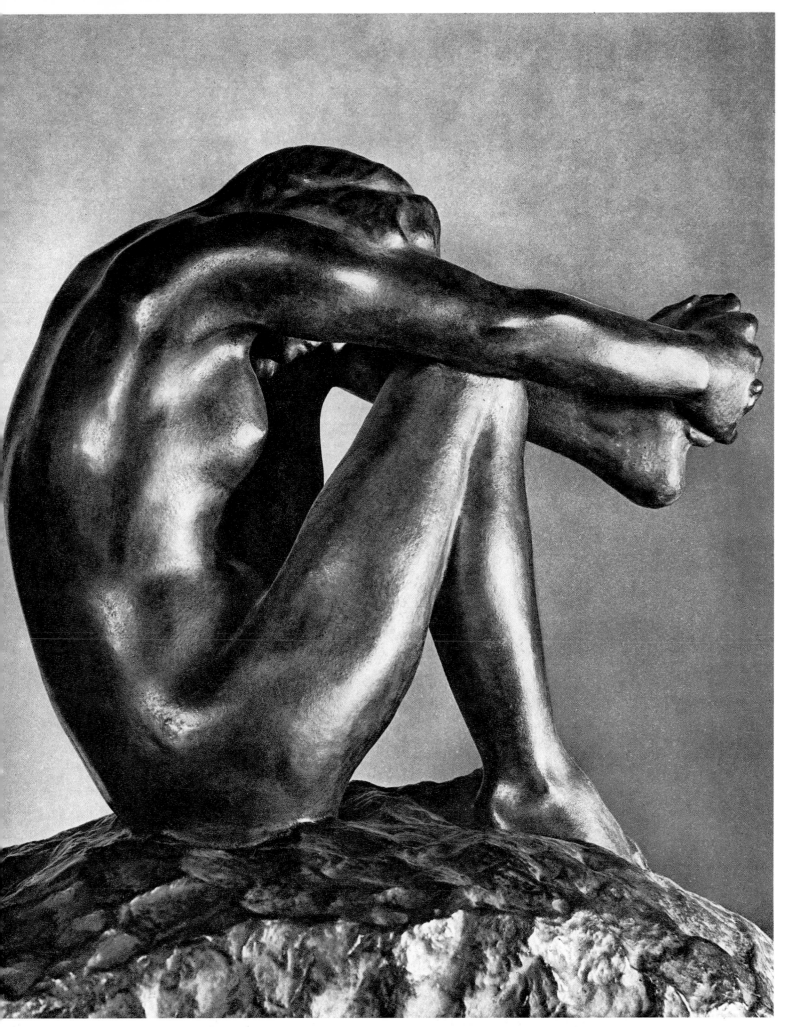

61. DESPAIR. BRONZE. 1890.

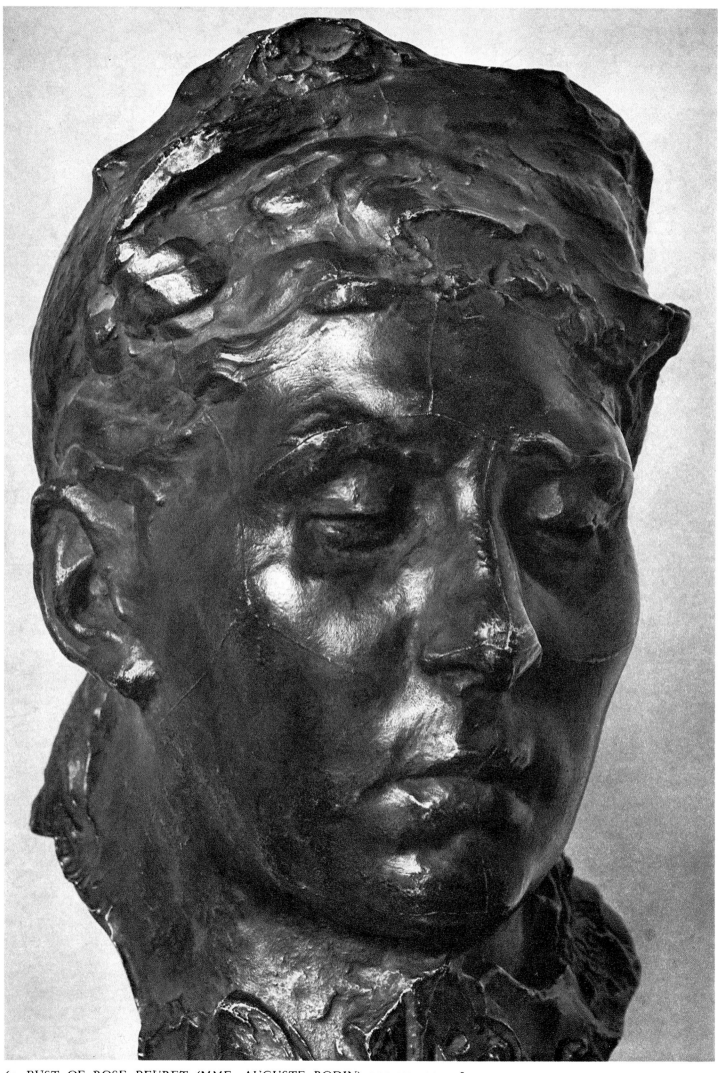

62. BUST OF ROSE BEURET (MME. AUGUSTE RODIN). BRONZE MASK. 1890.

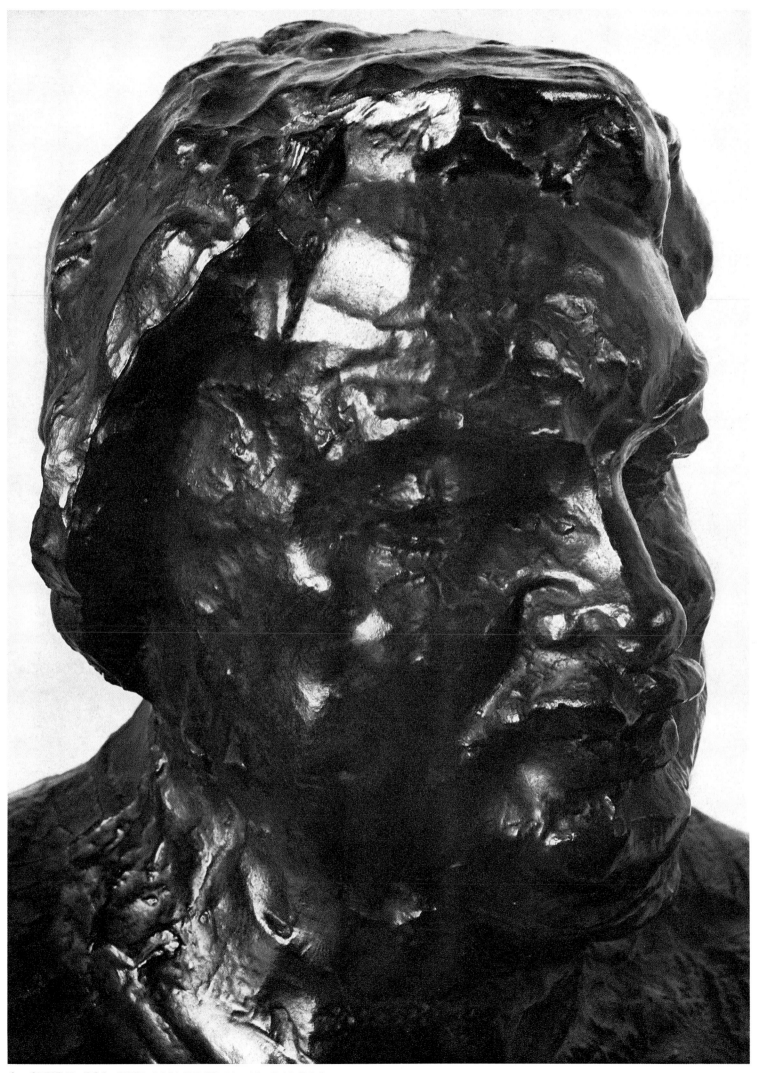

63. STUDY FOR THE MONUMENT TO BALZAC. BRONZE. 1893.

64. BALZAC. PLASTER. 1897.

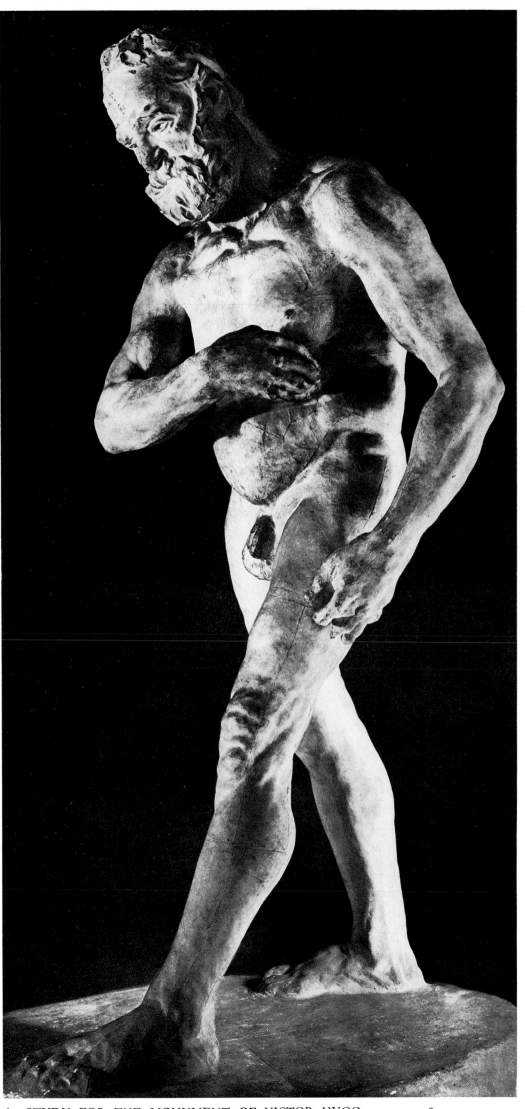

65. STUDY FOR THE MONUMENT OF VICTOR HUGO. PLASTER. 1897.

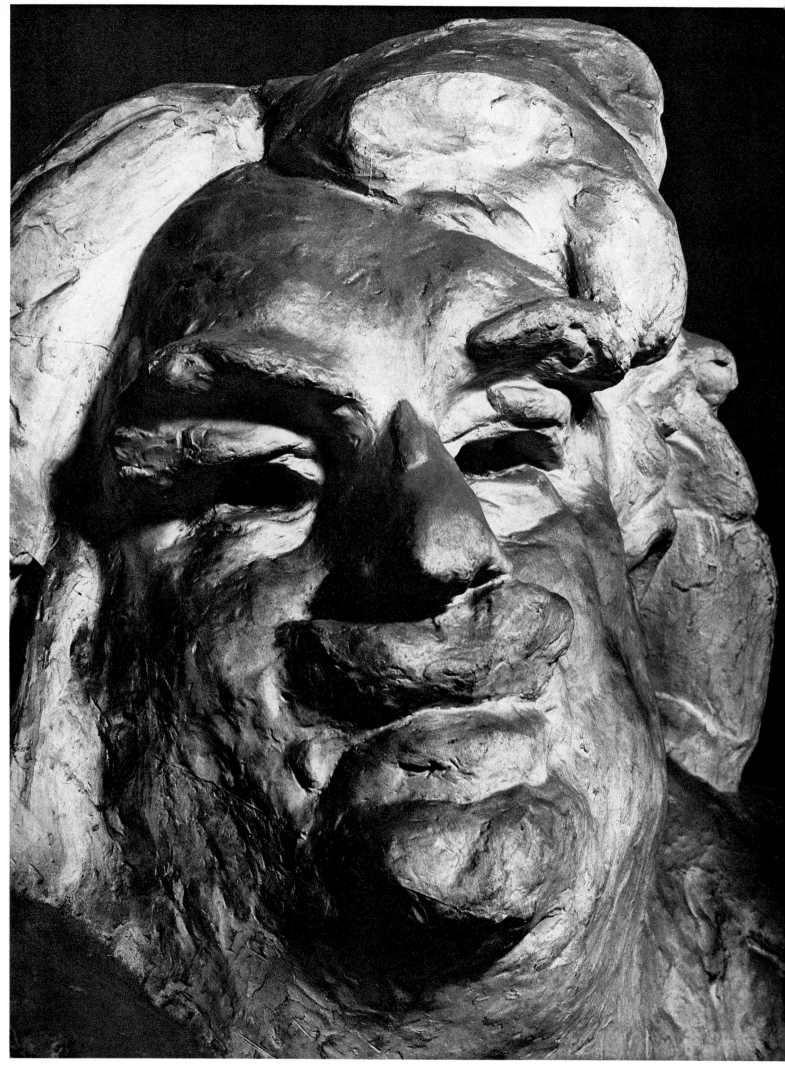

66. BALZAC. DETAIL.

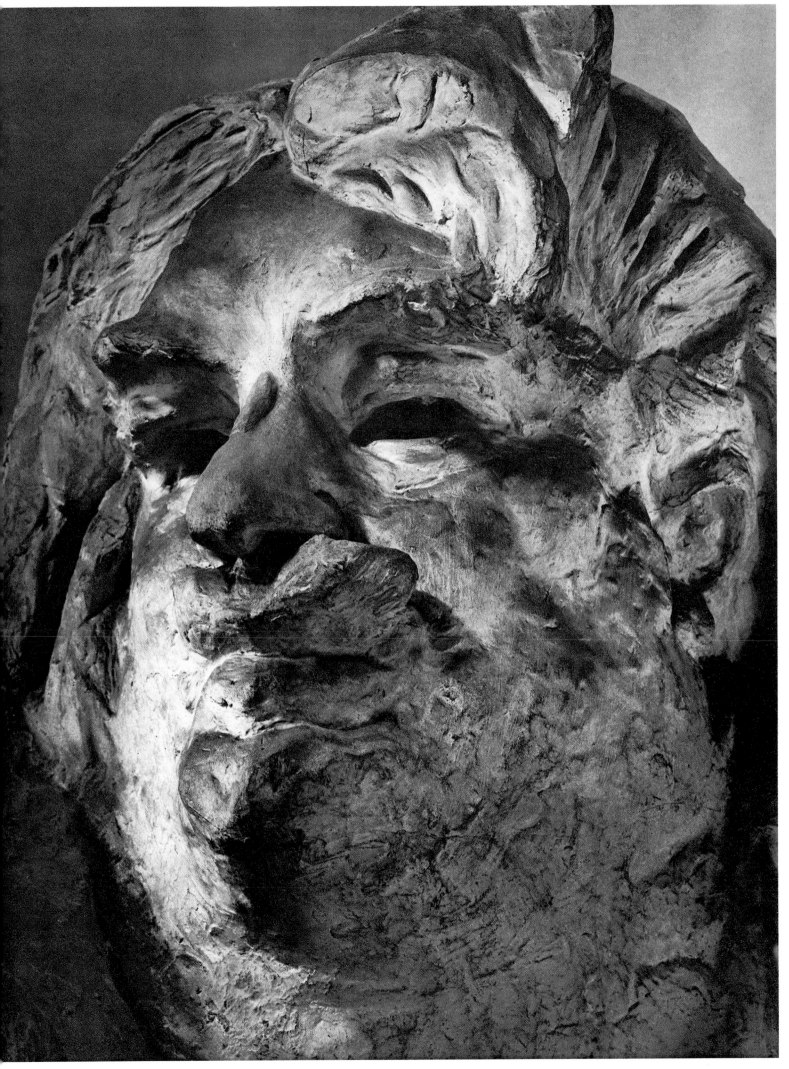

67. BALZAC. DETAIL.

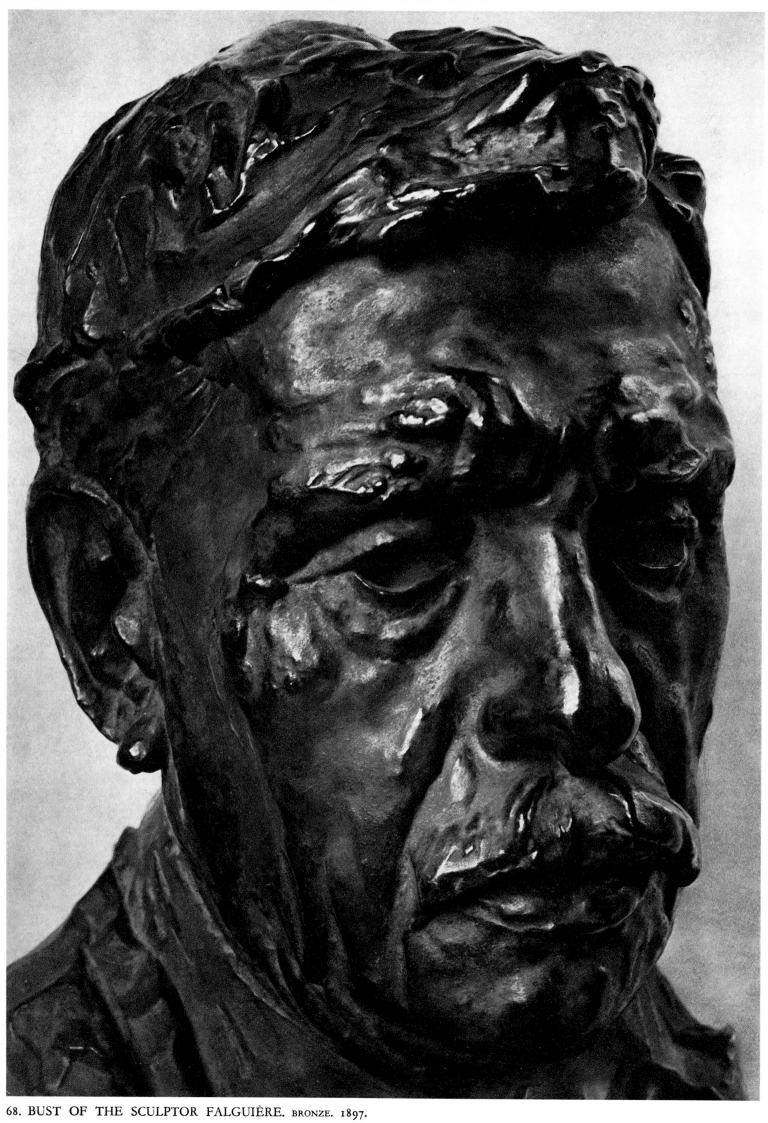

68. BUST OF THE SCULPTOR FALGUIÈRE. BRONZE. 1897.

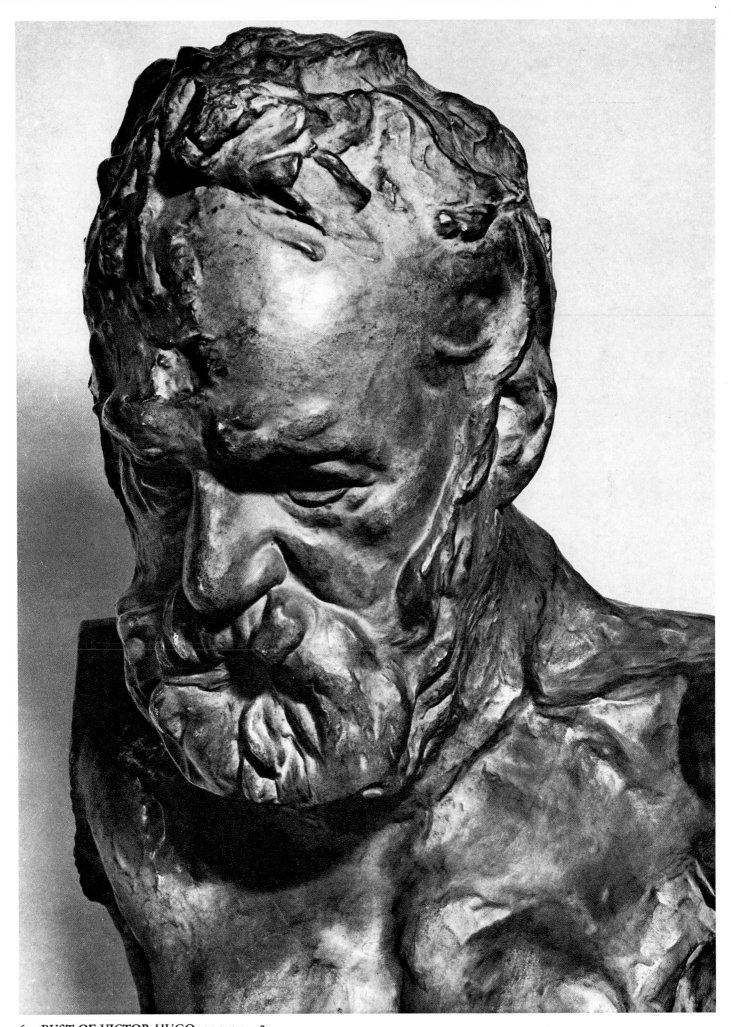

69. BUST OF VICTOR HUGO. BRONZE. 1897.

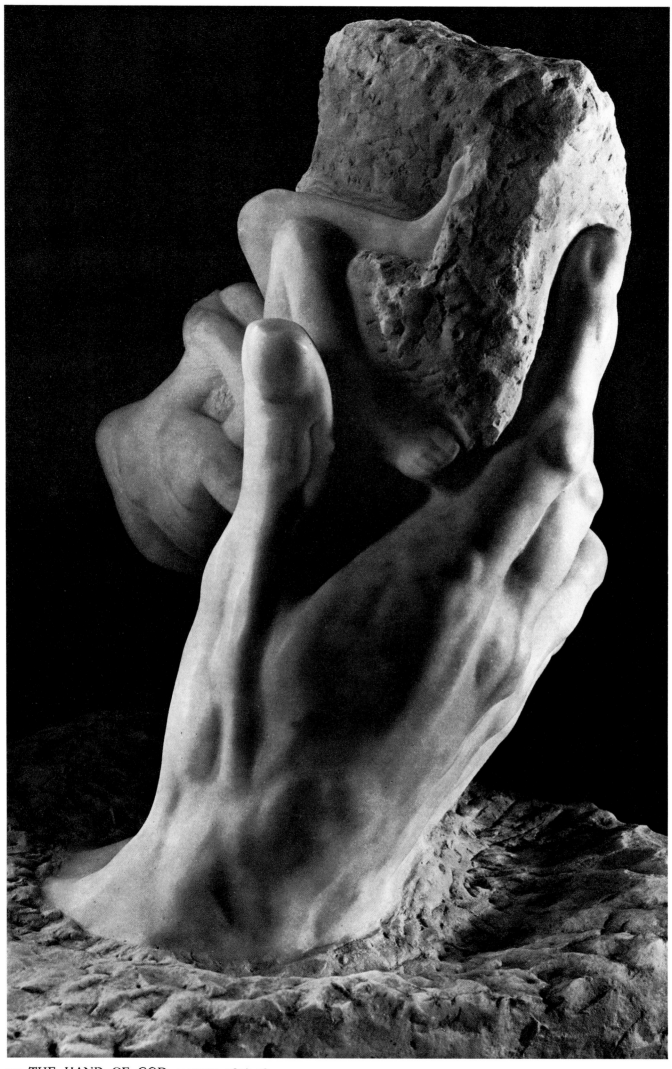

70. THE HAND OF GOD. MARBLE. 1897–98.

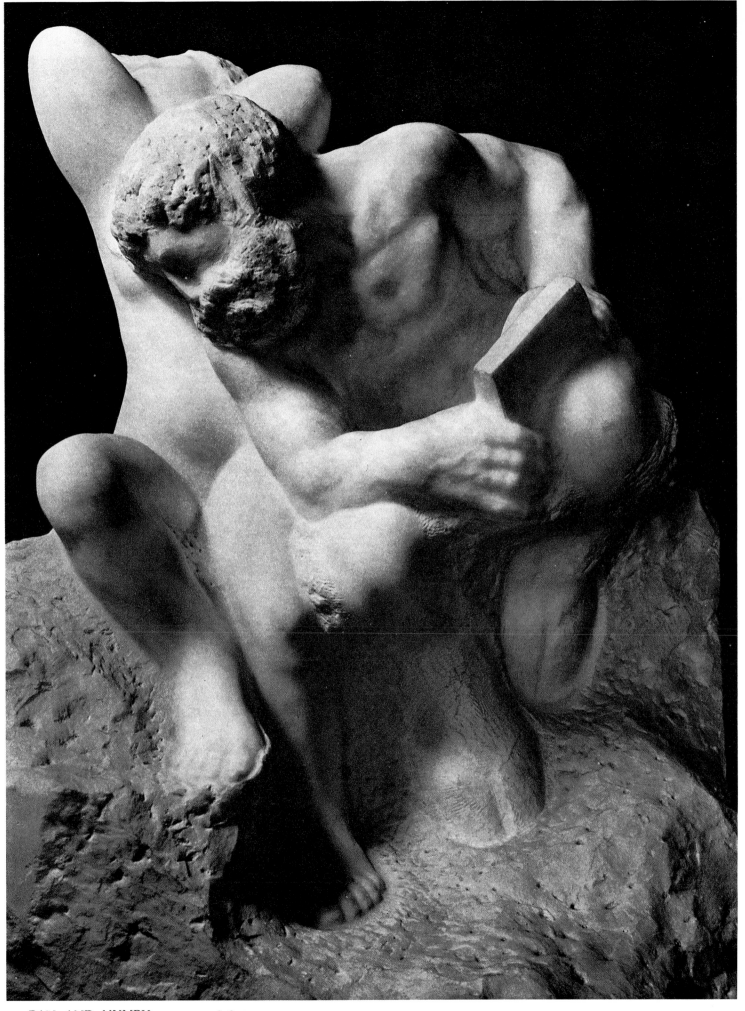

71. PAN AND NYMPH. MARBLE. 1898.

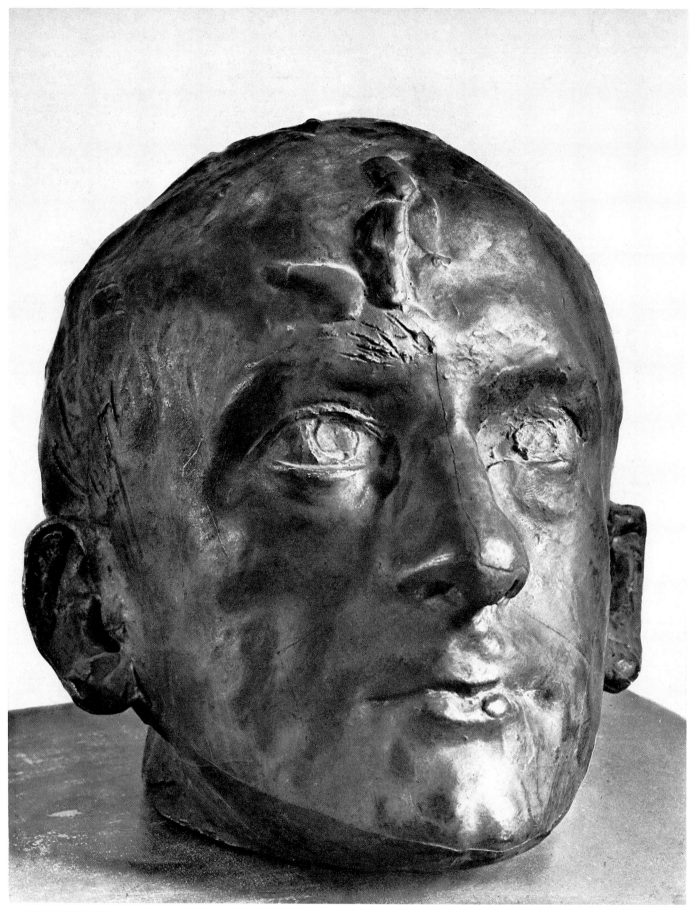

72. BAUDELAIRE. PLASTER. 1898.

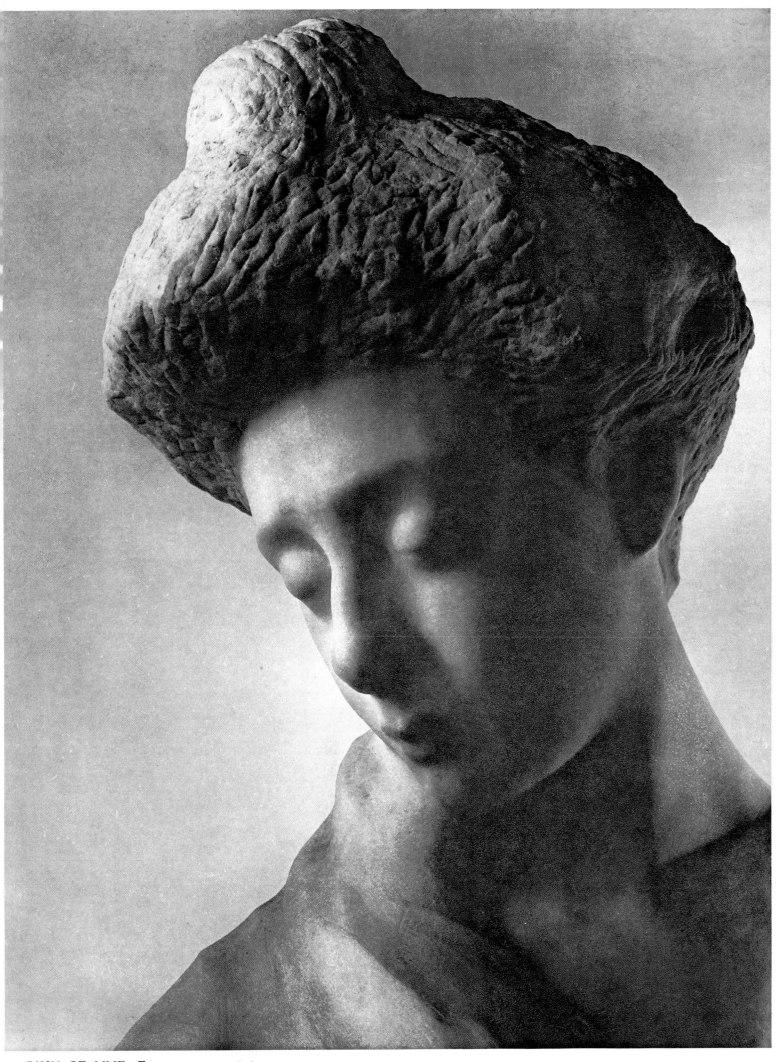

73. BUST OF MME. F . . . MARBLE. 1898.

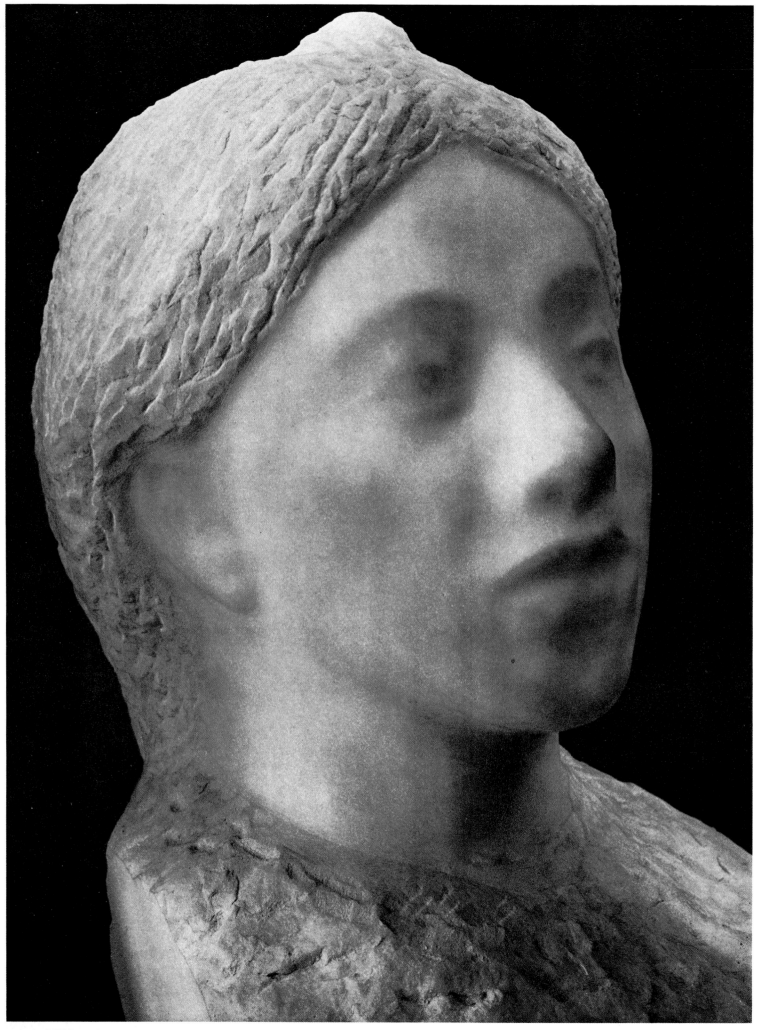

74. A MUSE. STUDY FOR THE WHISTLER MONUMENT. MARBLE. 1902-3.

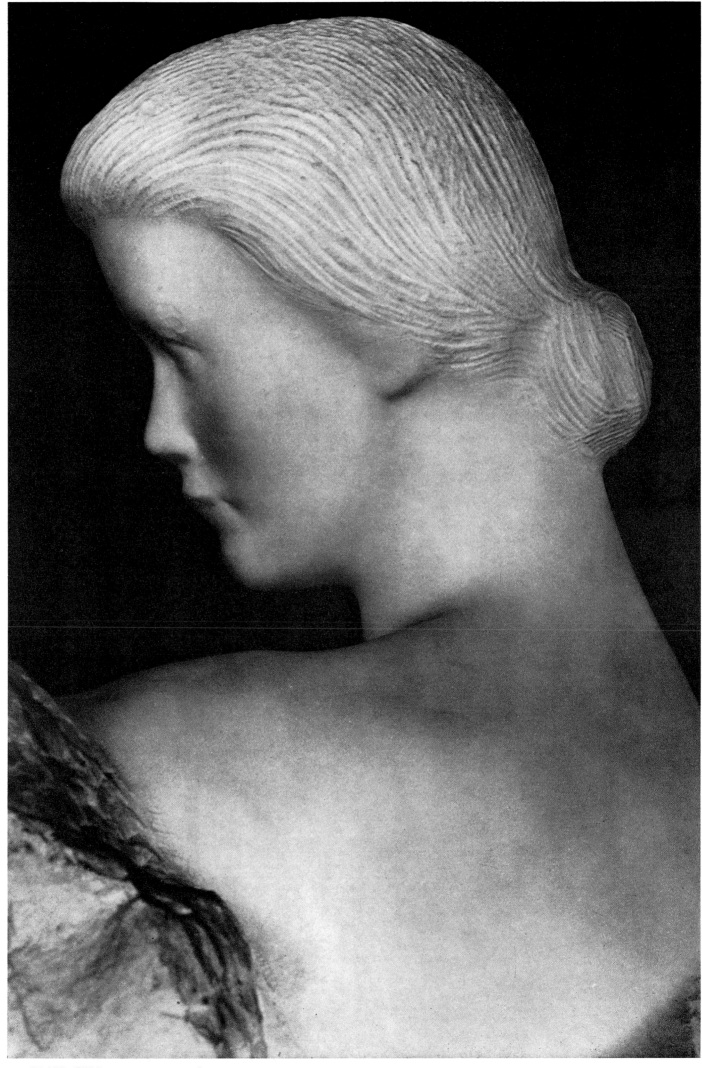

75. SLAV GIRL. MARBLE. 1905-6.

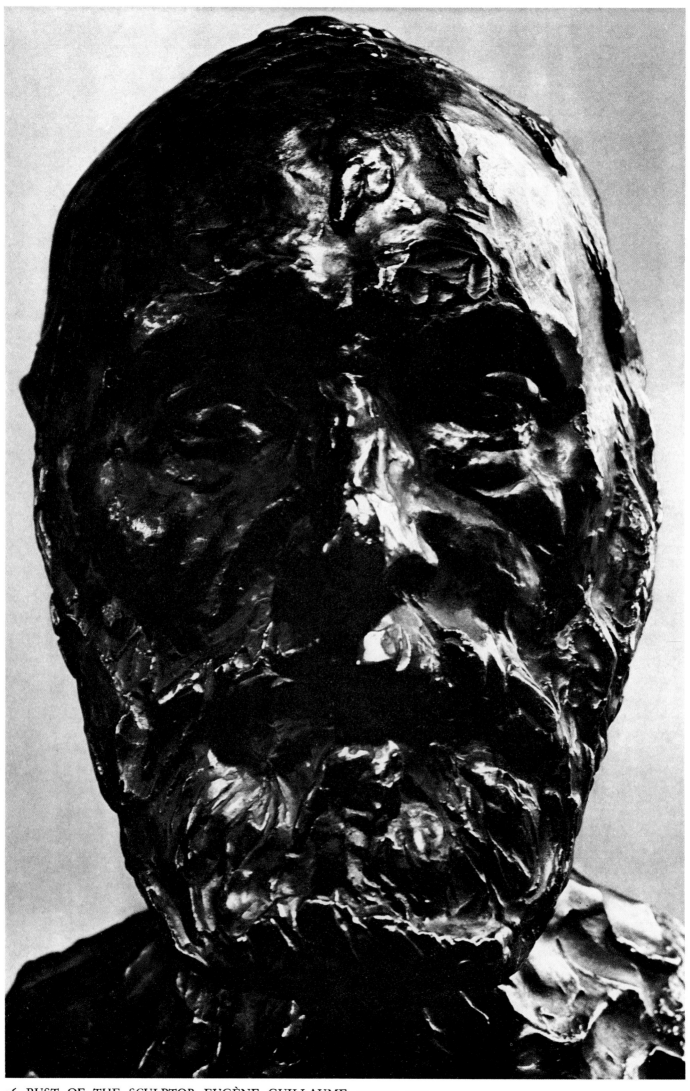

76. BUST OF THE SCULPTOR EUGÈNE GUILLAUME. BRONZE. 1903.

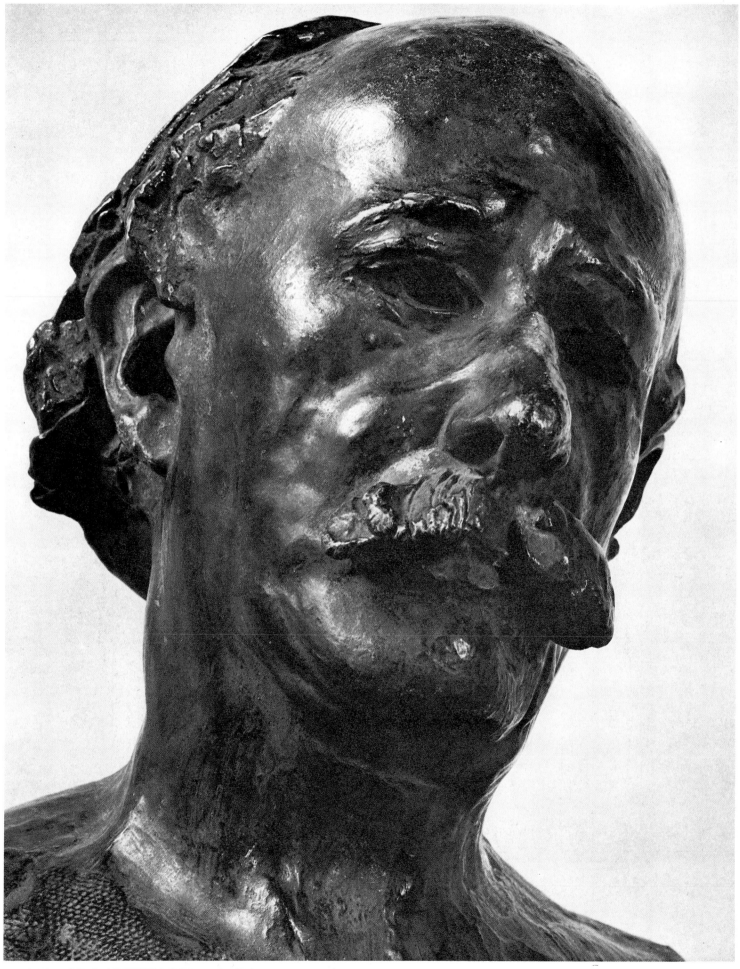

77. BUST OF MARCELIN BERTHELOT. BRONZE. 1906.

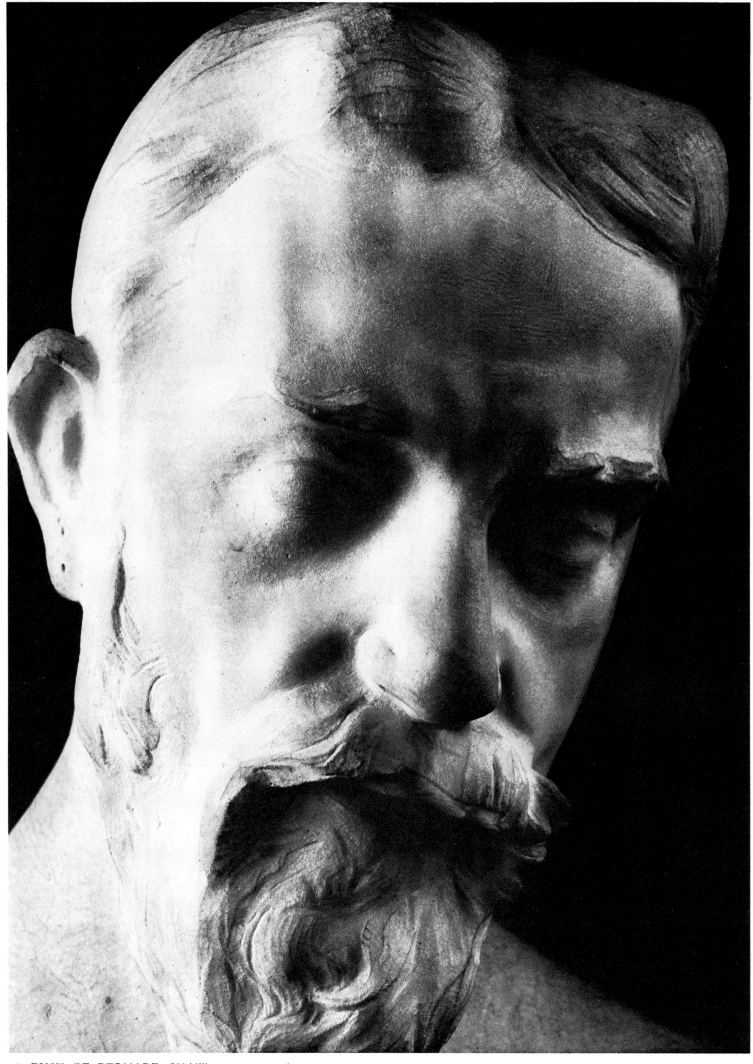

78. BUST OF BERNARD SHAW. MARBLE. 1906.

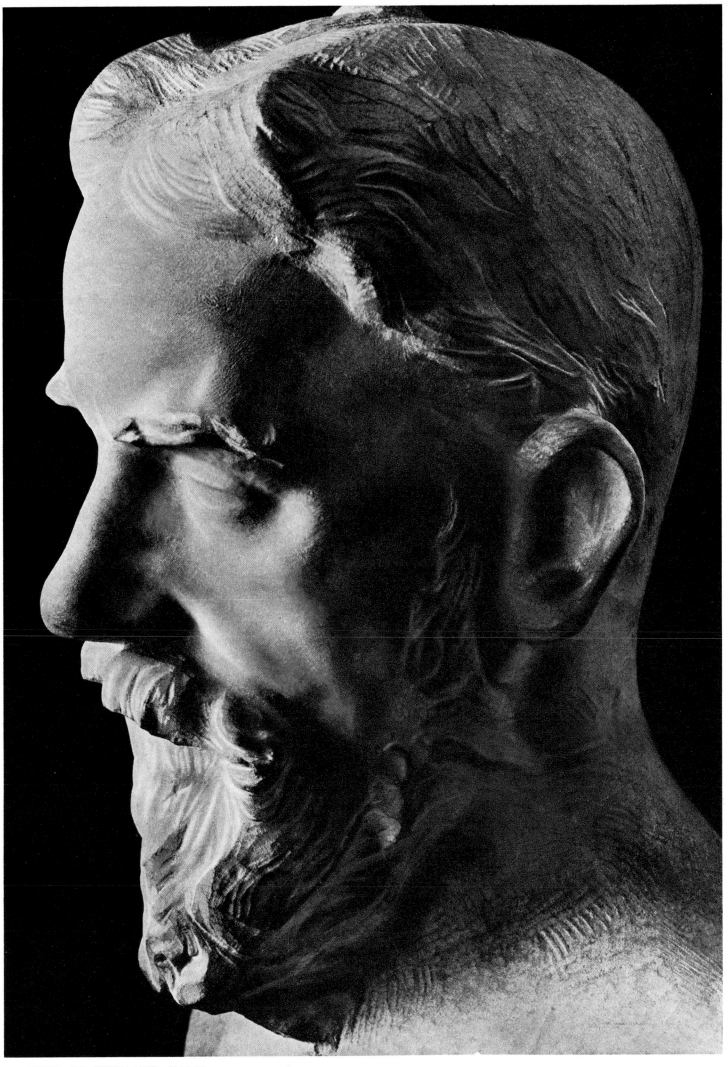

79. BUST OF BERNARD SHAW. MARBLE. 1906.

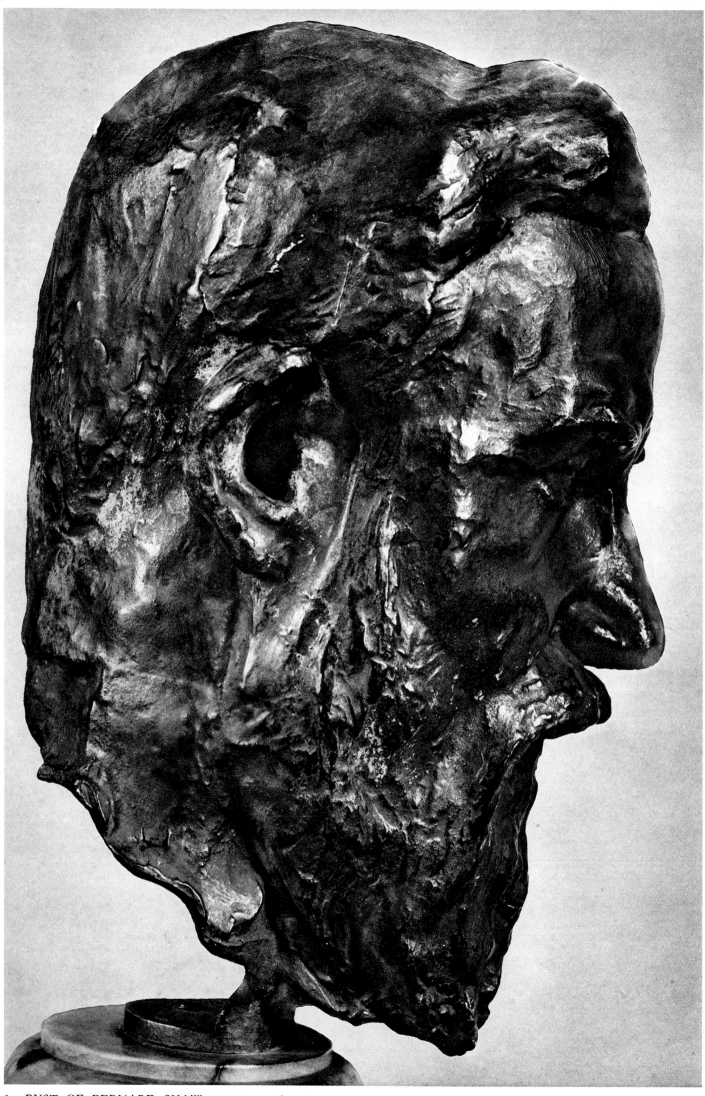

80. BUST OF BERNARD SHAW. BRONZE. 1906.

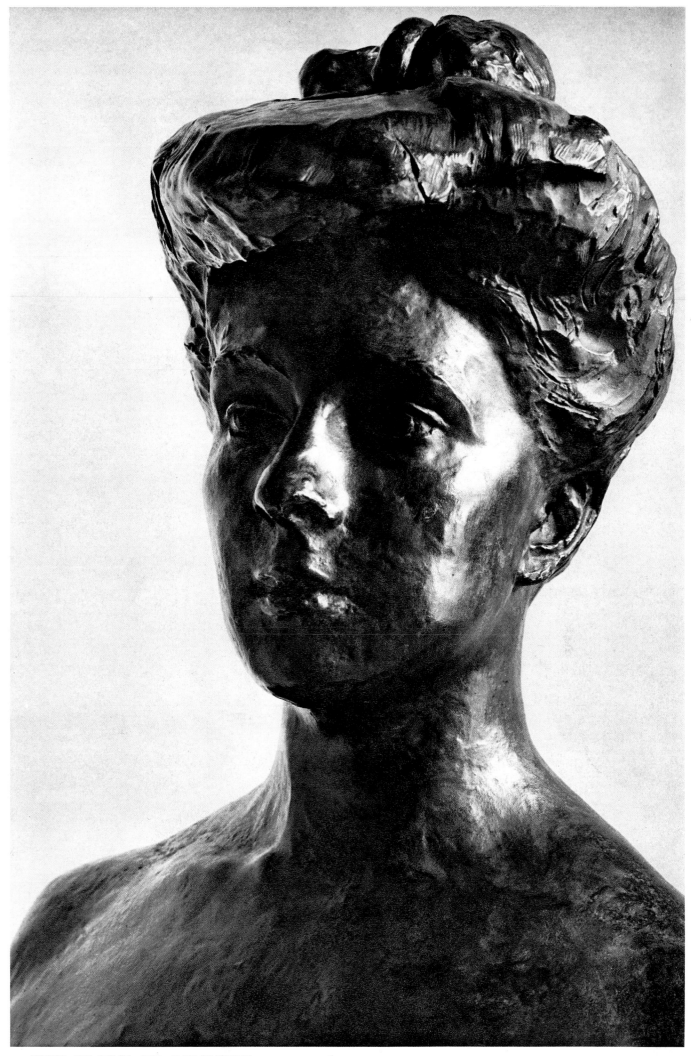

81. BUST OF MME. DE GOLOUBEFF. BRONZE. 1906.

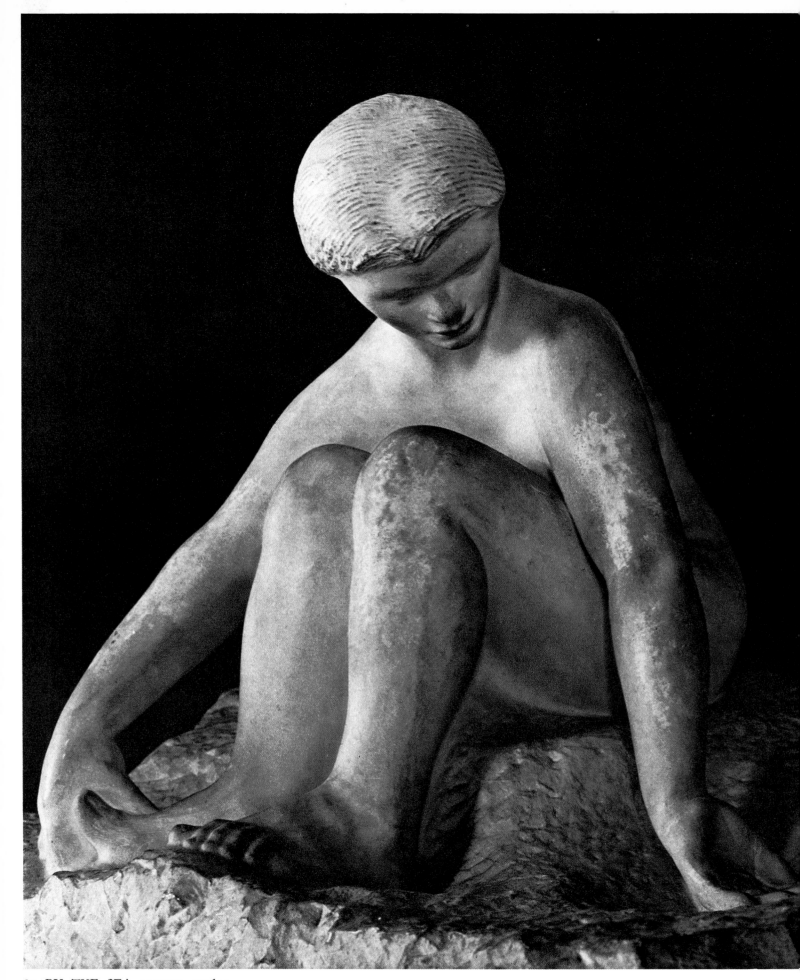

82. BY THE SEA. PLASTER. 1906–7.

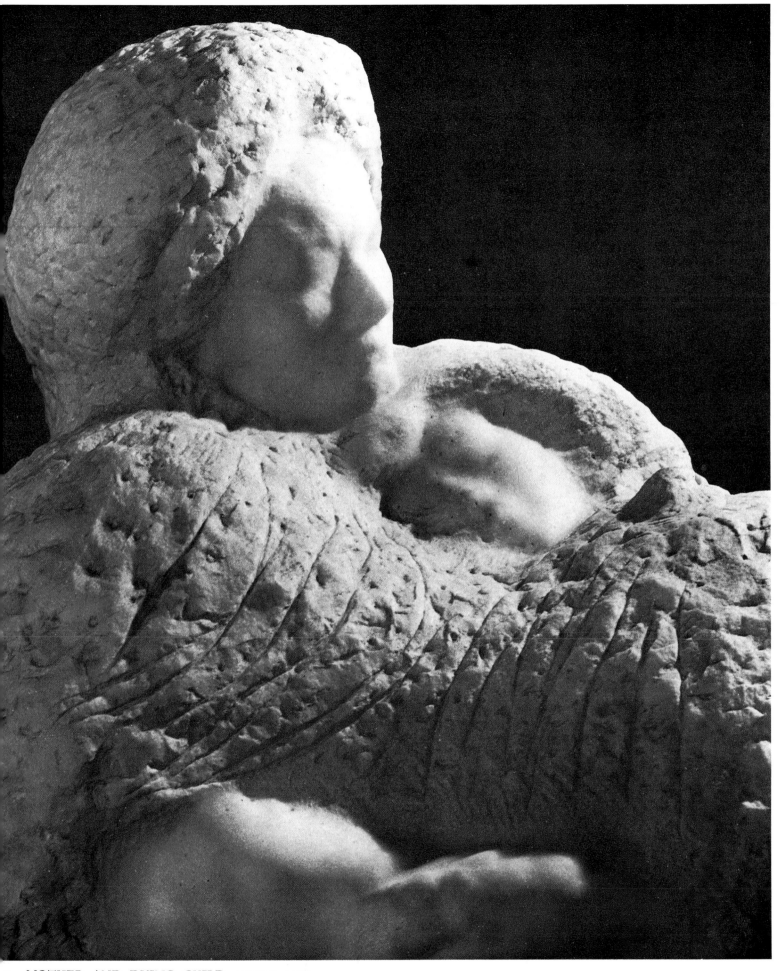

83. MOTHER AND DYING CHILD. MARBLE. 1908.

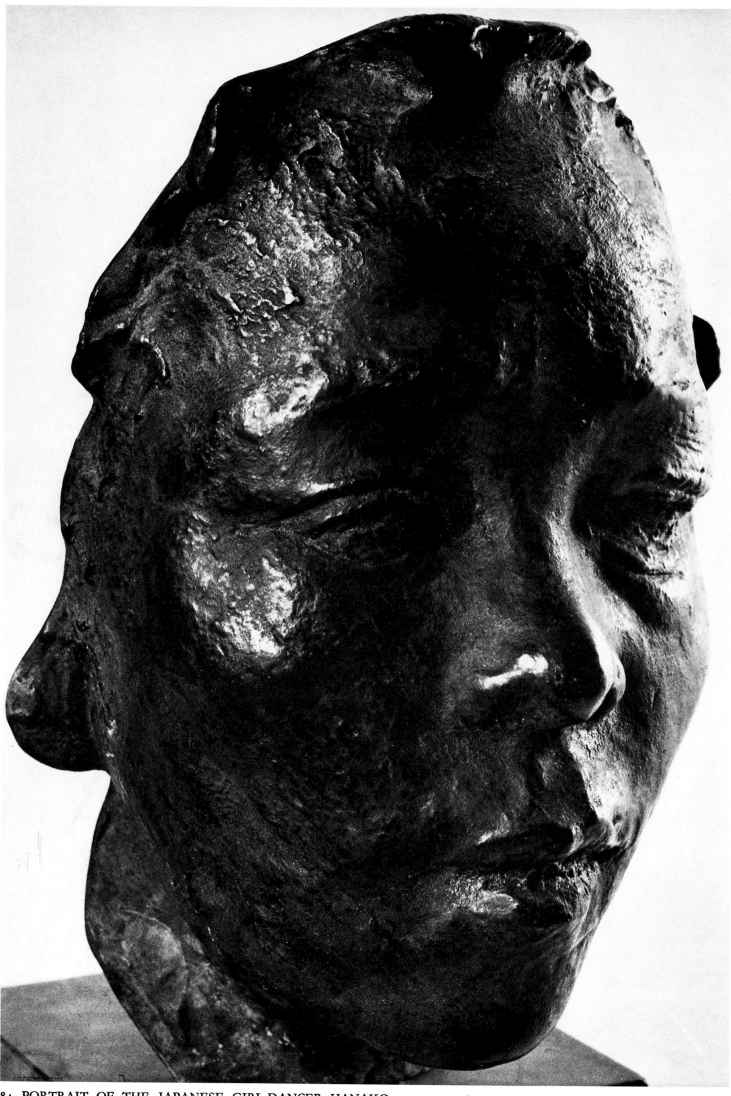

84. PORTRAIT OF THE JAPANESE GIRL-DANCER HANAKO. BRONZE. 1908.

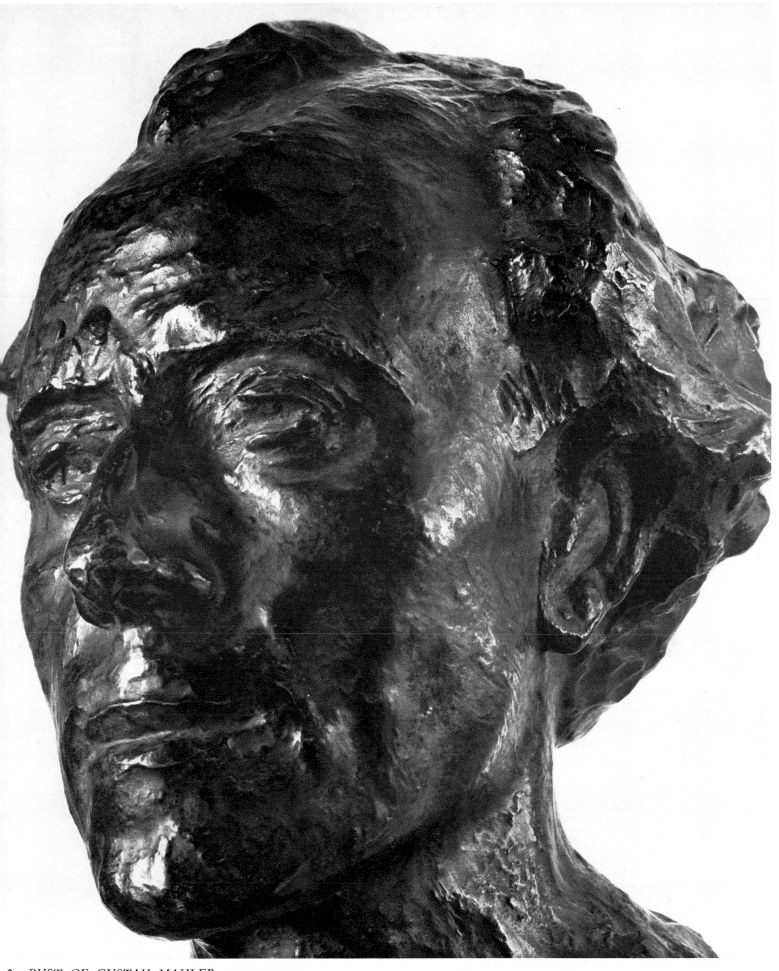

85. BUST OF GUSTAV MAHLER. BRONZE. 1909.

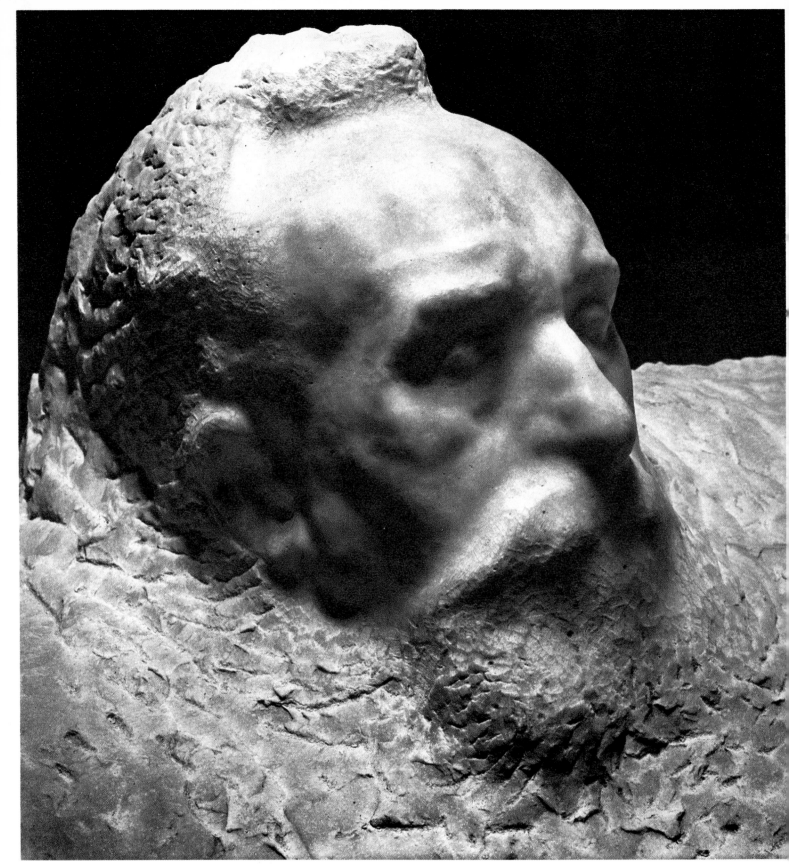

86. BUST OF THE PAINTER PUVIS DE CHAVANNES. MARBLE. 1910.

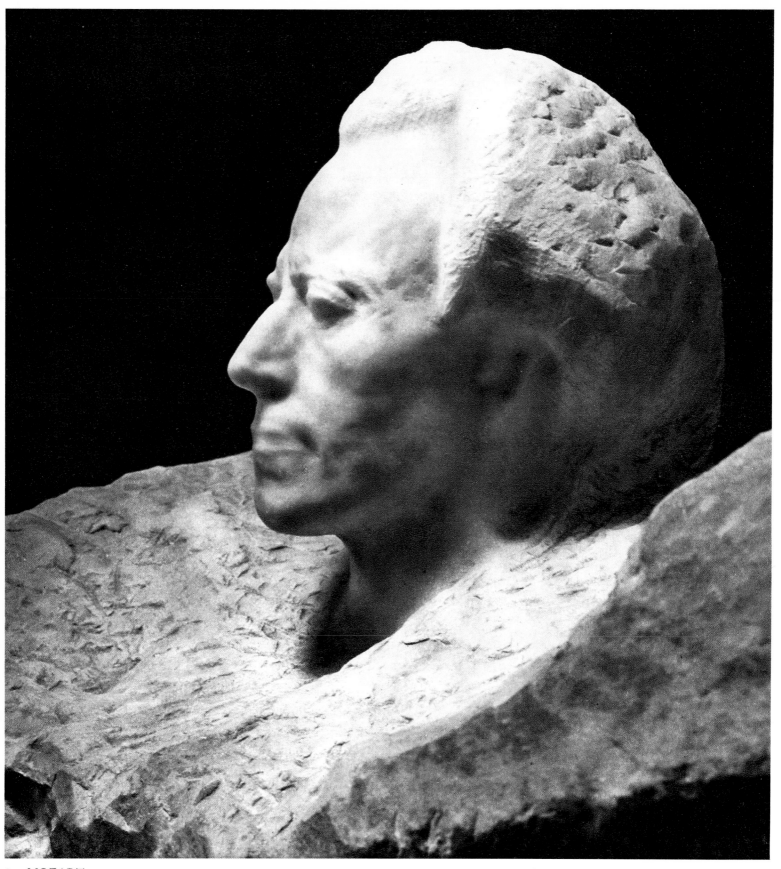

87. MOZART. MARBLE. 1910.

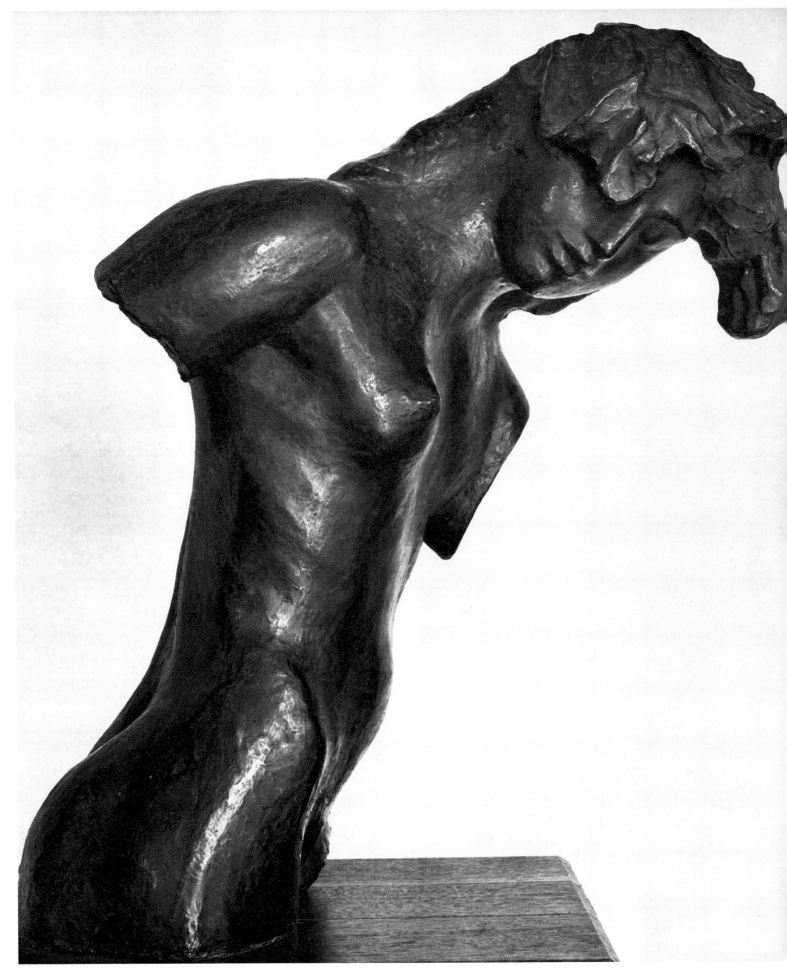

88. FEMALE TORSO. BRONZE. 1910.

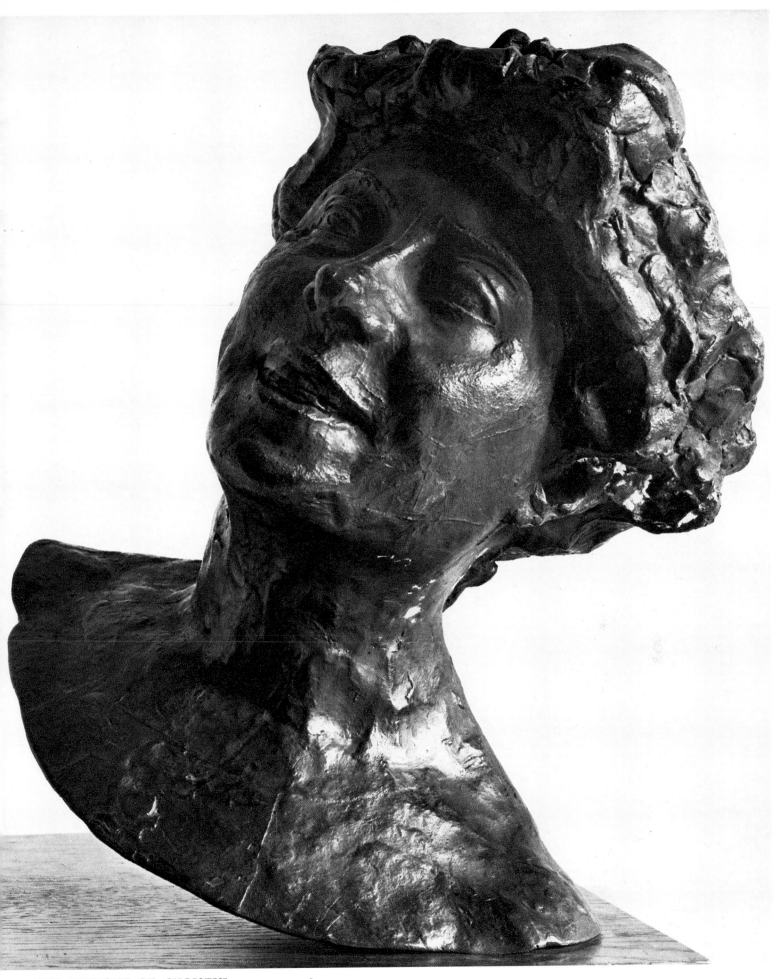

89. THE DUCHESS OF CHOISEUL. BRONZE. 1908.

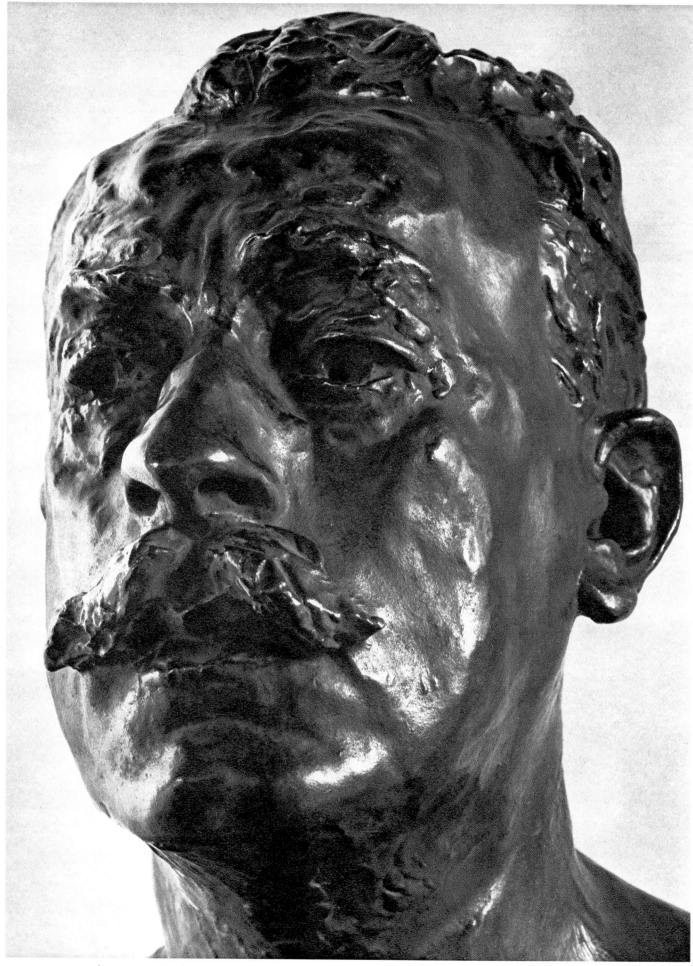

90. BUST OF ÉTIENNE CLÉMENTEL. BRONZE. 1916.

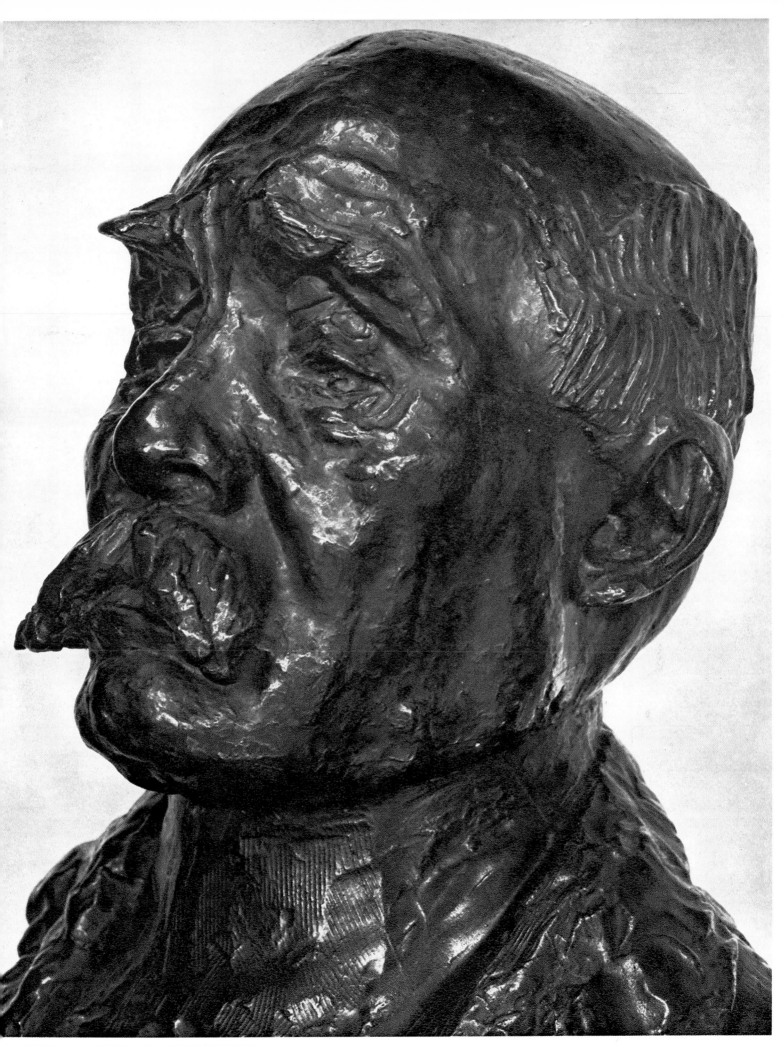

91. BUST OF GEORGES CLEMENCEAU. BRONZE. 1911.

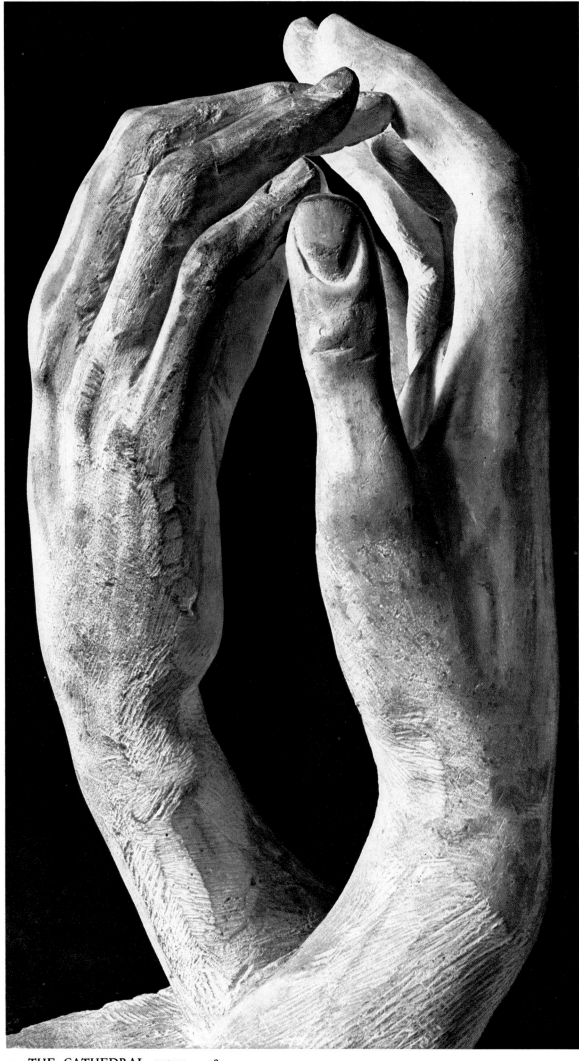

92. THE CATHEDRAL. STONE. 1908.

# Notes on the Plates

# Notes on the Plates

*Measurements are given in inches, first height, then width, then depth.*

1. RODIN'S FATHER. 1860. Bronze, $16\frac{1}{2}\times11\frac{1}{8}\times9\frac{1}{2}$. This bust is the artist's first known work. J.-B. Rodin, who was a Norman, came to Paris in the reign of Charles X, and was engaged as office boy in the Prefecture of Police. He retired with the rank of inspector in 1861 and died in 1883. This bust, modelled in Roman fashion, recalls an effigy of Cato or of Minucius Felix. Although inspired by antique statuary, it already manifests a very strong personality and remarkable technical skill. This youthful work was built up by successive profiles according to the method Rodin was to adopt each time he executed a portrait.

2. THE BLESSED FATHER EYMARD. 1863. Bronze, $23\frac{1}{4}\times11\frac{3}{8}\times11\frac{3}{8}$.
In 1863, Rodin's sister, who was a nun, died in the spring-time of life. The young artist felt the loss so keenly that he sought admission to a religious order close to the family dwelling, rue St. Jacques, just founded by Father Eymard. On joining the Fathers of the Holy Sacrament, he took the name of 'Brother Augustine'. But Father Eymard, who was a rare psychologist, was not slow to realize that this vocation, prompted as it was by fraternal grief, was unlikely to prove lasting. He therefore requested his novice to sculpture his bust. While the monk was posing, he managed to persuade Rodin to return to the world, to fulfil his artistic destiny there. The Church has since beatified Father Eymard, and we are constrained to join in the homage paid to this holy personage, without whom, perhaps, we might not have had the magnificent work executed by Rodin and dating from this epoch.
The bust of Father Eymard, vital among all those the artist sculptured, is characterized by an intense and luminous expression which shows Rodin's growing mastery of statuary.

3. MASK OF THE MAN WITH THE BROKEN NOSE. 1864. Bronze mask, $9\frac{1}{2}\times8\frac{3}{4}\times10\frac{1}{4}$.
This work has some affinity with the bust of the artist's father (Plate 1). It, too, breathes classical inspiration and reminds one of the Greek marbles. Thus we are advised that Rodin, although refused admission thrice to the School of Fine Arts, was working in solitude to acquire that classical education he was deemed unworthy to receive.
This mask is the more interesting as being that of an old Bohemian whom the young artist encountered on the slopes of the Rue Mouffetard, as busy a thoroughfare as one could wish, and close to the Horse Fair, where Rodin was fond of observing life. The work, refused by the Salon for being offered, with audacious simplicity, under the title 'Mask of Bibi' (the Bohemian's name), remodelled in 1872 as bust and in marble and sent in under the title: 'Bust of Mr. B. . . . ', was received this time with favour.

4–5. THE AGE OF BRASS. 1876. Bronze, $68\frac{1}{2}\times23\frac{5}{8}\times23\frac{5}{8}$.
The history of the conception and carrying out of this work is particularly interesting. It came after a period when the artist had been taking long country walks in the beautiful regions round Brussels, either alone or with his wife. This communing with Nature had made a deep impression on him, which was emphasized by the reading of Jean-Jacques Rousseau, who at the time and for long afterwards was his favourite author. Thus it was that the idea came to him to depict a purely natural man in the infancy of comprehension. He chose for his model a Belgian soldier who in private life was a carpenter. He was a physically perfect man, and, though not possessing much education, was very intelligent and able to understand the higher thoughts and ambitions of the sculptor. Rodin made a full size nude in plaster —a representation, as one critic put it, of one of the men who sprang to life from the stones cast behind him by Deucalion (the impressions of his visit to Italy a year previous were still very strong in the sculptor).
Completed early in 1877, the work was first exhibited at the Cercle Artistique in Brussels. Already charges were made against him of having taken a mould from Nature, though they attracted little attention. He was completely unknown. The work was then exhibited at the Paris Salon of the same year. The jury were quite unaccustomed to such realistic work. He was accused of imposture—of having taken a mould from the living subject. Such tricks were not unknown among inferior artists for small portions of the figure, but, as far as was known, had never been done for the whole body—and, as Rodin ultimately showed, could not possibly be done. The Ministerial authorities sided with the sculptor's critics, and the controversy was long and bitter. Rodin had moulds taken of the model's torso, and these were photographed to show that the procedure of which he was accused would have distorted the figure. Auguste Neyt, the Belgian model, offered to come to Paris to confound the detractors; and the controversy was not ended until a group of Rodin's fellow artists and a few critics, in a collective protest addressed to the Fine Arts Ministry, declared their faith in his genius, from other work which they had seen him execute.

As a compensation to the artist, the State, in 1880, acquired the bronze which had been shown at the Salon, and it was placed in the gardens of the Luxembourg museum. In 1890 it was removed inside the museum.

In contemplating this statue the student must bear in mind that originally the left hand held a stick on which the man was leaning heavily, as if to push himself up from the ground, on which his feet were still heavy. This staff was removed, as it threw a shadow on the moulding of the body on that side; but the position of the hand is only explained by imagining this staff still in position.

6–7. SAINT JOHN THE BAPTIST PREACHING. 1878. Bronze, 79×21⅝×38⅝.

The model was an Italian peasant who had never before been a model and knew none of the 'tricks of the trade'. The sculptor made him move about the studio, and when he was in an attitude that pleased him, he stopped him, saying simply 'Keep that pose'. This method was afterwards frequently followed by Rodin, as stated above. He himself repeatedly said he tried to interpret internal sentiments by the mobility of the muscles.

The Italian peasant afterwards became a well-known model. This work, so daringly original, and so different from the age-long religio-artistic conception of the Baptist, like so many other of the works of Rodin, aroused a storm of controversy. But, like the others too, it 'made its way', and the leading critics of several countries saw its greatness.

This St. John, said Grant Allen, is 'no seer of mysteries filled with prophetic fire, but a plain worn man of the people, an itinerant preacher.' He is 'marching ahead in a clumsy sort of way, ignoring the obstacles and the length of the road,' adds Gustave Geffroy. Edmund Gosse, in his speech at the dinner to Rodin in London in 1903, described the St. John as a 'wasted and bitter anchorite'.

Rodin worked arduously on this statue, which he first exhibited at the Ghent Exhibition in 1879, where it earned for him the great gold medal. The same year he sent to the Salon, in Paris, the bust of the Forerunner. Then he exhibited this statue in the Salons of 1880, 1881 and 1883, thereby enlarging the circle of his admirers. Sent to the Vienna and Munich Exhibitions by the Beaux-Arts, it scored a notable success there and assisted to spread the artist's fame in German-speaking countries. To-day still, in its decayed grandeur, in its wonderful simplicity, 'Saint John the Baptist,' in spite of the works of a more acute modernism later executed by the artist, remains one of his most moving creations, one of the most powerful.

8–10. THE GATE OF HELL. 1880–1917. Bronze, 248×157×34.

This monumental Gate, which was ordered by the State from Rodin in 1880, and was never finished, though he worked on it for over twenty years, was originally intended as a door for the Museum of Decorative Arts, which was

then planned. Later it was proposed to place it in the disaffected chapel of the old Seminary of St. Sulpice, in the Place St. Sulpice, Paris, which was to become an annexe to the Luxembourg Museum.

Never since Michelangelo has a sculptor planned a work of such greatness and magnificence. His original idea was to make direct interpretations from the scenes in the 'Inferno' of Dante, while in the scheme of arrangement he adopted the plan of Ghiberti's door of the Baptistry at Florence, with symmetrical panels. By degrees Rodin departed from this plan, as he also drifted more and more from Dante's conception of 'Hell' and conceived symbolical figures of his own inspiration. The only actual groups taken from Dante's poem which are now left are 'Paolo and Francesca' and 'Ugolino', besides the representation of Charon's bark depositing the souls to be judged by Minos.

The other poet who greatly influenced Rodin as his ideas progressed for the 'Gate' was Baudelaire, the tragic and sensual author of 'Les Fleurs du Mal', but it may be said that most of the figures are due to his own keen sense of the tragic perversity of life and destiny.

As the Gate exists to-day it contains 186 figures, and, as has been said elsewhere, Rodin was continually adding, withdrawing or exchanging figures or subjects, so that it became a perfect repertory for his various works.

On the top of the Gate the three 'Shadows' look down into the abyss as if seeing or reading there the famous words of the poet:

'Lasciate ogni speranza, o voi ch'entrate!'

Below them, in the centre of the tympanum, the 'Thinker' also contemplates the tragedy. On the panels are represented all the passions and vices of humanity. Nearer to the ground the figures become more independent of the subject. Right at the bottom are the lost women, as Baudelaire conceived them, mingled with figures from pagan mythology—centaurs, faunesses, satyrs, and abstract vices, especially the remarkable 'Avarice and Luxury', representing a miser and a courtesan. On the cornice at the top are thirty heads showing varied characteristics, as if they were a summary or analysis of the whole. Rodin had said to the Fine Arts Minister Turquem, who gave him the commission, 'I will cover the door with a lot of small figures, so that nobody can accuse me of moulding from life'. Anatole France wrote of this wonderful collection of groups: 'Recall the damned who are placed on the left of God on the fine portal of Bourges cathedral. In those representations of the theological hell, the sinners are tormented by horned devils who have two faces, one of which is not on their shoulders. You will not find these monsters in the hell of Rodin. There are no demons there, or rather, the demons hide themselves in the damned. The evil demons through whom these men and women suffer are their own passions, their loves and hatreds; they are their own flesh, their own thought. These couples who "pass so lightly on the wind" cry to us: "Our eternal torments are in ourselves! We bear within us the fire that

burns us. Hell is earth, and human existence, and the flight of time; it is this life, in which one is incessantly dying." The hell of lovers is the desperate effort to put the infinite into an hour, to make life pause in one of those kisses which, on the contrary, proclaim its finality. The hell of the voluptuous is the decay of their flesh in the midst of the eternal joy and triumph of the race. The hell of Rodin is not a hell of vengeance, but one of tenderness and pity.'
The actual size of the Gate was never decided.

**11, 13. THE THREE SHADOWS.** 1880. Bronze, 38¾×35½×17¾.
These three statues together crown 'The Gate of Hell'. It was the author's first idea that in front of them should be an unrolled phylactery bearing the famous inscription from Dante; 'Lasciate ogni speranza, o voi ch'entrate!' This intention, which explains to some extent the attitude of the three men, was not carried out.

**12. THE SHADOW.** 1880. Bronze, 75½×44×19¾.
'The Gate of Hell' consists of three figures of half natural size, who with slow and weary gesture seem ready to enter into eternity. This work is, so to speak, the pendant of 'Adam', also in this trinity of brass, and which was conceived after Rodin's trip to Italy in 1875. The influence of Michelangelo is manifest, but the artist's personality was already too marked to be utterly overwhelmed by Buonarroti. 'The Shadow', modelled in 1880, was exhibited in the 1902 Salon and acquired by the State in 1910.

**14-16. THE THINKER.** 1880-1900. Bronze, 78×51× 52¾. (Plaster model. 1880. 27×15¾×19⅝.)
'The Thinker' also was part of the original conception of 'The Gate of Hell', of which it might be said that it constitutes the soul. Moreover, Rodin at first wanted his statue to be called 'The Poet'. In the artist's view, the poet was that Dante whose work he loved so passionately and whence he had drawn so many wonderful designs. But this Dante met the same fate as the 'Balzac' at a later date. Rodin went beyond his first conception and widened the theme he had thus first chosen until it became a universal symbol. 'The Thinker', executed in half life-size for setting up in 'The Gate' about 1879, was exhibited at a height of 6 feet in 1900 in the Alma Pavilion which Rodin had built in order to house his masterpieces. A subscription was raised in 1906 to present it to the people of Paris. It is under this bronze at Meudon that the great master rests to-day close to his wife.

**17. THE PAINTER ALPHONSE LEGROS.** 1881. Bronze, 11½×7×9.
In 1871 Rodin paid a visit to London, during which he ran against his friend Legros, whom he had known in 1854 at the School of Design in the Rue de l'École de Médecine, conducted by Professor Lecocq de Boisbaudran. Painter, engraver, sculptor, Legros had emigrated to England after

the Commune, and was to remain there until his death in 1911. The two artists resumed their friendship, which took on a more intimate character from this moment and proved lasting. Ten years later, in 1881, Rodin executed the fine bust of Legros, and, in the same year, Legros painted a vivid and precious portrait of Rodin, at this decisive epoch of his career. It was Legros who taught the sculptor the art of engraving, in which he excelled, and to this fact we owe the well-known masterpieces of Rodin in this medium.

**18. THE PAINTER JEAN-PAUL LAURENS.** 1881. Bronze, 22×13×12¼.
Very soon after his return to France, Rodin became intimate with J. P. Laurens, upon whose bust he started work in 1881. The model also attracted him by the classical type of his expression, thus giving him an opportunity to pursue the study of antique sculpture. This large-shouldered bust recalls a sage of Greece. By way of return, J. P. Laurens put his friend in the frescoes of the Panthéon under the guise of a personage of the Merovingian Court. In 1900 Laurens wrote to the art critic Arsène Alexandre: 'You know my admiration for the great sculptor. He is of the race of those who walk alone, of those who are unceasingly attacked, but whom nothing can hurt. His procession of marble and bronze creations will always suffice to defend him—he may rely on them.'

**19. THE HEAD OF SORROW.** 1882. Bronze, 8¾× 9×10¾.
Rodin was often prompted to reproduce this or that fragment of one of his prior works, either singly or as part of a new composition. Thus this head, of striking intensity of expression, is a retaking of that of one of the children in the groups of 'Ugolino' and 'The Prodigal Son' (cf. pl. 21 and 56). Moreover, in 1905, having had a chance to meet 'La Duse' he was filled with such enthusiasm for her wonderful genius that he thought of adapting the head of 'Sorrow' to one of her passionate impersonations. He also thought of using it for the face of a statue of 'Joan of Arc at the Stake', which it was proposed in 1913 to remove to the United States.

**20. THE FALLEN CARYATID CARRYING ITS STONE.** 1880-1. Bronze, 17½×12½×12½.
This statue was originally part of 'The Gate of Hell', where it figured above, in the left angle uncovered by drapery. It was exhibited from 1883 in a gallery and reappeared in 1892 in the Salon, where it was praised by Rodin's admirers, who henceforth grew ever more numerous.

**21. UGOLINO.** 1882. Bronze, 15¾×17×13¾.
This group was one of the subjects for the 'Gate of Hell'. Rodin's imagination seems to have been greatly stimulated by this incident which is one of the most terrific in the whole of the 'Divine Comedy'.

'The Pisans,' wrote the old Italian chronicler Villani, the contemporary of Froissart, 'who had imprisoned the Count Ugolino, with his two sons and two of his grandsons, the offspring of his son Count Guelfo, in a tower on the Piazza of the Anziani, caused the tower to be locked, the key thrown into the Arno, and all food to be withheld from them. In a few days they died of hunger; but the Count first with loud cries declared his penitence, and yet neither priest nor friar was allowed to shrive him. From then on the tower was called the Tower of Famine, and so shall ever be.' The incident depicted is related by Dante as follows, the old Count speaking to the poet in Hell:

> 'When a faint beam
> Had to our doleful prison made its way,
> And in four countenances I descried
> The image of my own, on either hand
> Through agony I bit; and they, who thought
> I did it through desire of feeding, rose
> O' the sudden, and cried, "Father, we should grieve
> Far less, if thou wouldst eat of us: thou gavest
> These weeds of miserable flesh we wear:
> And do thou strip them off from us again."
> Then, not to make them sadder, I kept down
> My spirit in stillness. That day and the next
> We all were silent'. (Hell, canto XXXIII; Cary)

Ugolino seems in this powerful group almost to have been changed into a beast by his sufferings and the gnawings of his stomach. He drags himself on his knees over the lifeless or scarcely living bodies of his descendants. Perhaps he is thinking of how the children urged him to appease his hunger on their own flesh, and a contest is taking place in his mind between the beast who would fain eat and the higher being who revolts at such a monstrous idea, as is shown by the violence with which his head is thrown to one side. At the same time the sculptor lets us see the wolf-like look in the eyes of the emaciated creature who is scarcely human any longer:

> 'Whence I betook me, now grown blind, to grope
> Over them all, and for three days aloud
> Call'd on them who were dead. The fasting got
> The mastery of grief.'

In the first rough model which Rodin did for this subject Ugolino was shown seated with one of his sons lying over his knees, and another standing by his side.

**22. EVE.** 1881. Bronze, $68\frac{1}{2} \times 25 \times 30\frac{1}{2}$.
This statue was executed during the period when the artist conceived his 'Gate of Hell'. It was intended to be placed by the side of Adam, but subsequently it was detached from the *ensemble* and offered separately to the 1899 Salon, in its natural size. For more than twenty years the work has been known in reduced copies, and has enjoyed great success. It is one of the most beautiful incarnations of the female form since the Greeks, full of robust life and in a natural attitude,

suggesting her presentiment of coming motherhood as well as her natural anguish at thinking of the sorrow to which the coming generation is destined. The face is beautiful and tense with thought; the arms are folded over the breasts, one hand being raised as if to shield her face, the other grasping her left breast as if in pain or anxiety.

**23. THE THREE FAUNS.** 1882. Plaster, $6\frac{1}{2} \times 11 \times 7$.
This charming group is often called 'The Three Bretons'. Its model is the same figure reproduced three times. It has its place in 'The Gate of Hell' under the tympan on a level with the left folding door. It may certainly be dated 1882.

**24. HENRI ROCHEFORT.** 1897. Bronze, $29\frac{1}{2} \times 22\frac{1}{4} \times 13\frac{1}{2}$.
A plaster model of this bust was executed in 1884 and first appeared at an exhibition at the Georges Petit Gallery, where it was much admired, both because of the quality of the work and the personality of the model, who was a famous journalist. The bust, which is considerably bigger than the plaster model, was exhibited at the Salon of 1897.

**25. THE SCULPTOR DALOU.** 1883. Bronze, $20\frac{1}{2} \times 15 \times 8\frac{3}{4}$.
This bust, one of Rodin's most famous, of which there are casts in many of the great museums of the world, is dated 1883. Dalou was one of the sculptor's youthful companions: in their student years they both frequented the same 'Petite École', which turned out so many fine artists. Rodin met him again in London, in Legros' circle, and, on returning to Paris, they continued to see each other frequently. It was at this period that Rodin decided to stamp his friend's image in a work that, despite its modern air, reminds one of the finest busts of the Italian Renaissance.

**26-27. THE CROUCHING WOMAN.** 1882. Bronze, $33\frac{1}{2} \times 23\frac{3}{4} \times 19\frac{3}{4}$.
At this period the majority of the works which Rodin conceived, and which were not imposed upon him by a competition or definite order, were, so to speak, commissioned by 'The Gate of Hell'. In this monumental creation those visions disported themselves which he had carried about with him until the age of 40, when he cast forth impetuously all the people of his dreams. 'The Crouching Woman', who at first glance startled the critics, was one of the crowd of the damned who writhe in the tympan, as they used to do on the portals of cathedrals. This magnificent bronze, on the back of a prodigious example of anatomy, is without doubt one of the most amazing fragments of the sculptor, who here delighted in difficulties.

**28. MADAME LYNCH DE MORLA VICUNHA.** 1884. Marble, $22\frac{1}{2} \times 19\frac{1}{2} \times 14$.
Quite at the commencement of his career, towards 1882, Rodin chanced to meet Madame Lynch de Morla Vicunha,

wife of a South American diplomat; and he became a friend of the household. The young woman, who knew the artist's passion for classic music, often played Mozart or Beethoven to him, and, by way of recompense, the latter executed her bust. Done in 1884, it was exhibited in the 1888 Salon, where it aroused real enthusiasm. The State then acquired it for the Musée National.

Not one of Rodin's busts is more filled with the living and subtle charm of female beauty. The look in the eyes, the pose of the head, and the set of the mouth, which seems just to have been speaking, are all characteristic. The moulding of the marble is exquisitely delicate. The nosegay of flowers on the base of the bust strikes a note of homage paid to a charming person.

29. MRS. RUSSELL. Before 1888. Wax, $18\frac{1}{2} \times 11\frac{1}{2} \times 10\frac{5}{8}$.

This young woman, who was of Italian origin, married an Australian painter, a friend of Claude Monet, affiliated to the Impressionists, and living most of his time in Belle-Isle en Mer, where he had a property. Herself a genuine artist, she probably became acquainted with Rodin through Monet, and the sculptor, struck by her classical beauty, requested permission to make her bust. In 1888, he executed the work, which later was even cast in silver. The young woman gave the Master numerous sittings.

30-31. SHE WHO ONCE WAS THE HELMET-MAKER'S BEAUTIFUL WIFE. Before 1885. Bronze, $20 \times 10 \times 12$.

Here Rodin has taken a text from the old French poet François Villon, whose poem 'Les Regrets de la Belle Heaulmière jà parvenue à vieillesse' ('Lament of the Old Helmet-Maker's Wife on Reaching Old Age') is one of the most remarkable of his works. The former courtesan, once radiant with youth and grace, is now repellent with ugliness and decrepitude. Once proud of her charm, she is now equally ashamed of her decay. Bent double, she contemplates her withered breasts, her abdomen in folds, her arms and legs which are knotted like vine-stalks, while the skin falls over the hardly veiled skeleton. Beauty is only skin deep, says the sculptor, echoing the 'vanity of vanities' of the preacher. The sculptor's work is perhaps even more grimly expressive. Grotesque as it is, the spectacle is ineffably sad, for it is the distress of a pour soul who, still so tardily yearning after youth and beauty, and powerless before its decay, is the antithesis of anything spiritual. There is a pendant to this statue (notes M. Paul Gsell) in a strange statue by Donatello now at the Baptistery at Florence, which represents an old woman, nude, or rather simply draped, with her long hair falling thinly and sadly over her withered body. It represents Mary Magdalen, who has retired to the desert, burdened with years, and now macerates her poor body, in honour of God and to punish it for the care she formerly bestowed on it.

But the sentiment of the two works is widely different. The Magdalen, in her desire for renunciation, is filled with the mysticism of the middle ages. The old woman of Villon and Rodin still longs for her lost beauty, and is horrified to find herself resembling a corpse. The original model of this statue was a withered old Italian woman who had come to Paris to seek out her missing son. Falling into want, some of her fellow country people advised her to go and ask Rodin for help, and he, struck with her appearance, invited her to pose for him.

At first he gave the subject the form of a bas-relief on the left doorpost of the 'Gate', but about 1885 he returned to this subject and gave it the moving and admirable form under which we see it here.

32. KNEELING FAUN. 1884. Plaster, $22 \times 8 \times 12$.

33. ERECT FAUN. 1884. Plaster, $24\frac{1}{2} \times 11\frac{3}{4} \times 10$.

These two figures bring us back to 'The Gate of Hell'. They were among the first which were placed in the tympan, but most certainly they were not slow to leave the crowd of the damned to lead an individual life. We know of a bronze cast of the 'Kneeling Faun' belonging to a Romanian collector, which is dated 1884.

34-35. DANAÏD. 1885. Marble, $13\frac{3}{4} \times 28\frac{1}{2} \times 22\frac{1}{2}$.

This splendid marble ranks amongst the most justly renowned works of Rodin. It represents one of the daughters of Danaus, King of Argos, condemned in Hades to fill perpetually a vessel full of holes, as punishment for the murder of her husband. What exquisite rhythm and beauty of contour there are in this slim girlish figure, who has thrown herself down, face downwards, beside the stream in despairing abandonment, with the bottomless vessel under her arm. It was sculptured in 1885, in view of 'The Gate of Hell', but was suppressed in its final state. Exhibited for the first time in the Salon in 1890, it could be seen in the following years in Venice and Oslo under the title 'The Spring', and excited the same enthusiasm in these cities.

36-45. THE BURGHERS OF CALAIS. 1884-1886. Plaster, $82 \times 94 \times 75$.

(Plates 36, 37, 38, 39, 40, 44, 45. Studies for Burghers of Calais. 1884. Bronze).

The episode of the Burghers of Calais and the patriotic sacrifice of Eustache de Saint-Pierre and his comrades has been related by Froissart and Jean le Bel, his Belgian predecessor as chronicler and troubadour.

British military annals furnish few cases of more determined and noble resistance than that maintained for eleven months (1346-1347) by the burghers of Calais, under the command of Jean de Vienne, a 'commander worthy of the commanded'. Famine attacked them even more fiercely than the soldiers of King Edward, and still they resisted. It was only when, after almost incredible fortitude, they saw their last

hope dashed to the ground, at the very moment that they anticipated relief—it was only when Philip the Sixth came towards Calais, and then, not liking the aspect of the English defence, turned and went back again, that they allowed themselves to think of submission. Philip's cruel desertion was the death blow. They sent to Edward, who, however, would listen to no terms except unconditional surrender. The noble Sir Walter Mannay, however, spoke for them; and at last mercy was promised to all but six of the chief burghers, who were to come to him bare-headed, bare-footed, with ropes about their necks and the keys of the town and castle in their hands. The people of Calais were summoned by bell into the market place, and there the conditions of mercy were made known to them.

In 1884 the town of Calais opened a competition for a monument commemorating the heroic act of Eustache de Saint-Pierre. Rodin, struck by the narrative of the old chronicler, decided to make a composition which should commemorate the six hostages. The work occupied him some ten years, though the delays were not always his fault.

The Municipality, on inspection of the work, declared that the artist had not made 'the burghers sufficiently heroic'. It required all the persuasive powers of Dewavrin, the Mayor of Calais, who through seeing the sculptor at work had conceived admiration and friendship for him, the intervention of Alphonse Legros and of Charles Cazin—who had posed for the nude of Eustache de Saint Pierre—to quell the opposition. The work, inspired by the great masters of mediaeval sculpture and of Claus Sluter, was unveiled on June 8, 1895, in front of the Calais Town Hall and created a deep impression. Very fine replicas exist in London, Belgium and Copenhagen.

As with so many other of his works, Rodin was grieved at finding that many of his contemporaries did not understand his group, for a hot controversy again arose, as had been the case with the 'Bronze Age' and the 'Claude Lorrain' (to be repeated later with the 'Balzac'). 'They would have preferred,' Rodin said, in answer to some of his critics, 'gestures *à la Marseillaise*' (a reference to Rude's bas-relief on the Arc de Triomphe in Paris). 'I intended to show my burghers sacrificing themselves as people did in those days, without proclaiming their names.' Still there were more than sufficient admirers of the work to satisfy the artist.

The remarkable differences in character of these six hostages is evident to anyone who studies the group. The central figure is the aged Eustache, whose venerable head with its long hair is bowed, but not with fear or hesitation; he seems rather, in sorrowful resignation, to be in deep contemplation in the spirit of his own words, 'I have so good trust in the Lord God'. If his step is a little halting, it is from the privations of the long siege; his firmness is calculated to inspire his fellows. 'He was the one who said, "we must",' Rodin remarked.

The one next to him, who is probably Jehan d'Aire, holding the key which he is to hand to the King, also has no fear or

hesitation, but his whole body is tense with the effort to get strength sufficient to go through the ordeal and humiliation. His face—a clean-shaven, lawyer-like face—is set in grim sorrow at the pass to which his city is reduced. Behind him is the figure known as the 'Weeping Burgess', whose face is covered by his two hands, as if he were indeed faltering or regretting his decision, and were thinking of wife and children. Just behind Eustache, one of the men looks back to the city, while he passes his hands before his eyes as if to drive away some terrible vision, for his resolution is evidently not so stern as that of the two leaders. Of the final two, who may be the two brothers, the one in advance, whose movement is more hasty and nervous than that of Eustache, as if he would fain have the ordeal over, may be encouraging by his gesture the one behind him, the youngest of the group, who hesitates at now leaving life and its sweetness behind.

The three figures in the second row are all of them less resolute and less brave than the three in front, as is shown by their attitude. Their act is no less heroic for all that. Their feet are heavy, but their wills urge them on.

In this great group the physical aspect is subordinated to the spiritual, and the composition is instinct with the shadow of the impending interview with the redoubtable King and the forfeit they are to pay. The greatness of the deed they are accomplishing pervades them with an atmosphere of august sadness, and eliminates all meaner sentiments. They move one by their simplicity and the absence of gesture.

Each one of the six is visible from any leading point from which one may look at them, and so one feels the crowd of sorrowful citizens, women and children gazing after them from the battlements of the stricken town.

Rodin had wished to have the group placed on a high pedestal, but as this would have entailed having the figures very much more than life size, the suggestion was not adopted. Failing that, he said he would have preferred the group to stand on the soil, so that they might seem to be part of the population, but even this plan did not seem practical and was not adopted.

46. AURORA. 1885. Marble, $22\frac{3}{8} \times 22\frac{3}{8} \times 13\frac{3}{4}$.
It was Mademoiselle Camille Claudel, Rodin's pupil and a sculptress herself, who posed for this radiant marble, worthy of the name given it. From this masterpiece emanates a light that once seen can never be forgotten.

47. THOUGHT. 1886. Marble, $29\frac{1}{4} \times 21\frac{3}{4} \times 20\frac{1}{2}$.
Again it was Mademoiselle Claudel who served as model for this head which, despite its unusual presentation, aroused deserved admiration from the start. Executed in 1886, 'Thought' was not exhibited until 1896 in the Salon.
'There is no disturbing strain,' says Grant Allen, 'but the calmness and the remote expression of one absorbed by the inward working of the mind'; and Paul Gsell says: 'Abstract thought blossoms out of the midst of inert matter and illumines it with the reflection of its splendour, though it tries

in vain to escape from the shackles of reality.' Such are the ideas which Rodin sought—and with what success!—to express in this work, which is at once instinct with spirituality, and yet in the lucidity of the eyes, beauty of features and charm of pose, is unmistakably feminine. There is an intentional suppression of any sensuous element, even to the absence of the hair, which is covered by a cap. It has justly been described as the very symbol of Rodin's art.

### 48. INVOCATION. 1886. Plaster, $22 \times 10 \times 9\frac{1}{4}$.

This fine figure belongs to a period when Rodin was working with ardour at the 'Gate of Hell', for which he had just received the commission. A certain resemblance to the 'Old Man Suppliant' suggests that it was a feminine adaptation of the same subject. Madame Abruzzezzi, the model whom Rodin employed several times, seems to have posed for this work.

### 49. THE KISS. 1886. Marble, $75 \times 47\frac{1}{4} \times 45\frac{1}{4}$.

This piece is considered by far the most important of Rodin's classical works. It was shown for the first time in Paris in 1887, and was later exhibited at the Salon of 1898 together with the statue of Balzac.

### 50. FAUN AND NYMPH. (THE MINOTAUR.) Before 1886. Plaster, $13\frac{1}{2} \times 10 \times 10$.

Once more it is to the remotest ages of mankind that we are transported by this group, to resonances as deep and mysterious as some lines from Racine's *Phèdre*. Certain critics re-christened it 'Jupiter Taurus', but Rodin, whose imagination was haunted by the images evoked by reading about the Mycenaean civilization, did not accept this new title. Moreover, the work seems to have been in the first place a study for the group of 'Pygmalion and Galatea' excuted by the artist before 1886.

### 51. POLYPHEMUS. 1888. Bronze, $9\frac{7}{8} \times 5\frac{1}{2} \times 6\frac{1}{4}$.

Among the subjects which decorate the very fine Medici fountain in the Jardin du Luxembourg there is a statue of Polyphemus about to crush Acis and Galatea. This work of Ottin must have struck Rodin, who often had occasion to pass it during his youth, and when he conceived 'The Gate of Hell', there was an opportunity to introduce this mythological episode into his creation. But, after having modelled 'Polyphemus and Acis' in the right folding door, the sculptor realized that, plastically, the two characters, owing to their position, created gaps in the composition. The same year—1888—that he executed this group, he smothered the Acis in the plaster, and only preserved the Polyphemus.

### 52. THE METAMORPHOSES OF OVID. Before 1886. Bronze, $13 \times 15\frac{3}{4} \times 10\frac{1}{2}$.

Inserted in the 'Gate of Hell', in the right angle of the attique, the work, almost as soon as born, like many of its sisters, was detached from the monument to take on a life of its own. Two other titles that it bore, 'Volupté' and 'Les Fleurs du Mal', testify that it was conceived under the influence of the poems of Baudelaire, which, together with the 'Divine Comedy', were his bedside books.

### 53. FLYING FIGURE. 1889-90. Bronze, $20\frac{1}{8} \times 27\frac{1}{8} \times 11\frac{3}{4}$.

This figure, of an amazing audacity, in its agitating nudity, might well have been a study for the characters intended to surround the 'Victor Hugo seated', 'Meditation' and 'The Tragic Muse', a hypothesis which is equally valid for 'Iris, Messenger of the Gods', this prodigious creation of the artist. This 'Flying Figure', which is probably of 1889, was, however, utilized by Rodin, this time completed, in his group 'Avarice and Luxury'.

### 54-55. THE ETERNAL IDOL. 1889. Plaster, $29\frac{1}{4} \times 15\frac{3}{4} \times 20\frac{1}{2}$. (1889. Bronze, $6\frac{7}{8} \times 5\frac{7}{8} \times 3\frac{3}{8}$.)

A young woman is half seated half kneeling, with her head bending forward and a dreamy look in her face, while a man, kneeling before her, restraining his desire—his arms are behind his back—softly bends his head and plants a kiss under the left breast, over the heart. He has a restrained fervour that is at once mystical and amorous. She has a reserved sphinx-like expression. Is she, too, awakening to the current of love, or is she wondering at man's passion, which is unfathomable, for the beauty which he as yet hardly knows? The originality of the pose is unique in sculpture, rendering it one of the loveliest commentaries on the relations between man and woman that exist in art. Rodin is said to have adopted the title from the remark of a visitor, to whom he was explaining his idea. 'I see,' said the visitor—'the eternal idol!' And Rodin understood at once how suitable it was.

It certainly originated prior to 1889, for then it was known under the name of 'The Host'. It was exhibited in the 1896 Salon.

### 56-57. THE PRODIGAL SON. Before 1889. Bronze, $54\frac{3}{4} \times 41\frac{1}{2} \times 27\frac{5}{8}$.

This work, which figures in the right hand folding door of 'The Gate', was probably conceived between 1885 and 1887, for the subject is utilized in the 'Fugit Amor,' which is prior to 1887. It was first called 'The Child of the Age', and was exhibited under this title in the 'Salon de la Plume', to re-appear in 1905 in the Salon d'Automne, with an appellation invented by the critic, 'The Dying Warrior'. This interpretation of the Biblical episode reminds one, in the largeness and humanity of the conception, of Rembrandt's finest etchings.

### 58. OCTAVE MIRBEAU. 1889. Terracotta, $11 \times 7 \times 6\frac{5}{8}$.

Mirbeau was one of Rodin's oldest friends, and always defended him with his unsparing fire against the representatives of an obsolete academicism. He broke many lances in

the 'Balzac' controversy, and no one spoke better of the Master's water-colours than the author of 'Calvaire'. Moreover, Mirbeau, having prepared an édition de luxe of 'Le Jardin des Supplices', wanted it to be illustrated with his friend's works. For a copy of 'Sébastien Roch', belonging to Edmond de Goncourt, Rodin, as was his favourite custom, designed three profiles of the novelist on the cover. Mirbeau's bust, in terracotta, was done in 1889. There is also a medallion of the writer, which was exhibited in the 1895 Salon.

59. ROSE BEURET (MADAME AUGUSTE RODIN). 1890. Marble, $18\frac{5}{8} \times 15\frac{3}{4} \times 19\frac{3}{4}$.
Rose Beuret, born in 1845, of a humble family, became Rodin's companion at a very early age and shared his life in good times and bad, always keeping in the background. She died in Meudon shortly before Rodin, who had married her in his old age. Rodin made many busts of his wife, and was even inspired by her features for works of a more general character. This marble was placed by Madame Rodin, in 1916, at the disposal of her husband, for the Museum then being formed. Rodin had it cast in bronze.

60. BROTHER AND SISTER. 1890. Bronze, $15\frac{5}{8} \times 7 \times 7\frac{7}{8}$.
Perhaps under the influence of Carpeaux, which was stronger than is believed, Rodin always had a passion for sketching and sculpturing children. No doubt, 'Brother and Sister', the masterpiece of his maturity and dated 1890, is the most charming and affecting of the groups that inspired him with this taste from early youth.

61. DESPAIR. 1890. Bronze, $13\frac{1}{2} \times 10\frac{1}{4} \times 11\frac{3}{4}$.
Another figure originally intended for 'The Gate of Hell', where it is placed above the right folding door.
Retaken in the same part of the monument in three different settings, it shows how conscientiously Rodin worked at his subjects. This same year, 1890, Rodin detached the character to lend it a life of its own.

62. ROSE BEURET (MADAME AUGUSTE RODIN). 1890. Bronze mask, $10\frac{1}{8} \times 6\frac{3}{4} \times 6\frac{1}{4}$.
This portrait was done in 1890, in the full maturity of this fine woman's face, which had inspired the artist in the springtime of his union with more smiling images. The gravity of this face, combined with the sculptor's perfect command of his faculties, make this work an admirable and affecting creation.

63–64, 66–67. BALZAC. 1897. Plaster, $118 \times 47 \times 47$. (Plate 63. Study for Balzac statue. 1893. Bronze, $10\frac{5}{8} \times 11\frac{3}{8} \times 7$.)
The most remarkable incident in Rodin's career was that which was connected with this statue of Balzac. The Société des Gens de Lettres, the leading literary society in France,

after the Académie Française, had wanted a statue of the great romanticist, to be placed on a site in Paris. The work had, in 1888, been entrusted to Chapu, but he died in 1891, leaving only the commencement of his work, and having spent a portion of the 36,000 francs which was to be allocated for it.
Rodin then, at the suggestion of some of his literary friends, wrote to the Société (the president of which at the time was Emile Zola) offering to do the work, and the offer was accepted. Unfortunately he made the mistake of undertaking to deliver the statue in eighteen months. A great deal longer time than that went by, and no statue was delivered nor even a model submitted, so that the delay became the subject of popular jokes and quips. Relations between Rodin and the society became strained and some disagreeable correspondence passed. Zola among others grew inimical. There was a lawsuit, after which a new engagement was entered into, by which the commission was confirmed to Rodin, but without any time stipulation. He also returned the 10,000 francs, which had been advanced to him for the purchase of material, and agreed that he should receive nothing until the statue was delivered.
The material which Rodin had to work with was very meagre, but he set about a study of Balzac, his works, his habits and the country where he was born and lived, which was typical of the man but is probably very unusual in our days.
There is a bust of Balzac in existence by David d'Angers, and Rodin also had access to a daguerrotype of the novelist taken half-length standing, with his collar open showing his massive neck. But the best portrait of the novelist is the description by Lamartine:
'It was the face,' he said, 'of an element; a big head, hair dishevelled over his collar and cheeks, like a mane which the scissors never clipped; very obtuse, eye of flame, and colossal body. He was big, stout, square at the base and shoulders —much of the ampleness of Mirabeau, but no heaviness. There was so much soul that it carried it all lightly; the weight seemed to give him force, not to take it away from him; his short arms gesticulated with ease.' Théophile Gautier added that the novelist's usual expression was of intense mirth—a Rabelaisian hilarity ennobled by great power.
So thorough was Rodin's preparation for his task that at Tours, where he found an old tailor who had made clothes for Balzac forty years previously, he got him to make a suit from the old measurements.
Rodin started by making several nude models (he nearly always began by making nude models, whether he intended to clothe his statues or not) and others which did not satisfy him. He found that this was the most difficult sculptural interpretation he had ever undertaken. He was puzzled by the elements of the strange, abnormal lineaments of the man, his complex character and extraordinary personality, beside which there was his prodigious literary production to

be considered. Rodin set himself, as usual, to incarnate the great thinker in action, but also to create a Balzac with all his idiosyncracies. For this he had to continue the Gothic conception which he had partially and successfully tried with the Burghers of Calais, the subordination of form to the main idea and spiritual meaning of the character, and the simplification of the trunk of the statue into large surfaces adapted to the play of light and shade, in order to concentrate all the vigour of expression on the head. The result was this huge man ('a very living Balzac') with the powerful head and bull's neck, who throws upon the crowd that gazes up at him a look of deep but smiling irony tinged with sadness. His hands are crossed under the white gown, resembling a monk's garb, which he always wore when at work, the sleeves of which hang empty at his sides.

When the statue was at last exhibited at the Salon of 1898, side by side with 'Le Baiser', it is not too much to say that it was greeted with a chorus of scorn and ridicule. 'A cow,' said some of the people who went to see it, while critics with a choicer fund of expression talked of 'a snow man', 'formless lava', etc.

M. Roger Marx, that staunch friend, who wrote an interesting explanation of the work before the opening of the Salon, was unfortunately but little heeded. 'Rodin,' he said, 'has made it his business to seek for that which in this broad, frank, open face betokened will, power and genius.' He had got the man's personality—the height of the brow, the deep setting of the eyes and their keen brilliance, the bulky nose, and the sensuality of the thick lips. But besides all this, there was the complexity of the character—an indefinable smile made up of kindness and sarcasm, the defiance shown by the pose of the towering head, indifference to past insults, just satisfaction at the work he has accomplished, and faith in the judgement of posterity.

The Société des Gens de Lettres accepted the popular verdict and passed a resolution protesting against 'M. Rodin's rough model and refusing to recognize it as a statue of Balzac'! A split in the ranks of the society ensued, and Jean Aicard, the poet, who was then president, resigned with several others. The commission for a new statue was given to Alexandre Falguière. His seated statue is the one now to be found in the Avenue Friedland, Paris. Falguière's work should not be condemned so utterly as it has been by enthusiastic admirers of Rodin, and none who contemplate this statue can fail to note in it the influence of the great sculptor.

But the ridicule and contempt were by no means universal. Rodin was inclined at first to fight the society, but in face of the applause and admiration that came from other quarters he desisted. M. Auguste Pellerin, a wealthy art collector, asked him to sell the statue for 20,000 francs; and he received invitations from artistic bodies in London and Brussels to send the statue for exhibition to those cities. He replied to some of these friends in a charming letter acknowledging the encouraging testimonies of esteem and declaring that he had decided not to sell the statue—that it belonged to Paris and he would bide his time.

At the same time, it must not be forgotten that honest discerning criticism does not hurt, and that all those who criticized the 'Balzac' and thought that Rodin had carried his interpretation of the Gothic in sculpture to extremes were not mere scoffers and Philistines. Henri Rochefort, who could not be accused of being such, wittily said: 'To pretend to express the forty volumes which he (Balzac) left to the world in the contortions of the lips and the quivering of the nostrils, is carrying the *spirituel* a little far. It is the first time one has ever had the idea of extracting the brains of a man and putting them on his face! Let Rodin give us simply the nose of Balzac, his mouth, his forehead, with the structure of his powerful head, and in this transcription our own eyes will read the genius of Balzac. But for the love of art, let the sculptor spare us his commentaries.' Benjamin Constant, the artist, who passionately admired most of Rodin's work, was nonplussed at the 'Balzac', and it was the same with other distinguished critics and fellow artists. On the other hand, Octave Mirbeau prophesied that a day would come when the changing crowd, being more educated, would frantically applaud this work of genius.

An extraordinary thing is that there were not wanting some who accused Rodin of having voluntarily made his Balzac grotesque. His previous work should surely have supplied answer enough to such an absurd charge and proven the absolute and intense earnestness of the man. What! Rodin, whose eyes are like nothing else in modern sculpture, had made his Balzac with cavernous eyes as a joke! Rodin, who moulded hands as no others could do, had left the hands of Balzac (which are said to have been quite remarkable) out of sight, so that they should not draw attention from the spirit of contemplation in the face. Rodin replied to these charges in a few proud but scathing sentences: 'I shall fight for my sculpture no longer; it has for a long time been able to defend itself. To say that I patched up my Balzac as a practical joke is an insult that would formerly have made me writhe with indignation, but to-day I let it pass and go on with my work. My life has been a long course of study, and to accuse me of making fun of others is the same as to say I make fun of myself. If truth is to die, my Balzac will be torn to pieces by the next generation, but if truth is imperishable, I predict that my statue will make its way. . . .

'This work, which has been laughed at, which is being scoffed at because it cannot be destroyed, is the result of my whole life's study—the very pivot of my aesthetic feelings. I was another man the very day I conceived it. My evolution was complete, and I had knitted a bond between the old lost traditions and my own time, which every day will help to strengthen.

'By force or by persuasion, it will make its way in men's minds. Young sculptors come to see it here in the studio, and think of it as they descend the stairs again, to go in the direction whither their ideals call them. There are men of

the people who have understood—workers and those who, rare though they are in the crowd, continue the old traditions of the crafts in which each one did his work according to his conscience, and did not learn his art in the official catechisms.

'As to the public, they are not to blame. The fault lies with their educators. The sense of beauty and taste for reason are lost. There is no room for and no esteem among us for men who model their souls alone. And the huge majority are no longer interested in art, and see nothing more of art except through the eyes of a few elected judges. As for myself, knowing that life is short and my task is great, I shall continue my work far from polemics.'

Proud words—in the spirit of which he acted! How much of his own indomitable spirit Rodin put into his 'Balzac' it is not hard to see, for every artist puts into his work himself as well as his 'sitter'; and here Rodin had no sitter but an 'element', as Lamartine put it. Rodin's own words make one think of an English critic's judgement. 'No one in the intelligent world,' said Edmund Gosse, 'looks at sculpture to-day exactly as he did before Rodin put his mark on it.'

65. VICTOR HUGO STANDING. 1897. Plaster, $88\frac{3}{8} \times 35\frac{3}{8} \times 56\frac{1}{4}$.

As we have already had occasion to point out, Victor Hugo was one of the great subjects that preoccupied the genius of Rodin. Already in 1883 he had executed a first bust of the poet. When he received from the Beaux-Arts a commission for a statue for the Panthéon, the Director, M. Gustave Larroumet, was uncertain which position to assign to the hero; should he be seated or standing? It seems that there was some doubt upon this matter, since we have several studies of Victor Hugo standing. This one, the most important, shows how conscientiously Rodin grappled with his tasks. This nude, executed in 1897, is an enlargement of a plaster model done ten years earlier and shows that the sculptor thought of exhibiting the author of 'Les Châtiments' in front of the flood breaking on the shore.

68. THE SCULPTOR FALGUIÈRE. 1897. Bronze, $16\frac{7}{8} \times 9\frac{1}{2} \times 10\frac{1}{4}$.

When the Société des Gens de Lettres declined, in 1897, the statue of Balzac executed by Rodin, it commissioned Alexandre Falguière (1831–1900) to take the place of his illustrious colleague. But the latter bore no grudge against his friend, and to emphasize that he harboured no rancour for the substitution, he executed his bust, and had his own done by his happy and embarrassed rival. The two busts were simultaneously exhibited in the 1899 Salon.

69. BUST OF VICTOR HUGO. 1897. Bronze, $27\frac{1}{2} \times 19 \times 19$.

Rodin was introduced to the poet by his friend Roger Marx, who held an official post in the Fine Arts Ministry, and there is a letter in existence addressed to the 'dear and illustrious Master' in which Rodin expresses in ardent terms his desire to perpetuate in marble or bronze the features of the greatest poet of his time. Victor Hugo, who was then living in the Avenue d'Eylau (near to the present Place Victor-Hugo), and was old and tired, was not at all enthusiastic at the idea, especially as he had just before been pestered by an inferior sculptor to whom he had given a number of sittings, the result of which had been unsatisfactory, or rather nil. However, Hugo consented to allow the sculptor to come to the house to lunch whenever he liked and make sketches of him, so long as he himself should not be disturbed in his habits. The Hugo family kept practically open house in those days, and there were always others to lunch. The arrangement lasted for several months, Rodin going to lunch not every day, but sometimes several days in succession, and sometimes leaving out a number of days. During the meal the sculptor would sketch the poet continually and feverishly, with the result that he himself rarely got any lunch, for when it was over he rushed off to his studio to transpose his rough sketches to the clay.

When Hugo saw the bust, neither he nor the family were pleased with it; they considered it not flattering enough.

In reality, the work is only a replica of the head and shoulders of the 'Victor Hugo Standing' (plate 65). It was exhibited in 1897, and in 1900 occupied the best position in the Alma Pavilion.

70. THE HAND OF GOD. 1897–8. Marble, $24\frac{3}{4} \times 31\frac{1}{2} \times 20\frac{5}{8}$.

This magnificent fragment of the great Master, almost contemporary with the 'Balzac', and which is perhaps a meditation in the margin of this famous statue, is like a symbol of the semi-divine creation of the prodigious sculptor. It seems that when he was struggling to express the supernatural gift of the writing genius, he was tempted to create the image of the genius of statuary.

71. PAN AND NYMPH. 1898. Marble, $53\frac{1}{4} \times 30\frac{3}{4} \times 27\frac{5}{8}$.

'Pan and Nymph' was done at about the time when Rodin, who was nearing his sixtieth year, returned to those themes of Greek mythology which had always captured his imagination. Perhaps he was influenced by a fresh reading of the 'Metamorphoses' of Ovid, one of the three most abundant sources, with Dante and Baudelaire, of his inspiration.

72. BAUDELAIRE. 1898. Plaster, $7\frac{7}{8} \times 7\frac{1}{2} \times 9$.

The admiration which Rodin entertained for Baudelaire was certain to prompt him one day to attempt to model the features of the great poet. Having made acquaintance with a young writer, now forgotten, M. Louis Malteste, an enthusiast for his sculpture, and who bore a curious resemblance to the author of 'Les Fleurs du Mal', Rodin sought to discover in his living countenance the physiognomy of the great master. The sculptor, however, never brought this attempt beyond the stage of a sketch, which was executed in 1898.

73. MADAME F . . . 1898. Marble, $25\frac{5}{8} \times 24\frac{3}{4} \times 20\frac{1}{2}$.
In the admirable gallery of feminine busts executed by Rodin, none is more delicately affecting than this. The model was the wife of a great amateur of the arts, who was one of the artist's most devoted friends, and who had supported his genius from the first. The work is dated 1898, and comprises several variations.

74. MUSE FOR THE WHISTLER MONUMENT. 1902–3. Marble, $19\frac{3}{4} \times 11\frac{1}{2} \times 11\frac{1}{2}$.
Rodin, who had the cult of friendship, projected several monuments to the glory of great artists with whom he had been associated. One of these was to Whistler, and about 1902 he carried out a certain number of studies from a model, Mary Jones. This marble is one of the finest fragments conceived for this design, which went no further.

75. STUDY OF A SLAV GIRL. 1905–6. Marble, $25\frac{1}{4} \times 28\frac{3}{4} \times 21\frac{5}{8}$.
Rodin made a marble bust about 1906 using as a model this young Slav girl, who has not been identified. The following year, still under the charm of her unusual face, he executed another graceful work in her likeness (plate 82).

76. EUGÈNE GUILLAUME. 1903. Bronze, $13\frac{3}{8} \times 12\frac{1}{4} \times 11\frac{3}{4}$.
The sculptor Eugène Guillaume was an 'official' artist, member of the Académie des Beaux-Arts, of the Académie Française, director of the École des Beaux-Arts and of the Académie de France in Rome. After having long resisted the aims of Rodin, he conceived in his old age a great admiration for the works of the great sculptor and became his intimate friend.

77 MARCELIN BERTHELOT. 1906. Bronze, $17\frac{3}{8} \times 9\frac{1}{2} \times 9\frac{1}{2}$.
Rodin was associated with the great chemist, as is proved by copies of the latter's works dedicated to the sculptor. But it was not until 1906 that he executed this bust, one of the most admirable that came from his hands. At this period of his career, the artist, having penetrated the secrets of his profession, like a Rembrandt, a Titian, a Goya or a Delacroix, thought only of expressing the essential in a work. He had neither desire nor need to multiply detail. He had reached the stage when detail appears useless and even harmful.

78–80. BERNARD SHAW. 1906. Marble, $23\frac{5}{8} \times 22\frac{7}{8} \times 15\frac{3}{4}$. 1906. Bronze, $11\frac{3}{8} \times 7\frac{7}{8} \times 4\frac{1}{4}$.
It was perhaps through Henley and the circle of English writers who supported him almost from the start that Rodin made the acquaintance of Bernard Shaw. The famous dramatist, hater of all poses, would allow none but the author of 'The Thinker' to make his bust. The work, executed in 1906, earned the artist the praise of the formidable satirist, and Mrs. Bernard Shaw, in her turn, wrote Rodin that the

resemblance of the work to the model was so faithful that it frightened her.

81. MADAME DE GOLOUBEFF. 1906. Bronze, $19\frac{3}{8} \times 16\frac{1}{2} \times 9\frac{7}{8}$.
Madame de Goloubeff was one of the musicians who supplied Rodin with some of the purest joys of his life. In interpreting for him in a pure and expressive voice the finest songs of classical art, she evoked the sculptor's gratitude, which was admirably expressed by this bust done in 1906.

82. BY THE SEA. 1906–7. Plaster, $22\frac{5}{8} \times 32\frac{3}{4} \times 22\frac{7}{8}$.
The model for this charming study is the young, unidentified Slav girl who sat as a model for the marble bust made by Rodin the previous year (plate 75).

83. MOTHER AND DYING CHILD. 1908. Marble, $41 \times 39\frac{1}{4} \times 27\frac{1}{2}$.
Rodin's glory had become so great that he received commissions from beyond the seas not only for busts but also for funereal monuments. In 1908, Mrs. Thomas Merrill, desiring art to perpetuate the memory of her daughter who had died in tender years, applied to the great Master. It is one of the most moving works of the artist, himself gradually nearing eternity.

84. THE DANCER HANAKO. 1908. Bronze, $6\frac{1}{4} \times 4\frac{3}{4} \times 3\frac{1}{2}$.
This dance theme could hardly fail to arouse the enthusiasm of a sculptor who was so interested in movement. In his latter days he grew fond of noting in their spontaneity all the gestures of his models left to themselves in his studios and he liked to paint all their attitudes in water-colours. On the other hand, about 1900, there was in France a prolonged infatuation for dancing and the admirable interpreters of this art, Isadora Duncan, Loie Fuller, the Javanese dancers, Hanako, and the chorus of the Russian ballet. This mask of the Japanese Hanako is contemporary—1908—with these important studies.

85, 87. GUSTAV MAHLER. 1909. Bronze, $13\frac{3}{8} \times 9\frac{5}{8} \times 8\frac{5}{8}$.
MOZART. 1910. Marble, $12\frac{5}{8} \times 37\frac{1}{2} \times 24\frac{1}{2}$.
It seems that it was through Madame de Nostitz, a German friend of Rodin, that the latter made the acquaintance of the Austrian composer, famous for his symphonies and his great work 'The Song of the Earth'. Rodin found that he resembled Mozart, and when he had made his bust in 1909, he was inspired by his face to execute a bust of Mozart in marble (1910).

86. PUVIS DE CHAVANNES. 1910. Marble, $29\frac{5}{8} \times 49 \times 23\frac{5}{8}$.
The painter of the 'Life of St. Geneviève' at the Panthéon, of the 'Summer' and 'Winter' at the Hotel de Ville, Paris, of

the decoration of the Amphitheatre at the Sorbonne, and notable works at Rouen, Amiens and other French cities, and the decoration of the library at Boston, Mass., was an aristocrat and religious mystic and the 'utterer' of 'sweet but pallid harmonies' showing great elevation of thought.

There was no modern artist for whom Rodin had a greater admiration. 'To think he lived amongst us!' he exclaimed to M. Paul Gsell (reported in the latter's book, already quoted from). 'To think this genius worthy of the most radiant epochs of art has spoken to us, that I have seen him and shaken hands with him! It is as if I had shaken the hand of Nicolas Poussin. He always bore his head high,' continued the sculptor. 'His skull, which was solid and rounded, seemed made to don a helmet. His round thorax might have been accustomed to wearing a cuirass. One could easily have imagined him at Pavia fighting for honour beside Francis I.' In 1891 Rodin exhibited in the Salon the bust of his friend, and, the following year, he presented to it the marble. In 1910 he intended to begin executing a new marble destined for the monument it was decided to raise to the great painter's memory. This latter bust, although no more than sketched (the war, then the sculptor's death, having suspended the work) is of impressive appearance and makes a strange impression, from the fact that the face emerges, like the sea, from the enormous block of marble.

88. FEMALE TORSO. 1910. Bronze, $29\frac{1}{4} \times 13\frac{3}{4} \times 23\frac{5}{8}$.
This bronze, in its fragmentary state, has all the grace of a mutilated antique excavated from the earth. It radiates, through its youthful and supple limbs, so much life and beauty as to give the illusion of a complete and charming statue of this young woman, apparently carried away in the dizziness of this sacred dance. This figure dates from 1910.

89. THE DUCHESS OF CHOISEUL. 1908. Bronze, $11\frac{3}{4} \times 9 \times 6\frac{1}{4}$.
Rodin made three busts of the Duchess of Choiseul, one in bronze, one in marble, and one in terracotta; all of them were executed in 1908. He was on intimate terms with this American lady, who through her marriage became one of the prominent members of the French aristocracy.

90. ÉTIENNE CLÉMENTEL. 1916. Bronze, $21\frac{3}{4} \times 14\frac{5}{8} \times 11$.
This bust, executed in 1916, the year before the Master's death, is the last work which he completed. Étienne Clémentel was a prominent politician, who was several times a minister. He became one of the sculptor's three testamentary executors. This work, particularly moving because it is the artist's supreme labour, shows that, even on the threshold of death, the artist rough-hewed with great facility and retained a clear eye and hand of incomparable firmness.

91. GEORGES CLEMENCEAU. 1911. Bronze, $18\frac{3}{8} \times 11 \times 11$.
Rodin was from an early date on terms of intimate friendship with the great statesman, who, both as an influential politician and as a journalist, always stoutly defended and supported him. In 1911, Clemenceau had become one of the most prominent parliamentary figures of the day, yet desired that in his spare moments the sculptor should model his features. Before achieving the amazing resemblance of this bust, Rodin made several studies of it, but it is manifestly this unique bronze which will supply posterity with the truest image of this noble spirit and great Frenchman.

92. THE CATHEDRAL. 1908. Stone, $25\frac{1}{4} \times 13\frac{5}{8} \times 12\frac{5}{8}$.
Rodin always had a passion for modelling hands, so expressive in his view, so capable of displaying in themselves so many human emotions. Still in this period of the opening century pre-occupied with symbolism, more and more attached to the history of the religious architecture of the Middle Ages, the idea came to him one day in 1908 of representing the high pointed naves by two tapering hands joined in a gesture of prayer. Perhaps to accentuate the relationship uniting the symbol to the reality, he executed this work in stone.

# BUD ROBINSON
## A Brother Beloved
### By J. B. Chapman, D.D.

"On one occasion he (Bud Robinson) was in Little Rock, Arkansas, attending a convention and staying in one of the prominent hotels of the city. The first day of the convention he sat at a table alone. Before eating, he bowed his head and offered thanks "out loud." His words were inoffensive and deeply spiritual. A business man sitting near, seeing and hearing him, moved over to the table and asked permission to eat with him. At the close of the meal the man paid the bill and requested the privilege of eating with Uncle Bud three times a day as long as he was in the city, saying he would pay for the meals just for the fellowship and the pleasure of the conversation.

Once a highly educated man came to Bud Robinson's room, after hearing him preach. He began the conversation by saying, "I don't believe in the Bible. I don't believe God created man. In fact, I don't believe in God himself. I am an evolutionist. Man came from nothing into something. This is the teaching of science, which I believe, and I have no use for the Bible."

Uncle Bud heard the man's story, and then replied, "You are the most brilliant, the most cultured, the best informed man I ever met. You know more about science and philosophy in a minute than I could learn in a lifetime. But there is one thing I know, Doctor, that you don't know. I was once a sinner, a slave to tobacco, physically diseased, having had both my arms out of place many times from epileptic convulsions. One day I met Jesus. He healed my body. My epileptic spells passed forever. He forgave my sins, sanctified me wholly, and for many years has been my constant companion, and has never left me alone." The man looked at Uncle Bud and said, "I know nothing about the things of which you speak. I am utterly ignorant of such experiences, and, after all, perhaps you are as well informed in your line as I am in mine." Uncle Bud requested the man to kneel in prayer, and then prayed the heavens open, and this unbeliever was gloriously saved.

(Continued on back jacket flap)

BUD ROBINSON

1860 - 1942

# Did You Say He Is Gone?

By Haldor Lillenas

*Bud Robinson gone!*
*Did you say he is gone from this valley of tears?*
*That no longer a traveler on earth he appears?*
*He who traveled its highways for many long years,*
  *Did you say, did you say, he is gone?*

*Bud Robinson gone!*
*Did you say he is gone, that his tongue has been stilled?*
*He whose "Sunshine and Smiles" all the nation has filled;*
*That the cup of his wonderful life has been filled?*
  *Did you say, did you say, he is gone?*

*Bud Robinson gone!*
*Did you say he is gone to that shadowless land?*
*Shall we meet him again on that fair, golden strand?*
*Has the soldier obeyed his great Captain's command,*
  *Did you say, did you say, he is gone?*

*Bud Robinson gone!*
*Did you say he is gone? No, he lives with us yet,*
*All his sayings and deeds we shall never forget;*
*He will live with the years so we shall not regret*
*His home going—he lives with us yet!*

# BUD ROBINSON

## A Brother Beloved

By

J. B. Chapman, D. D.

*He has gone to meet Bud*

BEACON HILL PRESS
2923 Troost Ave., Kansas City, Mo.

22101

# CONTENTS

--------------✠--------------

# PREFACE

Bud Robinson has gone! It still seems strange that his chats no longer appear in the *Herald of Holiness*. His long lists of subscriptions come no more to delight and amaze us. He has gone—gone to be with his Jesus whom he loved so devotedly. But the blessed influence of his life lives on, reminding us how the grace of God triumphs over human limitations.

Upon receiving word of Bud Robinson's home-going my thoughts at once turned to the need of a biography that would extend that influence and present the story of his remarkable life to thousands of friends and also to the many who had not been privileged to see and hear him.

Wanting to lose no time in securing the family's approval for such a book, a long distance call was made to Rev. George Wise, a son-in-law, in Pasadena, California. The family's consent was quickly given. Brother Wise also agreed to write a chapter giving the details of Bud Robinson's illness, last days and death.

Next came the problem of selecting someone to prepare the manuscript. This was not so easily solved, the task being an arduous one and requiring immediate action. Considerable research would be involved. The biographer must be someone with an adequate background of the earlier days of the church in which Bud Robinson did most of his work. The assignment also would demand an individual who would have a sympathetic understanding of the subject's handicaps and limitations, as well as an appreciation of his points of strength.

All these factors pointed to Dr. J. B. Chapman. His contacts with Bud Robinson at Peniel, Texas; their relationship as editor and contributor; Dr. Chapman's

popularity as a writer both within and outside our own denomination—all seemed to indicate him as the logical choice.

Knowing something about his crowded schedule of speaking engagements and an already full load of writing, I rather hesitated to approach him on the subject. However, I made bold to state my case, and was delighted as well as amazed at his ready acquiescense to the proposition.

At the time, we were together at the Kansas City District Preachers' Convention. During the two days, Dr. Chapman frequently conferred with me about various points in regard to the proposed book. His enthusiasm seemed to mount hourly. Later, I wrote Dr. Chapman that his absorption in and devotedness to the task made me feel that my choice had been inspired.

From here on the book must speak for itself. It's now a case of proving the pudding. My close perspective may disqualify me as a competent judge. But I do think that our author has given a true picture of his subject. The case has neither been understated nor exaggerated. And Bud Robinson would have it that way. I believe he would approve the direct style of writing. I am sure that he would appreciate in particular the chapter of "Incidents and Sayings." He might forsooth be amazed at the things he said and did that live in the memory of his friends and that are now made available to all who wish to read. In my fancy I can hear Bud Robinson's inimitable chuckle at some of these anecdotes in which he figured with such ready wit and keen repartee.

And so we present to you Dr. Chapman's story of Bud Robinson, A Brother Beloved who loved his Lord supremely and his fellowmen unselfishly.

<div align="right">P. H. Lunn.</div>

CHAPTER ONE

## A BROTHER BELOVED

"Brother Robinson, I want you to meet Brother J. B. Chapman, a young evangelist and a friend of mine." From the couch rose a well-built man in his early forties, full-bearded, dressed in a Prince Albert suit, giving every evidence of measureless vitality and fairly beaming with hospitality. He extended his hand and gave me such a warm greeting as one would expect only from an old familiar friend. He inquired about my work and soon discovered and spoke lovingly of "Lonnie" Rogers and others whom we both knew. Three minutes earlier, at the door of the imposing looking house in which the great preacher and his family lived among a dozen or more young theologues, I had all but backed out of making the visit; five minutes later he and his wife, "Miss Sally," were offering me a home with the rest of the students there in order that I might go to school.

Thus, more than forty years ago, I first met Bud Robinson. It was late in the autumn of 1901, while visiting the college at Peniel, Texas. On the campus I met O. B. Kelley, a student whose acquaintance I had made earlier that year, and he told me that he was rooming and boarding in the home of Bud Robinson. Of course I had heard the name of Bud Robinson, and to find myself right in his home town was something rather more than I expected.

9

Brother Kelley assured me that Bud Robinson was without doubt one of the greatest preachers in the world and one of the best and most hospitable men one could meet in a lifetime. Along with his song of praise he continued to mingle invitations to accompany him to Bud Robinson's home where he was sure I would be welcome. He even assured me the great evangelist was anxious to meet me! Yet I could not quite put away the feeling that my attempt to see so important a personage was an unseemly intrusion. Who was I, an amateur preacher not yet out of my teens, that Bud Robinson should care to be bothered with being told my name? The feeling never lasted beyond the moment Bud Robinson took my hand.

Early in the visit he asked, "Have you come here to go to school?" When I said I could not enter school just then, he at once supposed my reluctance was based upon a lack of funds for expenses and said, "Now, you really don't have to have much money to go to school here. You can room right here with us. Miss Sally will give you a place at the table, and your living will not cost you a cent. Then if you can manage some way to arrange for your tuition at the school, you can get along all right." Just then Sister Robinson entered the room and he called her to witness that I would be received and welcomed. I went from his presence dazed and very nearly overcome. Outside I commented to Brother Kelley that surely the Robinsons did not mean that I could come there on so short acquaintance and be received and given room and board without price. Surely these people would not take a chance like that

on one whom they knew practically nothing about and whom they had just now seen for the first time. But Brother Kelley assured me they were perfectly sincere, and he joined in urging me to take them at their word, to cancel my evangelistic engagements and come at once to prepare for larger usefulness in the work of the ministry.

I did not make the arrangement and was never a student guest in the Robinson home, but I shall never forget that wonderful man, that wonderful woman and that wonderful home. From that day to the morning late in August, 1942, when a number of us from the Pasadena Camp Meeting ate our last breakfast with Bud Robinson, I was always remembered; and not once in that forty years was there ever a word or deed to mar the good impression of friendship and interest which a ministerial novice received on his first meeting with this great preacher.

When Rev. P. H. Lunn, Assistant Manager of the Nazarene Publishing House, approached me with the information that I had been selected to compile and write the life story of Bud Robinson, I began to ask, "What was Bud Robinson to the people who knew him and to those who heard of him, never having seen him?" I could not escape the conviction that to all Bud Robinson was "a brother beloved." It seems to me that there can be no title for his story like the name of the man, and that there is no subtitle more nearly the equivalent of that name than "A Brother Beloved."

One of the marvels of Bud Robinson was his ability to remember details. During the period when he trav-

eled the nation by train he could tell you from memory what railways served the different cities and towns, and often he could tell you the schedules of the principal trains. It has been said that at one time he knew and could quote from memory at least one-fifth of the Bible, and his mind was stored with all the useful information he ever obtained from reading or from listening to others talk.

Bud Robinson's recollection of faces and names was even more remarkable than his memory of places and things. I never heard an estimate of the number of people whose names he could recall upon sight, but I know the number was large beyond any reasonable comparison. This uncanny ability was used, not only on the great and near great, but upon the lowliest people whom he ever met. Along with his ready recognition and ability to call the name was his easy practice of recalling something complimentary about that person or his friends. If he ever ate a meal in the home he would remember the articles of food served and would mention details that made one know at once he was not generalizing.

He made everyone he met his friend. He was thoughtful of old people and patient with them beyond any reasonable expectation. He could always say something nice, and mean it, about little babies and their mothers. Strong men always thought of him as strong also. Poverty never failed to move him, and he would share his meal with the most dilapidated tramp that happened along. On the other hand, he was never overawed by the rich or the educated. He labored on

equal terms with the greatest preachers of his day: men like H. C. Morrison, Will H. Huff, Joseph Smith, Ed Fergerson and W. B. Godbey; he was often in revivals in Dr. Bresee's great church in Los Angeles. He was never embarrassed by the other's strength and never critical of the other's weakness. He would "boost" when a stripling tried to preach in his presence, and he would weep and shout when a veteran of the cross blew the gospel trumpet.

Bud Robinson was transparently sincere. He practiced all the things that psychologists recommend, but he practiced them without design or effort. He was wise in that he never claimed to be wise. He would stand up before a crowd or talk with an individual with the same show of interest. The large crowds did not frustrate him, the small crowds did not discourage him, and he met the individual with such perfect naturalness that one was bound to feel flattered by his attention. He could talk of his want of opportunity and of his lack of sense, and grow in the estimation of all while he did it. Once he was called upon to speak in the educational service at a District Assembly. In his opening remarks he said, "The only reason I can see for their asking me to speak in an educational anniversary is that by this means they can demonstrate how much preachers need to be educated." From this he went on to tell how he learned to read out of the New Testament after he was grown, studying by moonlight, catching a few words from the page while he turned his team at the end of the corn rows and seeking by hardest methods to know and understand the truths of

the gospel he felt called to preach. He was quite sincere in telling his own educational limits, but at the end of his talk his hearers felt that an interest in learning half as great as Bud Robinson's would result in their obtaining an education.

Within the last three years Bud Robinson was the principal speaker in the night services at a convention where I was speaker for the day meetings, but Bud Robinson was moved with the idea that I should speak in at least one of the night services, since, as he said, some people would not get to hear me in the daytime. I consoled him by proposing that he preach each night, and I would follow with an exhortation and invitation to people to come to the altar to seek the Lord. There were more than twenty seekers at each of the two night services, and Bud Robinson was so happy that he suggested the two of us form an evangelistic party. He said he would preach and I could exhort and we would have revivals everywhere. He was clearly glad that our combination seemed to work successfully, and that was all that mattered to him.

He was always in earnest. Many people laughed at his unique humor, and he laughed, too, but beneath it all there was with him a desire to do good and to save the souls of men that never weakened. When the first camp meeting was held at Columbus, Ohio, the committee, headed by Rev. N. B. Herrell, engaged C. W. Ruth, Bud Robinson, C. R. Chilton and me as the preachers. This was a rather full complement of preachers, and the committee told Bud Robinson that they wanted him there primarily that the people might

meet him, and that they would not expect him to take full turn with the younger men. They proposed that he preach only three times during the camp—once in the afternoon, once in the morning and once at a night service. He was assigned a tent and told that he need not attend meeting regularly and that he should spend much of his time resting, but Bud Robinson was on hand for all the major services, made a good hand at the altar, visited much with the people and took advantage of his light preaching schedule to go miles into the country to visit homes where there was a chance of doing good. I observed to Brother Herrell that it was evident Bud Robinson did not work because of necessity, but because of his real and genuine interest.

There was a "holy recklessness" and interesting abandon about Bud Robinson, especially in his pulpit ministrations, but for all that, he was a discriminating thinker and was thoroughly and consistently orthodox. Theological aberrations found no sympathy in his heart and mind. He was soundly scriptural and thoroughly Wesleyan. There were times when his applications of scriptures were personal and somewhat accidental. He often did what Spurgeon called "utilizing the text," but the gospel he preached from the utilized text was always sound and dependable. He was never carried away by any cult or counted as a supporter of any heresy. He was sometimes, during his long career of more than sixty-two years in the ministry, associated with those who later lost their bearings, but Bud Robinson, like Lincoln, agreed with men and went with them when they were right and parted company with

them when they went wrong. Because of this he was
at one time the object of unjust criticism. Under criti-
cism he was patient and followed the example of his
Master in refusing to open his mouth in his own de-
fense. Time justified Bud Robinson and proved his
worth and his mettle, and for many years before the
time of his decease he was beloved of his friends and
appeared to have no enemies anywhere.

Although Bud Robinson was better known as a
man of love, he was yet a man of high moral principles.
He was painstaking in his own practices and was bold
and definite in condemning sin and reproving crooked-
ness and hypocrisy. Once in describing John Appell,
the leader of the great camp meeting at Waco, Texas,
Bud Robinson said, "When the Lord made John Appell
He used only galvanized iron and barbed wire; there
is no molasses or honey in his makeup." And those
who were the subjects of Bud Robinson's Nathanlike
reproof had occasion to know that while there were
large quantities of molasses and honey in his constitu-
ency, there were also goodly portions of iron and blue
steel in his makeup, too.

Bud Robinson had not the slightest streak of doubt
as to the inspiration and dependability of the Bible, and
his intimate knowledge of the Book saved him from
being lopsided. He knew what the Bible said on every
important subject, and based his doctrines upon the full
revelation and not upon some selected portion of it. En-
forcing what he found in his Bible was his own experi-
ence. He had seen the seamy side of life in the days
when he was a great sinner. He knew the depravity of

the human heart from intimate contact with its fruits. He was himself the subject of an epoch-making transformation through grace. He was ever bold to offer hope and deliverance to the most abandoned. He found such full grace for his own need that he could not but preach "full salvation from all sin for all men through the blood of Jesus Christ." His walk with God was so Enochlike that he lived always in the vestibule of heaven, and harbored not the slightest fear that the future held anything but good for him and for all who are saved through Jesus' blood. He was always sure that God was with him, and that He would overrule when He was not permitted to rule. Even when he felt that the end of his days was near at hand there was no expression either of regret or impatience. The example proved again that the gentle are the strong. He did not shrink nor rush headlong. God's way was, as ever, his way, too.

The great men of the world have been of two general types—the Elijah type and the Elisha type. Elijah inspired fear and respect in the hearts of those who knew him, and when he was taken to heaven there was a distinct sense of loss—something in the order of a national calamity. Elisha was the intimate of the common man. People loved to have Elisha in their homes. They expected him to live among them, listen to their stories of sorrow and of hope, and when he died there was a sense of personal loss on the part of every person who knew him. Bud Robinson was of the Elisha type. He was a great preacher—a preacher of national and international reputation: it has been said that Bud

Robinson is more quoted in even the universities and
seminaries of the country than practically any other
preacher of his day. He was an author of note. He
was one of the most traveled men one would ever meet.
Yet we all thought of him as a friend and intimate.
Even when he was in the pulpit with the great crowds
before him, we all felt that he knew we were there, and
that he was trying to help us as much as he would try
to do if we were to go to him in private. We liked him
because he seemed to be preaching *for* us, rather than
*to* us. Then when he used illustrations, he used ones
familiar to us all. They were stories from the real lives
of real people, and the fact that the man before us had
been in the same sort of common places that we had
been in ourselves made us feel unafraid both of him
and of what life's rough experiences could do to us.
If I were to say now that a great preacher has gone
from us, if I spoke of a unique philosopher, a popular
writer or a great philanthropist, my words would be
approved, but the approval would be without enthusi-
asm. But our hearts respond when we realize "a broth-
er beloved" has lifted anchor and sailed on to the other
side. We are bereaved by the going away of a familiar
friend. And yet in death, as in life, he still serves us
as one from another plane of life could not do. The
very fact that Bud Robinson is dead is proof that death
is not altogether a calamity. We have an incurable con-
viction that evil cannot really befall one so holy and
harmless as he was. We are sure Bud Robinson has
gone to heaven, and his going makes us feel that going
to heaven is not so difficult as many think. On earth

his message was that what he could do any of us could do, and that same message comes back to us now from the city on high. We think of him in heaven still as our "brother beloved."

Bud Robinson laid no claim to greatness. In fact it was his claim that what he did was done in spite of the fact that he was born in poverty, was afflicted with epilepsy for a number of years in his earlier life, had no opportunities for formal education, was marked by a *biased* mouth and a lisping tongue, and burdened with limitations enough to "sink a battleship." The average person who sat and listened could not escape the feeling that if Bud Robinson could travel two million miles, write twenty books, help more than a hundred young people to get an education, preach more than thirty-three thousand times and lead a hundred thousand souls to Christ, almost anyone could make his mark in life if he would but devote himself to God and to the task of doing good. And yet we shall none of us see his like again on earth. Perhaps that is well. It will make it possible for us to enshrine the one Bud Robinson in our memories and take with us to the city of God the blessed fruitage of his deathless ministry to us and to all who knew him either personally or through his public life. Heaven seems more like home now that Bud Robinson is there.

CHAPTER TWO

## THE ROBINSON FAMILY

A windowless log cabin with a mud chimney that extended only halfway up the side of the cabin, a dirt floor in the one room, a hollow log for a cradle and very little other furniture—everything about the place branded it as a drunkard's home. And there, in the mountains of White County, Tennessee, on January 27, 1860, was born the child whom his parents named Reuben Robinson. It is nowhere stated in the sketches the man left behind just when and by whom he was first dubbed "Bud," but whoever gave him the name did a good job, for during all the years when he was engaged in preaching and writing no one ever knew him by any other name than "Bud Robinson."

The Robinsons were among the poorest of the poor in the Tennessee mountains. I think, however, there is ample evidence to justify the statement of Dr. C. A. McConnell that there were "generations of educated, cultured Scotch-Irish back of him." Bud himself says there was a time before his birth when his father was one of the largest tax payers in the county. It was liquor drinking, liquor making and liquor selling that brought the Robinson family into straits, and Bud never found it possible to show the slightest favor to the practices and to the traffic that brought about the conditions which existed in his childhood home. In that

21

mountain community, eighty-three years ago, drinking and drunkenness were all but universal, and the low moral standards which usually accompany liquor were there with a vengeance. Opportunities for education were meager, and such as were offered were not largely used: Bud Robinson had not yet learned to read when he was converted at twenty years of age.

Bud's earliest recollections were his father's absence in the army while his mother sought by all means to keep the family from freezing and starving, and the intrusion of a union soldier who took away their last work horse, old "Gin." At the close of the Civil War the father returned and the Robinson family moved to Tipper County, Mississippi. For a while the father attempted farming but soon resumed his making and selling of whisky. In a disagreement with the owner of the still, he narrowly missed either being killed or becoming a murderer. Next he tried the tar business. Finally, four years after coming to Mississippi, more reduced in fortune than ever, the Robinsons returned to the mountains of Tennessee.

Mother Robinson undoubtedly had been converted some time in early life. Bud remembers seeing her, when he was about twelve years old, come from the spring carrying their water supply and shouting the praises of God. But amidst the tests and trials of life, she seems not to have continued as a settled Christian.

About this time, in 1872, Bud's father, then sixty years old, died. The mother grew restless in those mountains "a hundred miles from a railroad, fifteen

miles from a postoffice, many miles to the old water mill, without churches and without schools." The three older children soon struck out on their own, and Mother Robinson was left with the ten younger children to care for. Bud was sixteen when she finally decided to migrate to Texas with her fatherless, poverty-stricken family.

She sold her few belongings and went ten miles to get a man to bring his wagon and take her and her family to Nashville, where they could get the train. The trip of one hundred miles to Nashville required three days and nights, and the train trip from Nashville to Dallas, Texas, required another three days and nights. The family landed, on September 18, in a straggling village on the banks of the Trinity River—Dallas in the year of 1876. The country about was largely given over to stock raising. Bud's mother soon found work for her sixteen-year-old son on a stock ranch, and thus was he launched upon the questionable career that usually engulfed a cowboy in those days. Moreover, the owner of the ranch was a Universalist and a skeptic. Being altogether uninformed and unregenerated, Bud readily absorbed the theories and imitated the examples of his employer and his family. The theory was that God brought them into the world without their consent and would take them out without their permission, and being a merciful God he was bound to take them to heaven. During his first week in that home they taught Bud to play cards. A few nights later they had a big country dance and the ranchman's

wife led Bud out on the floor to give him his first lessons in dancing. In a little while there were horse races, inasmuch as the ranchman and his brothers owned a race horse. Four years of life amidst such surroundings made Bud as "wild as an antelope," and it looked as though his doom was sealed for this world and the world to come.

But shortly after the move to Texas, Mother Robinson made a new start and, in addition to finding the peace of salvation for her own soul, prayed effectively for her children. At the age of twenty Bud was converted, and he gave much credit to her prayers and solicitations.

In "My Life's Story" Bud Robinson tells of his last meeting with his mother, more than forty years later. "After the closing Sunday (at Arlington), on Monday, I ran down to Hubbard City, Texas, to visit my old mother, who was at that time eighty-seven years of age. I spent two days with her. My little niece, Miss Eula Kain Hammers, took Mother and me to visit many of the beautiful old saints who listened to me preach over forty years ago. In those days I was a mere boy and they were middle aged men and women. When I went to see them many of them were from seventy-five to ninety years of age. I will never forget that little trip. My mother and I sang old hymns together in every home and the old saints would shout together. That trip lingers with me yet. That was the last time I ever looked on my beautiful old mother's face. The

morning I left her, I will never forget. Mother and I sang and quoted scripture and shouted together.

"After reading and praying together and having a shouting spell, I had to tell Mother goodby. Neither of us thought we would ever meet again in this world. The last time I saw Mother she was standing in the yard waving her hand at me and shouting just as loud as she could whoop. The next time that I see her will be at the great marriage supper of the Lamb."

That was May, 1920. In November, 1921, Bud was in a convention in Henryetta, Oklahoma. His mother was sick in Hubbard City, Texas, and those present asked if they should send for Buddie. But that heroic old mother said, "Why, children, don't you know Buddie is in a meeting, and what if he should come to see me go up and get my crown and a dozen souls should be lost?" And on that very night a dozen did come and give their hearts to God. An hour after the service closed a long distance telephone message notified the son that his mother had gone to heaven. At the close of the convention in Henryetta, Bud went to Hubbard City, to be with the loved ones for two days, but he could not bear to go out to the cemetery. "For I knew," said he, "that Mother was not there. I left Hubbard City, headed for the City in the skies."

In "Sunshine and Smiles" Bud tells how he prayed and worked for the salvation of his brothers after his own conversion. "They were all very wicked and drank and used tobacco and were profane swearers and seemed to take no interest in their own salvation. I prayed for

them for several years before they seemed to yield and
come to the Lord. I have gone to town and hauled them
home in a two-horse wagon so drunk they could not
get up. I would unload them and sit up with them
during the night and pray for them and keep them
from fighting with each other. After many years' strug-
gling and praying, the Lord saved my two youngest
brothers, and in a short time after they were saved, He
called them to preach. They worked for the Lord a
few years and were very faithful and true and were
filled with the Holy Ghost. Right in the bloom of
youth they both died and went to heaven praising
God." The oldest brother who was a desperate drunk-
ard and drug fiend, and the second oldest, who was a
great sinner but not an addict to tobacco or opium, were
converted finally.

In September, 1891, Bud Robinson went to George-
town, Texas, to enter Southwestern University prepara-
tory school to fit himself better for the work of the
ministry. There he met Miss Sally Harper, a well-
educated and highly cultured lady, and on the 10th of
January, 1893, they were married. Miss Harper brought
to Bud Robinson the very qualities he lacked most, and
contributed to his making in a measure which cannot
be estimated. She was his adviser and teacher, as well
as his wife, lovingly called "Miss Sally" during their
lifelong companionship. Sally Robinson preceded her
husband to the heavenly city by just two years, and it is
a joy to think of them together again now in the "Plains
of Light."

The Robinsons had two children, Sally and Ruby. Sally married Rev. W. A. Welch, and Ruby married Rev. George C. Wise. Both the Welches and the Wises live in California, and both families are blessed with boys and girls that do credit to the name of their worthy grandfather. Some of the grandchildren are ministers or ministers' wives, and all the children of both generations are fully devoted to the ideals of Bud and Sally Robinson whose memory they fondly cherish.

Bud Robinson was devoted to his home and family, but his passion for his work of evangelism was so fierce that he was not often at home, and did not usually stay long when he did come. This was the great sacrifice which a calling like his demanded. The Robinson home in Peniel, Texas, was the largest house in that college town, and wherever Bud went in those days he was wont to tell of the joy his home brought to him, and he was glad to make it a place where young men in training for the ministry could stay. His home in Pasadena, California, was, likewise, a roomy, homey place, a large house surrounded with lawns and fruit trees and shrubs—just such a place as would call to one from distant parts and be hard to leave when the time came for further wanderings. Much of the time this home, too, was a place to remember and talk about, so far as its owner was concerned. Perhaps it was always in his mind that when his active days were over, he would like to be at home: however he continued active to such a late day as to make that final stay a short one. In the meantime, before his fighting strength had

failed, "Miss Sally" entered into rest; and when he came home for the last time, he was tenderly cared for by children and grandchildren. That surely was as he would have had it, for it was as God arranged it.

## BUD ROBINSON'S PERSONAL CHRISTIAN EXPERIENCE

The sun was slipping down the western sky one hot summer day in the year 1880 when an old-fashioned Methodist circuit rider came up to a Texas ranchhouse. A wild young cowboy, called Bud Robinson, was commissioned to water and feed his horse. Fearlessly and as a matter of course the old preacher said grace at the table and as soon as supper was over read a long chapter out of the Bible and prayed as lustily as though he were in a camp meeting. He was definite and personal in his prayer, too—so much so that Bud thought the old preacher knew everything about them. Early the next morning the preacher was up and outside for "secret prayer," but his secret prayer could be heard all over the place. Then there were thanks at the breakfast table and another family worship service.

The old preacher at his departure shook hands with all, saying, "My friends, I can't get back to see you for a month," and rode away singing, "Amazing Grace, How Sweet the Sound!" Reporting the meeting, Bud says, "Though I was not saved and did not know God, it seemed to me that Jesus Christ had come to the frontier of Texas in the life of this preacher and that the devil was in a pack of wolves and the devil was fleeing before Christ."

At the end of the month the man of God came again and stayed three days that time. There were more prayers, more thanks at the table, more songs of victory. At the end of the stay the preacher announced that he was going to hold a camp meeting about eighteen or twenty miles away during the month of August, and that they were all invited to come. People came from distances as far as two hundred and fifty miles to the camp meeting, and the rich ranchman on whose place the meeting was held furnished beef for all. A spirit of revival came on the people.

Bud's story of his part in the camp is as follows: "Deep conviction had settled down on me the second day. I felt that I was lost. One day the preachers asked the workers to go down into the crowd and find a sinner and pray for him wherever they found him. A beautiful old mother with white hair and the finest face I ever saw came through the crowd. She looked like you could take a rag and wipe heaven off her face. She found me sitting on the back bench. There was no need of her saying, 'Young man, are you a sinner?' She looked at me and knew no Christian ever looked like I did. She went down before me on her knees and put her hands upon my bare knees where they were sticking through my dirty overalls and prayed for me as loud as she could. The devil got up and said, 'If you don't give her a cussing she never will quit.' But it seemed the Lord said, 'Don't you cuss this woman, she is praying for your lost soul.' Then it seemed to me the devil said, 'If you don't get up and run they are

going to get you.' But, beloved, God had come on the scene. I tried to get up, but could not get off of the bench. It seemed as though I were glued to it while the devil hissed in my face. That beautiful mother prayed louder and louder, and finally began to shout; and rising on her knees she commenced to beat me on the head until I thought I was going to sink through the ground into the pit. The old mother shouted as long as she wanted to, and when she finally arose she looked like she was half glorified."

The arrow of conviction stuck in Bud's heart. That night, in the midst of a tremendous altar service, such as were expected in the old-time camp meetings, he made his way to the place of prayer, taking with him such a burden for sins as one cannot long carry and live. There was around that altar such a prayer meeting that Bud afterward described it as "a life and death struggle." At the close of that prayermeeting Bud Robinson was converted and blessed with such an ecstasy that he could never describe it except by saying "the bottom of heaven dropped out and my soul was filled with light and joy." *78 - today*

That was on August 11, 1880. That very night as he lay under the wagon, he testified, "God called me to preach."

The crisis of conversion was so radical in the case of Bud Robinson that his whole subsequent course in life was related to that experience even as the tree is related to its root. To Bud Robinson all that was back of the August day in 1880 was always as distant as

though it had occurred during some previous visit to this planet. There was never any expression that suggested he felt any sense of loss in giving up the old life for the new. He was a pauper, he said, as a sinner, and he became a millionaire in one second by coming to Christ. His ragged, dirty clothes which he wore on the night of his conversion were always to him a symbol of his spiritual poverty and uncleanness. But that old-time conversion was not all ecstasy and demonstration, for it was followed by a changed life. The change was immediate and radical, so that from the very first, observers were convinced of the reality of the inner transformation because of the outer change which they could see.

The very next morning following his conversion, Bud went to the testimony meeting and there received such an outpouring of the Spirit as to confirm him and all present in the things of God. The manner in which the people responded to the leadership of this new convert was just a token and a prophecy of what was to come in the years ahead when that new convert would be one of the most sought after camp meeting preachers in the nation. At the close of that testimony meeting, Bud joined the Methodist Church and was baptized by effusion.

Summing up the story of his conversion, Bud says, in "My Life's Story": "Thank God for the fact that I had been converted, joined the church, taken the church vows and had been baptized. I was now on the road to heaven, in poverty, yet a millionaire; without a home,

BUD ROBINSON—

(1) *Soon after he was converted and began his ministry*
(2) *Taken about 1893*
(3) *Taken during his residence at Peniel, Texas.*

yet all heaven was mine. No doubt the reader has read the book, 'Twice Born Men.' I know what that means, for I was born the first time on the 27th day of January, 1860, in the mountains of Tennessee, but I was born the second time on the 11th day of August, 1880, on the beautiful prairies of dear old Texas. Herein lies the difference between the two: I was born a rascal the first time, as one of the first recollections of my life was that of stealing something. I was born a Christian the second time, and for more than forty-seven years (written in 1928) I haven't taken a thing in the world that did not belong to me."

At the close of the camp meeting Bud quit his job on the ranch and returned to his mother's home. Three months after his conversion, he attended a Sunday school for the first time in his life. Although he could not read, he listened eagerly to the reading of the scripture lesson. His testimony was the cause of a wonderful breaking up and a time of rejoicing in the class. The young teacher gave Bud a copy of the New Testament; from this Testament he learned to read, beginning with the first chapter of Matthew, and, using his Testament as a copy book, he learned to write. He was two or three days learning to write "Bud Robinson," but he persisted until he was able to record his thoughts in a hand that at least he himself could read.

Bud began to attend church regularly and tried to pray every time they called on him. He began to feel the pressure of his call to preach, but he had no education, no money, and it seemed to him he had no

friends, for everyone he approached on the subject was sure that God would not call one like him to preach the gospel. Just at this time of fateful decision, a new preacher came to the circuit and encouraged Bud to believe that if God had called him, He would help him, and he could be a successful preacher. Two weeks later the Quarterly Conference rejected Bud's request for license to exhort, and then, before adjourning, reconsidered and granted the license.

Bud took his exhorter's license seriously, and set about making opportunities for himself. Since no one invited him to preach, he went out on his pony, rounded up a crowd and made the beginning on his own responsibility. That first service was a success, for although there must have been much wanting in the sermon, three men were converted before the meeting closed. By the end of the quarter, Bud was able to report that he had preached ninety times, had prayed in over two hundred homes, and had had ninety conversions. During the following six years Bud usually preached on Saturday nights and on Sundays, and during the summer months he preached in three or four protracted meetings or camp meetings.

In 1886 Dr. W. B. Godbey of Kentucky, a well-known Methodist preacher of the old-fashioned John Wesley doctrine of perfect love or entire sanctification, came through central Texas; among other engagements, he held a meeting in Alvarado, Johnson County, just ten miles from where Bud Robinson lived. Bud heard Dr. Godbey and others preach this doctrine, and it ap-

pealed to him.  The lives of the people who professed
the grace of full salvation affected him, too, and Bud
Robinson became a seeker for the grace and blessings
of entire sanctification.  At first he was more or less a
secret seeker, and then, at the end of two years, he de-
cided he would be more likely to get the experience if
he preached it to others.  So he commenced to preach
holiness and continued to preach it during the two years
until he finally found it and gave testimony to it.  Some-
times he would preach that men should be sanctified,
then close by telling the people he did not himself have
the blessing, but that he was going to the altar to seek
it.  Sometimes others joined him in the search.

Indeed it was his own preaching on the subject that
finally brought him to the place of desperation where
he could no longer continue without the blessing.  Bud
Robinson's description of the inner struggles which he
endured during the ten years that intervened between
his conversion in 1880 and his sanctification in 1890 is
vivid and definite.  At first he was not sure that one
could have an experience that would stand the test of
life without fail.  Then he became convinced that such
an experience is possible.  And finally he became sure
that for him, at least, such an experience was indis-
pensable.

On the second day of June, 1890—on Monday after
he had preached the day before on, "Without holiness
no man shall see the Lord"—Bud reached the end of
himself while he prayed in his own corn field where
he had gone to work.  There came upon him such a

wonderful baptism with the Holy Spirit as can be known
and described only by those who have received such a
blessing themselves.  It was like the day of Pentecost
to the disciples in the upper room.  It was like the bless-
ing Charles G. Finney found that day while he prayed
in the woods a few days after his conversion.  Bud lay
there in the field from nine o'clock in the morning until
noon, so blessed and so happy that he could scarcely re-
main in the body.  Then he went to the house and gave
his testimony to his mother.  It grieved him that she
was not ready to accept the account of such a blessing
as being true and dependable.  To his great joy a few
years later, however, his mother entered into the blessed
experience that meant so much to him.

In "My Life's Story," written in 1928, Bud Robin-
son said, "I think the first year after God sanctified me
I had more people saved than I did during the ten
years that I preached as a licensed exhorter and licensed
preacher without the experience of holiness.  And yet I
want to thank God that from the first time I preached He
gave me souls.  I have no idea what kind of a condition
a preacher must be in and not be able to get people
saved."  In another paragraph of the same book, Bud
says, "I praise God that I was converted in time to get
into the holiness movement, and sanctified in time to get
the movement into me.  And today I am in the holiness
movement moving the movement, and the holiness
movement is in me moving me.  Glory to His name."

Opposers of John Wesley have sometimes claimed
that Wesley became weak in his advocacy of the "sec-

ond blessing, properly so called," toward the end of his long life. I think this charge is false. But if in time to come anyone should rise up to say that Bud Robinson ever became lax in his testimony to sanctification or ever preached it with less fervor toward the end of his days, that person will have to make his story out of other than whole cloth. The facts are that Bud Robinson never wavered, no, not for a moment in all those fifty and more years that intervened between that day in his corn field and that other day in November, 1942, when he was translated to heaven. It can be said of him, indeed, that "he kept the faith."

## TWO DECADES OF PROBATION

It was springtime again, the year of 1892, and the lengthening days found Bud Robinson looking eagerly forward to a summer of reaping in revival harvest fields. It had seemed like a golden day the previous September, a day of climax in his life, when he was privileged to enter the Methodist Southwestern University preparatory school. His pastor encouraged him and generous gifts from the people when they knew he had decided to go to school seemed to indicate that his desire for formal education was in the divine plan. Now, with mingled feelings, Bud put behind him the year of schooling, the only formal schooling he was ever to have.

Southwestern University and the Southern Methodists of Texas were not friendly to the Wesleyan doctrine of holiness in those days, and they did not go far out of their way to make a struggling young preacher who was pledged to preach this doctrine and testify to this experience feel at home among them. It had been a lonely year, for Bud Robinson loved fellowship, even as he loved people generally.

Nevertheless, he left Georgetown that spring day with many a backward look, for he had said "Goodby" also to Sally Harper, whom he met for the first time during the year. In subsequent years, Bud never said

much about what he learned that year, although he re-
membered thirty-eight years later, when he came to
write the story of his life, the names of eleven profes-
sors in the university proper, three who taught in the
preparatory school, and many young preachers who
were students there during that year; also, the names
of many lecturers who appeared on the university plat-
form, the pastor of the university church and the pre-
siding elder of the Georgetown District. He remem-
bered that the two literary societies were the Alamo
and the San Jacinto (both names connected with Texas'
war of independence from Mexico), and that he joined
the San Jacinto Society.

It is not likely that he did very much in the way
of getting started with the formal courses, but it is also
evident that he obtained a great deal of help in the way
of aspiration to learn, and he must also have found out
something valuable about how to go about learning
what he wanted to know. His interest in the education
of young people throughout the remainder of his life
proved that he never put any premium on illiteracy,
and that his own marked success was attained in spite
of his lack of formal education and not because of it.

Bud spent the summer of 1892 laboring with Rev.
Horace Bishop, presiding elder of the Georgetown Dis-
trict. His report of the summer's work is brief; he says
they saw hundreds of people saved and took hundreds
into the membership of the Methodist Church.

The Annual Conference was held at Waco in the
fall of 1892. Bud Robinson went to it, and the un-

known holiness preacher was deeply impressed by Bishop Hargrove, and the huge number of presiding elders, pastors and visiting ministers. He was impressed by the majesty and dignity of Methodism; but his heart leaped up when he turned a street corner in Waco one day and found a group of uniformed men and women preaching on that public, yet humble spot. Their zeal for souls and their readiness to hold meetings on the street took hold of him; it was his first contact with the Salvation Army, and he quickly decided to don the uniform and cap.

During the few months he was in the Salvation Army in Waco and in Austin, he was a faithful worker, and experienced some splendid successes. He never lost his sympathy with and love for the Army, and there was about him to the very end of his life something in the nature of a holy abandon in the work of God that reminded those who knew that the Salvation Army contributed something permanent to his usefulness. Many holiness preachers and holiness people found home and usefulness in the Salvation Army of that period. L. Milton Williams, afterwards known as a national and international evangelist, was at that time "Major" Williams in the Army. Will Lee, later the founder of a very successful mission work in Colorado, was "Captain" Lee.

Bud gives a very interesting experience connected with his army days. One day in his visiting work, he came to a little cottage somewhat back from the street where a little mother was running a sewing machine,

and her little tots were playing about on the floor. Bud told the woman he had come to pray with her and her children, but she forbade his praying in the house. He then asked if he might pray in the yard, but she forbade that also. Then he asked about praying on the sidewalk, and she said, "That is just with you about that." So out on the sidewalk, he removed his cap, sang a good Salvation Army song, and knelt and offered prayer. Bud remarks that he thinks he could not hear the sewing machine running while he was praying. On his round the next day Bud felt impressed to go back to that home again. He went just as though nothing had happened. The woman apologized for her actions of the previous day, while Bud excused her on the ground that she had been very busy. He prayed in the home with her consent that day. That night the woman came to the hall and was converted. She insisted that the Army people come to her house for dinner the next day that they might meet her husband who was a railway conductor. Within three weeks the husband was also saved, and Bud ever afterwards pondered how much would have been missed if he had not gone back to that home the second day.

At the end of only a few months Bud found that his voice would not stand the singing and preaching in the open air and in January, 1893, he left the Salvation Army. Chronology is a little uncertain in regard to the next five years of Bud Robinson's life. We know he returned to Georgetown to marry Miss Sally Harper on January 10, 1893, and we know that in 1898 he left

Georgetown to organize the Hubbard Circuit in Hill
County, Texas, for the Methodist Episcopal Church to
which he had by this time transferred his membership.
But of that five year period between his marriage and
his removal to Hill County we have scanty account.
Somewhere during that period, likely in the first part
of it, he was given his choice between giving up the
preaching of holiness and leaving the M. E. Church,
South. His own account of the matter was, "I told them
I had only one conscience and there are many churches,
so I would keep my conscience." Upon his withdrawal
from the M. E. Church, South, he reports that he "at
once" wrote to the presiding elder of the M. E. Church
to know if he would take a man who believed in sancti-
fication as a second blessing, and had the experience
himself. The answer was favorable and the transfer
seems to have been made without delay.

There was a "holiness prayer meeting" in George-
town, and the Robinsons were its promoters. Just how
they fared in either a spiritual or financial way is not
clear. In "Sunshine and Smiles" Bud refers to this
period, saying, "While I was trying to keep loyal to the
church and while the presiding elder would not let me
preach out of town, and the preacher in charge would
not let me preach in town, I ran a dye shop and wood
wagon to support my family."

That period, 1893 to 1898, must have been a trying
one for Bud Robinson, whose very nature bloomed out
under kindness, and whose heart was so ready to go to
any lengths, not involving sinful compromise, for the

sake of peace. There are intimations that there were
even physical hardships, involving clothing, food and
fuel, during that perod.

One thing that happened during this period which
Bud characterized as "long and weary," was Bud Rob-
inson's miraculous healing in 1896. Bud's own story as
related in "Sunshine and Smiles," says, "For sixteen
years I had occasional epileptic fits, and for fifteen years
I had paralysis, and for ten years bleeding of the lungs,
and my arms had been several hundred times pulled
out of place and put back. This statement may seem
extravagant, but it is literally true. Through the spasms
that I had, a keen pain would strike me in the arms and
they would be pulled out of joint. After a few years
they would not stay in place, and if I reached up a little
too high, or if I reached a little too far back, my arm
would come out of place. Or if in sneezing I threw up
my hands, either one or both of my arms would come
out of joint. When at work in the field and often at
night in my sleep I would turn and throw my arms out
of joint. Whenever my arms came out of place, I would
have to lie down on my back and my brother would put
his heel under my arm and get me by the wrist and pull
my arms back into place. My arms finally got so bad
that I had to leave them out of place because it was such
intense suffering to have them coming out of place and
then have them pulled back into their right place
again.

"God is witness that for those eleven years I had
never had one doubt about the goodness and mercy of

God and His power to save, sanctify and keep. . . . In 1896 I was wonderfully healed by the Lord. . . . God wonderfully healed me of all, clarified my mind and gave me His Word in my mind."

This marvelous healing was in answer to prayer and faith, and to the end of his days Bud never retracted his testimony regarding it. Yet he never became an extremist on bodily healing. He preached on the subject of divine healing and wrote a book on it, but he always maintained that healing from God is a gift, rather than a grace, and that God heals or withholds healing according to His own sovereign will. Regarding his own healing, he said, "I want health only for God's glory— if it is not for my good and His glory I don't want it." And in his reasoning on the subject, he concluded that suffering and pain are often ministers of God's mercy, since they make one to realize his dependence upon God, and they also act as restraining judgments upon those who would otherwise go to extremes even worse than they now practice. That his own healing was real, he would always witness. Once when he told of his healing, a physician in the audience, an unbeliever, approached Bud saying, "I don't believe your arms are out of place as you say, and I would like to satisfy my mind on the subject." Bud took the doctor into a small room and removed his coat. The doctor found the situation just as Bud had described it. Then the doctor inquired, "If God healed you, as you say, why did He not put your arms back into place as they normally should be?" Bud replied, "I can't answer that question, doc-

tor, unless, perhaps, He left me this way so as to convince men like you that there really was something the matter with me once." That his healing was permanent is proved by the fact that he worked harder than almost any man of his day and yet lived to be almost eighty-three years of age.

In 1898 Bud Robinson moved his family to Hill County and organized the Hubbard Circuit. His stay here was not long, for he left the circuit on the last day of August, 1900, to move to the campus of the holiness school that had been established the year before in the suburbs of Greenville, Texas, in the village afterward called Peniel.

Even while preaching on the circuit, Bud Robinson's heart began to reach out to wider fields.

In May, 1899, we find him listed as the preacher for the spring session of the Greenville Camp Meeting (where the school was really organized) and Dr. A. M. Hills called to the presidency. In July and August of 1900 we find him preaching in the Bates Camp Meeting in Denton County, and in the Denton Camp Meeting in the same county. In August he was one of the regular preachers in the summer session of the Greenville Camp Meeting. After these meetings he returned to the Hubbard Circuit to pack up his household effects and move to the new college campus.

With this removal, a new epoch in Bud Robinson's ministry began. His probation was over; he had made good, and henceforth he was to have a larger world "for his parish" than John Wesley reached in the days

of his personal ministry. He was forty years old—he had lived his first twenty years in poverty and sin; he had served ten years as an exhorter and occasional preacher; and now he had ended a decade of opposition during which he became convinced that he could turn loose every other dependence besides God and make his way as an itinerant holiness evangelist.

## Chapter Five

# A CAMP MEETING AND CONVENTION FAVORITE

"Columbus discovered America, but I discovered Bud Robinson," spake the eloquent Dr. Henry Clay Morrison in the General Assembly of the Church of the Nazarene in Kansas City, in 1936.

No story of Bud Robinson would be complete without taking into account the tremendous help he received from such men as Dr. Morrison and Dr. B. Carradine who, like the true prophets that they were, saw in Bud Robinson a rare jewel for the service of God before many other people were able to see it. When Bud Robinson came first to the Waco Camp and met Dr. Morrison he was very little known, and many who did know him were still uncertain about him. Dr. Morrison was unstinting in his praise both verbally and through the *Pentecostal Herald* of which he was founder and editor. He encouraged the committees in the largest camps of the country to call Bud Robinson as full time preacher. There were other loyal supporters, too, but because of the *Pentecostal Herald*, Dr. Morrison was able to give Bud Robinson the publicity he needed, just at the time when he needed it.

When Bud wrote his "Pitcher of Cream" in 1906, he already knew the leading preachers of the holiness movement throughout the country, and had become so intimately acquainted with them that he was able to

49

classify them on the basis of their outstanding charac-
teristics. His "Flock of White Doves" was composed of
M. L. Haney, L. B. Kent, Isaiah Reid, E. Davies, Dr.
Foote, Dr. P. F. Bresee, and Dr. Daniel Steele. His
"Big Four," whom he described as the greatest preach-
ers he had ever met, were: H. C. Morrison, B. Carra-
dine, C. J. Fowler, and Joseph H. Smith. Then came
his "Bible Number 7": Seth C. Rees, E. F. Walker,
W. B. Huckabee, G. W. Wilson, A. M. Hills, L. L. Pickett
and A. A. Niles. The "Big Six" were: D. F. Brooks,
John Hatfield, W. W. Hopper, L. L. Gladney, C. W.
Ruth and E. E. Fergerson. The "Eleven Young Giants"
were: Will H. Huff, H. W. Bromley, W. J. Harney, John
Paul, Andrew Johnson, I. G. Martin, John L. Brasher,
C. E. Cornell, Chas. M. Dunaway, James W. Pierce and
C. K. Spell. Then classifying his colaborers from an-
other point of approach, he had "The Four Cyclones of
Honey": B. Carradine, honey in the rock; Joseph H.
Smith, honey in the comb, C. W. Ruth and D. F. Brooks.
The "Four Great Teachers" were: W. B. Godbey, A. M.
Hills, L. L. Pickett and E. F. Walker. The "Three
Great Reasoners" were C. J. Fowler, A. A. Niles and
George W. Wilson. The four who were "all backbone
and wore galvanized iron breeches" were: B. S. Tay-
lor, John H. Appell, R. M. Guy and W. G. Airhart. He
listed as "Some of the Most Untiring Workers": R. L.
Averill, J. T. Upchurch, C. B. Jernigan, E. C. DeJer-
nett, C. M. Keith and C. A. McConnell. The great sing-
ers he said were: J. M. and M. J. Harris, Charlie D.
Tillman, Charlie Weigle, W. B. Yates, L. L. Pickett,

to say on the subject he had presented to the people. He and Bud Robinson were complements and had almost no similarities as preachers. For this very reason the two men made a balanced team. The admirers of each man claimed that his favorite was the big horse in the team and that he took the other along in order to give him a chance, but the truth was that these men were stronger together than the two of them were when they were apart. Bud Robinson was always an easy man to work with, but he was never quite as happy with anyone else as he was with Will H. Huff.

C. E. Cornell, who was a lay evangelist with headquarters in Cleveland, Ohio, for a number of years, and who was later pastor of the First Churches of the Nazarene in Chicago, Los Angeles and Pasadena, successively, was also a wonderful colaborer with Bud Robinson. Cornell was a direct, intense preacher, and one of the most successful exhorters that the holiness movement ever had. He could boost right through when another man preached, and then join in the exhortation and invitation with as much fervor as though he had delivered the sermon himself.

C. W. Ruth was another colaborer who was an evident favorite with Bud Robinson. He was a wonderful Bible preacher, and his thoroughness in presenting evidence worked in well with Bud Robinson's unique manner of enforcing by means of testimony.

Bud Robinson always preferred preachers altogether unlike himself. H. C. Morrison, Joseph H. Smith, Will H. Huff, C. W. Ruth, C. J. Fowler, Dr. Bresee,

E. F. Walker—and Bud Robinson! Such combinations
on camp meeting and convention schedules were the
usual, and no one was more happy to have it thus than
Bud Robinson himself. He would come along in the
next service after one of these giants of the preaching
art had lifted the people to the heavenlies, and in his
simple, inimitable manner would point the people to
Christ.

In 1916 Bud Robinson and Evangelist L. Milton
Williams agreed upon a plan for the purchase of a "Big
Brown Tent" and equipment for it, and the gathering
of a staff of specialists for the most pretentious evan-
gelistic campaign that either of them had ever under-
taken. They opened their meetings in the spring of
1917 and continued with large success for eighteen
months. I have never seen a complete list of the cities
this unusual evangelistic party visited, but I know they
included Arkansas City, Kansas; Oklahoma City, Okla-
homa; Wichita and Topeka, Kansas; San Antonio and
Austin in Texas; Des Moines, Iowa; and Hammond and
Bluffton in Indiana. There was a time when the "Big
Brown Tent" evangelistic party had within its number,
besides Evangelists Williams and Robinson, John E.
Moore, song leader; Brother and Sister A. L. Hipple,
property managers; Stephen Williams, publicity man-
ager; Professor and Mrs. Kenneth Wells, special singers
and pianist; Miss Lou Hatch and Howard Williams, Vio-
linists; and Miss Virginia Shaffer who was entirely in
a class by herself when it came to gospel solo singing.
This party of specialists gave holiness evangelism a

high rating wherever it went, and there remains to this day many evidences of the good done.

Bud Robinson was idle, so far as evangelistic meetings were concerned, for ninety days in the fall of 1918 on account of the epidemic of influenza which swept the nation and the world. Following this enforced vacation, he preached in and around Southern California until the last of May. Then he made his way on up to San Francisco, to join C. E. Cornell and D. Shelby Corlett in a meeting in Donnell Smith's church—the First Church of the Nazarene, San Francisco. On the night of June 1, 1919, occurred that tragic accident in which Bud Robinson was struck by an automobile and critically injured.

I have had the place of the accident pointed out to me in San Francisco. There really was no special reason why there should have been an accident there in the middle of the block. From all accounts, Bud Robinson was occupied with his thoughts, under the special burden on account of disappointments in connection with his home church, and he walked right out in front of a moving street car. When he saw his predicament, he deliberately chose to leap in front of the automobile, rather than to be run down by the street car. His choice was a fortunate one, for the street car would have undoubtedly crushed him to death, while the automobile did leave him a chance to recover.

The accident was all but fatal. The details of the whole matter were given by Bud Robinson in his little booklet, "My Hospital Experience," which had, I think,

the largest circulation of any of his books. When he
was able to travel and preach again, Bud made his hos-
pital experience one of his special topics, and through
his recital of his tests and trials and the testimony he
gave in connection with them, this tragedy was turned
into good account and made to bless multiplied thou-
sands of people. From June first until October Bud
was most of the time in the hospital. It was the first
of November when he took the train for his first engage-
ment in Boston. He stopped off in Chicago, and on
Sunday afternoon, in the First Church of the Nazarene,
made his first attempt to tell an audience about his hos-
pital experience.

In Boston he joined up with his old companions,
C. W. Ruth, Will H. Huff and Kenneth and Eunice Wells
for a series of conventions in Cambridge, Lowell, and
on south and west—on to Lansing; Indianapolis; Den-
ver; Tacoma; Portland; San Francisco; Los Angeles; San
Diego; Long Beach; and then back across the southern
way to Newton, Kansas; Oklahoma City; Emporia; De-
catur, Illinois; Louisville; and Indianapolis again. It
was just a round as some members of that party, in-
cluding Bud Robinson, had made a number of times be-
fore, and it was these short conventions that made Bud
Robinson's name a household word wherever lovers of
the work of full salvation are found.

In between the camp meetings, conventions and
special meetings of the large tours were numerous little
side trips for extra preaching. They were fruitful years.
Bud Robinson never put a premium on numbers, but

it is supposed that more than a hundred thousand people sought the Lord for justification or for sanctification in meetings in which he preached. He was all the more busy because there began to be a feeling with many that he would not be able to continue much longer, so they wanted him to be sure to come this time. Bud's own way was to say, "Everybody wants me to take a long rest—just after I come for a meeting with them."

## "IN LABORS ABUNDANT"

"At the close of the General Assembly—"

This great quadrennial gathering of the Church of the Nazarene of which Bud Robinson had been a member since 1908 marks the epochs of his life. At the time of the Assembly in 1923 he was past sixty-three years of age, and his accident with the automobile aged him faster than the years otherwise would have done. Nevertheless, he was able to preach and was the idol of the people.

As far back as the Assembly of 1911 in Nashville, Tennessee, Bud Robinson was to preach in the Sunday afternoon service. Things had been a little strained in the convention. When Bud got up, he told about his desire to be something for the Lord. He said he looked at the Lord's fine gospel chariot and longed to be the horses or the harness or some essential part of the chariot itself. But the Lord did not seem to need him for any of these places, and it looked like he was going to be left out. And so, finally, he cried, "O Lord, let me be the axle grease to make the chariot run smoothly." And the Lord said, "All right, Buddie, you may be the axle grease." The following week there were many candidates for the place of axle grease, and the chariot of the General Assembly ran with less friction.

During the 1923 Assembly in Kansas City the question of changing the name of the *Herald of Holiness*

came up. When the Church of the Nazarene founded its Publishing House at Kansas City in 1912 and chose C. J. Kinne for the first manager and Dr. Haynes for the first editor of the official organ, it was decided to call the paper the *Herald of Holiness*. For some months leading up to the General Assembly of 1923 there had been agitation in favor of changing this name to one that would contain the word "Nazarene" so that the paper and the church it represented would be identified in the minds of people generally. The idea seemed to have merit, and there was considerable expectation that the change might indeed be put into effect.

G. B. Collins, a layman and a long-time friend of Bud Robinson, was enthusiastically in favor of the change; when he presented the matter to Bud Robinson in private, Bud seemed to agree with him. Brother Collins was confident that the change would take place. When the debate came to the floor of the Assembly, however, opposers of the idea argued that to take the word "holiness" down from the banner of our church paper was an indication to the world that we were weakening on our holiness emphasis. Although champions of the change thought they answered very well, Bud Robinson could not follow through on anything that looked like retreat—he had been on the militant offensive too long. He arose to say, "I thought I was in favor of this change in the name of our church paper. But if anyone is likely to think that this change in name indicates a loss of emphasis on the doctrine and experience of holiness, then I am against it. Let's keep the

name, 'Herald of Holiness,' and all go out from here to boost the paper and take subscriptions for it. I will agree to get 1,000 subscriptions for the paper every year myself for the next four years, and I will get them for the *Herald of Holiness*." Evangelist Jarrette Aycock joined in with Bud by agreeing to get 1,000 subscriptions a year also; and the motion, put in the midst of a tremendous spirit of good will, such as Bud Robinson could inspire, was lost by an overwhelming majority. The subject has never been up for serious consideration since that time. *AMEN!*

Speaking of his relationship to the Church of the Nazarene, Bud was likely to add his own name to the list of General Superintendents, and explain to the people that the other General Superintendents had to be elected by the General Assembly, but that he was appointed, having just appointed himself. The Church of the Nazarene became a denomination in 1908, and it is likely that Bud Robinson did more to publicize in a favorable manner this church of his choice than any other one man who has been connected with it during its history. And yet Bud Robinson was never a narrow sectarian. The gospel of Christ was his one great theme, and he was so sure of his thesis of full salvation that he could be liberal even with those who did not agree with him. He was always loyal to what he learned from the Salvation Army, "A man may be down, but is never out."

For a good many months during the period after 1923 Professor L. C. Messer traveled with Bud Robin-

son, and the great evangelist never had a more faithful colaborer. Messer took the responsibility of keeping the car in order and driving it to the various destinations. He led the singing, and took over much of the preliminary part of the services, when there was not a regular director of the services. In addition to all this, he took special personal care of Bud Robinson, seeing that he got his rest, proper food and comfortable surroundings.

From 1923 on "Uncle Buddie" had taken on something of the status of an "institution." It was not altogether his preaching or even what he could do other than preach; it was just Bud Robinson himself. After the Assembly, he left to make a tour of one day and one service conventions with District Superintendent Chalfant on the Chicago Central District. By this time his influence was far too wide to be absorbed by Nazarenes alone. Everywhere he went Methodists, Mennonites, Quakers, Evangelicals and people of many churches gathered to see and hear him, and all were liberal in their support of whatever agency brought him within their reach. The habit of having "Bud Robinson Tours" was taken up by District Superintendents, promoters of colleges, missionary interests and others. Everywhere it was the same—the promoters could always be assured of crowds, if they could get Bud Robinson. Churches that might be lukewarm on the particular project being promoted would agree to a presentation—if "you will bring Bud Robinson." Then the promoters could present their project, raise money for vari-

ous purposes, sell books, make announcements and otherwise occupy the time, but the people would wait, and Bud Robinson would not become nervous. He often got up at an hour so late that the people could well have expected the meeting to close, and then go on preaching for an hour; no one would leave until he quit speaking. Sometimes Bud was tired in mind as well as in body, and at such times he was likely to be tedious. Nevertheless, there was always the possibility that there would be a flash of his old light and fire and wit, and people waited for that to come.

For almost two generations it has been the habit of preachers to quote Bud Robinson. There is no better way to awaken interest than to be able to say, "As Bud Robinson has said—" Usually the quotations are quaint, sometimes they are witty, but always they are apt, and serve to let in more light on a subject than the ordinary preacher can command in fifteen minutes of argument.

Bud Robinson estimated that he traveled two million miles during his lifetime, that he preached 33,000 times and that he saw 100,000 people seek the Lord in the meetings where he preached. It is known that he sent in over 53,000 subscriptions for the *Herald of Holiness*, the official organ of his church, during the period 1923-1942. Surely he was like Paul in that he was "In labors abundant"—or as Paul put it in the comparative sense, "In labors more abundant."

There is something very human and yet very beautiful in the picture we catch, after Bud Robinson's trip

to the Holy Land, of the beloved old gospel preacher sitting on the curb of Jacob's well in Sychar, where his Master once sat and talked with the sinful woman; or weeping in the Garden of Gethsemane where Jesus lay prone sweating bloody sweat; or standing before the ruins of the house of Martha and Mary in Bethany, near the tomb of Lazarus whose story Bud Robinson loved to preach about.

Bud Robinson is credited with two million miles of travel—even John Wesley's books record only two hundred seventy-five thousand. His journeys took him up and down and all around over the forty-eight states of our country and most of the provinces of Canada, until it is impossible to keep the web of travel chronologically straight. Yet there was still one journey that Bud Robinson, like most Christians, longed to make; and that was a visit to the land made sacred by the footprints of the Master whose he was and whom he served. He talked much of his proposed visit to Palestine, and more than once made fairly definite plans for the journey, only to find the sailing date had to be postponed.

Finally, in February, 1934, in company with Dr. J. T. Upchurch of Arlington, Texas, Rev. Julius Himes, and Dr. G. Frederick Owen and wife, now of Golden, Colorado, he sailed from New York for the Holy Land. Dr. Owen had been in Palestine twice before, and many hours of the sea voyage were pleasantly occupied with lectures and talks by Dr. Owen on the places they were soon to see. The ship stopped at the usual places in North Africa, and there Bud Robinson got his first

glimpse of real "foreign" life. It was ever afterward an amusing and interesting experience to hear him tell of the weaver who could manipulate his loom with hands and feet and produce such splendid results with such crude equipment. Bud was deeply impressed by the immensity of the pyramids. After his visit to Egypt he liked to recite from memory the area covered by the base of the great pyramid, the size of the stones, the height of the pile itself, and the estimated weight.

In Palestine Bud Robinson was more at home than many well educated people would be. His intimate knowledge of the Bible gave him an idea of the importance of places in Bible lands. He was not really interested in archeology; he just wanted to walk where his Master walked and to sit where his Master sat. Any place connected with the life of Jesus was to him a shrine, and there he could sit and meditate, kneel and pray, weep and laugh. All his telling about the places he visited was rich with accounts of his own inner feelings toward them so that the impression on listeners was that of a sermon, and not a mere lecture or travelogue. Many were the people who were drawn to church to hear Bud Robinson speak on his journey to Palestine and went away realizing, when the meeting was over, that they had been to hear an evangelist and soul winner.

When Bud Robinson talked about Palestine, he made that ancient land live again in the minds and imaginations of the people. He would tell of their approach to a certain place, what impressed them particu-

larly, how they read their Bibles on the spot, who prayed and how their souls were blessed and refreshed as they thought of the things that occurred there in the time of Christ or during the history of Israel. All his references were made with the ease of an expert. His mind was a veritable storehouse of facts and figures, and with a wave of the hand he could indicate directions and relative positions, and the crowds felt that they were almost seeing the places themselves.

Bud was no critic, and troubled himself not in the least about the debates of the specialists; instead his mind and heart were fired anew because of the evidences of the authenticity of his Bible which he found in the land where the Bible's principal Hero lived, died and was glorified. To Bud Robinson Palestine was a gigantic altar at which to worship and praise the true God through His Son Jesus Christ, and he made others feel the force of this appraisal. I have been to Palestine myself, having spent a number of weeks there, and yet I think Bud Robinson made the place more vital to me than even the personal visit was able to do. Under his unctuous spirit the deserts of the favored land blossomed again as the rose, and the bones of the ancients revived in the dry valleys. His tears of sympathy and joy were like rain upon the parched earth of the land of Canaan, and his eyes were like magic glasses through which ordinary mortals could look and see meanings and precious thoughts hidden in the dens and caves of the land of our Lord. Even people who knew the geography of the Holy Land well, and who might be classi-

*I'm so glad I ever knew Him personally*

fied as specialists on Bible history, were glad to hear
Bud Robinson tell his experiences in this tiny country,
sacred alike to Jew, Mohammedan and Christian.

While seeking to make us know and love Palestine
more, Bud Robinson also enabled us to know him bet-
ter and love him more. Many said, after Bud's return
from abroad, "Well, Bud Robinson may not be educated
in books, but he certainly does have an organized mind,
and he knows what to do with what he sees and hears."
It is never possible, of course, to make a complete dis-
tinction between natural endowment and acquired abili-
ty, and it is easier on the rest of us to say of men like
Bud Robinson, "Oh, God just made him that way." I
think, though, there is abundant evidence that Bud Rob-
inson purposely looked with both eyes, listened with
both ears, and built his intellectual house with the best
art he was able to command. Someone asked Bud if
he made any notes on his observations in Palestine; he
replied, "Oh no, I did not make any notes. If I had
made notes I might have lost the notes, and then I
would not have had anything. I just remembered what
I saw."

Bud Robinson came back from Palestine rested and
renewed physically, mentally and spiritually. He used
to say that his friends were all insistent that he take a
good long rest, but they all wanted the rest to begin
just after he held a meeting or convention for them. It
turned out that in all his active years he never did take
a voluntary rest. Sickness stopped him for brief peri-
ods now and then, and his terrible automobile accident

was the occasion for an enforced rest—if that could be called a rest. Such a schedule of service as Bud carried on was bound to show marks of wearing, and those who knew him best were quickest to observe these marks and to wish for something that would break into his incessant labors and give him a chance to renew himself. The trip to Palestine did just that for him.

Whatever brought revival to Bud Robinson brought revival to many others also. Bud, if he ever learned anything, immediately told someone else about it. If a new life impulse coursed through his mind and heart, he was instant to testify to it and to encourage others by it. The new illustrations which came to him by means of this visit to the Holy Land made all his preaching new. Many of us heard Bud Robinson during a period of more than forty years, and we often remarked to one another that we enjoyed hearing him tell the same stories, use the same illustrations and preach the same sermons we heard him use at the beginning. He was one man who seemed as interested in his talk the thousandth time he gave it as he was when the thought occurred to him first. It always seemed that he had the freshness of a discoverer, even when he was saying something he had said every week for the past thirty or forty years. Nevertheless, we all noticed that after his journey to Palestine he was new—not that he ever left off the old, but the old was afterward so mixed with the new that it was all fresh. Like Dr. W. B. Godbey, whom he so greatly admired, from that time on Bud Robinson talked of "the Holy Bible, the Holy Land, and

the holy experience," and he talked of these in turn, in pairs and all three at once.

One of the last manuscripts Bud Robinson prepared for the press was an account of his journey to Palestine. This he submitted to the Pentecostal Publishing Company of Louisville, Kentucky, and the booklet has appeared on the market. Both those who heard him speak about Palestine and those who missed this rare privilege will want this booklet, and all are assured of an intellectual and spiritual tonic in the reading of it.

It was a gracious providence of God that this man who sought so diligently to walk in the very footsteps of his beloved Master during a long life of consistent living should have been allowed, during a few weeks of his life, to trace those footprints in the land of Canaan. I like to think of his joy as he stood on the top of the tower that crowns the hill where his Lord stood on His last day upon earth and from which He ascended to heaven after He had given His disciples His final earthly benediction. Yes, let's leave him there; Bud would have liked us to think of him that way.

## BUD ROBINSON AS A WRITER

The first time writing was suggested to Bud Robinson he looked utterly blank. Sally Robinson used to say smilingly that he could stand up and preach, but when a piece of paper was put before him "he took stage fright" and could think of nothing to say. It was she who devised the plan of having him walk the floor and recite his experiences while she jotted down what he said. This was pretty much the manner in which *Sunshine and Smiles* and *A Pitcher of Cream,* as well, were written. They were among Bud's early books and are his most characteristic ones; beginning with the *Sunshine and Smiles* dedication—"I lovingly dedicate this book to the whole human family, to whom I am indebted for every idea expressed in it, for when I came into this world I knew nothing at all, not even the way to my mouth"—they sound just like Bud Robinson talked and include the things which made Bud Robinson famous. *Sunshine and Smiles* touches upon the high points in his life's story, and *A Pitcher of Cream* contains the "cream" of his unique sayings.

Sally Robinson also used to take pencil and paper to meetings and jot down Bud's sayings. The amusing sequel came when the writing got cold and Bud would deny saying what she had written! Much of *A Pitcher of Cream* is composed of short sermons and characteris-

tic sayings, the nucleus of which Sally took down from
her husband's public talks, afterward revised and en-
larged between them.

Once Bud caught the vision of another way to
spread the gospel, it became his habit to send reports to
the various holiness papers of the country, and his man-
ner of describing a place or a meeting or a preacher
was so entirely different that editors and publishers
were glad to give him space. *Sunshine and Smiles* was
brought out in 1902, printed in an edition of 5,000 copies
by the Texas Holiness Advocate Company at Greenville,
Texas. The next year the Christian Witness Company
of Chicago secured the copyright and brought out a
new and enlarged edition; many editions appeared and
the sale was always large—portions of the book have
even been translated into other languages, including
Chinese. Finding that writing gave him opportunity to
print the gospel as well as preach it, Bud Robinson was
found to be "easily entreated" in the matter of prepar-
ing copy for the printer.

Looking back, Bud said, "C. E. Cornell was the first
man who ever paid me for writing for a paper"; that
was the *Soul Winner*. Dr. H. C. Morrison, founder and
editor of the *Pentecostal Herald* at Louisville, Kentucky,
engaged Bud in 1904 to write a "Bud Robinson Cor-
ner" that continued for ten years in his paper. Bud
Robinson was also for a considerable time one of the
chief contributors to the *Pentecostal Advocate* while it
was printed at Peniel, Texas; and for almost twenty
years his "Good Samaritan Chats" were a weekly fea-
ture in the *Herald of Holiness*.

In 1904 appeared two booklets, *The King's Gold Mine* and *Walking with God or the Devil, Which?* and in 1906, his second sizable book, *A Pitcher of Cream;* the dedication is intriguing, for it reads, "I lovingly dedicate this book to old Jessie, the best friend we ever had, who has provided us with Jersey milk and sweet cream for lo, these many years. If there is a land of perpetual clover where Jersey cows go, may old Jessie have an abundant entrance in"! Bud Robinson's first dollar size book, "Lazarus," came out in 1909. "Mountain Peaks of the Bible" appeared in 1913 and was followed in pretty regular succession by *Honey in the Rock,* a book containing seventeen of Bud Robinson's sermons; *My Hospital Experience,* covering the story of his accident in San Francisco, and his long fight to get back on his feet again; *Bees in Clover; Nuggets of Gold; The Holy Land; My Life's Story;* and *Does the Bible Teach Divine Healing?* Altogether there have been twenty books and booklets, and there is another book or two still in manuscript form.

Just a few years ago, Dr. J. W. Montgomery, a man always alert to use any and every means for publishing the gospel, had Bud Robinson record a few of his brief talks on master records. This work of recording was really quite a task for Bud, but in days to come many will rejoice over the privilege of hearing that familiar voice which, for more than half a century—sixty-two years, was so constantly used to blow the gospel trumpet.

After the *Pitcher of Cream* Bud was able to dictate to a stenographer or to write on his own typewriter,

and he continued to use one or the other of these two methods to the close of his life. He finally gained the necessary freedom and confidence to prepare his copy and send it on to the editors without assistance, but he was always utterly indifferent to spelling and punctuation; however, the editors were so glad to get his material that they never complained of the extra work involved in getting it ready for printing.

I have never heard that the literary critics cared much for Bud Robinson. Speaking strictly from the approach of material, it is true that Bud Robinson was very limited; books like *Lazarus, Mountain Peaks of the Bible* and *Bees in Clover* were just printed editions of his preaching material. Bud knew this, and he wanted it that way, for he was first and last the preacher and evangelist, a soul winner and a soul saver. It happened that he was a great entertainer, but that was incidental —a by-product of Bud's way of saying things.

In spite of the critics' disregard, the common people like Bud Robinson's books just as they love Bud Robinson. His books have reached an aggregate circulation of more than half a million copies. No doubt there are multitudes of people now living and yet to be born who will read Bud Robinson's books and be blessed in their reading.

That is all Bud Robinson desired, so surely "he being dead yet speaketh."

CHAPTER EIGHT

## AT THE RIVER'S CROSSING

Bud Robinson wrote, on July 29, 1942, that he had been to church only five times in eight months. These months of waiting for the ferryman must have been somewhat trying, but in the same letter he remarked that the people had been kind in coming to see him, and that he did so enjoy their visits. During August the great evangelist's health improved enough that he was able to be present for one service almost every day of the Pasadena Camp Meeting. One morning he had a group of the camp meeting workers along with his daughters and grandchildren down to his house for breakfast. He was exceedingly cheerful, proving himself, as always, a peerless host and showing us about the house with a warm interest.

Just slightly more than a week after that breakfast, on September 8, Bud Robinson became seriously ill and was never out of his house again until he went to "the house of many mansions" on November 2, 1942. Most of the sketches of these seven weeks of waiting at the river's crossing, furnished by friends and loved ones who were near during the last days, are reprinted from the Memorial Number of the *Herald of Holiness*.

For many years Bud Robinson contributed a feature known as "Good Samaritan Chats" to the *Herald of Holiness*. The last of these "Chats," which appeared

October 12, 1942, began as always, "Beloved Samaritans," and then went on:

"The reader will remember that St. Paul said in Second Corinthians chapter thirteen, verse eleven, 'Finally, brethren, farewell. Be perfect, be of good comfort, be of one mind, live in peace; and the God of love and peace shall be with you.' There are enough B's in this one verse to make honey enough to spread honey an inch thick on every man's biscuits in the United States.

"Notice that he said, 'Be perfect,' then he said, 'Be of good comfort, be of one mind, live in peace; and the God of love and peace shall be with you.' I do not believe the apostle meant that a man could be perfect physically in this world, and I do not believe he meant he could be absolutely perfect mentally, for in the fall of man we went down mentally, physically and spiritually. I believe the new birth and the baptism with the Holy Spirit will do a great deal for your mind and for your body, but I think a man could get to heaven with a weak body, and with an untrained mind, but he could not go to heaven full of sin. So the great work of the atonement—while it is threefold—spirit, soul and body, is to cleanse and purify the nature and fill the man with perfect love and enable him to live a clean, consecrated Christian gentleman right here on this planet.

"After traveling more than two million miles I have met with multiplied thousands of people who, while they had a weak body and a mind which was not in good state of cultivation, yet they enjoyed a Christian

experience that gave them victory over the world, the flesh and the devil. I have met people who were blind who enjoyed perfect love; I have met those who were deaf who enjoyed perfect love, and I have met those who were crippled and deformed who enjoyed perfect love; so the greatest thing in the world is perfect love or Christian perfection.

"Now the second B is, 'Be of good comfort,' and there is no man who can be of good comfort if he does not have the abiding Comforter.

"The third B is, 'Be of one mind,' and the only way in the world to be of one mind is to get rid of the carnal mind, leaving the mind of Christ to rule and reign in your life.

"Also, the scripture says, 'Live in peace.' The reader will remember another text of scripture which states, 'And the peace of God, which passeth all understanding, shall keep your hearts and minds through Christ Jesus,' and another great text on peace is, 'Great peace have they which love thy law: and nothing shall offend them.' So a man can live in this world, in spite of the devil and difficulties and surrounding circumstances in such harmony with God the Father and God the Son and God the Holy Ghost, that the devil will be unable to rob that man of his peace. He may be peeled and scaled and blistered by the devil, but if he has the peace of God that passes all understanding, as Brother Will Huff used to say, he can walk right down through the tar buckets of hell, and the devil cannot throw tar on his white robe.

"But he adds in another verse, 'And the God of peace shall be with you.' The reader will notice that there is enough gospel in this one verse to save the United States, and one verse of scripture, rightly understood, will convince any man in the world that the Bible is an inspired Book. In spite of the devil and unbelievers, Jesus Christ is the only being who ever walked this planet who actually could say, 'Come unto me, all ye that labour and are heavy laden, and I will give you rest.'

"Japan has no peace to offer to the world. Germany has no peace to offer to the world. Italy has no peace to offer to the world. The Church of Jesus Christ is the only institution known to God, men or devils, that can offer a peace that passeth understanding. And I am so glad that we found it out. The greatest thing in the world is to know God, and the reader will remember that John says (17: 3), 'And this is life eternal, that they might know thee the only true God, and Jesus Christ, whom thou hast sent.' To know God the Father, and to know God the Son, and to know God the Holy Ghost, and to believe every word of the Bible, from the word 'In' in the Book of Genesis, to the word 'Amen' in the Book of Revelation, is to be a multimillionaire.

"May Heaven smile on the Good Samaritans.
                    *"In love,*
                              "UNCLE BUD."

When the doctor was called to see Uncle Bud the day he was taken ill, he told the members of the family that there was little he could do, but that he would do what was possible to make the patient comfortable.

Those who were permitted to visit the sickroom came away with wet eyes and tender hearts, feeling that they had been at the bedside of a saint who would soon be at the throne-side of his blessed Lord.

Nurse Rilla M. Chapman testifies as follows:

"It was my privilege to be one of Rev. Bud Robinson's nurses. Uncle Buddie was truly a man of God; a marvelous example of patience, amid intense physical suffering, never complaining. At first he desired to be healed in order to keep on preaching; finally with no encouraging signs, he turned his prayer to asking God, if it was His will to take him to heaven, and to please let it be soon, and then he turned his mind to thinking of heaven. He would say, 'Think of heaven, and all who are waiting for us.'

"One day he said, 'Nursie, the chariot is coming soon, and I want you to be here when it comes.' Many times we felt drawn nearer to heaven as we sang and prayed together, and especially when he commenced to say, 'I am on the banks of the river, the River of Life.'

"What a wonderful Savior we have to fit us up for heaven, then we can truly ask, 'O death, where is thy sting? O grave, where is thy victory?' For the gift of God is eternal life."

Nurse Laura R. Patten says:

"It was a great privilege to have been with Uncle Bud Robinson in his last days. God was magnified in him, and I felt the presence of the Divine ever around him. In his deep suffering one day he lay back on his pillow as if he were crossing the border, as he did many

times. There he communed with the Lord, sweet peace came to him, and his pain was eased and he had rest, and his face was beautiful. The Ninety-first Psalm ever was in my mind: 'He that dwelleth in the secret place of the most High shall abide under the shadow of the Almighty. . . . With long life will I satisfy him, and show him my salvation.' We give thanks unto God for such a person as Uncle Bud Robinson, for I feel that my life has been enriched through this contact with him."

Rev. George C. Wise, son-in-law of Bud Robinson, whose "Intimate Appraisal" constitutes one of the features of this book, wrote the obituary and gave an account of the funeral. There were statements of tribute and sympathy from men and women all over America; a few of these were read at the funeral, and some of them were printed in the Memorial Number of the *Herald of Holiness*. All expressed sincere love, and all agreed that we shall not see his like again until we see him on the "evergreen shores" of heaven.

The obituary and the account of the funeral service are reprinted from the *Herald of Holiness*:

### Obituary

"It was a cold wintry day, January 27, 1860, which marked the beginning of a life equipped only with 'a bundle of tendencies,' and placed amid an environment adverse to hopeful anticipation. Civilization had not come to the mountain regions of Tennessee. In one sense, life was simple: A log cabin on the mountain side; small clearings for cultivation; crude implements in comparison with modern times; sparkling springs and rip-

pling brooks; no schools and no churches. Such was the beginning of the life of Bud Robinson.

"When but five years old, his father, Immanuel Robinson, and his mother, Martha Jane Robinson, moved to the state of Mississippi, where one unfortunate event led to another during the four years spent in this part of the country. In 1869, with a few household goods on the wagon, pulled by a little yoke of oxen, a big tar gourd full of tar swung from the coupling pole of the wagon, his father and mother and seven other children, besides himself, left the swamps of Mississippi and started back to the mountains of Tennessee.

"In 1876, after the death of his father, his mother sold what little they had and moved to Texas. They settled in Dallas County, near Lancaster. After an endeavor as a share-cropper, which did not pan out any too well, Buddie, as he was called, hired out to a man on an adjacent ranch and worked for three years.

"It was while employed on this ranch that the old circuit rider, a Methodist preacher, spent the night at the ranch and upon another occasion spent several days. These were disturbing times, completely upsetting the practices and customs of the ranchers.

"It was in August of 1880 that plans were completed and arrangements made for a camp meeting in the community near the ranch. Mrs. Martha Robinson planned to go and arranged to take Buddie with her. It was on the eleventh day of August that the Lord was able to reach his heart with conviction, and about eleven o'clock that night he was gloriously saved.

"That same night, while lying under the wagon with his hat on a mesquite stump for a pillow, the Lord called him to preach. He had no education, he stuttered so badly that he could hardly tell his name, yet the first year of his ministry saw about three hundred converted in his meetings. The first four years that he preached the people gave him $16.00, which would make $4.00 a year for his services.

"January 10, 1893, he was married to Miss Sallie Harper at Georgetown, Texas. For two years he served the Hubbard circuit, but the remaining sixty years of his ministry were given to evangelism.

"He traveled over 2,000,000 miles.

"He preached over 33,000 times.

"He saw more than 100,000 souls at his altars.

"He spent around $85,000 in helping young people with their education.

"He secured over 53,000 subscriptions to his church paper, the *Herald of Holiness.*

"He wrote fourteen books and sold more than a half million.

"In spite of his handicaps of physical ailments, lack of education and speech impediment he was able to make *Who's Who* in California.

"For a number of years 'Uncle Bud' was a member of the Bresee Avenue Church, located just a block from his home. He enjoyed the fellowship of the good people and was loved and respected by all. His life was one of great activity. His will to his dying hour was to live and to do. He would say, 'Why, I am only eighty-

two, my brother lived to be ninety-six. It seems that I have done nothing at all. I have not touched the borders of what could be done.'

"On September 8, 1942, he was taken seriously ill. For eight long weeks he suffered intensely. At 8: 53 Monday night, November 2, he bade farewell to all that is mortal and entered the realm of the eternal. His last Chat in the *Herald* was significant of his home-going. He centered his comments around that verse in Second Corinthians 13: 11, 'Finally, brethren, farewell. Be perfect, be of good comfort, be of one mind, live in peace; and the God of love and peace shall be with you."

"He is survived by two daughters: Mrs. Sallie Welch of Delano, California, and Mrs. Ruby Wise, of Pasadena; fourteen grandchildren and two great-grand-children; two sisters, Mrs. Mollie Dean of Pasadena, and Mrs. Carrie King of Hubbard, Texas."

## Funeral Service

"Thursday, November 5, people began to stream into Pasadena, California, from the four corners of the district. The body of Uncle Bud Robinson was to lie in state at the Bresee Avenue Church of the Nazarene of which he was a member. The time was from twelve to one o'clock, but before the doors were open the people had already begun to come that they might have a last glimpse of the 'best loved man in America.' Dean Hildie of Pasadena College played softly many of the old hymns of all churches.

"At two o'clock the service was scheduled to begin. The great church was filled to its utmost capacity. There

were many sprays of gorgeous flowers brought in and
wired from over the nation.    On the huge platform ev-
ery available chair was filled by ministers.    Mrs. J. Rus-
sell Gardner played several of the old songs especially
loved by 'Uncle Bud.'    The Girls' Trio from Pasadena
College, sang so beautifully, 'Zion's Hill.'    Dr. H. Orton
Wiley, president of Pasadena College, read the thirty-
fifth chapter of Isaiah.    Dr. J. W. Goodwin, General Su-
perintendent Emeritus, prayed.    Dr. A. E. Sanner, Su-
perintendent of the Southern California District, read
a few of the many telegrams, and spoke briefly of the
life and influence of 'Uncle Bud' throughout the nation
and the world.    Dr. J. Russell Gardner, pastor of the
Bresee Avenue Church, reviewed the life of 'Uncle Bud'
and made some brief remarks of his last visits with him.
Rev. Joseph Ransom, assistant pastor to Dr. Gardner
and music director at the church, sang 'Amazing Grace.'

"Dr. Henry B. Wallin, pastor of the First Church of
the Nazarene at Long Beach, preached the main ser-
mon, using for his text the words of Jonathan to David:
'Tomorrow—thou shalt be missed.'    Dr. Wallin empha-
sized the place that 'Uncle Bud' had filled in his world
ministry; that he would be missed in every department
of the church, and by multiplied thousands of friends.

"For more than forty-five minutes almost a thou-
sand people filed by to see and to pay their last respects
to the man who was everybody's friend.    Here were el-
derly people, middle-aged people, young people and chil-
dren in their mother's arms.    Here were educators and
here were students.    Here were people from various na-

tionalities and from many denominations. All of them felt that 'Uncle Bud' was theirs, and he was. Approximately one hundred ministers were in attendance, most of whom served as honorary pallbearers. Those serving as active pallbearers were: Revs. Ralph Hertenstein, V. P. Drake, L. D. Meggers, Lloyd Byron, John Mandtler, and Russell C. Gray.

"The committal service was conducted by Dr. Orval J. Nease, General Superintendent. At the Mountain View Cemetery, where the interment was made, a group of singers from the church and school had preceded the procession and were singing while the families and friends were gathering. Thus another soldier has fallen from our ranks, and he shall be missed."

## AN INTIMATE APPRAISAL

### By George C. Wise

(Rev. George C. Wise is a son-in-law of Bud Robinson, having married Ruby Robinson, second daughter of "Bud" and "Miss Sally." This appraisal by a member of the family—one who was for a time very closely associated with Bud Robinson—was written in answer to a very special request, and the material throws a great deal of light upon the unofficial phases of the life of our "Brother Beloved."—J. B. Chapman.)

During most of Bud's life both of his arms were out of their sockets at the shoulder, allowing him only a limited use of them—for example, he was unable to raise his arms above his head. Many years ago someone sold him on the idea of certain exercise that he adopted and practiced vigorously as long as he could be about. His habit was to waken early—usually just before the crack of dawn. Being awake, what better time would he have for his exercises than a moment like this? So he began to kick vigorously to the count of ten, first with one leg and then with the other. After twenty full counts he raised his body to a sitting position and fell back again, flat on the bed. My side of the bed, being part of the whole— Well, no, he never asked me to get up, but at the moment it always seemed

to be a rather convenient thing to do. Thus we were
off with an early start for another meeting.

During few of his eighty-two years of life could
Bud Robinson be truly said to have had good health.
There was usually anywhere from one to several ail-
ments in his body, including diabetes. He never wor-
ried much about them, though; as long as things were
no worse, according to his philosophy, his health was
good. In many places, however, were physicians in-
terested in "Uncle Bud"; out of the goodness of their
hearts, they prescribed a remedy. The very next night,
likely as not, we were in another town and emerged
armed with another prescription, vastly different from
the first. Bud Robinson, always wanting to get well,
gave each a trial. The only difficulty of the procedure
was the uncertainties centering around just which reme-
dy produced what!

Bud Robinson often said there were just three
things he would rather do: "First," he said, "I would
rather preach holiness than anything in the known
world." He meant it, too; he liked to have people
around. It was never a source of relaxation for him to
seclude himself. The more people there were, the bet-
ter he liked it. The second thing he enjoyed was riding
in an automobile. He rode literally multiplied thou-
sands of miles each year, but he never tired of it; it
was always a source of joy to him to ride some more.
Finally, he enjoyed fishing. Elaborate technique never
complicated his pleasure; he simply dropped a line into
the water and waited; and nobody got a greater thrill

than he did when the fish were attracted to his line. It
was a familiar thing to hear that Bud Robinson had
been deep sea fishing in California with the brethren,
or spent the day at the Lake of the Ozarks, or among
the lakes of Michigan and Wisconsin, or—during the
winter months—down among the lakes, fish and good
people of Florida.

One of the unusual places for Bud Robinson to be
was home. Often perhaps ten days or two weeks out
of the entire year were spent at home. For more than
sixty years he toured the United States and Canada as
few men ever did; a man who traveled two million
miles could never have done that by staying in one
place long at a time. He worked his section of the
world as thoroughly as a farmer works a piece of ground,
up one row and down the next. One way he had of
describing his busy life was, "When the rooster was
crowing, I was up, shaking the sand out of my socks,
getting ready for another run."

Once in a while, though, Bud Robinson was at
home, and then neighbors came over especially to see
him. The living room resounded with laughter, and
there was a constant rattle of conversation, heard by the
other members of the family as they were busy here
and there. Suddenly all would become very quiet; pres-
ently the front door opened and closed gently. A mysti-
fied member of the family stepped in to see what had
happened. No explanation was necessary, for there
upon the living room couch lay the host, the Rev. Bud
Robinson, fast asleep! But then, nobody expected Bud

Robinson to adhere strictly to the forms and ceremonies recorded in books on etiquette. He was not built that way. He had an individual way of doing things, as well as of describing what he saw, heard and felt. He was different from the rest of the world, and folks loved it.

Bud Robinson's ability to sleep was one of his greatest assets. When the job at hand was ended, he completely laid aside all his cares and responsibilities and went to sleep. It made no particular difference as to the time—he could sleep any time. It was of little consequence as to the place—he could sleep any place. There are scores of ministers who have traveled with him on tours for ten days, two weeks, and a few have attempted a thirty-day period. At Bud Robinson's pace more than one began to feel that a nervous breakdown was inevitable, but Bud Robinson, like "Old Man River," just "kept rolling along." People seemed to marvel at "Uncle Bud's" ability to travel hundreds of miles and arrive at the meeting fresh and able to preach well. Few knew the secret; he sat in the front seat of the car and slept by the hour.

Bud's ability to sleep had its other side, too. He liked the old-fashioned way of bedtime devotions, and it was our custom to pray before retiring. Bud always took his turn at prayer and he usually did fairly well, but when he began to pray for the public roads and the postoffice, we knew that he had gone to sleep.

Once in a while Bud Robinson used to say to me, "Son, Mother and I are getting old; I may have to leave the field any time. You may have to take care of us.

If I should buy a business, will you run it for me?" Usually I let him talk on, but one day he put the question to me squarely, "If my health breaks and I have to leave the field, we may have to go to the poor farm. I'll buy a business and you can run it for us."

"Dad," I replied, "you are welcome to live with me any time, anywhere. You and I are ministers of the gospel, however. I do not at all think that we will ever go to the poor farm, but if we do, we will go there as holiness preachers, and not as business men." We probably *would* have gone to the poor farm, too, if we had tried business, for Bud Robinson was never a business man. He invested in the copper mines, but he did not get rich; he bought property in Florida during those boom days, and after paying heavy taxes and assessments for many years, he gave the property away.

There was really no need for "Uncle Bud" to be a business man; truly, "all these things" materially *were* added unto him as he sought the kingdom of God during more than sixty years. The people gave him multiplied thousands of dollars during his latter years. Often in a single service as much as a hundred dollars came in—and he usually had more services than days.

Yet, during the years that I have known him, I do not recall his bank account's being in excess of one thousand dollars long at a time; usually it was far below that mark. To be able to give was one of the greatest pleasures Bud Robinson ever enjoyed. For many years before he died, he purposed in his heart that when he

did die, there would be no fortune for friends and relatives to quarrel over. His desire was realized, too.

Bud Robinson has been called "the best loved man in America" and "everybody's friend." The president of one of the largest banks in the West would drop whatever he was doing and talk for an hour whenever Bud Robinson came into his bank. Among his friends were state governors, college presidents, judges, bankers, physicians, merchants, preachers and laymen — great and small, young and old, black and white.

He really loved folks, from old people whom he tenderly respected to the children whom he gave pieces of money and called pet names. Sometimes it was "Old Sugar," or "Apple Blossoms," or perhaps "Peach Tree Blooms," that he called them. Whatever it was, the children felt honored to be christened by "Uncle Bud." There are many children, now grown up, who still feel, "I am the one 'Uncle Bud' called 'Old Sugar'." He often said, "I guess I am everybody's uncle!"

Somebody once interrupted Bud Robinson to ask, "Uncle Bud, how do you remember all this?" To this he replied, "Well, sister, what's the use to forget?" Early in his Christian life Bud Robinson came to the conclusion that if anything was worth your time and trouble to learn, it was equally important to remember, and he trained himself to remember. In one sense he was an uneducated man, but when he attempted a description of a condition or a situation, it was apparent that few things escaped his observation.

The memory which he possessed was not a gift straight from heaven. It was an achievement, realized largely because he applied himself; at one time he was able to quote one-fifth of the Bible from memory. He made use of his minutes, hours and days. Even up to his last illness he came to his meals and announced that he had read so many *books* in the Bible. Not a paragraph in the church papers was missed, and the morning and evening editions of the daily paper were given a thorough going over.

Besides the vast amount of Scripture memorized, he committed to memory scores of the old hymns and songs, and almost to his dying hour he was able to sing with you practically any song of your choosing. One of his greatest weapons in fighting temptations, depression and discouragement was to draw from his memory the words of some of those old hymns, and then sing his way to victory.

He trained himself to remember not only the Scriptures and the songs, but people as well. Once your name was fixed in his mind he never forgot it. His habit was to grasp your name, study your features and associate you with something related to your meeting with him or your background; the chances were that the next time you saw him, although a number of years had elapsed, he would call you by your name and tell you the year, place, day of the week and people who were there at the former meeting. Often people used to ask, "Uncle Bud, do you know me?" and they usually

got this characteristic answer, "Know you! why, I would know your hide in a tanshop!"

He liked to amuse people with his memory for details. Sometimes he would get up and tell the names of his grandchildren, giving their ages and birthdays. Somebody usually looked me up after the service and asked how many children I had and what their ages were. I could tell from the twinkle in their eyes that they were not particularly interested in knowing the birthdays of my children, but they wanted to see if I could remember as well as my father-in-law. As a matter of fact, I usually did not—I didn't need to. I knew that my children were born, I never had any difficulty knowing that when they were around, and they always told me in advance when their birthday would be.

In the fall of 1941 Bud Robinson developed angina pectoris. We could tell that Bud Robinson realized he had finally reached the summit of the "great divide," for he began to look backward at the life he had lived. Here were mountain peaks he had scaled, and out there were the valleys across which he had traveled. Patches of bright sunshine were clearly visible, checkered by shadows of canyons and clouds. To us it looked like a life of which to be proud; but what seemed so much to us from where we were, seemed so small to him from where he was. "It seems to me," he said, "that I have done nothing at all." There, he stood with no price in his hand, save the price which the Son of God had paid for the redemption of the world; with no merit, save the

merit of the shed blood—a great man, but a humble soul.

He traveled for a while longer, but it became evident as the weeks passed that he must quit the field of evangelism. Under the doctor's care he was put to bed and for several weeks was not allowed to be up. He improved, then, and during the summer of 1942 he spent but two days in bed. In August, during the Southern California District Camp Meeting, he was able to attend at least one service each day.

On September 8, 1942, he was taken seriously ill; as I sat by his bed, my mind wandered to thoughts of his long life. His travels had taken him from Old Orchard, Maine, to Los Angeles, California; from Seattle, Washington, to Key West, Florida. For more than sixty years he had gone up and down, in and out, round and round, back and forth over the nation, until his journeys traced on a map look like a fine net. Added to this personal ministry were more than 500,000 copies sold of his books, "chats" in the *Herald of Holiness* for almost twenty years, eighty-five thousand dollars invested in the lives of young people to assist them in their preparation for Christian service, and 53,038 subscriptions sent to the Publishing House for the *Herald of Holiness*. His life truly became a strong woven net with a nation-wide drag, bringing men into the kingdom of heaven.

During these last days he sometimes seemed startled at the thought of dying, and exclaimed with something of alarm in his voice, "The paper! the paper! what will

become of the paper? I had not thought of it before. If I should die, what will become of the *Herald?*" I assured him that the *Herald* was a real part of a great organization, and it would live on after we were gone. "Well," he said, "I believe the boys will carry on."

At other times he looked up and said with a smile, "Well, so we are going to heaven!" In his half-conscious moments he seemed to believe that he was traveling; when awakened to take medicine, he asked, "Where am I now? When is there a train out of here? How far is it, and where do I change for Heaven?" Most of the time he was fully conscious; often he said, "Heaven can't be far away; I must be almost there." Near the end he looked beyond us one day and said softly, "I am on the bank of the river of life."

It had been a long, long trail that began winding down the hills of Tennessee on the eve of the Civil War. Two million miles it extended to the banks of the river of life; it had taken Bud Robinson eighty-two years, nine months and six days to follow it to its end. Now, the laborer would soon be rewarded. The warrior waited silently before his Great Commander. The servant of the Most High soon would know complete liberation and eternal emancipation, freeing him from all the effects of sin. The child of God awaited his Father's embrace.

Then the pilgrimage ended, and the evening of November 2, 1942, at eight fifty-three o'clock was Bud Robinson's coronation day.

*Reading from top of page:* (1) *Wedding picture taken in 1893;* (2) *family group taken in 1905 or 1906;* (3) *Uncle Bud and Miss Sallie taken in 1922;* (4) *Mrs. George C. Wise (Ruby), Bud Robinson, Mrs. Robinson, Mrs. W. A. Welch (Sallie).*

# BUD ROBINSON

## Lon Woodrum

He was a funny sort of fellow,
  Said he came from Tennessee—
Shirt was busted at the elbows,
  And his trousers at the knee!
Ran into a gospel meeting
  Somewhere down Texas way,
Heard a preacher preaching
  About the Judgment Day!

Don't know who was preaching—
  Some nameless son of God!
Don't know about his converts—
  Except the one called "Uncle Bud"!
But if in all his fishing
  He never caught another one,
He sure did land a whopper
  In this Bud Robinson!

Bud couldn't read the Bible,
  Couldn't write his name—
But he outwrote the bishops,
  And preached his way to fame!
Wherever English language
  Is spoken or is read
The preachers will be saying
  The things that Bud has said!

Bring in your biggest skeptic,
  Bent with heavy study,
Against their arguments
  I'll stand our Uncle Buddie!
I'll show the road he traveled,
  Winning souls in North and South—
I'll take the shining record
  And shut the cynic's mouth!

Now Bud is gone some place—
  Of course we all know where!
It'll be a place of holiness—
  And Jesus will be there!
They'll sing "Holiness forever!"
  Till they shake the highest dome—
There's holiness in heaven—
  So old Bud will be at home!

# UNCLE BUD ROBINSON

## By Raymond Browning

The people of this land ne'er saw a person half so quaint
As Uncle Bud Robinson, our weeping, smiling saint.
He weeps a bit and laughs awhile, then says some
searching thing
As keen as any surgeon's knife yet never leaves a sting.
A log house in the Cumberlands of eastern Tennessee
Is where his boyhood days were spent in direst poverty
And when his drinking father died and friends laid him
to rest
That mountain widow took her brood of children and
moved West.
Far out upon the Texas plains where life was hard and
rough
Our Bud grew up a cowboy and the toughest of the
tough.
You've heard him tell how he was dressed when first
he sought the light,
Trousers and shirt, pistol and boots, ready to swear and
fight.
But God had sent across those plains one of His brave
good men,
A circuit rider who would beard the lion in his den.
And where he found those reckless men out on the wild
frontier
Like Christ's ambassador he stood and bade them come
and hear.
'Twas such a man that Buddie heard, poor, crude, un-
lettered boy.

I've heard him tell the story and have wept then
    laughed with joy.
Bud said, "That preacher preached on hell until I
    feared its woe
And then he preached on heaven until I surely longed
    to go."
Down in the altar straw he fell and stammered out a
    prayer
Then heaven broke upon his soul and Jesus met him
    there;
And such a miracle of grace this world has seldom
    known
For not a letter did he know and he a man full grown.
But after work of day was done out on the moonlit plain
He learned to read his Bible first and through and
    through again
He read that Book, devoured it, until his memory
Was stored with truth. His mind became a royal treas-
    ury,
And when that lisping tongue turned loose in sermon,
    speech or prayer,
His sayings and his epigrams were jewels rich and rare.
The Methodists were cautious when he asked the right
    to preach.
The licensing committee listened to his uncouth speech
And one good sympathetic soul said, "Don't turn Bud
    away.
He hasn't sense enough to use the license anyway.
He cannot hurt the church a bit and may be 'twould be
    wrong

If we should not encourage him.  Let's help the boy
    along."
Another said, "Some kind of test must show in our re-
    port.
Let's ask some simple questions and be sure to make
    them short."
One said, "Buddie, tell us have you studied Geography?"

"I didn't know there's such a thing," said Bud, "it's
    news to me."
"Now, what's the longest river in the world? of course
    you've heard?"
"River of life," came the reply, "I've read that in the
    Word."
"And what's the highest mountain peak?"   (This ques-
    tion was the last.)
"Mount Zion," came the answer—and the brethren said
    he passed.

Some years went by.  There came a time when Bud
    was sanctified.
Then camp meeting was all aglow and as the rising tide
Swept sinners to salvation and saved ones to second
    grace
Our preacher hungered after God and wore a troubled
    face.
He knew he had been brightly saved and yet within
    his breast
The carnal mind would stir and rage and would not let
    him rest.

He sought the blessing, prayed for peace, yet still the
    fight went on
Until next day when in the field he prayed while thin-
    ning corn—
But let him tell the story in his ever-thrilling way
Of what took place in that cornfield that memorable day,
"All of a sudden tassels on the corn were turned to gold
And Jesus in His chariot through that old cornfield
    rolled.
His great hand took out of my heart the last remains of
    sin
And flung them into Adam's grave and then the joy
    came in—
A hogshead full of honey in my soul and, don't forget,
There's just a lot of beehives that I haven't robbed as
    yet."

No matter where this preacher went he set the folks
    on fire.
The crowds turned out to hear him preach.  He stirred
    the devil's ire.
Among the Texas Methodists there was a mighty host
Who little knew of Wesley and less of the Holy Ghost.
Some ministers of carnal mind and much of worldly
    pride
Had fits and spells and nearly died when folks got sanc-
    tified.
Of course they knew 'twas in their creed and so they
    kept professing.

That they "believed in holiness but not a second bless-
    ing."
Now to the simple trusting souls this matter seems quite
    plain
That the "first blessing" is that grace by which we're
    born again
And then the Holy Ghost must come to cleanse from
    inbred sin.
This is that "second blessing" when the Spirit dwells
    within.
However these blind leaders called poor Buddie to their
    court
And tried him for such heresy and made proceedings
    short.
They took his license, turned him out, their Pilate-hands
    washed clean
And that is why Bud Robinson became a Nazarene.

He's met the beasts of Ephesus and never lost a fight
For years he's buffeted the storms and now the port's
    in sight.
He's nearing threescore years and ten and still he
    preaches on.
We'll never see his like again when this brave soul is
    gone.
Young men and women clothed and fed from his own
    meager store
And trained in school to teach and preach have gone to
    foreign shore.

The sun ne'er sets on these his wards who number sixty-
   three,
And preach salvation from all sin with holy liberty.
His books are sold by thousands and his sayings never
   fade.
When Bud got on God's altar then a genius was made.
The final word on lodges by this humble man was said.
'Twill be retold a thousand times long after he is dead.
"Some folks always follow the Lamb" (his lisp I cannot
   quote.)
"And these folks are too busy then to ever ride the
   goat."

The chariot of the Lord will come for this good man
   some day
And tens of thousands will be sad to know he's slipped
   away,
But heaven will seem nearer and my soul with glory
   fills
When I think of Buddie shouting on those everlasting
   hills.
The scars of battle will be gone, the loneliness and pain.
The tears he wept for all the lost will never come again.
No more he'll wander through the land like one who
   had no bed.
Earth's sorrow is forgotten and eternal joy's ahead;
And I can hear him saying in that concourse of the
   blest,
"I didn't save them all, dear Lord, but I have done my
   best."
                         —*Herald of Holiness*, April 10, 1929.

AMEN

## JUST ABOUT BUD ROBINSON

### BY GRACE CHAPMAN RAMQUIST

#### BUD ROBINSON'S LIFE

"Buddie had been working for the Unitarian whose wife taught him to dance and play cards—both most entrancing to a nature like Buddie's. This was after Mother had gathered her little family of ten and moved to Texas. Like other states there can be found in Texas just the kind of society one likes best, and while Buddie found the wild unsaved ones, Mother found where there was to be a camp meeting, and persuaded Buddie to go.

"There was where he tried to get a game of seven-up with the young men and couldn't; where he tried to spark the little red-headed girl and couldn't succeed at that either; where the old lady prayed for him until she prayed through to victory. The little preacher in the short coat told how Jesus loved the sinner, and the old man with white hair stood up and asked any that wanted to meet him in heaven to come up and give him their hands. Then it was Buddie decided if ever he was going to do anything religious, that was the time; and he started down the aisle. His pistol—which he had taken along to shoot some fellow with, if he fooled with him, felt as if it weighed as much as a mule, and his deck of cards in the other pocket felt as heavy as a bale of cotton.

"When they said, 'Fix a seat for this young man, he's mighty deeply struck,' he could not have sat in a rocking chair; but fell across the split-log mourner's bench on his face. Someone turned him over on his back, and he screamed until you could have heard him a quarter of a mile. He felt like he was over hell on a broken rail. Mother heard them praying and screaming, and knew by her feelings that it was Buddie. Then the light of heaven broke in on his soul, and he began to climb the benches and tell folks he had religion; though he had never had any before and had seen very little, but he recognized it when he got it. That night he lay awake under his wagon, too happy to sleep, while all the stars came out on dress parade and danced together.

"The Lord came to him there, and asked him if he would preach the gospel, and of course he was glad to do anything the Lord said. The Lord seemed very near and beautiful, and folks were just a shining throng that served him; so to Buddie, just converted, lying on the bed under the wagon, preaching for the Lord was easy.

"Buddie went to conference, and when the time came, they sent him out and discussed his case, and decided they couldn't license him. But one man got up and befriended him. He said that while he knew that he was sick and afflicted; yet the little fellow might be discouraged, and couldn't do any harm with the license; so they decided to grant him license. He took it home, the happiest boy that ever had license to preach. Moth-

er read it to him, and he used it. He drummed his own crowd, and preached in schoolhouses, private houses, brush arbors, anywhere, so that the gospel be preached.

"Then under the life and preaching of Ben Cassaway he was convicted for a holy life and heart. One night Buddie preached on 'Holiness,' and with a friend had gone to the altar on his own altar call. The next morning he was working in the cornfield, the corn was in swab tassel, and preaching to himself on the text, 'Follow peace with all men and holiness, without which no man shall see the Lord,' when the Lord came down and so filled him with glory that he fell in the fence corner. God continued to pour in the glory until the cornfield seemed full, and the corn blades shone, and he was afterward satisfied that the Lord wasted enough glory on him to save Texas. He had to ask the Lord to stop or he would 'be dead in a minute.'

"The first time I ever saw Buddie to know who he was, was in the fall of 1891. There was a meeting in the university, and he was put up to preach. His hair was long and curled at the ends; his coat was faded brown on the top of his sleeves and his shoulders, but when he raised his arms it revealed that it was striped, much the worse for wear. He had on a pink necktie, quite soiled. He had forgotten either to take it off or to tie it. He was sallow and thin.

"There had been a standstill in the meeting, but when he had finished his experience he made a call for those who wanted to meet him in heaven. There wasn't

a boy left behind of the four hundred students—they moved forward like a sea."

Thus Sally Robinson, in the book published in 1913, *Buddie and I*, tells part of Bud Robinson's story. A year and a half after she first saw him in the university prayer meeting, on January 10, 1893, they were married. Both of them were so weak and sickly that folks predicted they would starve.

Giving his own testimony, Bud Robinson said:

"When the Lord found me, there was nobody else that wanted me but the devil. No man can tell just what God can do with a human being. When He found me I was all done up in my body; not one easy day came my way; but the blessed Christ touched my soul and blotted out my life of sin. Then, bless His dear name! He touched my mind and enabled me to study His blessed Word, and made it real and plain to me. Then He touched my body and my fearful troubles disappeared; and He even touched my mouth, and my stuttering disappeared. He then touched my social standing and gave me friends all over the land."

Bud described one of his early experiences in the following words:

"One morning a number of years ago I was out of food. We had simply eaten up the last bite. After breakfast the Lord said to me, 'Harness up your ponies, hitch them to your hack and go to town.' I had nothing in town to go after, I had no money to buy anything with, and so far as I knew there was no one to see me.

"But I obeyed the Lord, hitched my ponies to the hack, drove into town, tied my ponies to the rack, and walked up and down the sidewalk and shook hands with old friends until it was almost noon.

"I was pretty hungry, didn't have a nickel; but after awhile a drunk man came down the street, so drunk that he simply walked all over the sidewalk and came staggering up and got his arms around me and said, 'I mean every word of it.' He said, 'We are going to stand by you with our money.' And I said, 'All right, George, that will be mighty nice for you boys to stand by me.' He said, 'You bet your life we are going to.'

"He ran his hand down into his pocket and took out a handful of silver dollars. He was so drunk he staggered off and nearly fell off the sidewalk, but staggered back up to me and said, 'Now this is yours; every dollar of it.' I took the money and put it in my pocket. He reached over and patted me on the shoulder and said, 'We are going to back you, old boy.' I shook hands with him and he went on down the sidewalk.

"I went into the grocery store and bought a lot of groceries and got home in time to have a good dinner.

"There was one of the clear leadings of the Lord for me to go to town. I didn't know why I was going, but God had a drunk man with a pocketful of silver for me. He had to send it to me by a drunk man. So far as I could see there was not a church member in that part of the country who lived close enough to the Lord that He could talk to him and tell him what to do. But,

thank the Lord, He can impress a drunk man to help
a preacher."

In the spring of 1912 the Robinsons sold their home
in Peniel, Texas, and moved to Pasadena, California.
Looking back, Bud said that he could name at least five
young men who had lived in their home in Peniel from
one to five years and had gone out to become college
presidents. Bud's description of the dirt-breaking for
their new home in Pasadena is very interesting:

"I have seen a few dirt-breakings for schools, or
colleges, or universities, or courthouses, but a regular
breaking for a private home was never seen by this
scribe until he held one on the ground where our new
home is to stand. We invited our pastor, Rev. Seth C.
Rees, and family, and we gathered under a large peach
tree and sang a hymn. I read the eleventh chapter of
Hebrews, and then we had some fine speeches and a
great season of prayer. As we prayed for everybody
who might come under the roof and prayed for the
contractor and every carpenter and for every plank
and nail and sack of cement and all the material that
goes into the make-up of a house, the Lord came down
upon us. We wept as we prayed and God poured out
His Spirit on us and we were blessed until I cried until
it was easier to keep on than it was to stop. I have
never been in a more refreshing, heart-melting service.
It was plain to me that the Lord was pleased with such
a dirt-breaking as we had. Fine talks were made, first
by Sister LaFontaine, and then by Brother Rees, and
then by Sister Ames, and then by Brother Ames, and

then by Miss Sally, and when the speeches were all
over we all knelt there on the sand, and the praying
began. It was like an altar service. When the prayers
were over we all gathered at the spot where the house
was to stand and each of us in the name of the Lord
threw out a shovelful of sand. After some twenty or
more of us had thrown out a shovelful of sand, we all
sang, 'Praise God from Whom All Blessings Flow.' We
left the ground feeling that we had been to God's house
to worship and that God was in His temple to own and
bless His children. Let me say that it would be a good
idea for the Nazarenes all over the United States to
never erect a building of any kind without first reading
the holy Scriptures on the ground and offering prayer
to God for His protecting care. We ought to be different
from the rest of the folks."

On the night of June 1, 1919, occurred Bud Rob-
inson's terrible automobile accident. C. E. Cornell wrote
to the *Herald of Holiness*:

"The writer with Brother Bud was engaged in hold-
ing revival meetings at San Francisco in connection with
the District Assembly. One Sunday night, after the
evening service, Bud was on his way home. In cross-
ing the street, a fast running auto going toward the ferry
was nearly upon him, and he sprang toward the center
of the car track to avoid being hit; instantly he observed
a street car going the other way would hit him, and he
sprang again to avoid the car, when an auto running
alongside the car, that he could not see, and the driver

of the auto could not see him, struck him and hurled him thirty feet. He was picked up by the police and sent to the receiving hospital. The writer was called at 1: 30 a.m., and then learned of the accident.

"We found him in much pain, but was then not aware of the extent of his injuries. He was removed to the Lane Hospital the next morning and a surgeon and another doctor called. They planned to have him examined the next morning at 7 a.m. Bud was then suffering awfully. The doctors found that his right arm was broken with a jagged break that protruded through the flesh and severed the muscle three-fourths off. They also found that his left arm was broken and in addition the ligaments under the arm broken, which made a very serious condition. They also found that his left leg was broken between the ankle and the knee, and that this was a bad break also. They operated on him and put him together with fair hopes of recovery. Through it all Bud never lost his composure, his cheerfulness, nor his faith in God. He was radiant, cheerful and trustful."

The First Church at Pasadena celebrated the fiftieth anniversary of Bud Robinson's entering the ministry, and his seventieth birthday, on January 26, 1930. There was a great crowd; the seats were taken upstairs and downstairs, and the standing room around the wall on both floors. Bud Robinson reported his part in the meeting as follows:

"After Brother Little had made a fine speech and had taken a love offering for old Bud, then it was up to

me to make good, and the thing that entertained the people much was a pair of old-fashioned leather saddle-bags which I carried down and showed them. None of them had ever seen the saddlebags of an old, early day Methodist preacher. I told them that at one time these saddlebags were my trunk and my pillow; also that they contained my suitcase; also that they contained my private library, and were my bookcase."

There is wistful longing, never to be realized in this life, in a bit that Bud Robinson wrote in 1931:

"In my life I have walked cement sidewalks and looked at brick walls and watched for the green light to come on so I could cross the street, until I am hungry to get out on a farm and be quiet and listen to the voice of God as He talks to His children when they get quiet. After the dust and smoke and hurrah and knock down and drag out and fuss and fight and look for work and expect somebody to come along and hire you, I would like to eat my own bread and drink my own milk and listen to my own calf bawl and my own hens cackle and my roosters crow, and read my own Bible and pray with my own wife and children and sleep in my own bed in my own home, a happy free man."

BUD ROBINSON AND HIS GOOD SAMARITANS

When Bud Robinson was able to write again after his hospital experience, he was especially anxious to place the *Herald of Holiness* in the hospitals and other public institutions of the country:

"Last year I spent three months in a great hospital and never heard of a religious paper being sent to any

of the people there. Some may have been sent, but I never saw or heard of them, and it has been in my mind and heart for months to do something of this kind, and now the Lord has opened the way.

"The devil will see to it that his poison is placed in the depots and hotels and public libraries, while we as a people have the best and cleanest reading matter on the face of the earth, and yet make so little effort to get the best reading matter before the dying multitudes of this poor, sin-cursed earth."

He had to call for help in his campaign to distribute the *Herald of Holiness* widely, and conceiving of his readers as his helpers in this task, he dubbed them "Good Samaritans." Thus, on May 5, 1920, began Bud Robinson's "Good Samaritan Chats," which continued for twenty years. A precious part of them were the prayers he penned for his "Good Samaritans" from time to time:

"Let every Good Samaritan memorize my daily prayer and once a day get on your knees and join me. Here it is: 'O Lord, give me a backbone as big as a sawlog and ribs like the sleepers under the church floor; put iron shoes on me and galvanized breeches and hang a wagon load of determination up in the gable-end of my soul and help me to sign the contract to fight the devil as long as I have a vision and bite him as long as I have a tooth and then gum him till I die'."

"My prayer is now that the Lord will turn a hogshead of honey over in your soul and just let it ooze out between your ribs until you will be so sweet that ev-

ery bumblebee and honeybee in the settlement will be abuzzing around your doorstep."

"Ten thousand blessings on your head; and may the Lord set the sideboards of your soul out and load you up with bread from the King's table, and as you run over the rocks and ruts of life may some of the bread jolt off for the hungry multitudes; and when you come to the marriage supper of the lamb, may there be a great crowd following your wagon."

## TRIBUTES TO BUD ROBINSON

That Bud Robinson was deeply loved and appreciated was evident from the letters, telegrams, messages and tributes that poured in at the time of his death. All praise was not reserved for his funeral, for many tributes came to him down through the years:

"Bud Robinson, one of the most remarkable men of his age, is shaking this nation, not by intellect, but by his sweet, godly spirit. It is this that makes the multitudes laugh and cry when he talks."—Rev. A. C. Smith in 1907.

"Bud Robinson is six feet of the Holy Spirit and can quote the Bible all day. What the Lord has done for that man is simply phenomenal."—J. Preston Gibson.

"Dear Bud, he loves everybody, and when he finds someone whom grace has touched and put some of the divine in, Uncle Bud loves him much."—Brother Agnew.

"We were glad to have Uncle Bud with us at Headquarters October 12th. Uncle Bud not only brings a pocketful of subscriptions to the *Herald of Holiness* each time he comes, but is always a blessing, bringing 'sunshine and smiles' to everyone."—*Herald of Holiness*, 1925.

"The paper wouldn't be complete without dear Uncle Bud Robinson's 'Good Samaritan Chats.' And the paper has no better booster than Bud Robinson with his two favorite texts, 'Holiness' and the '*Herald of Holiness*'."—*Herald of Holiness*, 1931.

### Bud Robinson Praises Preachers

There is a sermon on "The Duty of Praising People" with the text, "I praise you" (1 Corinthians 11: 2). Bud Robinson practiced this friendly duty, and was always in his own unique way saying something good about those with whom he came in contact. A few examples are:

"He is simply a nugget of gold wrapped up in silver."

"He is as good as Dr. Price's Cream Baking Powder which is advertised 99 and 99-100 per cent pure."

"It is remarkable how preachers raised in different parts of the country can get saved and sanctified, unite with the Church of the Nazarene and meet anywhere in the United States and their hearts run together like two drops of water."

"He has the softest heart and the hardest head of any man in the Church of the Nazarene."

"They are big enough to be little and at the same time they are little enough to be big and that makes a great man. I have met so many fellows that were too big to be little, and sorry to say, their next station is the scrap pile."

"He is so good that it is easy to love him."

"He is so kind that you could wipe kindness off his face with a rag."

"There are three things about his [Joseph Owen's] preaching that are wonderful, here they are: when he gets up to preach the bench on which you are sitting feels perfectly comfortable, when he has been preaching for ten minutes, the bench feels perfectly soft, and when he has preached for forty-five minutes, you forget that you are sitting on a bench at all."

## BUD ROBINSON SAID

Besides reports to various holiness papers, his "Chats" in the *Herald of Holiness*, and thirty-three thousand sermons, Bud Robinson wrote a number of books—*Honey in the Rock, Sunshine and Smiles, A Pitcher of Cream, Bees in Clover, My Hospital Experience, Nuggets of Gold, The Story of Lazarus, Mountain Peaks of the Bible, The King's Gold Mine, Walking with God, Two Sermons, Does the Bible Teach Divine Healing?* and *My Trip to the Holy Land*. Whether he wrote it or spoke it, he had a quaint, pointed way of expressing his ideas; ever since I can first remember people, and especially preachers, have been in the habit of getting the attention of their listeners by beginning, "Bud Robinson said—"

Below a few favorites are quoted, as well as some other sayings just as good, but perhaps not so well known.

"A guilty conscience is a mighty poor bedfellow. I've just got to keep Bud Robinson saved; I've got to keep company with him, travel with him, and sleep with him.

"A dying man said, 'All that I have given away, I have kept, and now have: but all that I kept I now lose'."

"The priests and rulers were busy killing heifers, and offering sacrifices, and burning incense to God. He came to town and they didn't know Him. God comes now occasionally and the people don't know He is there."

"You've got to be a sanctified man to be natural: the unsanctified man is abnormal."

"If I ask any one of you what is your favorite chapter, you will say the 23rd Psalm, 'The Lord is my Shepherd.' Well, if the Lord is your Shepherd, then you are his sheep; and if you are His sheep, He can shear you. You try to shear a goat and it will alarm the settlement. But a sheep won't bleat. Can the Lord shear you any time this year?"

"If you set your affections up yonder you won't have to move 'em."

"The justified man is a milk drinker. When he cuts his spiritual teeth, becomes sanctified, he can go to eating solid food."

"The young man said, 'Brother Robinson, I'd like to ask you a question. When you get down to pray why don't you confess your sins like Pap?'

" 'Well,' I said, 'maybe your Pap hasn't quit sinning yet.  I have'."

"The Lord doesn't know a circumstance.  Circumstances are all man-made."

"God was never guilty of giving a low standard. We get the low standard after we become backslidden."

"You may 'jew down the Jews,' 'jew down' the Gentiles, but you can't 'jew down' God.  You can't get a dollar blessing on a ninety-five cent consecration. You've got to pay down the whole dollar on the counter in order to keep the blessing."

"Any preacher is much better off to plan something big and do half of it than he would be to plan to do nothing and do it all."

"When I think of it, I can hardly stand it to think that the dear Lord would allow me to run with the people called holiness people.  It seems to me I ought to take a week's lay-off, to do nothing on earth but shout and celebrate."

"Established!  Why most people in their religion are like folks used to be on the frontier of Texas—just squatters.  And when a squatter moves you can't tell which way he is going.  He is just as liable to go backwards as forward."

"Holiness is a cube; you can turn it over as often as you choose, and it stands straight up every time."

"I had rather be good than anything I ever heard of in my life."

"The Lord Jesus can take an old, guilty sinner, and clean him out and fill him up and send him out all

in a flame of love and glory, and can put his neck under the yoke of burden, with the bow of promise under his neck, and the man can pull all day and lie down at night and not know he has been hitched up."

"Well, glory! A little faith in a big Jesus is the key that unlocks the gate and lets the lamb into the clover field where the hummingbirds hum and the honeybees make honey all the year around. A fellow in the clover up to his eyes forgets all about a yoke and a burden. In fact, in the kingdom of our Lord Jesus Christ we have found out by experience that the heavier the burden, the lighter the yoke and the higher the clover."

"The holiness folks give all they have, and then give on credit."

"You have to put weights on a man who walks with God to keep him down on this old earth at all. Enoch walked with God, up and down, and he talked to God and God talked to him. And one day God said, 'Enoch, come, go home with me and stay all night.' And Enoch said, 'Well, all right.' And he went. But he hasn't come back. You see, there hasn't been any night there yet. And if we want to see Enoch any more we'll have to go to him."

"Let every Nazarene take courage, buckle up his belt a little tighter, and lay his last nickel on the altar, and throw his hat in the air, and leap up and down because of the fact that he is in a church where he can preach holiness as straight as a gunstick, and can look for the coming of Jesus, and can shout himself hoarse

any time he gets ready, because he is saved and sancti-
fied and filled with the Holy Ghost."

"If we will use both eyes, and see a hungry world
with one and a great Savior with the other, the devil
will hear from us.  If we pray on one knee and run
on the other to bring word to the starving multitudes
that we have found Christ bigger than the devil, we
will get at least one of their ears and we will fill it so
full of the Bible and holiness that they will never get
over it in this world.  Glory to Jesus!"

"It was hot overhead, and it was hotter underfoot;
the devil put up a fight, and strange to say, he used
some of the Lord's sheep.  Of course, their wool was
short and dirty and full of cockleburs, but we had to
accept them as sheep, and so we do, and just go on with
the battle."

"We did our best to put some burrs in their wool
that will be there until shearing time."

"The most beautiful thing I ever saw was a poor
sinner coming through at the altar with tears and
prayers and laughter and shouting all mingled togeth-
er, because he had unloaded his burden and had found
Christ."

"A converted man is a baby in the cradle, and a
wholly sanctified man is a man with his breeches on and
his haversack on his back and his gun on his shoulder,
with both eyes open and saying, 'Where is the enemy?'
and not, 'How many are there?' "

"When you shear a sheep you'll get no noise and a
sack of wool.  When you shear a hog you get noise and
no wool."

"Not long ago in a city in the United States, I preached Sunday night to over seven hundred people on the 'Second Blessing.' Just four blocks away a pastor in a hundred thousand dollar church with a membership of two thousand, preached to twenty-seven people by actual count of one of the stewards."

"No finer crowd above ground; everyone of them a thoroughbred, and the one you are with last seems to be the best."

"But, O Lord, deliver us from that kind of holiness that is holiness under the brush arbor and something else behind the brick wall. Down in Coon Hollow it's 'holiness or hell,' and up on College Heights we take no stock in this green-eyed fanaticism."

"The blessing will make any young man a success at home or abroad."

"The *Herald of Holiness* is a white-winged messenger loaded to the waterline with good things for the hungry heart and life and mind."

"We can afford to fail at almost any other point, but we must have revivals."

"Here is a strange fact: the rich have so much and enjoy it so little, and the poor have so little and enjoy it so much."

"We are not even looking for a good place to slow up."

"We had folks to peddle."

"Wherever you go and find Nazarenes you find a band of the best people on earth and they are simply

pitchers of cream, and also sacks of salt and some of them would remind you of bowls of honey."

"Already a lady asked me if I had false teeth and I told her that I did not, that there was nothing false about my teeth that they were shop-made and the real thing and no make believe."

"Let us keep true and keep on fire and keep as sweet as honey, and keep level-headed, and keep the uplook and walk on our knees and pray out of our hearts and give out of our pockets and shout in the teeth of the devil and preach the Word and victory is ours."

"Do you sort of feel like the Lord has turned that hogshead of honey over in your soul, that I sometimes preach about, and that the honey itself is sort of oozing out between your ribs, and have you any of those symptoms down in the bottom of your soul that you are heaven-born, heaven-bound, heaven-thrilled, and heaven-filled, and that by the help of the Lord you are 'climbing up Zion's hill'?"

"You can't live any better on the outside than you are on the inside."

"I remember that one time when I was in a hard place the devil came up and suggested that if the people had stood by me I could have put it over, and I notified him that the man who could not take the material he had on hand and succeed with it was a failure. The man who waits for somebody else to put him across is already a flat failure. When God sends out a man he can do it."

"The year 1931 came creeping around the corner and was already here and doing business before the most of us fellows were out to see what was going on."

"Strange, the people who believe the Bible never get enough of it while the crowd who don't believe it can't stand any of it."

"It takes a big fellow to get down with the little fellow, but, sorry to say, a little fellow often thinks he is too big to get down with a fellow his size."

"I have been cleaned up and cleaned out and filled up and sent out and charged and surcharged and wound up and now I have nothing to do but just unwind and run down and shine and shout and the devil can't come around and tell me to cut it out."

"In many places over the nation now they don't like the words *second blessing,* and when we dodge the second blessing we take the backbone out of holiness and it can't stand alone. And in taking out the backbone we also at that same time extract its teeth until it can't bite. And in so doing we also take the fire out until it can't burn. You take the backbone and teeth and fire out of holiness, and you have nothing left but a beautiful, well-rounded, up-to-date, twentieth century fad. It is holiness without being holy, and that, of course, would not offend any of the worldly church members." AMEN. BUDDIE.

## INCIDENTS AND SAYINGS

The unusual qualities of mind and heart of Bud Robinson often were revealed in seemingly unimportant incidents. Upon one occasion he and "Bill" Yates, a singer of national reputation, having closed a campmeeting in Mississippi, where they had enjoyed few conveniences, and being in need of rest and good food, went to a hotel in Memphis. The hotel lobby was well filled with men, sitting, reading, or in conversation. Bud Robinson slowly approached the desk where the following conversation took place between him and the clerk: "What will a room cost us tonight in this here hotel?" "Two dollars and up," replied the clerk. "Two dollars and up whur?" came the question. The clerk, rather taken off his feet, began to explain: "You see, sir, we have inside rooms and outside rooms, some being higher than others." "Would you want an inside room?" "Shore," replied Uncle Bud, "ef we wanted to be outside we would not come in." By this time, the men reading and talking in the lobby had laid down their papers and were in convulsions of laughter. The clerk's face was red with embarrassment. Uncle Bud continued with a chuckle, "Now, brother, see here, I don't want to buy the hotel, I just want to sleep in it one night. I live down in Peniel, Texas, in a thirteen room house, and ef you will come down there to

see me, I will let you sleep in my bed, kick the foot-
board, and snore as loud as you wish, and hit won't cost
you a cent." Then he reached for his bag, chuckled
some more, and followed the bellboy to the elevator
while the clerk wiped the sweat from his brow and the
audience broke into yet louder laughter. On another
occasion he was in Little Rock, Arkansas, attending a
convention and staying in one of the prominent hotels
of the city. The first day of the convention he sat at a
table alone. Before eating, he bowed his head and of-
fered thanks "out loud." His words were inoffensive
and deeply spiritual. A business man sitting near, see-
ing and hearing him, moved over to the table and asked
permission to eat with him. At the close of the meal,
the man paid the bill, and requested the privilege of
eating with Uncle Bud three times a day as long as he
was in the city, saying he would pay for the meals just
for the fellowship and the pleasure of the conversation.

Once a highly educated man came to Uncle Bud's
room, after hearing him preach. He began the conver-
sation by saying, "I don't believe in the Bible. I don't
believe God created man. In fact, I don't believe in
God himself. I am an evolutionist. Man came from
nothing into something. This is the teaching of science,
which I believe, and I have no use for the Bible."

Uncle Bud heard the man's story, and then replied,
"You are the most brilliant, the most cultured, the best
informed man I ever met. You know more about sci-
ence and philosophy in a minute than I could learn in
a lifetime. But there is one thing I know, Doctor, that

you don't know. I was once a sinner, a slave to drink and tobacco, physically diseased, having had both my arms out of place many times from epileptic convulsions. One day I met Jesus. He healed my body. My epileptic spells passed forever. He forgave my sins, sanctified me wholly, and for many years has been my constant companion, and has never left me alone." The man looked at Uncle Bud and said, "I know nothing about the things of which you speak. I am utterly ignorant of such experiences; and, after all, perhaps you are as well informed in your line as I am in mine." Uncle Bud requested the man to kneel in prayer, and then prayed the heavens open, and this unbeliever was gloriously saved.—R. T. WILLIAMS, *General Superintendent.*

### SELECTED SAYINGS OF BUD ROBINSON

"Money is a commodity that will purchase anything in this world except happiness, and is a passport to every country except heaven."

"The first time I ever saw the ocean, I sat down and cried, and said, 'Praise the Lord! Here is one thing I have seen that there is enough of'."

"Once when I visited an ear specialist, I said, 'Doctor, I can hear perfectly well out of this ear; and I can't hear at all out of the other. What do you think is the matter?' The doctor said, 'Uncle Bud, I think the biggest trouble with your ear is just old age.' But I said, 'No, doctor, I don't agree with you at all. You see I can hear perfectly well out of my right ear, and can't

hear at all out of my left ear, and yet you know these
ears were born at exactly the same time'."

Looking at the hillside farms in North Carolina,
Bud Robinson said, "These farmers ought to make a lot
of money—they have turned their farms up on edge
and are farming both sides."—RAYMOND BROWNING.

---

After quoting John Wesley in one of his sermons
a man came up and chided Bud Robinson for being so
old-fashioned as to believe in Wesley and his doctrine
of holiness.  Uncle Bud looked at him and said, "Who
be you?  Every boy and girl in America who is eleven
years old knows who John Wesley was, but I never seen
you till just this minute."  During the last years of his
ministry his pronunciation doubtless improved, but
earlier it was so unusual as to in itself be funny.  Always
humorous, though sensible, it bothered Dr. Fowler when
the people laughed so much during Bud's sermon.  At the
camp meeting at Mooers, N. Y., years ago Dr. Fowler
preceded Bud's sermon with an exhortation not to laugh
but listen.  He gave them such a severe reprimand that
the people thought it would be almost a sin to laugh.
However, when Uncle Bud stated in his first sentence
that "Lazarus was thick," uncontrollable merriment
swept the listeners.  Even Dr. Fowler joined in the hearty
laughter.  Buddie was at our home when his daughter
Ruby was expecting her sixth child.  At family prayer
he was praying for her.  We all laughed and cried to-
gether.  He was so frank and friendly with the Lord,
telling Him about the other children, and how he want-
ed his daughter to have as many children as there were

apostles and that now No. 6 would make her half way through. I never met "Miss Ruby," as he called her that day, but am sure she must have felt that wonderful prayer. At our camp at Beacon, N. Y., he related in his sermon how it was the healthiest place he had ever been, and in all his travels had never been in a place so long without hearing of a death somewhere. He said, "I ain't even seen a dead hen since I came here." Mrs. L. A. Reed took the hint and said, "Uncle Bud, you shall have a chicken for supper."—PAUL S. HILL.

————

When I was pastor at First Church, Pasadena, Bud Robinson was a member of my church. Once when he was at home for the holidays, we announced he would speak on Sunday afternoon. Those who know southern California, know that folks do not rally for a Sunday afternoon service, especially during the holiday season. But Bud Robinson never failed to draw a crowd, even in his home town. While eating my Sunday dinner, I told my family that this service would test Uncle Bud's popularity in his home church. Before the meal was over the custodian called and said to me, "Get the ushers on their job for the house is filled now and they are going to the galleries." This was long before time for the service.

One day we were invited out together for dinner. A long platter was filled with golden brown fried chicken, everything from light to dark meat, drumsticks to gizzards, was set before us. The lady hostess, so pleased that Bud Robinson was in her home for the first time,

stood back of him and said, "What is your choice piece Uncle Bud?" He replied, "Why pick over it; ain't we goin' to eat all of it?"

He was a man who loved children, and they all loved him. When our little girl, Mavis, at the age of eleven, went to be with Jesus, Uncle Bud was unable to attend the funeral. Some months later we saw him, and when Mrs. Harding and I met him we were all crying. He put his arms around both of us and called us "Children," and said amid sobs, "children, we know where she is when the curfew blows." We received many letters and wires of words of sympathy, but the words of this mountaineer philosopher have cheered us thousands of times and we have passed them on to others passing through sorrow.

Bud Robinson always had good things to say about everyone. If he ate a meal and the lady had only fried apples, he would boost the cook and say she was the greatest cook since Eve fried apples for Adam, and her husband was a miracle worker. Once when he had spent the night with a family in Missouri, in a preacher's home where there was a large family, he bade them goodby and asked God's blessing upon the home, and then gave them the love offering he had received the evening before. Driving away he sat in silence until one of the party asked him what was wrong. He said, "Well, we will have to go back." They took him back and he gave the preacher's wife some more money and then rode away singing cheer to the rest of the party. That family of children are growing into manhood and womanhood. They are here where I am pastor, at-

tending college, but they still remember Uncle Bud's wonderful visit.

Years ago, we were walking across the camp ground together. A lady came running up to him and looking him square in the face said, "And you are Bud Robinson?" He said with a chuckle, "I pay his tax." She said, "I came five hundred miles to see you." Then she said, "You look like Jesus." He didn't swell up over this, even though it was the greatest compliment any man could receive, but he cried and wiping away the tears said, "Just pray that I will live like Him."

When with a group of his fellow ministers he was the center of attraction and entertained them with his stories. Sometimes professional men get critical of others in like professions, or of the people they serve. Immediately Uncle Bud would lose his interest and you would hear him singing "Amazing Grace" as he twiddled his thumbs. He perhaps knew more human weaknesses and sometimes even sins of the folks under discussion, but he knew it would not help them to tell it, but would hurt him.

Some of his close friends, given to impersonations, sometimes entertained their friends imitating Uncle Bud, with his quaint lisp. Even this writer they say is proficient at it. On one occasion in company with my friend of years, Rev. N. B. Herrell, for whom I was holding a meeting, said to me, "Call up Mrs. Herrell and imitate Uncle Bud and we will have a good dinner today." I did so, and when Mrs. Herrell said, "Well, Uncle Bud, what do you want for dinner?" I said, "Oh, chicken and dumplings, I guess, and some home-made ice

cream." When we got to the house, using Uncle Bud-
die's phrase, "the perfume of chicken broth pervaded
the settlement." The nice white linen table cloth was
spread and one of the boys was on the porch turning the
ice cream freezer. But I would prefer to imitate him
in his humble spirit, his forgiving heart, his optimism,
and to look only for the good in everyone. This humble
philosopher, Second Reader preacher, and author from
the Tennessee hills! He was at home with a King in his
parlor, or with a peasant in the kitchen.—U. E. HARDING,
*Pastor* College Church, Nampa, Idaho.

———

Bud Robinson and Dick Albright were great friends
and colaborers. On the face of Dick's tombstone at East
Liverpool, Ohio, is a Bible, four by four and one-half
feet in size. On the open Bible is the following:
"Thy word is a lamp unto my feet, and a light unto my
path" (Psalm 119: 105). "Mark the perfect man, and
behold the upright: for the end of that man is peace"
(Psalm 37: 37). "As for me, I will behold thy face in
righteousness: I shall be satisfied, when I awake with
thy likeness" (Psalm 17: 15). "And there shall be no
night there; and they need no candle, neither light of
the sun; for the Lord God giveth them light: and they
shall reign for ever and ever" (Revelation 22: 5). On
the back of the stone in five-inch letters is the word,
SALVATION. Uncle Bud and a few friends conduct-
ed a memorial service before this stone. Bud read the
verses given above, and said, "Bless God, that just looks
like old Dick. That is the most wonderful tombstone I
have seen in all my travels and it marks the grave of a

sanctified man." He then quoted many scriptures regarding the sanctified, and prayed as only Bud Robinson could pray. All present were deeply moved by the Holy Spirit.—O. L. BENEDUM, *Superintendent*, Akron District.

———

In a convention sponsored by the National Association for the Promotion of Holiness at Newton, Kansas, in 1920, I first met and had the privilege of hearing the noted evangelist, "Uncle Bud" Robinson. During the intervening years as pastor, evangelist and District Superintendent I have had the privilege of being quite closely associated with him, and his beautiful example of perfect love has been a blessing and benediction to my life.

One of the outstanding characteristics of "Uncle Bud" was his love and consideration for others. He loved people and they felt that he loved them. I took him to Beaumont, Texas, in January, 1939, for a ten-day revival meeting. Our church there was passing through a crisis and I felt that the ministry of this apostle of perfect love would help us in the solution of our problem. We arrived for the opening service and the worst blizzard in the history of southeast Texas was on. There were about thirty-five people in an auditorium that would seat four hundred. I was concerned as to how this man who was accustomed to speaking to packed houses would adjust himself to this situation. When I presented him to the small congregation he arose and said, "Friends, I am so happy to see you this stormy night, and I just want to say that I believe that

each one of you has more religion than I have, for if it had been announced that one of you were going to preach here tonight I think I would have stayed at home and toasted my shins by the fire. And yet all of you have come out to hear this old man preach second blessing holiness." Those words so warmed the hearts of all present that soon the tears were flowing and we felt we had already been repaid a hundredfold for our trip through the storm.

It was during the above mentioned meeting that "Uncle Bud" celebrated his eightieth birthday. We had planned a morning service and ministers and laymen from over the district were to have been present. When time arrived to start for the church Mrs. Mathis and I saw to it that he was bundled up good so he would not get cold. He had a little difficulty getting into the car. When he was finally seated he chuckled and said, "How times have changed. Sixty years ago I could get on a bronco while he bucked and bawled and now I can hardly get into a car with it standing still and the door open."—I. C. MATHIS, *Superintendent, Dallas District.*

---

Mrs. Brown asked "Uncle Bud" if he liked fried mush. He replied, "Sister, I like nothing better and get less of it." At the close of breakfast some pieces of the fried mush were left on the platter and Uncle Bud pulled the platter up to him and said, "I just can't stand that old fried mush in my sight," and he proceeded to put it out of sight.

When traveling the district with "Uncle Bud," I became quite carsick one morning as we crossed the

Rockies. Later "Uncle Bud said, "Melza Brown was the seasickest man I ever saw on dry land."

As "Uncle Bud" viewed the Rocky Mountains, he said, "Brethren, the Lord surely did some great work around here."

One of Uncle Bud's unusual characteristics was his perfect confidence in an automobile and the driver. He slept soundly as the car rolled over the Rocky Mountains, as we went up and down and around and around. Horseshoe bends and hairpin turns, grades and passes, cliffs and one-way roads were all taken by "Uncle Bud" in perfect ease. He would awaken only once in a while to praise the Lord, and immediately drop off to sleep again. At the end of the journey he would exclaim, "Wasn't that a great trip," mostly taken by sleeper for him. — MELZA H. BROWN, *Pastor,* First Church, Nampa, Idaho.

————

"Uncle Bud" was in Boston, Mass., conducting a revival in a Methodist church, and was stopping at a hotel not far away. One morning he started down the street to a restaurant for an early lunch. It was bitter cold and the snow was falling. A tall, shabbily dressed young man came up to him and said, "Mister, will you please give me a nickel. I'm hungry." "Uncle Bud" said, "I don't mind giving you a nickel, but if I do you'll walk right into that saloon and spend it for beer."

"No, I won't," answered the young man, "I'm really hungry."

"But what can you get for a nickel?" asked "Uncle Bud." "There's a cheap eating place not far from here

where I can get a bowl of soup and some bread for a nickel," he replied.

"Well, if you are hungry," said "Uncle Bud," "you just come right along to the restaurant and eat with me." When they were seated at the table "Uncle Bud" said, "How would you like to have a nice steak and some fried potatoes?"

"If you please, sir."

"And half a dozen fried eggs?"

"If you please, sir."

"And a big piece of pie and a cup of coffee?"

"If you please, sir."

Bud said, "When I saw that fellow eat I was prepared to believe what he had said about not having had anything to eat for two days."

After the meal was over he said to the young man, "Brother, at two o'clock I'll be right over yonder at that Methodist church preaching and I want you to come and hear me. Will you be there?"

The man said, "Mister, I'll sure be there if I ain't dead."

He was there all right, and listened attentively. "Uncle Bud" took him out to supper and then gave him money to pay for a bed that night. For several days he cared for him, and preached to him, and, as might be expected, the young man got saved and friends found a job for him.

When "Uncle Bud" left Boston the young man insisted on going to the train, and carrying his grip, and when the two parted the young man broke down and

cried like a child. He said, "Brother Robinson, I hate
to see you leave. You're the best friend I've ever had."

More than a dozen years passed by and "Uncle Bud"
went out to North Dakota to preach in a campmeeting.
One day he was in his tent getting ready to preach
when a big, tall, handsome man rushed in and grabbed
him and jumped up and down laughing and crying.
Finally he said, "Brother Robinson, don't you know
me?"

"No, sir, I never saw you before in my life," said
"Uncle Bud."

"Oh, yes, you have. Don't you remember that fel-
low that came up to you one morning in Boston, and
asked you for a nickel?"

"Yes, I remember that, but surely you ain't that
man?"

"I'm the same one," he said.

"But what are you doing out here?" asked "Uncle
Bud." "I'm preaching. It's a long story, but after you
left Boston, I worked hard and studied my Bible, and
soon I felt the call to preach. One day I picked up a
copy of *Zion's Herald* and saw where a District Super-
intendent, out here in North Dakota, needed some young
men. I wrote to him and asked if he could use me
and he wrote for me to come. The Lord has blessed
me in my work. I've married a fine Christian girl, and
she and my little boy are right out here in the buggy,
and she's crazy to see you."

"Uncle Bud" said, "We went out to where a pretty
young woman was sitting in a nice, rubber-tired buggy,

and on her lap was the finest looking little fellow I 'most ever saw. He was just as white as sugar, all except his hair, and that looked like molasses candy. She took my hand and cried, and said, "Brother Robinson, I never can thank you enough for saving such a good husband for me."

"Uncle Bud" closed by saying, "And, friends, he didn't cost me very much—about two dollars and eighty-five cents was all, and I'd spend that much money any time to get a preacher for the Lord."—RAYMOND BROWNING, Bennettsville, S. C.

---

Although "Uncle Buddie" was denied the opportunity for a formal education, he had a keen appreciation of the value of such training and, in fact, was amazingly well informed through wide reading on a broad range of subjects. However, as with other handicaps, he was big enough and humble enough to refer to his educational limitations in jocular vein. I remember that when he was asked to speak at the educational anniversary of a District Assembly in Chicago, he began by saying in his amusing and inimitable way, "I don't know why I have been asked to speak at this educational meeting, unless it is to show the need of a good education."

Holiness schools never have had a better friend than "Uncle Buddie." Characteristically, his interest in Christian education found expression in practical service. Through the years he assisted in raising multiplied thousands of dollars for various colleges in times

of emergency. Furthermore, his sense of the impor-
tance of an adequate education made him the bene-
factor of scores of young people whom he assisted sub-
stantially in securing college training. He also took a
keen personal interest in them, encouraging and chal-
lenging them to rise above the ordinary and to attain
places of unusual influence and blessing in the work of
Christ.

Rev. Will Huff, the noted evangelist now of sainted
memory, was a conspicuous example of this special and
individual interest. Early in Brother Huff's college
career "Uncle Buddie" said to him, "Will, somebody
will become the outstanding holiness preacher of your
time, and it might as well be you." There can be little
doubt that such interest, encouragement and challenge
to excel had much to do with the unusual ministry of
that great holiness preacher. Rich indeed will be the
eternal reward of our beloved "Uncle Buddie" for the
investment he made in the training of consecrated
young people.

In his prime, Uncle Buddie's wit, speed and skill
at repartee surprised and disposed of critics and heck-
lers completely and unceremoniously. I recall well his
story of one of these encounters.

Uncle Buddie was preaching to a large crowd and
made a rather sweeping statement to the effect that
there were "no mysteries in the Bible," evidently mean-
ing that God in His good time would make all clear.
Instantly a man arose in the rear of the building and
shouted, "You say there are no mysteries in the Bible.

What about the he goat that came from the west and
never touched the ground?" In a flash "Uncle Buddie"
answered, "Well, brother, as he came by, I'd hang my hat
on one horn, my collar and tie on the other, and have
a poor, unregenerate sinner just like you!" With that
the heckler went down as if he had been shot.—Hugh C.
Benner, *Pastor*, Kansas City First Church.

---

Bud Robinson's ability to estimate men properly
and render a just verdict is shown in the following.
Asked his opinion about a certain Nazarene preacher,
he said, "He lacks just a little of being the greatest suc-
cess or the greatest failure you about ever see. A little
bit either way would do it."

My first meeting with him was in the Utica Avenue
Church in Brooklyn. After a brief getting acquainted
period, I asked him if he did not think there might
be some advantage that he had over others who had
not come up over the hard road of poverty and lack
of education, etc. He replied, "I don't know about the
advantages, but I can tell you some of the disadvan-
tages."

I had mentioned Dr. C. J. Fowler who was at that
time the president of the National Holiness Association.
Comparing himself with Dr. Fowler he said, "Dr. Fow-
ler was born so nice." Then he continued to tell of a
meeting with Dr. Fowler in California where a drunk-
en woman made comments during the sermon so that
Dr. Fowler could not preach any more. Uncle Bud
stood up and said, "Now, Dr. Fowler, let me try," and

proceeded to say as how it was a drunk woman, they should be glad it was not themselves, and that God could save her and save them too, and that they all needed Jesus. He made an altar call and several responded. During the altar service, Dr. Fowler knelt beside him and prayed, "O Lord, make me more like Bud Robinson."—PAUL S. HILL.

"Uncle Buddie" well understood the characteristic reactions of human nature, and was frank enough to confess them. While he and a friend were visiting in the new science laboratory of the college where I was assembling some apparatus for the fall semester, I overheard the following choice bit of wisdom: "Well, Brother, you have had experience with a holiness school, and I have had experience with a holiness paper, and we are both much wiser."

On his return to Pasadena from an evangelistic tour, he was rehearsing to a group of college professors some of the experiences of the summer. "You know," he said, "I have just come from a place where they are thinking of starting another school. I told them not to do it. I told them that a holiness school was like a pair of shoes. They squeak loud when they are new, but they get pretty flat when they are old."

Even when plied with foolish questions, his ready wit never failed him. To a sister who said, "Uncle Buddie, why is it that your hair is so much grayer than your beard?" he replied, "Why, sister, you know it is about twenty years older." Always simple, always sin-

cere, what a great man he was!—H. Orton Wiley, *President*, Pasadena College.

In a zone meeting in Clovis, New Mexico, "Uncle Buddie" referred to the text, "Consider the ant, thou sluggard." He told us of the industry and thrift of the ant, and said, "There isn't a lazy one in the whole outfit. Why, in harvest time, every morning when the first rooster crows, every ant rolls out and begins to shake the dirt out of his socks getting ready for the chase." He applied this to the harvest of souls that is now ready to our hand, and the thought has been a great blessing to me.—R. C. Gunstream, *Superintendent*, New Mexico District.

———

Bud Robinson and L. Milton Williams were conducting a revival in Calgary, Alberta. A learned man, a Greek scholar, one of the translators of the American Revised Version of the New Testament, attended the services. One day he said to me, "That evangelist from Texas knows he is not a scholar, but there is something about him that touches my heart. He does not know Hebrew and Greek, but he does know God, and I can sit at his feet and learn." Once in our home, when he was past seventy-five years of age, my wife suggested to "Uncle Buddie" that he should retire. But he almost shouted, "Retire, no. I am refiring. I want to hit the ball." And then as though the idea were reverberating in his mind, he repeated, "I want to hit the ball." And he did.—E. E. Martin, *Superintendent*, North Pacific District.

In the autumn of 1940 "Uncle Bud" made a tour of of our district. Several times during the first few days he expressed anxiety as to how "Little Mother" (referring to his wife) was getting along—she had not been well ten days before when he left home. I offered to relieve him of the rest of the tour that he might go home to his sick wife. But he said, "No, Brother Knight, Little Mother knew when I left that she might not live until I returned. She has all the care that it is possible for humans to give her, and I better wait until I hear again." Two days later, just before time to preach, word came that Sister Robinson was very low and that there was no hope for her recovery. But even then, with rare courage, he walked to the tent where several hundred people awaited his message, and preached with power and glory, mentioning only at the end of the service that his wife was dying 1,500 miles away, and that he must leave to go to her bedside. Two days later he was to stand there to see her die. May I have such courage and faith as were his to possess.—JOHN L. KNIGHT, *Superintendent*, Abilene District.

———

"Uncle Bud" was a man of courage, as well as a man of love. I saw him threatened by a mob in the fall of 1913, but he never flinched, and continued the meeting until the time announced for it to close.— L. E. GRATTAN, *Superintendent*, North Dakota District.

———

Mother picked out a large grapefruit, prepared and served both halves to "Uncle Buddie." He was pleased, and said, "Sister Cove, I hope the Lord will place my

house near yours in the heavenly Jerusalem. Your family has always been nice to their old 'Uncle Bud'." Then bowing his head reverently, he said, "Dear Lord, we thank Thee for the big pieces." One day he insisted that my sister, then a small child, should play a piece of music that was on the piano. The family was aghast, but "Uncle Bud" said, "The devil has no music. It all belongs to God. Perhaps the devil has some music fixed up so it will fit into places of amusement. But before it was fixed like that it belonged to the heavenly Father." At North Reading Camp "Uncle Bud" had preached in the morning, and was to preach again in the afternoon. He had been sick, and very much needed rest. But soon after lunch my sister, Edith, found him sitting in the midst of a crowd that had gathered about him to listen to his talk. She insisted that he go and take rest. But he answered, "Oh, no, little Edith. I am resting fine. I just love people, and it rests me to talk to them and have them talk to me."—MARY E. COVE, Member Woman's General Foreign Missionary Council.

---

When I was a lad of fifteen, some young men took me into Bud Robinson's home in Peniel, Texas, and prayed for me a long time. I was not converted then, but that visit to Bud Robinson's home made a lasting impression on me. One day Bud said to me, "Brother Jarrette, some of the young preachers use me as an excuse for not getting an education, and they think I don't know much. I may not use good English, but there is scarcely a book that has been put through the

Reading from top of page: (1) *Will Huff and Bud Robinson;*
(2) *Dr. H. C. Morrison and Uncle Bud;* (3) *four veterans of
the cross, Bud Robinson (age 75), Dr. D. F. Brooks (age 90), Dr.
H. C. Morrison (age 78), Commissioner Samuel L. Brengle (age
75);* (4) *Rev. and Mrs. Bud Robinson at home.*

channels of the holiness movement in the last thirty years that I have not read, and I have studied and studied hard." Once we went together to hear Sherwood Eddy speak on conditions in Russia. Bud took no notes, but that night in the meeting he quoted all the principal facts and figures that Dr. Eddy had given out.—JARRETTE AYCOCK, *Superintendent,* Kansas City District.

"God bless you and little Sister Florence. The good Lord has brought you back to America to tell us how our prayers have been answered. I have been apraying for you every day of the year. I remember the missionaries one by one by name every day in prayer." This was the way "Uncle Buddie" greeted us at the General Assembly in 1940. I thanked "Uncle Bud" for his prayers and assured him he would share in the reward for every soul saved and every church organized. But he answered, "I am not looking for reward. I am counting on you, Brother Will." I went away with a lump in my throat, and longed to get back to my work in the Island Empire.—W. E. ECKEL, Missionary to Japan.

At our last meeting "Uncle Buddie" shook my hand, and said, "Sister Fitkin, thank God that you and 'Uncle Bud' are still on the way to heaven." He wrote me last on July 29, 1942, and said, "I have been to church only five times in nearly eight months, but the Lord has been so beautiful to me."—REV. MRS. S. N. FITKIN, *President,* Woman's Foreign Missionary Society.

"Uncle Buddie's" last service before going to the Holy Land and the first after his return was held in the East Rockaway church. Reporting on the Great Pyramid he told the acreage it covered, its height, width, shape, number of stones it contained and estimated weight. Concluding he said, "If you don't think that's some pile of rock go look at it for yourself and see."

At the Beacon Camp Meeting, without effort, he told of leaving California New Year's Day and gave his hour of departure, and continued the story of his trip across the United States, naming churches and preachers visited in their order until he came to the camp in July. Continuing he told his proposed schedule until he arrived again in California in time for Christmas. He gave the time of all train connections and distances as well as the number of *Herald of Holiness* subscriptions received en route.

Rev. C. B. Jernigan and "Uncle Bud" were both at our house at the same time. When Bud was absent from the room we were talking of his unusual memory of dates and events. It was agreed to test his memory by a blind question referring to a date and incident Brother Jernigan knew. When the questions was asked "Uncle Bud" replied, "Yes, sir. That was the time we had the horse pasture meeting. I got there about half past two in the afternoon and we drove out to the tent and had a great time." He also gave the date.—PAUL S. HILL, *Pastor*, East Rockaway, New York.

———

Up in the high Rocky Mountains, I said to "Uncle Bud" one day, "Do you keep physically fit about all

the time?" He replied, "Oh, yes, Doc, as long as I give attention to my eating, physical exercises and sleep, I get along. But when I neglect these I get to feeling low and no good. Then I take myself in hand, and say, 'Here, Bud Robinson, you know what you ought to do to keep yourself in good condition. Now get busy and do it, for I am going to make a man out of you, old Bud, or I am going to kill you'." I have often used this as an illustration of how we ought to take ourselves in hand for discipline, Bible study and prayer, that we may be strong, healthy Christians.—C. W. DAVIS, *Superintendent,* Colorado District.

---

Our little girl heard "Uncle Buddie" preach, and after that always looked for his picture with his "Good Samaritan Chats" in the *Herald of Holiness.* One day "Uncle Buddie" came to our house. He did not get out of the car himself, but when our little tot saw him, she exclaimed, "That is 'Uncle Buddie,' that is 'Uncle Buddie,' just like in the paper." "Uncle Buddie" drew a nickel from his purse, and said, "Any little girl that can remember Old Bud is worth a nickel." That nickel is now safely tucked away in a scrapbook and is known as "Uncle Buddie's nickel."—NORMAN R. OKE, *Superintendent,* Manitoba-Saskatchewan District.

---

In a letter along with a manuscript, Bud Robinson once wrote, "It is strange how an educated man can spell a word only one way, while right on the same page you will see how I can spell the same word five different ways." Accompanying one of Bud's articles

was a memorandum to the editor which said, "You know I am not very good at this punctuation business, so here are a lot of periods, commas, etc. [and he included a considerable number in a line across the page]. Just sort these in wherever they belong."—P. H. Lunn, *Assistant Manager,* Nazarene Publishing House.

———

"Uncle Bud's" brother Andy was given to drink, and sometimes to the use of drugs. Often in his desperation he would take Bud's clothes and exchange them for liquor, and one morning Andy was gone and so were his brother's boots. In spite of his drunkenness that had continued through years, "Uncle Bud" was patient with his erring brother, and loved him tenderly. They were living on a farm in Texas, when Bud got so disturbed about Andy's condition that one morning he refused to eat breakfast. He said that Andy must be saved, and that he was going out to the barn and pray for him. He knelt down on a pile of cottonseed and prayed until noon, and then until dark. His mother tried to persuade him to eat, but he refused, and late in the night he came to the house and slept a few hours, and then went back to the crib of cottonseed to pray for Andy. Three days he fasted and prayed with but a few hours of sleep. On the fourth morning Mother Robinson wept and begged him to eat, but he said, "No, I've got to pray for Andy. He must be saved." He prayed all the morning and past noon. About two o'clock in the afternoon poor old Andy came staggering home. The first thing he said was, "Where is Bud-

die?" Mother Robinson said, "Oh, Andy, Bud's out in the crib in the cottonseed praying for you. He's going to die if you don't get saved." Andy went right out to where Bud was kneeling in the cottonseed praying. He put his arms around him and said, "Buddie, please pray for me." Right there in that old crib Andy prayed through to victory. Later God called him to preach and Andy never wavered from that time. He lived a useful life and died in the faith.—RAYMOND BROWNING, Bennettsville, S. C. *GLORY! IT WORKS.*

---

My father, Rev. C. O. Moulton, used to travel and preach with Bud Robinson. One night the two stayed in the same room in the home of Rev. F. M. Messenger in Chicago. In the morning, "Uncle Bud" said, "Well, praise the Lord! If I had not got saved I never would have slept in as nice a bed as this." Once when he was with my parents in New England, he very much missed being away from his family, and said, "I wish I could see my Sally, and roll on the floor with the children and bite their ears a little bit." When food for the crowd ran short one day, my mother bought ham to finish out. Some at the table were opposed to eating pork, and when the ham appeared, they made some uncomplimentary remarks about it. But Bud Robinson said, "Praise the Lord for the food! I eat what is set before me and ask no questions for conscience' sake." My mother was always thankful for Bud Robinson's thoughtfulness that day.—M. KIMBER MOULTON, *President,* General Nazarene Young People's Society.

I arrived at Trevecca College, Nashville, Tennessee, in September, 1910. The president, J. O. McClurkan, met me in the vestibule and said, "Yes, my boy, you are here to attend school. Go right into the chapel and hear Bud Robinson preach." Bud told that day of two cross-eyed Irishmen who ran together when they met on the street. One said, "Why don't you look where you are going?" The other replied, "I do, but why don't you go where you look?" Just last winter "Uncle Bud" and his granddaughter walked into the dining room at Olivet Nazarene College unannounced. "Uncle Bud" greeted us with, "Well, praise the Lord! Hurrah for us!" The students wanted "Uncle Bud" to pray. He prayed the Lord to bless the poor folks, and then said, "Lord, you know that is us."—A. L. Parrott, *President,* Olivet Nazarene College.

———

I preached the last sermon that "Uncle Buddie" ever heard. It was during the California Camp, this past August, where Dr. Chapman and I were doing the preaching. Bud Robinson came to the afternoon service and heard Dr. Chapman preach on the subject, "Beulah Land." He sat there throughout the service and cried and shouted and had much to say about the message. He returned that night and talked about the *Herald of Holiness* and took a number of subscriptions. Turning to me he said, "Holland, I am not feeling well, but I want to stay for this service tonight." He did stay and that was the last time I ever saw "Uncle Buddie."—Holland B. London.

Bud Robinson was with us often for tours on the Ohio District. He called our well spread tables "Ohio poverty." We stopped for breakfast in a cafe. He said to the waitress, "Little sister, what have you got for breakfast?" She said they had "'Most anything you want," but later she came back to report she could fill only part of our order. Then Bud ordered oatmeal with "real cow's cream." The waitress did not like this so well, and said, "What kind of a place do you think this is?" "Uncle Bud" replied, "Little sister, when you have traveled this country over a million miles and worked it like a farmer works a farm, you will know the difference between real cow's cream and this here canned stuff." Once I had arranged with "Uncle Bud" for a tour of the district, but observing that he made no record of the engagement, I asked if he would be sure to remember it. He replied, "I was with you last year, wasn't I? We started up at Toledo, and then went down to Dayton, and then to Cincinnati, and then to Portsmouth." He went on and named every church we visited, practically every home we stayed in, and enumerated a mass of details I had completely forgotten. And by this I learned he would not forget the next year's date.—CHAS. A. GIBSON, *Superintendent*, Ohio District.

———

Bud Robinson was a true friend of the cause of Foreign Missions. He always greeted us personally with a hearty handclasp, and "How is my angel, today? Bless your heart good." Our missionaries abroad and

our workers at home will miss this good friend.—MRS.
PAUL BRESEE, *Executive Vice-president* of the W.F.M.S.

———————

As a young boy I kneeled at the altar in Bud Robinson's meetings, and when he was grown aged I saw him in the hospital at Nampa, Idaho, where, although in pain himself, he was solicitous about the soul of everyone who came into his room.—IRA L. TRUE, *Superintendent,* San Antonio-Monterrey Mexican District.

———————

Bud Robinson was a guest in our home. At evening prayer he remembered "Miss Sally," Sally and Ruby the daughters, the two sons-in-law, and each one of the grandchildren by name, asking God to protect and bless. His intimate devotion to his family amidst activities which gave him a place in the Hall of Fame impressed and blessed me.—A. D. HOLT, *Superintendent,* Virginia District.

———————

I saw Bud Robinson first in Los Angeles First Church in 1923. When I was introduced to him by my pastor, Rev. Fred A. Smith, Brother Smith told "Uncle Bud" how he had just been telling me of his ability to remember names and faces. "Uncle Bud" said simply, "Well, son, what's the use of havin' a noggin if you don't use it?" In my own home in Des Moines, Iowa, I found "Uncle Bud" in the sitting room when I arose at 6: 30 a.m. He had already prayed for an hour, covering all the interests of the church, and had taken a bath in unheated water—and he was nearly eighty. On

another occasion, also at a time when he was nearing eighty, he arose at four a.m., ate a hearty breakfast, stopped on the front porch to quote a Psalm in a loud voice, then climbed into the car with his son-in-law, George Wise, and started for home in California—two thousand miles away. A few days later he wrote me that they "drove straight through," and that they "outran the streamliner," and reached Pasadena at 9 p.m. on the day after they left our house.—HARDY POWERS, *Superintendent,* Iowa District.

———

One day at the old "Bates Camp Meeting," founded by my father and my wife's father, Bud Robinson was shining Dr. H. C. Morrison's shoes. Dr. Morrison inadvertently discoursed upon the subject of his good "Kentucky blood." When the shoes were shined, Bud said, "Dr. Morrison, I have no blood to brag about. All I have is the blood of Jesus—but it is enough." Dr. Morrison gathered Bud into his arms and said, "Buddie, you are always ahead." On Sunday afternoon Bud stood in the pulpit with tears coursing down his face, and said, "When God wanted to give a message to the world, He just took St. Paul and dipped him in the blood of Jesus and wrote across the world, 'Follow peace with all men and holiness, without which no man shall see the Lord'." God's holy anointing was upon him, and the Spirit of God swept over the crowd like a storm. —J. E. BATES, *Evangelist.*

———

In 1911 Bud Robinson came to the Boise Valley in Idaho, where I was working as a young licensed

preacher. His meeting in the Methodist church in town was closed on account of quarantine, and we asked him to come out to the schoolhouse in Apple Valley for the five days he could spare before his next engagement. He came. God gave us souls. We raised what little money we could, and then gathered an offering of apples, potatoes and other produce and sent it to his family in Texas. Twelve years passed, and I walked into a church where he was preaching. He stopped, came down to meet me, and said to the crowd, "This is Brother Pounds. The last time I saw him he was driving a pair of black horses gathering up apples and potatoes to send to my family. That offering lasted all winter and we canned some of the fruit for summer use." I never forgot this great man's willingness to serve anywhere, nor his wonderful memory for details nor his devotion and loyalty to God and the church.—EARL C. POUNDS, *Superintendent*, South Dakota District.

Bud Robinson was past eighty when he made his last tour with us on the district. One day he told me that he had commenced to feel that some time within the next five years he would have to slow down some, and he wanted me to help him get a small farm near some good church where he could rest about half the time and preach in conventions the other half. I hunted a place of prayer for myself, and asked God for more faith and courage.—L. T. WELLS, *Superintendent*, Kentucky District.

While I was pastor at Akron First Church, we had Bud Robinson announced for a service to begin at 7: 30 p.m. At five p.m. we received a wire saying he could not arrive until 9: 30. The house was crowded at 7: 30, but the people waited until he came, and then he held them for an hour amidst weeping and shouting and praising God, and I believe some will make it to heaven on account of the blessings of that meeting. Once a woman, seeking sanctification, said, "Brother Bud, I believe I have everything on the altar except my tongue." He replied, "Well, sister, the altar is about sixteen feet long. I think you can get it all on."—H. B. Macrory, *Pastor,* First Church, Cleveland, Ohio.

———

It occurred in a campmeeting at Frost Bridge, Mississippi, and "Uncle Bud" was the evangelist for the occasion. The last Sunday had arrived and "Uncle Bud" had got up to preach in the afternoon service. A great throng of people was present and there was every reason to expect the camp meeting to have a happy and triumphant closing day; but listen to what happened. "Uncle Bud" said, "Just as I got up to preach I happened to look over to my right and there near the end of the altar bench stood the biggest bulldog I ever saw in my life. He was a big, bench-legged yellow dog, and his gaze seemed to be directed to something over to my left. I looked and there stood a big white bulldog, and while I was taking my text the two dogs met right in front of the pulpit and passed a few remarks and took hold. I said, 'Won't somebody take these dogs

out of here?' Then one fellow yelled, 'Let 'em fight!'
One man said, 'My dog ain't never been whupped,' and
another said, 'And my dog ain't never been whupped'."
Then "Uncle Bud" called out, "Where is the high sheriff
of this county?" Now it happened that the camp meet-
ing shed stood right on the dividing line between two
counties, and two men arose and came forward. While
the two dogs were battling and women and children
screaming these two sheriffs had a brief consultation,
and then announced that unless the owners of the two
dogs came forward and separated them that each sheriff
would proceed to shoot a dog right through the head.
The owners came and each man got his dog by the hind
legs and some other men proceeded to choke the dogs
until finally they were able to pry them apart. "Uncle
Bud" concluded by saying, "One feller tuk hith dog and
went off into the woods to my right, and about half of
the crowd followed him. Then the other feller tuk hith
dog and went off to the woods on my left, and the rest
of the crowd followed him, and the campmeeting was
over, and that was the meanest trick the devil ever
done me."—RAYMOND BROWNING, Bennettsville, S. C.

------

I met Bud Robinson at the Red Deer Camp Meet-
ing in Alberta, in 1926. I was a young pastor, and was
greatly blessed by his story of his hospital experience,
and was impressed with his wonderful ability to quote
the Scriptures from memory. Twelve years later I met
him again at the Sunday school convention in Bethany,
Oklahoma, where I was being entertained in the "Bud

Robinson Hall" on the college campus. I did not expect
recognition, but he spoke my name, and said, "I am
glad you are being entertained at my home." The last
time I saw him, several years later, was when he was
making the last tour of the North Pacific District. I
asked if he remembered me, he grasped my hand, and
said, "Why, yes, you are one of my boys, and I pray for
you every day of my life." Then he told of his system-
atic prayer plan by which it seemed to me to take us all
in. It has often encouraged me in times of test to know
I was being remembered in prayer by Bud Robinson.—
J. R. SPITTAL, *Superintendent*, British Columbia Dis-
trict.

It was a session of the Southern California District
Assembly. Pasadena College had been moved to its pres-
ent site and lots were being offered for sale in the new ad-
dition. Dr. Bresee was presiding. Bud arose and said,
"I have just been thinking how nice it would be if you
folks would buy me a lot, and I would build me a house
and come out here to live." The suggestion was all that
was needed. The lot was purchased, and Bud Robinson
built his house—the house in which he lived until the
end of his days.—E. P. ELLYSON, *Editor Emeritus*, Sun-
day School Publications.

Bud Robinson was late to a camp meeting in which
I was also one of the preachers. People insistently
asked when Bud would be there, and we all talked
much of the treat that was yet ahead. A newspaper re-

porter had been covering the meeting in a very acceptable manner. Bud preached on the afternoon of his arrival, and the next morning the report in the paper began: "Well, the great 'Uncle Bud' has arrived. He says he is from the hills of Kentucky or Tennessee, and to hear him no one would doubt it." Then the reporter went on to give a list of "Uncle Bud's" phrases. While waiting for dinner that day "Uncle Bud" read this report, and I could see his sides shake with laughter while he read. That night when Bud started to preach, he said, "Some people do not like my grammar, but God never called me to preach grammar, He called me to preach the gospel." The people got the gospel that night, and the altar was lined with people seeking God. —J. W. GOODWIN, *General Superintendent Emeritus.*

———

During my twenty-eight years as pastor and District Superintendent, my soul was often refreshed by the ministry of "Uncle Bud" Robinson. A few days before he went to heaven, Dr. H. B. Wallin and I called to see him. He received us most graciously, although he was very weak. He inquired about our wives and children, calling each by name, and then asked about the various pastors on the district. After this his mind wandered back to camp meetings and conventions of the past, and his words were of his comrades of those other days. His words came slowly, but his face was alight, his eyes gleamed with holy fire and he made a characteristic gesture as he emphasized how they preached in those days. Then he sought to show us

how they used to sing. In a low, sweet, faltering voice
he sang:

> "Come, ye sinners, poor and needy,
>     Weak and wounded, sick and sore;
> Jesus ready stands to save you,
>     Full of pity, love and power.

> "Let not conscience make you linger;
>     Nor of fitness fondly dream:
> All the fitness He requireth
>     Is to feel your need of Him."

He lowered his head to rest, while we in tears took
our last goodby.—A. E. SANNER, *Superintendent,* South-
ern California District.

———

Uncle Bud Robinson visited Ontario twice. The
visits were eight years apart. The second was in July,
1941, when he came with Dr. G. B. Williamson, to tour
for Eastern Nazarene College. In His introduction on
this second trip he reviewed minutely all the places he
visited and preached on his first trip, eight years before.
One of the places, where he had preached on an after-
noon, was open but a little while, and most of us had
forgotten that we ever had such a place. But "Uncle
Bud" did not forget.—ROBERT F. WOODS, *Superintend-
ent,* Ontario District.

———

Rev. Harry Carter and family and myself and fam-
ily had gone to Olivet for the College Commencement
and Camp Meeting in 1922. On our way to the dining

hall, after the morning service, we met "Uncle Bud" Robinson. He sized us up, and said, "Well, where did this gang come from?" We told him who we were and that we were there to attend the meetings. He said, "That is fine. Just make yourselves at home around here. You look mighty good to me." We never forgot this warm welcome, and that afternoon while being blessed under the ministry of Bud Robinson, it came to me as almost an audible voice, "This is your crowd, and the sooner you get into it the better." And so Bud Robinson was both the cause and the occasion of our finding our place in the service of the Lord. He was with us for his last complete tour in November, 1941, and, as he would put it, "rolled up almost a thousand subs. for the *Herald of Holiness.*" Thank God that we ever knew this great and good man.—JESSE TOWNS, *Superintendent,* Indianapolis District.

Many years ago a band of holiness people secured a large hall in Boston, and put on a convention. "Uncle Bud" was invited, but he was not well-known at that time, and was not expected to take a major part on the program. At first the meetings were not very well attended, but what happened may be best explained in his own brief account. "When my friends knew that I was going to Boston to preach they told me about the educated folks there, and told me to be very careful about my language and my grammar and my verbs. I really tried to do that, but one night I was up trying to preach and the Lord blessed me nearly to death, and

I had a shouting spell and forgot all about my verbs and said, 'I feel just like I'm a settin' on a rainbow swingin' my feet'." There were two reporters in the audience and next morning one of the daily papers had a big cartoon of Bud Robinson sitting on a big rainbow swinging his feet. From that day through more than seven weeks the big hall was crowded and Bud Robinson was the chief attraction.—RAYMOND BROWNING.

I first met "Uncle Bud" at a convention in Louisville, Kentucky. Later while serving as Superintendent of the Georgia District, we made several tours together. It was my privilege to be with him in one of these tours on his seventy-fifth birthday anniversary. A fine dinner was given in his honor, with a large group in attendance, at the Y.M.C.A. in Waycross, Georgia. "Uncle Bud" said that the "two-story" cake symbolized regeneration and sanctification, and that the number of candles on it reminded him of a prairie fire. The ability of Bud Robinson to see something good in everyone and to love everyone seems unsurpased among mortals. By common consent, he was the ambassador of good will for the Church of the Nazarene. Everybody loved him, because he loved everybody. More than once he has told the writer, "I could not love you more than I do." And when he had completed his last tour of our district, and farewells were being exchanged on the lawn of the district parsonage in Atlanta, he said to me, "I love every hair in your dirty little old head!" This statement, highly imbued with that humor so characteristic

of "Uncle Bud," was, nevertheless, spoken in such sincerity that it left no doubt that Bud Robinson loved me, even me.—P. P. BELEW.

———

The last service I was in with "Uncle Bud" was the opening service of the Annual W.F.M.S. Convention at Akron, Ohio. On Sunday he spoke three times in Cincinnati, early on Monday had a radio broadcast, and then drove more than three hundred miles across the state of Ohio. For the Monday night's service we could not get the Armory, so had to go to one of our churches seating seven hundred and fifty people. We packed in eight hundred people but the overflow crowd would not be denied. On this occasion he was speaking of his trip to Palestine.

When "Uncle Bud" had spoken fifty minutes, without any previous warning we asked him to stop. We declared a recess of fifteen minutes. In that time we were able to get the first crowd to file out through a rear door, and the crowd that had been waiting in the street filed in to fill every seat and take all available standing room. When the speaker began he did not repeat so much as a sentence, but began with the second crowd where he left off with the first and spoke for another forty-five minutes. The next morning when he was on time for the 9 o'clock service, he was questioned as to why he did not get some much needed rest. His reply was that he was afraid something would happen and he did not want to miss it.

It was our privilege to call on "Uncle Buddie" at his home in Pasadena last February, about eight months before his homegoing. He looked well and was quite cheerful. He affirmed that he was still in the fight. He said he had been busy that morning and had just completed a list of one hundred and fifty great holiness preachers that he had worked with, that had already gone to heaven. It was evident that he was nearing the Eternal City.—C. WARREN JONES, *Foreign Missions Secretary*.

While waiting for the opening of the evening service, Brother Robinson discovered that the mosquitoes were especially bad. While brushing them away, Bud Robinson was musing. Finally he said, "These mosquitoes are the most religious I ever saw: they always come to church, they always sing and pray, and when they pray they always get on their knees. And the remarkable thing about it is they always get an answer to their prayers." While touring with him on the Eastern Oklahoma District, where I was at that time the Superintendent, I used to try to stay in the room with him at night or in a room right next, so as to be able to take care of him. One morning early he sat up on the side of his bed, and called out to me, "Praise the Lord, Doc!" Immediately I inquired how he made it through the night and how he felt. He replied, "Fine, and I am all ready to go again. And, Doc, if the devil ever tells you that I don't love you, just hit him on the noggin with a big ear of corn from the land of Canaan and tell him he is a liar."—W. A. CARTER.

I roomed with Bud Robinson one night while we were traveling in the interest of money for the Bud Robinson Hall at Bethany-Peniel College. I awoke in the night and heard Brother Robinson praying quietly. I heard him call the names of a number of the leaders and missionaries of the church, and ask God to bless them. He finished by saying, "Thank you, Jesus," and immediately he was asleep. During that trip he was rather careful about his diet, and had along cubes from which to make bouillon broth, which he often accounted as sufficient for the evening meal. But in the Smith home in Waco, Texas, he found a large platter of pork backbone and a round plate of cornbread in front of his plate. I noticed that the bouillon cubes went quickly into his pocket, and he ate heartily of the backbones and cornbread. After a little while I mentioned to him that he had forgotten his cubes. He replied laughingly, "I have to stand before the Lord only once, and I figured there was no better way than to be full of cornbread and backbone."—L. T. CORLETT.

———

I heard a Presbyterian minister introduce Bud Robinson in Robinson's Chapel in his home community. The minister said he had traced the Robinson genealogy and found there was a Robinson Chapel in Ireland, and that there had been a line of Presbyterian elders in the Robinson family for more than six hundred years. Just about a year before his death a man came up to the rostrum, shook hands, and said, "Hello, 'Uncle Bud'." Bud looked at the man earnestly and said, "Ain't you

the fellow who went out to Bon Air Schoolhouse with
Cousin Lige Weaver and me eleven years ago and I
preached?" The man replied in the affirmative, and I
marveled at such memory.—J. D. Saxon, *Superintend-
ent*, Tennessee District.

---

Some preachers I have known must have a favor-
able atmosphere and environment in which to put forth
their best efforts. "Uncle Bud" had the unusual ability
to create such an atmosphere. In fact he seemed to
carry his own environment like a terrapin carries his
shell. I saw this happen the day we visited the School
of Religion at Duke University. Some of the students
had heard of "Uncle Bud," and the young minister who
was the president of the ministerial student association
said in introducing him, "The name Bud Robinson has
been a familiar one in our home ever since I can remem-
ber." However, most of the students seemed merely
curious to see and hear a man who had been remarkably
successful as an evangelist, although lacking the usual
educational and cultural advantages that are expected
to be in the equipment of a preacher. Whatever may
have prompted them to attend, we were informed that
every teacher and every student of the School of Re-
ligion was present. They were quiet, courteous and at-
tentive, but I could not forget that we were on the
campus of a great liberal university where the preach-
ing of Bible holiness might not be welcomed. It was
a tense moment.

"Uncle Bud" got up quietly and leaned on the pul-
pit and began without apology. Duke University with

all its magnificence seemed to fade away and for twenty-five minutes we were right in the midst of a second blessing holiness camp meeting. "Uncle Bud" was telling of his early life and his conversion and call to the ministry; and then he took us down to that old cornfield in Texas and told us how Jesus came riding through in a chariot of fire and sanctified him wholly while he was thinning corn. My son-in-law, Jack Moore, and I were saying "Amen," and the rest of the congregation were looking happy. The old hero had won his crowd and blessed them.

After the service the faculty and the students took us to a special dinner in a big dining hall, and "Uncle Bud" was the honored guest. After the meal was over students hung around "Uncle Bud" for an hour and a half listening to his stories until finally I had to pull him out and start on the way to our next appointment. After we were gone a divinity student approached one of the professors who was thought to be rather critical and modernistic and said to him, "Doctor, what did you think of 'Uncle Bud's' sermon?" The doctor's face grew serious, and he said, "Really, I have no criticism to make of 'Uncle Bud.' That old man is one of God's prophets." —RAYMOND BROWNING, Superintendent, Carolina District.

———

Once, on the old site of Olivet Nazarene College, "Uncle Bud" was helping raise money for the school. He said, "Now you just as well give it, for if you don't you won't have it anyway. I was out in the Middle

West holding a meeting, and wanted to go into Kansas City on the midnight train. I was tired, and thought I would take a sleeper. The ticket agent said the sleeper would cost me four dollars. I said, 'Four dollars?' and he said, 'Yes, sir, four dollars.' I told him I would sit up and save my four dollars. So I sat up. But now where is my four dollars? The railroad didn't get the four dollars, and I haven't got it. So where is it? You better give your money to the school and then you will know where it is."

At the National Camp Meeting at Eaton Rapids, Michigan, it was "Uncle Bud's" time to speak on a hot Sunday afternoon. But before Bud's time to come on, four or five college presidents were introduced and given time for short talks. Their speeches were correct in every particular, and I wondered what "Uncle Bud" would say after all that. But my concern was needless and my sympathy was wasted, for when "Uncle Bud" arose, he said, "Well, I have enjoyed the speeches of these splendid gentlemen, and agree with all they have said. But I can make a better speech in favor of education than any one of them. If you will just listen to me for the next forty minutes you will all agree that a fellow ought to have an education." The crowd forgot about the row of college presidents on the platform, and laughed and cried while "Uncle Bud" preached on "The Two Works of Divine Grace," and at the close the altar was lined with hungry seeking souls.—R. V. STARR, *Superintendent*, Michigan District.

During a period covering thirty-four years, I was in forty-one engagements with Bud Robinson. In a meeting in a large city church, Bud's denunciation of secret and public sins became so terrible that the church people got up a petition asking that he leave town. That night he attacked sin in such a manner as I never heard before, and then at the close said, "Your old petition didn't go through, but old Bud did. Go home now, you have all you can stand for one service." During our first camp meeting together, at the postoffice one morning, an old man asked Bud, "How is the camp meeting up on College Hill?" "You never saw anything like it," Bud replied. "How is the music?" continued the questioner. "You never heard the like," said Bud. "And how is the preaching?" persisted the old man. Bud's eyes flashed, "Bless God," said he, "I know that is good, for I am doing it myself." One morning I heard Bud Robinson quote one thousand passages of scripture before arising from his bed. Sitting on the camp meeting platform one day, he said, "Some of you *fellers* out there could not sell your brains as second hand, for you have never used them yet." The last time we were together, he said, "I have traveled two million miles, had more than 100,000 people at my altars, taken more than 50,000 subscriptions for the *Herald of Holiness,* and am still fighting the devil at the age of eighty. And I will fight the devil as long as I have a fist, bite him as long as I have a tooth, and gum him till I die."—A. S. LONDON, *Sunday School Evangelist.*

Bud Robinson was an educated man, even though he never went to college, and he accounted himself an example proving how much one misses who does not have formal education. He helped pay the way of several students through Trevecca College, and helped 103 students in various schools of the country. He planned to come to our zone to raise money for a "Bud Robinson Memorial" building on our campus, and he was never permitted to come for that purpose, I believe we shall have a Bud Robinson Memorial building on Trevecca campus some day because of His faith in and for such a project.—A. B. MACKEY, *President*, Trevecca College.

———

Touring more than half a year in all with Bud Robinson, I discovered many new angles of his colorful life. His patience during an all-day wait behind a wrecked train en route to Marlington, West Virginia, was most refreshing. He reasoned that our Christian progress and speed to glory were as rapid as if the wheels were still turning underneath. For hours he entertained the people in the coach until all worries and impatience seemed to vanish. He then seized the opportunity to leave a clear testimony to the saving grace and sanctifying power of his Lord and Savior.

In a lecture to preachers, he said, "Don't fuss at the folks. If you're sent to the sagebrush to preach to fieldlarks, just tell them they are the nicest birds around there, and when you pass the hat you will get as much as any preacher in the settlement."

After urging pastors to undertake worth-while things for God, and to use all of their energy in building the church, he prayed thus: "Bless all live preachers in the church, and please, Lord, give them all the health and strength that the other kind are wasting. If you have any use for dead-head preachers in the glory world, load up as many as possible and get them there as quick as you can. Then send us as many live soldiers to take their places here."

No one could surpass Bud Robinson in loyalty to a cause. When a large church wanted him to speak, but was unwilling to give an offering to the home mission interest for which he worked, he refused to accept, saying, "If they don't want what I'm giving my life for, they're not getting me."

Late at night when we had car trouble, farmers were afraid to open the door until the name of Bud Robinson was mentioned. Then the lady of the house got up and dressed in order to come to the car to meet him. When the engine was hot, and we stopped for water at another farm home, the man of the house sent for their neighbors to come and meet him, saying not many Sundays passed without the preacher quoting him from the pulpit.

Bud Robinson's greatness was revealed by his interest in little things. When we stopped for gas, I asked, "How's business and religion in these parts?" The attendant, a stranger to us, replied, "As far as I can tell, the Nazarenes and oil stations are taking Indiana." "Uncle Bud" continued to tell that story as

long as he lived.—J. W. MONTGOMERY, *Superintendent,*
Fort Wayne District.

———

We were in a home mission church. The crowd,
while good for the place, did not number more than
75. Bud Robinson poured out his soul upon the people
for fully an hour, called penitents to the altar and
stayed to help in prayer. I said, " 'Uncle Bud,' you are
not well. Our people are glad to have you, but they
do not expect so much of you. You must take care of
yourself. Take things a bit easier." His reply was
characteristic. He said, "Son, this old soldier won't be
here much longer. If I get my work done, I shall have
to do my best."—OSCAR J. FINCH, *Superintendent,* Kan-
sas District.

———

Few ever have faced life, at least such a life as
Reuben Robinson found, with a greater handicap. Born
into a Tennessee mountain home of abject poverty; an
epileptic whose frequent falls had dislocated his shoul-
ders until it was impossible for him to put on his coat;
tongue-tied; and with a stammering speech that made
its understanding painful, if not impossible, to the listen-
er. In such a condition, wholly illiterate, three mighty
factors came into his life which were to bring to light
one of the greatest miracles of modern times: He found
Jesus Christ; he found Sally Harper; God called him to
preach His gospel.

In those early days I have seen him standing upon
the platform, in all his uncouthness of dress and person,
stammering and stuttering in intense eagerness to speak,

until he would fall prone upon the floor, foaming at
the mouth, unconscious. Again and again I have seen
him stand with tears streaming down his face, unable
to say but six words, "Come to Jesus. He loves you."
And the people would come, filling the altar with seek-
ers.

Notwithstanding the poverty of his early home,
Reuben Robinson had generations of educated, cultured
Scotch-Irish back of him. "Miss Sally" taught him to
read his Bible—and Bud memorized a third of it. He
became an ardent reader of books, and later a volumi-
nous writer.

God healed his epilepsy; healed his stammering,
and unloosed his tongue, until he became one of the
most sought-after and loved speakers that America has
produced. From Boston to Los Angeles, from Calgary
to Houston, thousands thronged to hear him, charmed
by his wit, but no less by his advocacy of holiness.

Buddie walked so long and so closely with the
Master that he became like Him. Today he is with
Him.—CHARLES ALLAN McCONNELL, *Professor Emeri-
tus,* Theological Department, Bethany-Peniel College.

———

Since all of the other workers have gone to their
reward who were associated with "Uncle Bud" at the
time of his terrible accident—"smash up" as he called
it—in San Francisco, in June of 1919, perhaps I should
give some of the incidents surrounding that event. We
were in a revival in our First Church there, beginning
the week before the District Assembly; Donnell J.

Smith was the pastor, Rev. C. E. Cornell, then pastor of Los Angeles First Church, and "Uncle Bud" were the evangelists, and Mrs. Corlett and I were the evangelistic singers.

"Uncle Bud" had come to the city fully a day before the meeting began. Mrs. Corlett and I had been there almost a week. On the day before the meeting started, "Uncle Bud" and I had gone across the bay to the city of Oakland. He was passing through the greatest trial of his life. The burden upon his heart was crushing; frequently he would look off into space and wipe tears from his eyes. He spoke briefly of his grief; frequently he would sigh a prayer in a voice slightly above a whisper. He was not bitter, he had no unkind or harsh words for those responsible for his grief. While he was passing through deeper waters than he had gone through before, he was not being overwhelmed by them, rather he was relying upon God and seeking to find His way through them. For thirty hours previous to his accident he had fasted and prayed. It was the united opinion of all of us close to him at that time that the inward battle he was fighting was the cause of his accident, for his mind was so occupied and he was praying so constantly that thoughtlessly he stepped from the sidewalk into a line of fast-moving traffic on what was then one of San Francisco's busiest streets. It is sufficient to say that God brought him out victorious over his great trial and grief, and that the experiences of this time, his bitter testing and the suffering caused by the accident, God worked together for "Uncle Bud's" good and to make him a greater blessing to the world.

Never shall I forget the scene at the city emergency hospital on the morning following his accident. Brothers Cornell and Smith and I walked into the ward where the police had herded the accident victims and drunks gathered up the night before. We came to the bed on which our beloved brother and coworker was lying. He had been terribly mangled; both arms were broken, one so badly crushed that the bone had protruded through his flesh and clothing and the doctor despaired of saving it, and his left leg was almost as badly broken. He was in extreme pain, although it had been deadened somewhat by the opiates administered by the attendants, and they had done little more for him than to give these opiates, for they did not expect him to live through the night. He had bled considerably after being placed upon the bed until the bedclothes were covered with large spots of blood, and the blood had dried on his clothing which had been only partially removed.

Soon arrangements had been made by Pastor Smith to have "Uncle Bud" taken to the Leland Stanford Hospital. The ambulance came and the attendant picked up the mangled body of "Uncle Bud" in his arms to place him upon the ambulance cot. This handling caused him excruciating pain. I picked up his clothing and carried it to the ambulance. For some unknown reason, it fell to my lot to go with him in that ambulance, while Brothers Smith and Cornell went by car to the hospital. This ambulance riding was not a new experience to me. On at least three occasions I had been

carried in an ambulance; twice as an accident victim, and once as a soldier severely wounded on the battle-field of France. I knew from experience what Bud was suffering. He seemed to feel my sympathy in his suffer-ing. The shock of moving him from the hospital bed was severe, several times during that trip to the Stan-ford Hospital it looked like he would die. I had my hand upon his most of the time; and prayed for him almost the entire distance.

He would ask, "Do you think I can make it, son?"

"Sure, 'Uncle Bud,' you'll make it. You must get well. We can't do without you just now," I would re-ply.

He said often to me privately and to hundreds of audiences to which he related his hospital experience, that he was sure he would have died in that ambulance if it had not been for the praying and boosting he got on that trip.

We called on him frequently at the hospital. On one occasion when Brother Cornell and I went to see him, this conversation took place:

"Hello, Bud. How are you today?" said Brother Cornell.

"Well, Clarence," replied "Uncle Bud," "I've just been alyin' here thankin' the Lord that I'm not as bad off as I might be; and not as bad off as some other poor fellows have been. You see, I have only both arms and one leg broken, and I'm a whole lot better off than a feller with both arms and both legs broken. Wouldn't I be in a fix if my other leg was broke too?"

That was Bud's whole philosophy summed up in one short statement. He always looked upon the bright side.

On the last visit that "Uncle Bud" made to Bethany, Oklahoma, a group of us, including "Uncle Buddie," were gathered in the home of Dr. Lewis T. Corlett to spend the evening. He entertained us that night largely with the relating of interesting experiences of his life. The one experience most outstanding to me was the relating of a vision that he had soon after he was converted. It was at the time when he was struggling with the call to preach. Out under a moonlit Texas sky he prayed for a considerable time. Finally he yielded to the call of God. As he meditated on what that call might mean to him, he said that God gave him a vision of what his life might become under the blessing of God.

I asked him how the life he had lived compared with the vision he had that night. He replied that his life had been lived very much as he saw it in that vision. This is most astonishing to us as we consider the circumstances of his conversion, his physical afflictions, his illiteracy and the utter absence of favorable factors which contribute to such a life. It was God's pattern for his life, and it became to Bud what "the heavenly vision" became to the Apostle Paul, and, he like Paul "was not disobedient to the heavenly vision."—D. SHELBY CORLETT, *Editor, Herald of Holiness.*

————

In the early spring of 1939 I secured Bud Robinson for a tour among the churches of the Wisconsin Dis-

trict. The special interest of the tour was home missions. At the time the newspapers were full of stories about Hitler and Mussolini. The weather was cold, and "Uncle Bud" would often come up the aisle of some crowded church with his overcoat, muffler, gloves and overshoes on. As he approached the front of the church, he would turn and face the congregation, and say, "Beloved, it looks like Hitler and Mussolini are about to start a World War and knock God off the throne. But I have had a talk with the Father and He told me He does not intend to vacate." The effect upon the people was like that of the beginning of a great fire.—C. T. CORBETT, *Superintendent*, Wisconsin District.

---

When I accepted the District Superintendency of the Chicago Central District, and commenced to publicize my plans, someone asked Bud Robinson if he thought I was doing all I said I was doing. Bud's reply, as reported to me, was, "Anybody knows Chalfant doesn't do all he plans to do. But I'd rather be like Chalfant and undertake to do a whole lot and do half of it than to plan to do nothing and do it all." And then he announced, "Some say it can't be done, but I am going over to Illinois and Wisconsin to help Chalfant do it." He came. We made the tour by train—that was in the spring of 1923. We had only thirty-five churches in Illinois and Wisconsin. We raised money to buy twenty tents. In the fall of 1924 he came again. Wherever we went the houses were filled with people, and we often had three services a day. One day Bud

took 110 subscriptions for the *Herald of Holiness*, and the people gave him $80 for his services. My last day on earth with Bud Robinson was July 20, 1941. We had a house full at Lewiston, Ill., at the Sunday school hour, a tent full at Canton at 11 a.m., a mission hall full in Pekin at 2 p.m., and a house full at Peoria First Church at 7: 30 in the evening. We made forty places in three weeks and the people gave Bud Robinson $462 for his services.—E. O. CHALFANT, *Superintendent*, Chicago Central District.

———

When I was a lad of about ten years I first saw "Uncle Bud" Robinson. My parents had taken me to a big tent meeting at Jamaica, L. I., N. Y., where the engaged evangelists were Dr. C. J. Fowler, Will Huff and Bud Robinson. Sitting on the front seat, my feet barely touching the sawdust, I listened intently to "Uncle Buddie" as he stirred and amused my young heart. I shall never forget one sentence of his which caused me to laugh right out loud. He said, "If you thuck until you get the theed, then you will thuck-theed" (succeed). I have never forgotten it. On August 23, 1942, forty years later, we were leaving our Pasadena pastorate to accept the pastorate of Chicago First Church, and drove past his house. We stopped for just a moment at the curb as he was sitting on his front porch. He waved goodby to us and shouted, "I hope you get so blessed in Chicago First Church that you will have to be identified."—L. A. REED, *Pastor,* First Church of the Nazarene, Chicago, Illinois.

nation I received my fi
first local preacher's
members of the first C
in Texas.

I knelt by his bec
life's sunset and held I
"Henry, it ain't far tc
to Glory."

In those pioneer
the humble kitchen o
Threadgill, and while
statement, "John, I an
feel yourself above m
bodiment of humility.

In the closing we
less. In his delirium I
ers and shouting ther
son-in-law, Rev. Geor
and Ruby pray me ba
to be 89 years old and
he put his all into it.
"Henry, preach secon
—HENRY B. WALLIN,
California.

The unique man
was forced upon me
heard him preach to
ered from all over th
before. When he aro

My first recollection of "Uncle Bud" Robinson dates from my boyhood. We were living in Lansing, Michigan, and my mother took me with her to attend a service of the National Association for the Promotion of Holiness, held in the First Methodist Church of that city. "Uncle Bud," and if memory serves me correctly, Dr. C. J. Fowler, the man referred to as "logic on fire," composed the convention team. The people laughed and cried in response to this lisping prophet like a field of grain moves with the summer breezes. It was at this convention that copies of *A Pitcher of Cream* and *Bees in Clover* fell into my hands and were eagerly read with all the fascination of a boy's book of adventure. Little did I dream that it would be my privilege to be closely associated with this "best loved man of the holiness movement," in many an experience which warms my heart even to this day.

Tears and laughter were never far apart in the equipment of this man who was ever seeking to persuade men to the way of holiness experience, holiness schools and holiness periodicals. "Uncle Bud" loved people, that was one reason why people loved him. No kind act was ever lost upon him. His appreciations of sermons, brown-backed biscuits or babies, while always expressed in superlatives, were always sincere and wholesome.

At the General Assembly of 1936, held in Kansas City, Missouri, one of the high points of that gathering was the public greeting exchanged between Dr. H. C. Morrison and "Uncle Bud." After an embrace of each

*now in Heaven*

*of these dear old saints*

other that thrille
tears, Dr. Morriso
Columbus could b
he wanted the wo
had discovered Bu

I have never
lating of a wholes
and perhaps the l
that which had to
"Uncle Bud" lov
eating them and

My family v
"Uncle Bud's" gu
is located in the
Mountain stream
which abound wit
man's paradise.
baited by our ho
responded to the
left nothing but
perfect host, wall
hot fish in one ha
ling and shouting
saying "Praise the
ORVAL J. NEASE,

It was my |
Robinson when a
ness University a
bers of the same

and noted his personality, I had a let-down feeling. "This crowd will be disappointed," I said to myself. He had preached only a little while, when I felt my heart strangely warmed. "I guess it won't be bad after all," I thought. Soon I was sitting on the edge of the seat listening to every word. I was caught in a wave of holy hilarity that swept over the entire crowd. For forty minutes "Uncle Bud" held my attention. I was utterly forgetful of all about me.

I wept as he told of the hunger and poverty of his boyhood days. I shouted for joy when he told of his marvelous conversion and the night following when he lay under the wagon and watched the stars as God brought them out on dress parade to celebrate his conversion. My face burned with shame for the ministry as he told how he cut cordwood for fifty cents a cord, when he was so weak and sickly that he could hardly swing an axe, then took the money and gave it to his preacher who in turn went to the store and came back smoking a long black cigar. I lived my own experience of sanctification anew as he told of the skimming process God took him through, and of how he shouted himself hoarse amid the glistening corn blades in his own field. I sat up, stung with the lash of truth, when he pictured the difference between true and false professions by telling of the old farmer's pigs that could tell the difference between the loaded and the empty wagon. The rattle of the wagons revealed the truth, loaded or empty.

With eyes red from crying, sides aching from laughter and my conscience smiting me for not praying more

for the service and the salvation of souls, I became aware that the sermon was over and that "Uncle Bud" was ready to make an altar call. I felt certain that no one would come, because he had said nothing about the horrors of hell, the terrors of the judgment day nor of the dangers of grieving the Spirit away. But when he said, "Come on," they came and they came in a hurry. They were all broken up. I had never heard such praying before. About fifty men and women prayed through that night. That service convinced me for all time that "Uncle Bud" was unique, Spirit led and in a class by himself.—D. I. VANDERPOOL, *Superintendent, Northwest District.*

---

My father had gone to heaven. My mother was sick. The year was 1914. I was trying to support my mother and two sisters. Mother craved strawberries, but they were twenty-five cents a box, and that was much beyond what I could spare out of my small earnings. On Sunday I prayed the Lord to help me get the strawberries for Mother. Monday morning on the way to the street car I passed "Uncle Bud's" house—he lived but a half block from us. He was out spading in his front yard. As he came over to greet me he took fifty cents out of his pocket, handed the coin to me, and said, "Here, daughter, take this and buy your mother some strawberries." No one but the Lord had told him to do this. I cried while telling him about my prayer, and when I got home that evening Mother had a full crate of strawberries that "Uncle Buddie" had bought

and sent over. He was a grand neighbor and friend.
—Mrs. J. E. McAbe Kiemel.

———

Preaching in my pulpit at the Oakland First Church
of the Nazarene, Bud Robinson said, "Modernism is
being disrobed and its skeleton riddled with sanctified
fire." Preaching on "Holiness" at the Nazarene Camp
Meeting in Pasadena, California, some years ago, he
said, "Inbred sin is sin in the breed. It manifests itself
through devil-possessed men, in a scrap, for instance."
From the First Church of the Nazarene pulpit of Pasa-
dena, he said, "Sin is moral insanity compounded. Two
young men while I was holding meetings in Portland,
Oregon, stole an automobile, then took on liquor, crossed
the drawbridge that divides East and West Portland,
but on coming back, the drawbridge had swung around.
The tender yelled to them to stop, but they cursed him
and broke the chain, and into the river fifty feet below
they plunged. Their bodies were taken out of the Wil-
lamette River five miles below, the next day." On an-
other occasion, when "Uncle Bud" was urging Chris-
tians to pray and serve God, while carrying on their
business profession at the same time, he used the bull-
dog as an example in action. He said the reason for a
bulldog's nose being so high up, is "so he can hang on
and breathe at the same time." In preaching from the
text, "The More Excellent Way," from a holiness camp
meeting platform in southern California, "Uncle Bud"
said, "I could quote 6,000 verses of Scripture from mem-
ory when at my best, and have preached twice, and

committed to memory as many as 75 verses of scripture a day."

Preaching from the Church of the Nazarene in Tulare, California, on "Holiness," he said, "Leaven is a type of sin. Pride in the heart of man is the only thing that makes everyone else sick, except him."—FRED M. WEATHERFORD, *Pastor*, Medford, Oregon.

———

Bud Robinson did not have school advantages, but he had a fine mind and made good use of it. Of course it is his amusing sayings that we remember. Once in our Nashville camp meeting he said, "If I wanted to be worldly wise, I would join the evolutionists—they say we came from nothing. Then if I wanted to stay with this crowd, I would join Mrs. Eddy—they say we are nothing. Then if I decided to follow them, I would join Pastor Russell's outfit—they say we are going to nothing. There you have it: we came from nothing, we are nothing and we are going to nothing." "Uncle Bud" said, "Once when I was younger than I am now, I went to a place to hold a meeting, and things did not just suit me. I took my text and for about an hour I skinned both the saints and the sinners, and nailed their hides to the wall, like I used to do coon hides. On my way home, the Lord came and climbed into the buggy with me, and asked for the privilege of saying a few words. He said, 'Now, Bud, you have skinned the people and nailed their hides to the wall: what are you going to do with these hides?' I saw the point and was a little more careful in my skinning ever afterward."

Speaking of this machine age, Bud said, "Humanity is divided into two classes: the quick and the dead, for all who are not quick are dead." He told about the lawyer who asked him many questions he could not answer. Finally Bud said to the lawyer, "Well, if you are so smart tell me why a pig eats so much." The lawyer was nonplussed, and Bud said, "That's easy. He eats so much because he is trying to make a hog of himself." —H. H. WISE, *Pastor*, First Church, Nashville, Tennessee.

---

It was my privilege to make one of the last extensive tours with "Uncle Bud" that he ever made in the interests of the kingdom. It was in the summer of 1941. We traveled together for eighteen days. I was amazed at the endurance of his physical strength and still more amazed at the vigor and clarity of his mind. It was a real privilege to be with him. The Crusader Quartet of Eastern Nazarene College traveled in the party also. All of them look back upon those days with "Uncle Bud" as one of the high points in their experience.

As I reflect upon my association with him in those days and my knowledge of him through the years, there are two things that make an indelible impression upon my mind and spirit. First, was his love for Christ and his gratitude for the great experience of salvation which transformed his life and made him the unique person that he was and gave to him the great ministry which resulted in so much good being done. The second thing

that impressed me was the fact that he was possessed of a really great mind. It is true that he was denied the privileges of education in his early life and never knew what it was to attend the institutions of learning which have made such large contributions to the lives of others. Nevertheless, when he dedicated himself wholly to God, he had much to offer for there was a keen mind that God saw fit to use in a very outstanding way. In intellectual capacity, he was superior. If all his quaint, wise sayings could be compiled, they would make a remarkably sound and inspiring philosophy of life. There was wisdom in his words. Their effectiveness was greatly increased by the uniqueness of his mind and personality. They held the interest of multitudes of people because they were spoken in his own distinctive style. He had great capacities and they were dedicated wholly to God.

There was one incident which he related to us privately as we traveled along the highway one day which made a great impression upon me. It shows his keen insight into human nature and, at the same time, his wonderfully good and Christlike spirit. He told us of a letter he had received some time before from a brother, whom I shall not name, in which the writer took occasion to criticize "Uncle Bud" severely. He discounted greatly the "Good Samaritan Chats" in the *Herald of Holiness*. He accused him of being insincere in always boosting everyone who entertained him and ridiculed with stinging sarcasm to a length of ten typewritten pages. "Uncle Bud" said that at first he was

tempted to write him in the same vein, but he decided
not to answer for a few days and when he did, this is
the substance of what he wrote:

"Dear Brother:

"I received your letter a few days ago and I wish
to thank you for it, for it has been a blessing to me in
this way. I have decided that people generally are so
much peeled and skinned and blistered that from now
on I shall do my best to say more kind and encouraging
words to them and about them than ever before, for I
believe they need all the encouragement that they can
get. Many people seem to appreciate my 'Good Sa-
maritan Chats' in the *Herald*, and I consider this suf-
ficient justification for continuing to write them. Thank
you for your letter and God bless you."

"Uncle Bud" said he did not hear from the brother
for some time but after several weeks, he wrote to
"Uncle Bud" and humbly apologized for his previous
letter. I am sure that all of us can learn a lesson from
that reply. He knew how to use cutting sarcasm him-
self. There were plenty of faults in the man who wrote
the letter for him to point out and magnify, but instead
he chose rather to make his stinging words a means of
grace to his own soul and used them as an inspiration
for more words of good cheer to the people who thronged
his pathway as he journeyed through life.—G. B. WIL-
LIAMSON, *President*, Eastern Nazarene College.

———

Once when I expressed concern that more souls
were not finding God, and was low in spirit, I asked

"Uncle Bud" why it was so.  He said, "Son, remember that when you do your best, and plant with tears, holiness seed never rots."  One time "Uncle Buddie" told us about preaching in a street meeting.  A man in the crowd got disgusted with the meeting and spit right in "Uncle Buddie's" face, and "it ran down over my shirt bosom," he said.  Someone in the crowd to which he was talking said, "And what did you do, 'Uncle Bud'?" "Uncle Bud" replied, "Well, I took my handkerchief and wiped it off.  What would you have done?"—GLENN GRIFFITH, *Superintendent*, Idaho-Oregon-Utah District.

---

While I was a student at Asbury College, "Uncle Bud" visited the school.  One day as I was coming from the dining hall he called to me and said, "Roy, I have had an accident with my watch.  I wonder if you could get one for me before the evening service."  I promised that I would.  Late in the afternoon I went to his room where I found him on his knees before his open Bible. I started to withdraw so as not to interrupt him, when he said, "It is all right, son.  Come right in, I was just talking to Father about the service tonight, and He has just told me that there will be twenty at the altar." After chatting a few minutes longer about common interests back home in Pasadena, I left, realizing that I had been on holy ground and was somewhat dazed over his statement that bespoke such intimacy with the Father.  I looked forward to the evening service with wonderment.  Would twenty people seek God that night? I shall never forget the feeling that I experienced as the

twentieth seeker did bow. "Uncle Bud" really had heard from his Father. This experience made a profound impression on me as a lad looking forward to the Christian ministry.

In a recent conversation with Dr. Donald Householder, associate pastor with Dr. Bob Schuler of Trinity Church, Los Angeles, the following incidents were related to me. In the midweek prayer service of the above church, when news was received of the death of "Uncle Bud," the order of service was automatically changed and a spontaneous testimony meeting began among a surprisingly large number in the congregation who had either been saved or greatly blessed under his ministry. One of the most interesting stories was that told by Dr. Schuler himself. Friends of Dr. Schuler will remember that some years ago, due to a technicality, the court sentenced him to a prison sentence in Los Angeles. "Uncle Bud," having heard of it prayed, "Lord, help the Supreme Court to immediately consider Bob Schuler's case and release him so that he can attend his General Conference which is to meet in Texas. They need him down there. When he arrives have the brethren ask him to preach." The following morning in Sacramento the Supreme Court Justice said, "Let's consider this Bob Schuler case even though it isn't on the docket." They did, reversing court action, called Los Angeles and asked that Bob Schuler be released. Dr. Schuler caught the first plane for Texas and as he walked in for the opening session the powers that be said, "Here is Bob Schuler; he's just out of jail and

ought to have something interesting to tell us. Let's ask him to preach." Dr. Schuler testifies that "Uncle Bud" prayed him out of jail.

In this same meeting Mrs. Clifton, mother of the proprietor of the famous Clifton Restaurants, testified that, many years before in the Midwest, while attending a camp meeting where "Uncle Bud" was the evangelist, she found herself financially embarrassed in that she lacked funds to pay her hotel bill to the amount of five dollars. She made this a matter of earnest prayer. At the close of a service, when most of the people had left the auditorium, she returned to get her shawl that she had left on the platform. "Uncle Bud" was standing by the pulpit, and as she picked up her shawl said, "Sister, have you been asking the Lord for some money?" Surprisedly she said she had, as he reached into his pocket and took from it a five dollar gold piece, adding that the Lord had told him that someone in the service that afternoon needed five dollars. When he asked the Lord how he might know who among these hundreds of people needed five dollars He said, "You wait on the platform at the close of the service and I will send a lady to get a shawl." After giving her the money he said, "Sister, let me tell you how I got that money. Some time ago while in the West I was invited to dinner. When I turned my plate over at the dinner table I found a five dollar gold piece under it. As I picked it up the Lord said to me, "Bud, this is not for you, it is for someone in the Midwest. So don't thank me for it,

sister, the Lord gave it to me to give to you."—Roy
Cantrell, *Superintendent*, Minnesota District.

---

Mr. —— had distinguished himself as an avowed
infidel. His library shelves were filled with books
written by unbelievers and skeptics. This blatant de-
fier of God and rejecter of the Bible, with his elegant
home and the broad acres beyond it, was the dominant
figure in his community. Into this neighborhood a stut-
tering, stammering, ignorant young Irishman came to
hold a brush-arbor meeting. At the close of a service,
an elegantly gowned young woman stepped forward
and said, "Brother Robinson, will you grant me a fa-
vor?"

Looking at her earnestly, Bud Robinson replied,
"If it ith in my power, thister, I will."

She said, "It is something you can do. I want you
to talk to my father about his soul."

Bud said when he thought of the great man and
his elegant home, he almost fell upon the ground. But
he had given his promise and he could not draw back.
The following morning he arose very early, had a long
season of prayer, and visited in a number of homes to
get his courage up, then rang the bell on the door of
the infidel's mansion. While standing there thinking
what he would say when a servant opened the door, it
suddenly swung ajar and the big infidel confronted him.
Bud was so dumfounded he stood there in confusion
unable to open his mouth until the man said, "Good

morning," to which Bud stammered out, "Good morning, thir," and went no farther.

The man looked amused as he asked, "I believe your name is Robinson, isn't it?"

Bud said, "Yeth, thir, that's my name," and stopped.

The man interrogated, "Aren't you conducting a meeting down in the brush arbor?"

"Yeth, thir, that's what I'm doin'," replied Bud.

"Won't you come in and have a seat?"

"Yeth, thir, if you please." Bud entered the elegantly furnished home, sank into a chair and was so abashed he had no idea what to do with his hands or his feet. He sat there confused and bewildered. The man endeavored to engage him in conversation and asked, "What do you think of Demosthenes?"

Bud looked up earnestly and said, "Who wuth he?"

The man explained and then asked him, "What is your opinion of the Darwin Theory?"

"Whath that? I never heard of it." When the man explained, Bud replied, "I don't know, but I think Mr. Darwin wath wrong, because I can remember as fur back as my grandmother, and she never looked like a monkey." Then it was Bud's turn. Looking the big infidel right in the eye, he asked him, "Brother, what do you think of Jesuth Christ?"

It was the infidel's time to stammer, but before he could reply, Bud said, "Leth pray," and down on his knees he went. His stammering tongue became a flame of fire that scorched that infidel's soul like molten lava. When Bud arose from his knees wiping the tears out

of his eyes with his coat sleeve, he extended his hand
and said, "Brother, come to the meeting," and walked
out.

That night when he arose to preach, he was amazed
to see the infidel on the front seat. But he stammered
through his sermon, gave an altar call, and down went
the infidel in the straw and prayed through to God.

Later this man wrote his experience for the public
press and declared that he had never had any trouble in
confusing any person who discussed religion with him;
"But," said he, "when I opened the door that morning
and looked at that poor, ignorant Irishman, something
struck my heart that I could neither gainsay nor throw
off." I thought, 'Surely God does not think more of that
ignorant crippled Irishman than He thinks of me.' So
I decided to find God or die in the effort, and that is
why I am a Christian today."—J. T. UPCHURCH, Dallas,
Texas.

It was during a revival meeting in our home town,
Duncan, Oklahoma, that I first met "Uncle Buddie."
He was to be entertained in my father's home. How
anxiously we awaited his arrival! It was late when he
reached town, so he went directly to the service. The
big tabernacle was well filled and the speaker kept the
attention of his crowd from the beginning to the end.
My father, being ill, was unable to attend—a disappoint-
ment this was as he had heard so much of about "Uncle
Buddie." When we reached home "Uncle Buddie"
stepped into the sickroom, father expressed his keen
disappointment at not being able to attend the service

and asked what his subject was,. "It was holiness, Brother Peck," was the reply. At this he repeated his text and began to laugh and cry and quote scripture till Father forgot his illness, sat up in bed and laughed and cried with his guest. "Uncle Buddie" repreached his message with as much interest as at the old tabernacle.—FLORENCE DAVIS, *Vice-president*, General Council W.F.M.S.

---

Several years ago while District Superintendent in the East I was privileged to take "Uncle Bud" to our home in New York state for a service. At that time there was no church in Brooktondale but services were being held in our home anticipating a church. "Uncle Bud" spoke to a crowded cottage, every nook and corner being filled with interested listeners. It was several years later that my mother-in-law was talking with "Uncle Bud," telling him of the new church that had been built across the road from the cottage where he spoke that night. In an effort to explain just where the church was built she reminded him that the site was directly across the street from the house. "Oh, yes," replied "Uncle Bud." "You mean where that field of buckwheat stood." This incident tells of his photographic mind and memory that enabled him to so endear himself to the personal lives of thousands of people across the country.—H. V. MILLER, *General Superintendent*.

---

As a youth of seventeen, I was stricken with pleurisy while working on the farm and confined to the house

for several weeks. For three years I had been resisting
the Spirit of God and fighting a call to preach. The in-
tensity of the conflict which raged within was largely
responsible for my breakdown in health. Having ex-
hausted the limited reading matter in the home, I picked
up Bud Robinson's *Honey in the Rock* and began to
read his unique sermons on holiness. As I read my
fear of the implications of surrender to Christ and my
dread of the ministry were replaced by a great hunger
for God and a desire for the beautiful experience which
he described. It was only a short time until I was defi-
nitely saved in my own bedroom, and two weeks later
was sanctified at Cleveland Bible Institute where I had
registered to prepare for the ministry. Several years
went by before I saw Bud Robinson, but the reading
of his book marked a definite change in my life, and
more than any other one thing, influenced me toward
holiness. — J. C. ALBRIGHT, *Pastor*, West Somerville,
Mass.

---

Back in the early eighties of the past century, Texas
was considered a wild, unconquered domain. Even at
that late date the desperadoes of other states sought safe-
ty in Texas localities where the six shooter spoke more
forcefully than the statutes enacted in Austin. A cer-
tain south Texas town was ruled over by a lawless
gang that had no special regard for man or God. Yes,
it was a tough town until an ignorant, unlettered young
cowboy rode into town on a mangy pony of unknown
breed.

This lone cowboy carried no visible weapons of war and was not seeking trouble but trouble came when he alighted from his saddle and announced he had come to conduct a revival meeting. At first he was accepted as a joke, but when the people began to respond to his messages, the toughs of the community decided the affair had gone far enough and they had better take a hand in it.

Their heckling methods of interference were disturbing the meeting and interfered with some people's attendance of the services. The cowboy preacher bore with it patiently and good-naturedly for awhile, then quietly decided that the gang must be dealt with, so he retired to a secluded spot to pray about it. On his way back to his room he passed the home of the ringleader of the disturbers and saw him sitting on his porch.

Walking on, as if to pass the house, he came opposite the gate, turned abruptly, passed through the gate and walked up to the town tough. Looking at him earnestly, he said, "Good morning, brother, are you saved?"

The man answered with an oath, and declared that he had no confidence in the preacher or in anything he said, and wanted nothing to do with him or his kind.

The preacher asked, "Brother, do you want to go to hell?"

To which he received the reply, "Yes, I would as soon be there as anywhere else."

"Then," said the preacher, "if you want to go to hell and won't let God save you, I am going to git right

down on my knees and ask God to git you off on the first train, because you and your gang are disturbing the meeting and are keeping others from gitting saved."

Down on his knees the cowboy went and began to pray at the top of his voice, and he told God how mean this town tough was, and how he had borne with him and tried to get him saved, "but he won't git saved, and says he wants to go to hell. I beg Thee, dear God, to git him off at once, so we can go on with the meeting."

The prayer was concluded with a shout and, picking up his hat, the cowboy passed through the gate and walked hurriedly to his room. He had scarcely closed the door when the wild cries of a woman rang through the air. Opening his door, he looked out and saw the wife of the tough coming right down the middle of the street, with both hands raised above her head and screaming at the top of her voice, "God has killed J. C. in answer to Bud Robinson's prayer."

A crowd quickly gathered at the home of the town tough, and found him lying on the ground with an overturned chair beside him.

The woman declared her husband, J. C., was sitting on the porch when he tipped his chair back, lost his balance, and plunged head foremost to the ground. She said she rushed to him as he was breathing his last breath, then wailed, "God killed him in answer to Bud Robinson's prayer."

After the dead man had been laid out, and prepared for burial, the woman went to Bud Robinson and pleaded with him to pray for her husband. She said,

"God killed him in answer to your prayer. He was a wicked man, but I believe if you will ask God to bring him back, He will answer your prayer, and will give J. C. one more chance."

Bud replied, "Sister, he was a wicked man, and made other men wicked. He said he wanted to go to hell and to hell he's gone and I guess he'd better stay there."

But the woman continued to plead and beg until Bud picked up his Bible and said, "Sister, I feel sorry for you. I don't know whether God will hear me or not, but for your sake, I'll go and pray for him."

Some of those present declared they never heard such a prayer fall from human lips as Bud Robinson prayed beside that dead man's body. While he was praying, the man threw the sheet aside and sat bolt upright and the people began to shout and praise the Lord.

The place of worship was packed that night. Some wept, some shouted, while others looked on in wonder and amazement. At the conclusion of the sermon, J. C., the town tough, rushed to the altar of prayer, fell upon his knees weeping, then suddenly sprang to his feet, rushed out of the house, sprang upon the first horse he could reach and rode madly down into the swamps from whence he never returned, and was never heard of again, but the revival swept on and many were saved.

The community was changed from one of the toughest spots to a revival center because Bud Robinson came to town and dared to believe God.—J. T. Upchurch, Dallas, Texas.

We were driving along the beautiful highway en route to a meeting. Bud was so quiet I thought he was asleep, so I drove along singing a few lines from first one old hymn and then another. Presently "Uncle Bud" chuckled, and said, "Doc Jim, you are a wonderful singer. In fact you have them all beat: you can sing a half dozen songs with one tune." It was "Uncle Bud's" last appearance at the Texarkana Holiness Convention. He said, "I want to pray for you all." When he came to me, he said, "There is old Doc Jim. You know, Lord, how we love him. If the old devil, the old dirty devil that he is, ever sticks his head over on Doc Jim's side of the fence to tell him we don't love him; please help Doc Jim to just take the biggest ear of corn he can find in the land of Canaan and crack the old devil on his old dirty head, and tell him to just keep his head on his own side of the fence." That prayer has blessed me many times. December 15, 1941, we closed our tour of the Western Oklahoma District, not knowing it would be "Uncle Bud's" last with us. We all bade him good night, and said, "Come again soon." "Uncle Bud's" car rolled away into the night on the way to his sunny California home. But we shall see him again in the morning when our day's work is finished.—J. W. Short, *Superintendent,* Western Oklahoma District.